The Roman Banquet

Images of Conviviality

Dining was an important social occasion in the classical world. Scenes of drinking and dining decorate the wall paintings and mosaic pavements of many Roman houses. They are also painted in tombs and carved in relief on sarcophagi and on innumerable smaller grave monuments. Drawing frequently upon ancient literature and inscriptions as well as archaeological evidence, this book examines the visual and material evidence for dining throughout Roman antiquity. Topics covered include the relationship between Greek and Roman dining habits, the social significance of reclining when dining in public, the associations between dining scenes and death, the changing fashions of dining at the end of antiquity, and the use of banquet scenes in the art of early Christianity. Richly illustrated, *The Roman Banquet: Images of Conviviality* offers a full and varied picture of the role of the banquet in Roman life.

Katherine M. D. Dunbabin is a professor of classics at McMaster University in Hamilton, Ontario. A scholar of the British School at Rome, a Humboldt Fellow, a Visiting Fellow at All Souls College, Oxford, and a Jackson Lecturer at Harvard University, she is also the author of *Mosaics of the Greek and Roman World*.

The Roman Banquet

Images of Conviviality

Katherine M. D. Dunbabin

McMaster University

CAMBRIDGE
UNIVERSITY PRESS

PUBLISHED BY THE PRESS SYNDICATE OF THE UNIVERSITY OF CAMBRIDGE
The Pitt Building, Trumpington Street, Cambridge, United Kingdom

CAMBRIDGE UNIVERSITY PRESS
The Edinburgh Building, Cambridge CB2 2RU, UK
40 West 20th Street, New York, NY 10011-4211, USA
477 Williamstown Road, Port Melbourne, VIC 3207, Australia
Ruiz de Alarcón 13, 28014 Madrid, Spain
Dock House, The Waterfront, Cape Town 8001, South Africa

http://www.cambridge.org

First published 2003

Printed in the United Kingdom at the University Press, Cambridge

Typefaces Bembo 11/14 pt. and Cochin *System* LATEX 2$_\varepsilon$ [TB]

A catalog record for this book is available from the British Library.

Library of Congress Cataloging in Publication Data
Dunbabin, Katherine M. D.
The Roman banquet: images of conviviality / Katherine M. D. Dunbabin
p. cm.
Includes bibliographical references and index.
ISBN 0-521-82252-1
1. Gastronomy – Rome – History. 2. Dinners and dining – Rome – History.
I. Title.
TX641 .D85 2003
641'.01'30937 – dc21 2003043509

ISBN 0 521 82252 1 hardback

For
William

Contents

Colour plates follow page 60.

List of Illustrations

BLACK-AND-WHITE FIGURES

Preface

My involvement with Roman dining customs began when my husband, organizing a conference on symposia, demanded that I contribute a paper on Roman dining rooms. At the time I was beginning a book on mosaics and did not entirely welcome the interruption, being in some doubt as to whether I would have enough to say. The path on which I then embarked led eventually from the layout of mosaics and the function of the rooms they decorated, to the illustrations of dining scenes, and to the relationship, often far from straightforward, between these scenes and the evidence for actual dining practice. In the process, I found myself learning much about the development of Roman iconography and taking a new look at the social role of Roman art. Subsequently, it has become clear how well adapted was the theme of dining to an approach that would bring the visual and artefactual material together with the evidence of other sources, both literary and epigraphic. The study of ancient dining is fashionable today, as classicists have followed anthropologists and sociologists in recognizing the central place of food (and drink) and foodways in the structure and fabric of society. But this recognition is not a discovery of the New Historicism of the late twentieth century, but a revival of a scholarly interest that can be traced back to the Renaissance, and which drew, not only on the extensive literary sources that deal with dining in antiquity, but also on the artefacts and works of art that illustrate its practice. My own aim in this study has been twofold: to explore how art can be used as evidence for social and cultural history, while giving due weight to the conventions and pressures that governed the production of the images themselves.

The genesis of this book was an invitation from the Department of the Classics at Harvard to deliver the Carl Newell Jackson Lectures there in 1998. The original four lectures have been expanded into six chapters, but I have maintained the basic format and division of the subject matter, and resisted the temptation to try to include a much wider range of material and to cover topics outside the scope of the lectures. The week that I spent in Harvard in October 1998 was a memorable experience, combining productive academic discussions with frequent practical demonstrations of the importance of convivial commensality. I am grateful to the department, not only for making that week so enjoyable, but also for its subsequent interest in the publication and especially for the contribution of a generous subvention, which has made possible the inclusion of the colour plates. My thanks go especially to the successive Chairs of the Department, Greg Nagy and Richard Thomas, and to Kathleen Coleman, for continued encouragement and assistance.

Much of the writing of the book took place in another distinguished institution of higher learning that appreciates the role of dining in collegial life. From January to June 2001, I was fortunate to hold a Visiting Fellowship at All Souls College, Oxford; it would be difficult to imagine a more congenial atmosphere and surroundings in which to accomplish the task of finishing work on a manuscript. Much help has been provided in Oxford over the years by the staff of the Ashmolean Library, now the Sackler. In Rome, I benefited from the hospitality of the British School and the American Academy, as well as from the facilities of the German Archaeological Institute Library and Fototeca.

The travel essential for a study such as this, and the other expenses of research, have been supported by a grant from the Social Sciences and Humanities Research Council of Canada; I acknowledge with gratitude the continuing support of the Council. The cost of photographs and publication permission has been assisted by a grant from the Arts Research Board of McMaster University.

In addition to the original lectures at Harvard, parts of this book have been presented in public lectures at the University of Toronto; the German Archaeological Institute and the British School at Rome; the University of Minnesota; the Università di Perugia; Royal Holloway College, London; the University of Nottingham; and the Institute of Archaeology and All Souls College, Oxford; as well as to the Association for the Study and Preservation of Roman Mosaics. On each occasion, and often in very different ways, questions from the audience, and subsequent discussions with friends and colleagues, have challenged my ideas and helped to clarify my thinking.

I am grateful to all the museums, institutions, and individual scholars who have provided photographs, answered my enquiries, or granted me permission to reproduce illustrations. Acknowledgement is made where appropriate, in the captions to the illustrations and/or in the notes, but I want to mention here the assistance of the following: Jessica David (Art Resource, NY); Shari Taylor Kenfield (Princeton); A. Rieche (Bonn); V. Mesquita (Lisbon); P. G. Guzzo (Pompeii); S. De Caro (Naples); W. Jashemski; E. Cicerchia, F. Buranelli (Vatican); J. Packer; H. R. Goette (Athens); M. Maass (Karlsruhe); E. Milleker (New York); Valerie Scott, A. Giovenco (Rome); G. Migatta (Rome); T. Fiedler (Berlin); R. Giglio; H. Hellenkemper (Cologne); F. Bisconti (Rome); and L. Becker (Worcester MA). Special thanks for help in obtaining photographs, for advice and assistance, or for fruitful and enjoyable discussions of Roman dining go to Janine and Jean-Charles Balty, Alix Barbet, Amanda Claridge, Marlia Mundell Mango, Zeev Weiss, and Roger Wilson; also to Janet Huskinson and an anonymous reviewer for helpful suggestions.

At McMaster, I want to acknowledge my debt to the many current and former students who have assisted me in my research, and especially to John Tamm, Anna Bart, Jan-Mathieu Carbon, and Amanda Cooney. Carmen Camilleri has been a constant source of help with the practical details of preparing a manuscript, as with much else.

This book is dedicated to my husband, William Slater, who first impelled me to undertake the study of Roman dining, and has continued to provide support, encouragement, and sometimes stimulating disagreement ever since.

Ancaster, Ontario
September 2002

The Roman Banquet

Images of Conviviality

Introduction

An obscure Roman named C. Rubrius Urbanus, probably at some point in the first or early second century AD, ordered a handsome grave monument, the upper part carved with a figured scene, the lower with a long inscription (Fig. 1).[1] The monument was intended, the inscription states, for himself, Antonia Domestica his wife, and Cn. Domitius Urbicus Rubrianus his son, as well as for his freedmen, freedwomen, and their descendants. What made it unusual was not so much the figured scene but the verse inscription below, by which he sought to explain and describe its significance:

> While life was granted him, he always lived sparingly
> saving for his heir, mean too with himself.
> Here he bade himself be artfully sculpted by skilful hand,
> merrily reclining after his own demise,
> so that at least he might rest recumbent in death,
> and enjoy assured repose there lying.
> His son sits on his right, who followed soldiering
> and died before the sad funeral of his own father.
> Yet what good does a merry image do the dead?
> This is the way they ought rather to have lived.[2]

To the modern observer, these verses, composed or commanded by the deceased, strike a discordant note. A gravestone should not be a 'merry image', yet it is so described; and it is the futility of its very cheerfulness which engenders the pessimism of the final lines, and devalues the thriftiness

and self-denial of the opening. Rubrius Urbanus clearly thought a great deal about the significance of what was carved on his tomb. The figured scene showed the father reclining on a couch beside a table, holding in his hands a wreath and a cup; while the son, in military uniform, is seated and holds out his hand to his father. For a Roman observer of the time, both image and verses spoke a familiar language, but one capable of evoking a wide range of associations. The stone makes use of a visual theme well known in funerary contexts, which will be discussed in Chapter 4 of this book: the single banqueter reclining on a couch, a scheme known to modern scholars as the Totenmahl motif. The verses themselves emphasize by repetition the concept of reclining, both at a banquet and in the repose of death; and open with a Horatian theme, the futility of saving what one's heir will enjoy, only to invert it poignantly with the death of that heir, and end with the further paradox that one's own tomb should teach one to enjoy life.[3]

As this stone shows, a picture of a banquet could mean many different things to a Roman viewer. Convivial eating and drinking formed one of the most significant social rituals in the Roman world, inextricably interwoven into the fabric of public and domestic life. Communal banqueting played an essential role in the relationships of members of the elite with their dependents, with their potential supporters, or even with their entire community, as well as in their interaction among themselves; it marked the humbler gatherings of the nonelite, of freedmen, and even sometimes slaves, in their guilds and religious associations. The banquet recurred in several different guises in funerary rituals and the commemoration of the dead; and it characterized religious festivals, large and small.[4] If we know little about the normal family meal in antiquity, at least as we understand it today, we have a great deal of information from written texts about the dinners at which the rich entertained their friends, associates, or clients. Such texts are found in works as diverse as the letters of Cicero, Pliny the Younger, or at the end of antiquity Sidonius Apollinaris, describing (with approval or otherwise) dinners they have attended or given. Juvenal or Martial satirize inhospitable and arrogant hosts; Martial composes epigrams on the gifts of food, tableware, and other objects that might be distributed at the Saturnalia; and Statius or Martial provide sycophantic accounts of imperial banquets. Horace's sympotic poetry celebrates the very ambience of its purported performance; the dinner of the rich and vulgar freedman Trimalchio is the setting for Petronius' extravagant fantasy; and the recipes preserved under the name of Apicius recall the complexity of the cuisine. Greek literature has in the

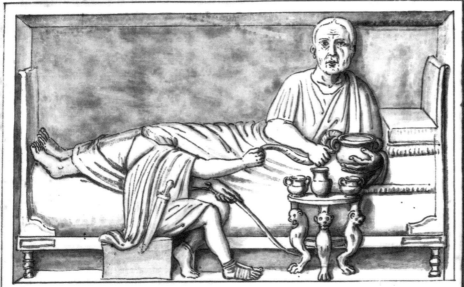

QVI·DVM·VITA·DATAST·SEMPER·VIVEBAT·AVARVS·HEREDI·PARCENS·INVIDVS·IPSE·SIBI
HIC·ACCVMBENTEM·SCVLP·GENIALITER·ARTE·SE·IVSSIT·DOCTA·POST·SVA·FATA·MANV
VT·SALTEM·RECVBAS·IN·MORTE·QVIESCERE·POSSET·SECVRAQVE·IACENS·ILLE·QVIETE·FRVI
FILIVS·A·DEXTRA·RESIDET·QVI·CASTRA·SECVTVS·OCCIDIT·ANTE·PATRIS·FVNERA·MAESTA·SVI
SIC·QVID·DEFVNCTIS·PRODEST·GENIALIS·IMAGO·HOC·POTIVS·RITV·VIVERE·DEBVERANT
C·RVBRIVS·VRBANVS·SIBI·ET·ANTONIAE
DOMESTICAE·CONIVGI·SVAE·ET·CN·DOMITIO
VRBICO·RVBRIANO·FILIO·SVO·ET·LIBERTIS
LIBERTABVSQVE·POSTERISQVE·EORVM·ET·M
ANTONIO·DAPHNO·FECIT

Figure 1 – Funerary relief of C. Rubrius Urbanus, drawing from collection of Cassiano dal Pozzo. London, British Museum, Franks 364. ©Copyright The British Museum.

unwieldy tomes of Athenaeus and the chatty table-talk of Plutarch preserved material about the customs, lore, and culture of dining from the previous centuries. These sources, and the many others that survive, can naturally tell us much about actual dining practices and the cultural ideals and expectations inherent in banquets of this type, but they have inevitable limitations. They are often misleading as sources for contemporary practice, filled as they are with satirical exaggeration and with archaizing and idealizing references; and all authors, even those that give the greatest appearance of objectivity,

write with their own biases. Moreover, all write from the viewpoint of one particular section of Roman society, the educated upper-class male.[5]

Other types of evidence can offer more varied insights. Many hundreds of inscriptions, mostly on gravestones like that of Rubrius Urbanus or on the bases of honorific statues, allude in one way or another to the banquet; their lack of detail and often conventional formulation are compensated by the light they cast on the assumptions and ideologies of a much wider circle than those who produced the written texts. In addition, the archaeological record provides a wealth of material evidence: architectural remains of rooms that appear to have been designed for dining, evidence for their furnishing and layout, and vessels and apparatus used at the banquet. Many works of art illustrate scenes of dining and drinking, and these form the primary focus of this book. The analysis and interpretation of these scenes cannot, of course, stand alone; they need to be combined with the evidence of the archaeological material and with that of the written sources, both literary and epigraphic, to provide a fuller picture of the social and cultural context.

I choose to use the word 'banquet' as a generic term for the festive consumption of food and drink in Roman society, although in English it has implications of a grand formal occasion that does not always correspond to the events under discussion. The more neutral 'dining' might seem preferable, except that it seems to place the emphasis predominantly upon the consumption of food, to the exclusion of the drinking party. Although the latter played a much smaller role in the Roman world than the *symposion* had in the Greek, the Greek tradition nevertheless had a profound impact upon the iconography of Roman art, and many of the figured monuments represent drinking rather than eating. The most general Latin term is *convivium*, which means literally 'living together'; it conveys associations of festivity and conviviality, with the consumption of food and drink implicit but not overtly stressed, for which 'banquet' seems the best English equivalent. Similar associations can also be conveyed in Latin simply by the use of words meaning 'to recline', as Rubrius Urbanus does in describing the image on his tombstone. The Romans, like the Greeks, lay down to eat and drink in good society, or on formal and ceremonial occasions; and this characteristic position was sufficient in itself to identify the convivial context to which the words refer.[6]

Modern interest in the dining customs of Greek and Roman antiquity began with the antiquarians of the Renaissance. Several scholars of the sixteenth and seventeenth century left learned works with titles such as *Antiquitates convivales* or *De Triclinio*, in which the literary sources were

exhaustively combed for information about ancient, predominantly Roman, dining practices.[7] The nineteenth- and early twentieth-century writers of handbooks about Roman private life also compiled detailed studies of Roman behaviour on these occasions, on the basis almost exclusively of information in the literary texts, supplemented only occasionally by that of inscriptions, and in a largely synchronic form that took little account of variations over time, or of practices outside the circles which produced the texts.[8] Much twentieth-century classical scholarship, however, relegated these matters to the marginal position of studies of 'daily life' and the like, or left them to the sensationalist re-creations of the cinema or television. Not until the 1980s did the influence of anthropologists and modern social and cultural historians awaken a new realization among classicists of the potential contribution of the study of dining customs, of commensality, and of the consumption of food in general, to the understanding of ancient society and culture. The result was a sudden awakening of interest, concentrating in particular on the Greek *symposion*, which elevated sympotic studies to the status of a fashionable subject. A series of interdisciplinary colloquia brought together contributions from classical philologists, social, political and religious historians, archaeologists, and art historians, together with specialists from other cultures of the ancient world, from Mesopotamia to Judaism and the New Testament. These demonstrated the diversity of aspects involved in the study of the subject and their potential for mutual illumination; one approach can no longer suffice for the study of a phenomenon so complex and many sided as ancient dining.[9]

II

The images of dining and drinking in Roman art, which offer the starting point for the studies in this book, appear in a wide variety of media. They show groups of banqueters or single participants, or present cognate subjects or extracts from larger scenes: the servants, ready to attend on the guests; food and drink that might be set before them; and the entertainment that they might be offered. The theme appears to have become established in Roman art around the turn of the first century BC to the first century AD; it disappears, apart from some specific uses in Christian iconography, in the fifth to sixth century AD. The great majority of examples come from two types of context: domestic or funerary. Within the house, scenes of the banquet and related themes are found on wall paintings (most of

those that survive come from Pompeii and Herculaneum, and therefore date before AD 79), and on mosaic pavements, from a much wider geographic and chronological range. In a funerary setting, these scenes also occur as wall paintings in tombs and less often on mosaic pavements; the decoration of Christian catacombs belongs in this category. Banqueting themes were also used for funerary sculpture: as statues in the round or carved in relief on the fronts or lids of sarcophagi, on smaller monuments such as urns and altars, or on stelae to be erected over the grave. Other uses are more exceptional. Objects destined for use at the banquet, such as drinking cups and other vessels, not infrequently contain some allusion to that function in their decoration; full-scale scenes of the banquet occur on two huge silver plates, inlaid and gilt, of the fourth century AD, luxury objects designed as much for display as for use. Also from Late Antiquity dates the appearance of illuminated manuscripts, both pagan and Christian, where banqueting scenes in the contemporary manner are used to illustrate episodes from epic or from the Old or New Testament.

These images have often been used as illustrations in discussions of the Roman banquet derived from literary sources. Learned scholars of the sixteenth and seventeenth centuries, seeking to explain the references in the written sources to Roman customs, such as the habit of reclining to dine, turned for illustration to the figured monuments that were discovered in the excavations of their time, or that were available for study and observation in the collections of the great.[10] More recent works have often continued to draw on the visual material in similar unsystematic fashion, as casual comparison for studies whose principal material is textual. In this book, the images are treated instead as primary sources to be analyzed in their own right and within their own conventions and traditions, and to be compared with the evidence offered by architectural remains and artifacts.

From such sources, much information can be derived that illuminates the patterns of behaviour at the banquet and the social intercourse of the diners, more clearly often than any surviving written material. Thus the monuments not only provide clear examples of the layout of the three couches in a traditional Roman triclinium, and of the single semicircular couch known as a *sigma* or *stibadium*, which became the regular pattern for formal dining in the later Empire, but they also give vivid illustrations of the way that such arrangements must have affected communication and contact between the various participants. Images and artifacts can cast light on the practices of mixing and serving the wine; they can represent not only the types of vessel that might be used, but also the manner of

their use. Questions such as these are of much more than antiquarian interest. The changing patterns of behaviour over time, in different geographic and cultural settings, and in varying contexts of use, reflect variations in the banquet's role in society, and in the atmosphere and ethos that characterized it.

Nevertheless, any approach to the visual material that looks on it primarily as a source of information about actual practice in real life is both limited and potentially misleading. The images are in no way intended to act as mirrors of reality. Like all artificial constructs, their form and content are the products of a combination of social and cultural factors. The artisans who created them were the heirs of a long tradition, and followed long-established conventions. At times, it is likely that earlier models were deliberately followed or adapted because they were seen as imbued with desirable associations or evocative force. More often, however, the ancient artisans drew from training and habitual practice on a common stock of motifs and figures, which they varied and adapted to suit the immediate purpose, and which could persist with little change for centuries. Insofar as the scenes were intended to evoke a contemporary event, as opposed, for example, to a scene from mythology, it might be desirable for some details to conform to recognizable current practice. However, these could coexist with others traditional to the genre and remote from contemporary experience. In any analysis of the images, it is necessary to take these conventions into account and to distinguish as clearly as the material allows the part played by tradition in their formation.

Yet the images were also produced for a specific context. They had to serve the aims of the patrons, such as Rubrius Urbanus, who commissioned or purchased them. Their creators had to adapt them to those aims, either directly in the case of specific commissions or more loosely in producing objects destined for purchase. The ideas that these images were called on to express, and the messages they were required to convey, could range from ideals of the life of culture and affluence, to the self-projection of the wealthy in public and civic life, to beliefs and hopes about death, and even, as we have seen, to a more personal view of all of these. Some contain internal clues to identify the dominant message; a few combine image with written text, like the monument of Rubrius Urbanus (although this is rare, at least in our surviving evidence). Many are more ambivalent; it will be seen repeatedly in this book that the banqueting motif, like much of Roman art, was fundamentally multivalent and owed much of its popularity precisely to its ability to convey a range of significance. Overall, however, the evolution of the iconography, the selection of details to include, the

exclusion of others, and the varying emphasis accorded them, reflect patterns of ideology and cultural values as much as they do changes in actual practice.

III

Some important aspects of Roman banqueting are notably absent from the surviving art. With the exception of one fragment of a relief showing the banquet of the Vestals, the banquet does not appear on the great official monuments of imperial Rome.[11] Nor does any surviving work represent the emperor as banqueter. Accidents of survival must be allowed for; we cannot rule out the possibility that the subject might have figured on wall paintings or mosaic in the decoration of imperial palaces. Nevertheless, our surviving evidence suggests that, despite the fascination shown by biographical sources for the gastronomic and convivial habits of emperors, and the political use of the banquet by many emperors, the banquet did not form part of imperial iconography; there is nothing in art to set beside the awed poems in which Statius wrote of Domitian's appearance at state banquets, or Pliny's praise of Trajan for his unassuming behaviour and condescension to his fellow guests.[12]

Nor were banquet scenes a component of traditional religious iconography. Although the ceremony of the *lectisternium*, at which images of the gods were placed reclining on couches as if participating in a banquet, had been an important part of Roman religious ritual at the time of the mid-Republic, neither it nor the related *pulvinaria* appear to have been represented in art.[13] Mythological banquets of the gods are also seldom represented in Roman art or in Greek. The main exception is Dionysus, constantly represented as engaged in drinking parties with his companions and followers; Hercules also appears as banqueter and carouser, both alone and in company and competition with Dionysus. Their iconography undoubtedly overlaps and melds with that of contemporary banquet scenes, both in the sense that 'real' human figures are shown in the poses or with the attributes of figures from the Dionysiac world, and that objects and practices familiar in contemporary life can be introduced into the mythological setting. More broadly, Dionysiac associations were inseparably interwoven with the ideology and ambience of the banquet, for the Romans as for the Greeks: Dionysus, his followers and his attributes, appear repeatedly on the floors and walls of dining rooms, and decorating the couches, vessels, and other apparatus used at the feast.

Nevertheless, I have not included these scenes of Dionysiac and Herculean festivities in this study. Discussion of them cannot be divorced from the much longer and more complex tradition behind them, iconographic and religious, and would require the study of questions that go beyond the scope of this book.[14] In the later Empire, banqueting scenes figure, although in a minor role, in the iconography of some of the mystery religions popular at that time, such as Mithras's banquet with the Sun god, or the monuments of the Danubian rider gods: these too raise questions outside the limits of the present work.[15] Christian uses of banqueting scenes will be discussed in Chapter 6.

A mainly chronological organization is adopted in the opening and closing chapters. Chapter 1 looks briefly at the Greek and Etruscan traditions, at the evidence for dining in early Rome, and at the differences that separate Roman practice from that of the Greeks. Chapter 2 turns first to the architectural evidence for Roman dining, from the Republic and early to mid-Empire, and compares it to the Greek and Hellenistic material; then the focus shifts to the representations of the banquet in the art of the early Empire at Pompeii and Herculaneum, and the extent to which these were indebted to Hellenistic tradition. The two central chapters have a more thematic structure. Chapter 3 is devoted to the role of the banquet in Roman public and civic life, and the artistic and archaeological remains that illustrate this role. In Chapter 4, the focus is on the banquet motif as funerary decoration, the reasons that made this imagery so frequent in funerary contexts, and the close links in Roman thought between death and the *convivium* of the living. Chapter 5 then turns to the development of the banqueting theme in the art of Late Antiquity, the late third and fourth centuries AD, and Chapter 6 to the adoption of the theme in Christian art, and to the end of Antiquity.

In the earlier chapters, I concentrate mainly upon the evidence from Rome and Italy, with only occasional examples drawn for comparison or amplification from other parts of the empire. This has necessitated the (reluctant) omission of numerous works of outstanding intrinsic interest, but which have features that appear characteristic of their locality: for example, the mosaic of the Bulls and the Banquet from Thysdrus in North Africa, with its reference to the amphitheatre associations apparently peculiar to Africa, or the scenes on the great funerary monuments of Igel and Neumagen in Augusta Treverorum [Trier] near Gallia Belgica.[16] A fuller study of the differences between Rome and the various provinces, of the adoption of some elements of Roman (or Graeco-Roman) iconography

in other parts of the empire and of the maintenance, or the development, of distinctive local traits, would require a book in itself. In Late Antiquity, however, a greater degree of uniformity prevailed between Rome and many regions of the empire, at least in the art commissioned or patronized by the wealthier classes; my examples in the two final chapters, therefore, draw more freely from a wider geographic range.

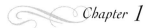

Romans, Greeks, and Others on the Banqueting Couch

THE RECLINING BANQUET

In the ancient world, to lie down to eat and drink while others stood to serve you was a sign of power, of privilege, of prestige. The custom appeared in Greece by at least the seventh century BC, almost certainly adopted from the Near East, where it was a mark of luxury and the prerogative of kings and mighty rulers.[1] In Greece, it became the distinctive behaviour of the aristocratic society of the archaic period; it is closely linked with the appearance of the *symposion* as a central social phenomenon. This was a gathering of upper-class males, focusing upon communal and ritualized drinking, and accompanied by music and poetry in which the symposiasts themselves participated; our earliest written testimony from the Greek world for the practice of reclining comes in the works of poets such as Alkman in the late seventh century and Alkaios in the sixth, which, at least in part, were composed to be sung at the *symposion*. By the end of the archaic period, the practice had been adopted by groups outside the traditional aristocracy, and became the characteristic mark of a wider social class, all those with wealth to spare and leisure to enjoy. By this time, reclining, both at the drinking party and at the meal which, by Greek custom, normally preceded it, was the normal position for males belonging to the upper levels of society.[2] It formed part of an elaborate pattern of cultivated behaviour, and of manners that needed to be taught; a passage in Aristophanes' comedy the *Wasps*, written in the later fifth century BC, shows the sophisticated young man Bdelykleon giving his rustic old father Philokleon a lesson in how to recline correctly and arrange his legs elegantly, along with other comportment appropriate for the *symposion*.[3]

Both the reclining banquet and the *symposion* itself rapidly spread far and wide to peoples with whom the Greeks came into contact through trade and settlement. Their influence is seen very early in Italy, especially in Etruria, where the practice is attested almost as early as in Greece itself. It has been described as a 'tracer for Greek influence in the barbarian world', which was indeed very much how it was looked on by the Greeks themselves.[4] In early Rome, according to the Romans' own later traditions, the practice was not known and the Romans sat to eat. The information, preserved in much later writers, is derived from Varro in the first century BC; but it is couched in the most general terms, with implications of heroic practice in the most distant antiquity, and does not appear to be based on any reliable source.[5] It is not in fact clear at what point the reclining banquet appeared in Rome. It will be suggested later in this chapter that it is likely to have been established, as an aristocratic practice, in Rome, of the kings, the sixth century BC. Nothing in our sources indicates whether the custom continued to be practised during the early Republic, but it is hard to believe that patrician families would have abandoned it.[6] Knowledge of it is at least implicit in the ceremony of *lectisternium*, at which images of the gods were placed reclining on couches, with offerings of food and drink on a table before them. Livy dates the introduction of this rite to 399 BC, supposedly modelled on Greek practice; it does not necessarily reflect normal convivial behaviour in Rome at the time.[7] It is usually thought that at some point in the course of the third century BC, under the influence of Roman conquests in southern Italy and the Mediterranean and the growing wealth of Roman society, Roman banqueting habits began to be transformed by the spread of Greek models; reclining, if not already adopted, might be expected to have been foremost among them. But given the vagueness or silence of our sources, it may have been established long before then, and merely spread to wider social groups and a greater variety of occasions.[8] In the comedies of Plautus, written at the end of the third century and beginning of the second century BC, the characters are represented as reclining to eat, apparently as normal domestic practice.[9]

The immense growth of foreign imports that followed the Roman conquests of Greece and Asia Minor in the second century BC opened Rome to the full flood of Hellenistic convivial luxury, along with a whole host of other allegedly decadent practices. A famous passage of Livy ascribes the origins of this foreign luxury to the booty brought back to Rome by the army from Asia and exhibited to the populace in the triumph of Cn. Manlius Vulso in 187 BC; this introduced the Romans to the use of ornamented couches and precious hangings, of elaborate vessels and furniture, of music

and dancing girls, and even of specialized cooks.[10] By the late Republic, the first century BC, the art of fine dining had been developed to the full, and we find the great gourmets and *bons vivants* such as Lucullus or Hortensius, famous for the luxury and elegance of their dinners. There was also a political side to the practice. Banquets hosted by members of the great noble families were semipublic events, characterized by the display of wealth, and offering opportunities for forging contacts. The complex system of mutual obligations, especially those between patron and client, which were fundamental to Roman social structure, was closely interwoven into the patterns of hospitality.[11] The more idealized Roman view of dining is expressed by Cicero, when he makes the aged Cato commend the early Romans for choosing the term *convivium* (literally 'living together') to describe 'the reclining of friends at a banquet, because it implies the conjunction of life', in preference to the Greek terms 'drinking together' or 'eating together'(i.e., *symposion* or *syndeipnon*).[12]

In Rome, as earlier in Greece, the practice of reclining to dine spread vertically through society, so that a custom originally aristocratic was imitated by lower social groups. It is hardly surprising to find it widely adopted by wealthy freedmen and other social *arrivistes*; in Petronius' satirical account of the dinner of the fabulously rich freedman Trimalchio, it is a matter of course that all the company recline. At the huge public banquets offered by aspiring politicians to all the populace, which played a major part in the political life of the late Republic from the second century BC onwards, and which were developed on an even larger scale subsequently by the emperors, we hear of couches and triclinia spread in public places for vast numbers; doubtless the opportunity to recline and be served was regarded as a valued part of the benefaction.[13] Even slaves might recline on occasion, as a mark of favour from their master or at the feast of the Saturnalia, when the normal order of society was turned upside down.[14] But reclining never lost the connotations of status and luxury, the mark of a privileged order of society, and of behaviour which must be learned and practised.[15] It was undoubtedly adopted widely throughout the Roman Empire, in regions where such behaviour was previously unknown, by members of the local elite eager to display their rapid acculturation; the 'elegance of banquets' is among the Roman customs by which Tacitus says the Britons were seduced into acceptance of slavery. To what extent indigenous customs of sitting to eat may have continued to prevail in some regions, even among the wealthier classes, is hard to assess; variation must certainly be allowed for, but evidence for reclining can be identified in almost every region of the empire, mostly in the architectural forms of dining rooms.[16]

THE IMAGE OF THE BANQUETER

Along with the custom went the image. The image of the reclining ban-
queter was one of amazing and enduring potency, and among the most char-
acteristic of all Graeco-Roman art. For more than a thousand years, from the
late seventh century BC to the fifth century AD, scenes of the reclining ban-
quet were used in an extraordinarily wide variety of contexts. They decorate
the surface of drinking cups and other vessels, the walls of tombs, the walls
and mosaic floors of rooms in private houses; they are carved on grave mon-
uments or on religious buildings. They were adopted and used by peoples of
different languages, social structures, and manners, not only throughout the
Greek world, but in Etruria, archaic Italy, in Rome, and through most of
the Roman empire, in regions as diverse as Egypt, Palmyra, and Germany.
The basic motif, which persists through all the changes of time, place, and
culture, shows the banqueter reclining in a standard position, leaning on his
left elbow, his torso upright, his legs stretched out sideways, usually with
his right knee bent. It may be used on its own, or in a convivial group, and
there is usually at least one attendant, normally serving drink. After that, the
variations begin: the number and nature of the participants, the objects that
they hold, their deportment and behaviour whenever they break away from
the standard pose; the role and nature of attendants and subsidiary figures;
the arrangement of furnishings, the indications of setting.

The earliest known appearance in art of the scene of the reclining ban-
quet is usually taken to be that on a famous Assyrian relief from Nineveh
showing the Garden Feast of Assurbanipal, dated ca. 646–636 BC (Fig. 2).[17]
It shows the king lying on a couch under an arbour, drinking from a bowl

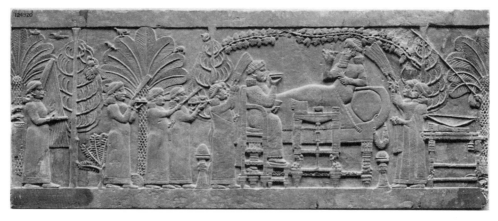

*Figure 2 – Nineveh, relief, Garden Feast of Assurbanipal. Ca. 646–636 BC. London, British
Museum WA 124920. © Copyright The British Museum.*

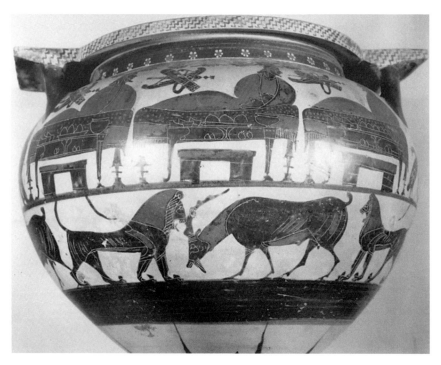

Figure 3 – Corinthian column krater with frieze of reclining banqueters. First quarter of sixth century BC. Paris, Musée du Louvre E 634, Photo Chuzeville.

in his hand; his queen is seated on a throne at the foot of the couch, also holding a drinking bowl. A table before the couch holds various objects, attendants bring offerings, fan the royal couple, and make music. The scene appears here as part of the royal ceremonial, a visible expression of opulence and power, focused exclusively upon the persons of the king and queen.[18] A few decades later, shortly before 600 BC, the reclining banquet appears for the first time in Greek art in the decoration of Corinthian pottery, that is, of the vessels and drinking cups that were used at the *symposion*. Here, however, there is no longer a single banqueter; a continuous frieze of figures reclining on couches encircles the vase (Fig. 3).[19] This emphasis on collective dining remains characteristic of the numerous banquet scenes in Greek vase painting that follow for the next three centuries, principally in Athens and subsequently southern Italy. The imagery of the vessels often alludes, directly or in more subtle ways, to the occasions of their actual use at the *symposion* itself. Above all, Attic red-figure pottery of the late sixth and fifth centuries BC provides one of the richest sources for the iconography of the banquet, with extraordinarily vivid scenes of the most varied aspects of the celebrations (Figs. 4, 5).[20] The great majority show human participants

Figure 4 – Attic red-figure kylix attributed to the Foundry Painter, side A: symposiasts. Ca. 490–480 BC. Cambridge, Corpus Christi College, courtesy of the Master and Fellows of Corpus Christi College, Cambridge.

in scenes of communal festivity; mythological or divine figures are rare. Much less common on vases is the motif of the single banqueter, for which the appropriate term 'monoposiast' has been proposed; it is used especially for heroes and demigods such as Dionysus and Heracles, or for Achilles in scenes of the ransom of Hector.[21] A different category of monument picks up the theme of the single banqueter, used as an honorific image. The models probably came from the Near East, like the reclining dynast painted on the wall of the late archaic tomb of Karaburun II at Elmalı in Lycia. In the Greek world, the theme appears on votive and funerary relief sculpture, starting a long series that stretches into the Hellenistic and Roman periods.[22] Other contexts for the banquet in Greek art are rarer, but include the occasional use of banquet scenes, communal again, on temple friezes; sculpture in the round is represented mainly by small terracotta figurines of individual banqueters that were used as votive offerings in sanctuaries or placed in tombs.[23]

Many recent studies have been devoted to the subject of the banquet in Greek art. The massive volume of J.-M. Dentzer, *Le Motif du banquet couché* (1982), studies the development of the motif in the Near East and the Greek world from the seventh century to the fourth century BC, across a range of media and contexts. Although the significance of the reclining

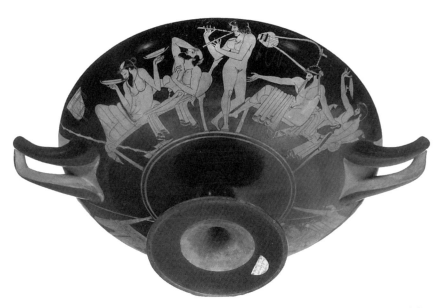

Figure 5 – Attic red-figure kylix attributed to the Foundry Painter, side B: symposiasts and flute girl. Ca. 490–480 BC. Cambridge, Corpus Christi College, courtesy of the Master and Fellows of Corpus Christi College, Cambridge.

image naturally varies at different periods and in different contexts, Dentzer stresses its continuing role as evocative of power and privilege. Other studies have focused on more specific categories of material, with particular attention inevitably given to the Attic vase paintings. In addition to works that analyze specific aspects of the theme, such as entertainment or the role of *hetaerae*, numerous publications (associated especially with the French school of François Lissarague and his colleagues) have endeavoured to decipher the complex codes that governed the imagery, and to use the depictions as clues to a reading of the ethos and ideology that underlay and pervaded the *symposion* itself.[24]

The visual imagery of the banquet during the archaic and classical periods has therefore been extensively investigated since the early 1980s, and has contributed a major share to the new appreciation of the role and the significance of the *symposion* in Greek culture. With the transition from the classical to the Hellenistic period, this material becomes much less abundant. The end of the practice of painting vases with figured scenes (a few minor exceptions apart) removes this major category of depictions. Banqueting scenes continue on one major series of objects, the funerary reliefs, which indeed grow much more common and important; some recent works have begun to analyze the iconography of these reliefs more carefully, and to explore the role that the banquet plays on them.[25] Apart from this series, however,

little survives, although there can be no doubt that the banquet could pro-
vide an important theme in major painting on wall or panel. This has been
demonstrated spectacularly for the early Hellenistic period by the discovery
of a late–fourth-century Macedonian tomb at Agios Athanasios near Thes-
saloniki, whose facade contains a painted frieze showing a *symposion* between
a group of komasts and one of soldiers.[26] That other Hellenistic paintings
showed the banquet away from any funerary setting can be deduced from the
Roman paintings from Pompeii and Herculaneum discussed in Chapter 2,
which are evidently based on Hellenistic models or prototypes; the specific
subjects are sometimes enigmatic, but suggest illustrations of well-known
scenes from comedy or even *novellas*, or romanticized versions of *hetaerae*
and their lovers.[27]

Roman art inherited this Hellenistic tradition, but varied it and intro-
duced new elements. Isolated or anomalous early examples apart, banquet-
ing scenes appear to have become established in the Roman repertory in the
first century BC; surviving versions become common only in the first cen-
tury AD.[28] These derive, on the one hand, from domestic settings, especially
the wall paintings of the houses of Pompeii and Herculaneum, and, on the
other hand, from a range of funerary contexts which include both painted
tombs and various types of sculpted tomb monument, in relief or in the
round. Other media, such as mosaic or decorated metalware, are important
in the later evolution of the theme, but do not appear among the earliest sur-
viving examples. The distinction between domestic and funerary contexts
is clearly essential to an understanding of the message that the subject was
intended to convey and to the response of its audience, and certain elements
of the iconography and methods of treatment are, not surprisingly, peculiar
to one or the other. At the same time, as is seen often in the chapters that
follow, the two spheres are closely and inextricably interrelated and no clear
division between them is possible.

WINE AND WOMEN IN GREECE AND ROME

Although many aspects of Roman convivial behaviour were undoubtedly
derived from that of the Greeks, some striking differences are apparent be-
tween Greek practice, as attested in sources predominantly of earlier date,
and that of the Romans. It must be remembered, however, that in neither
culture were these practices static and monolithic, and that many changes
of fashion are now barely perceptible; all generalizations on these matters
would require qualification on closer study. One such difference, the nature

of the spaces and rooms used for dining in each culture, the layout of fur-
niture, and the arrangement of the diners, will be discussed more fully in
Chapter 2. Two others may be considered more briefly here: the position
of women, and the role played by food and drink in the course of the ban-
quet. I illustrate here the extent to which Greek practice in these matters
is reflected in the prevailing iconography; as seen later, the response of the
Roman artists to differences between their Greek models and the practices
of their contemporary environment was complex.

The Greeks separated the main meal, the *deipnon*, from the *symposion*
which followed it; in formal dining, serious eating was confined to the first
part, the main drinking took place at the *symposion*. Many other forms of
commensality apart from the *symposion* were of great importance in the life
of the Greek city, especially the communal meal that followed a sacrifice;
and the earliest representations of the banquet in Greek vase painting appear
to show a conflated image that combines both eating and drinking. But from
the late archaic period onwards, the *symposion* dominated the selection of
visual material. This is especially clear on Attic red-figure pottery of the late
sixth and fifth centuries BC; regardless of whether the scenes on these vases
show a thoroughly decorous group or a wild orgy, the emphasis is entirely on
drinking, not eating. The participants hold drinking cups, the servants draw
wine from the *krater* and bring it in jugs. If there is food represented on the
tables, it seems to be the simple snacks of cakes that accompanied the wine
at the *symposion*; it is never elaborate.[29] It is noteworthy that the sacrificial
meal, for most people the principal occasion when meat was eaten, has made
so little impact on the iconography of these vases. A quite different series
of scenes shows the preparation of the meat from a sacrificed animal, but
this is kept firmly distinct from the main series of scenes of the *symposion*, at
least on the Athenian vases. But in different contexts the vase painters can
show banquets of a different nature; when gods and heroes such as Dionysus
or Heracles are shown reclining, large strips of meat are prominent on the
table before them, and Achilles may even hold a knife in his hand. Given
that the vessels bearing these depictions were to an overwhelming extent
those used at the *symposion*, the wine cups, jugs, mixing bowls, and jars, this
concentration on the drinking party is hardly surprising; there is a direct
link between function and decoration. But the near-exclusive focus on the
symposion affects scenes of the banquet in Greek art in other contexts and in
other media. The frieze of the temple at Assos in Asia Minor, of ca. 530 BC,
shows a row of men reclining holding drinking vessels; while in funerary art
the theme is found in the Tomb of the Diver at Paestum from ca. 470 BC,
whose interior walls are painted with scenes of a sympotic group of men

Figure 6 – Paestum, Tomb of the Diver, north wall, showing kottabos *players and male lovers. Ca. 480–470 BC. Paestum, Museo Archeologico Nazionale. Copyright Scala/Art Resource, NY.*

enjoying the pleasures of wine, the game of *kottabos*, music, and homosexual love (Fig. 6).[30]

Conspicuous on one end wall in the Tomb of the Diver is a large vessel, the mixing bowl or *krater*; it is set on a table among garlands, a nude boy with a wine jug stands beside it (Fig. 7). Its presence stresses one of the most important aspects of the classical Greek *symposion*, the communal distribution and consumption of the wine by all participants. The wine was mixed with water for all purposes except the preliminary libations to the gods; only gods and barbarians drink their wine neat, civilized men must mix it with water. The written sources recommend varied proportions, but almost always with a preponderance of water; the comic poet Aristophanes, for instance, commends three parts of water to two of wine.[31] Mixing for the whole company was done in the *krater*, from which it was then distributed; the *krater* was therefore of central significance in both practical and symbolic terms. This significance is conveyed not only by the impressive quality of many surviving ceramic *kraters* (although the wealthy undoubtedly used more valuable ones of metal), but also by the prominence of the *krater* in the *symposion* scenes on Corinthian and Attic vases, where it appears repeatedly as one of the main foci of attention.[32]

Roman practice differed in several important respects. The Romans did indeed make a distinction, in the field of private hospitality, between the drinking bout that might follow the meal and the dinner itself. But the drinking party, the *comissatio*, never played the same sort of role in Roman society that the *symposion* had in Athens. We hear of the *comissatio*

Figure 7 – Paestum, Tomb of the Diver, east wall with krater. *Copyright Nimatallah/Art Resource, NY.*

mainly in connection with the notorious drunkards, Mark Antony and his like, and the gilded youth of the Roman aristocracy, not as a central social function.[33] The ideology of commensality focused much more on the dinner; it was here that the games of status were played out, and that display and representation were concentrated. Numerous literary sources make clear the attention paid to the food and the importance attached to its variety, richness, and elaborate preparation; they range from the extravagant accounts of the satirists, above all Petronius' magnificent satire of the dinner of the rich freedman Trimalchio, through the endless series of sumptuary laws with which the Senate battled fruitlessly to control expenditure on banquets, to the actual recipes preserved for us under the name of the famous gourmet Apicius.[34] Unlike classical Greek usage too was the fact that wine accompanied the meal throughout, and indeed was served as an aperitif; and distinctions emerged also between the wines from different regions, and between those of different vintages: the concept of the *grand cru* appeared first among the Romans.[35] It is also clear from numerous written sources that Roman practice in the matter of mixing wine was fundamentally different from that of the Greeks of the classical period, and much more varied.

Communal mixing may have been current at the *comissatio*, together with a president (the *magister* or *arbiter bibendi*), who dictated the quantities to be drunk; this seems to have been a conscious adoption of Greek sympotic habits.[36] But we hear more often of more varied practice, emphasizing individual choice rather than communal sharing. Especially important for the Romans was the use of hot and cold water for mixing. Ice or snow might be used in place of ordinary cold water, whereas the use of hot water (*calda*) was regarded as characteristically Roman, and complicated vessels (known as *authepsae* or self-boilers) were devised to heat it on the spot. Many sources make it clear that the process of mixing was normally performed to the taste of each guest, and at least sometimes in the drinking cup itself rather than in a separate mixing bowl.[37]

Another well-known difference between Greek and Roman convivial practice concerned the presence and role of women. In Greece, reclining at dinner was a male prerogative. Respectable women did not normally attend the *symposion* of guests, nor the *deipnon* that preceded it. On occasions where women were present, for example at wedding feasts, they would be seated, not reclining. It is possible that there may have been some religious feasts for women only, for example in the cult of Demeter, at which women did recline, but we know little about them.[38] Again the distinction is fully confirmed by the iconography. In the vase paintings women appear frequently, but the viewer is left in no doubt of their status and role. They are entertainers, flute girls and dancers, and prostitutes; sexual gratification is presented as one of the principal pleasures of the *symposion*. Some are evidently meant to be seen as higher-class courtesans, *hetaerae*, who recline on the couches with the men, share the wine, and take part in the singing; their deportment is sharply distinguished from that expected of a respectable citizen woman, and they are often partially or completely nude.[39] In contrast, on a different category of Greek monuments, women whose respectable status is intended to be manifest are portrayed as present at a banquet. These are the reliefs where a single male banqueter is accompanied by a woman seated either on a separate chair or on the end of his couch. Some of these (the earlier examples) can be identified as representing heroic or semidivine figures, others are funerary; they are discussed more fully in Chapter 4. The comportment and demeanour of these women are modest and restrained, they take no active part in the banquet, and the thrones on which many of them sit indicate their high status; they are clearly to be understood as the consort of the hero or the wife of the dead man.[40] It was essential for an iconographic scheme to be evolved that would leave no doubt

about their status; the seated position is designed to convey this beyond any question.

The Greek prohibition against the presence of respectable women at a banquet lasted a long time, and was seen as contrasting with Roman practice, where women participated in banquets reclining together with the men. In one of Cicero's speeches against the corrupt Roman governor Verres, he recounts an incident that occurred at a party at the house of a citizen of the Greek city Lampsacus: the Romans tried to persuade their Greek host to summon his daughter to join them, and the host replied that it was not the custom of the Greeks that women should recline at the *convivium* of the men.[41] Roman moralists saw it as one of the marks of the extent to which their own customs had changed for the worse from good old Roman simplicity and morality; in the old days, they claim, women had sat to dine. By the late Republic, and throughout the imperial period, there is no doubt that elite women could and did attend mixed banquets, and that they would recline when they did so.[42] Nevertheless, practice varied widely. On many occasions, all-male dining was indubitably the norm; and the Greek-style parties with elegant but far from respectable women of the demimonde that the poets describe are unlikely to be entirely based on fiction.[43] Many grander feasts were composed entirely of male guests, and we also hear of Livia, the wife of Augustus, entertaining the wives of the senators while her son Tiberius entertained the Senate. The sources unfortunately give no indication whether at such all-female events the women reclined or sat.[44] There are also occasional suggestions that the more old-fashioned may have continued to see it as a mark of modesty and respectability for women (perhaps especially older women) to sit to dine.[45] As will be seen in later chapters, Roman art continued for many centuries to be inconsistent in its portrayal of the position of women at the banquet: both seated and reclining women are found, in a variety of different contexts, an anomaly which almost certainly reflects not only the use and adaptation of different models, but also a fundamental ambivalence both in actual practice and in the ideology that lay behind it.[46]

HELLENISTIC PRACTICE

Relations between Roman and Greek convivial practice were of course much more complex than these basic and rather simplistic distinctions can indicate. The Romans themselves were indeed fully aware that distinctions

existed; they used phrases on occasion such as drinking 'in the Greek fash-
ion', or referred to certain customs as characteristic of the banquets of the
Greeks. However, our understanding of the precise significance of these
references is hampered by the fact that we have little knowledge of Greek
convivial behaviour at the time when the Romans would have come into
contact with it, in the late Hellenistic period.[47] Some of the changes noted
above almost certainly took place in the course of the Hellenistic period.
One example may be the change in drinking fashions exemplified by the
disappearance of the communal *krater*. Recent studies have drawn attention
to the apparent disappearance of *kraters* from the repertory of Hellenistic
ceramics. Part of the explanation may lie in the increased use of vessels of
precious metal, as the rich laid on ever more lavish entertainments. But it is
also suggested that the practice of communal mixing may already have been
in decline in the Hellenistic period, at least among the less wealthy members
of society; instead they may have preferred to have their wine served in small
jugs, mixed in the cup to their own taste, or in a small bowl for one or two
alone.[48] If this is correct, Roman practice in this respect had already been
foreshadowed in the Hellenistic period, and was merely carried further by
the Romans.

The emphasis on rich and varied food elaborately prepared, which we
find in the Roman literary sources, had also undoubtedly appeared earlier
in the rich society of the Hellenistic kingdoms. The art of cookery, in fact,
was developed in the Greek world from the late classical period onwards,
and Greek writers on cookery are known as early as the fourth century BC.
The Romans of the late Republic imported both many new foodstuffs and
the specialized cooks to prepare them from the Greek world; the increased
power, wealth, and wider geographic extent of the Empire simply added
ever greater refinements.[49] This was only one aspect of the convivial luxury
which the Roman moralists had no hesitation in blaming upon the cor-
rupting influence of their conquests in the East, which had destroyed the
traditional austerity and simplicity of custom of the Roman Republic. From
the same source came the apparatus used to serve the food and drink: the
vessels of gold, silver, or crystal; the hangings and draperies of rich materials;
the well-groomed, highly trained, elegant slaves performing different func-
tions; all the material trappings which gave the opportunity for display and
social differentiation. In the late Republic and early Empire, sophisticated
Romans looked upon the Hellenistic world as the natural source of all that
comprised the life of pleasure and culture, from the skilled slaves to serve
and entertain them to the food they ate and the clothes they wore in their
periods of leisure. There can be little doubt that elegant upper-class parties

at this time were in many aspects closely modelled upon the symposiastic life of the contemporary Greek world. The extent to which they retained specifically Roman features will have varied in different circumstances, but the different ingredients became inseparably entwined.[50]

How far the Hellenistic world had also anticipated Roman practice by permitting the presence of respectable women at the banquet is much harder to gauge. As seen above, Cicero quotes a Greek in the 70s BC as claiming that this was not acceptable; but the speaker is a citizen of the small city of Lampsacus, referring to his unmarried daughter.[51] In the more cosmopolitan cities at this date, rich married women could play prominent roles in civic life; we find them in the epigraphic record making donations to their fellow citizens, which occasionally included public banquets. At some public banquets male and female participants were apparently feasted separately, but it is not clear that this was always the case; it is hard to imagine that such powerful and rich women never took part in private festivities together with their husbands. It is even more unlikely that Hellenistic queens never participated in royal feasting, as Cleopatra undoubtedly did with Mark Antony; and it is plausible to suppose that they will have expressed their power and importance by reclining when doing so. But to the best of my knowledge, there is no direct evidence of this.[52]

ETRUSCAN BANQUETS AND EARLY ROME

There were of course other ingredients in the eclectic cultural mixture that made up Roman art, and indeed Roman behaviour. Foremost among them must be considered the Etruscans, who confront us in their own way, and at an earlier date, with the problems of distinguishing Greek imitation from native ideology and practice. The banquet unquestionably played a prominent role in Etruscan culture from an early date.[53] Our first evidence for it comes almost entirely from the funerary sphere: finds of drinking services and banqueting equipment in graves from the late eighth century BC onwards. In the seventh century, seated figures are portrayed as banqueters on funerary monuments, for instance, on the lid of a ceramic funerary urn from Montescudaio near Volterra.[54] The reclining banquet appears in Etruscan art only a few decades after its first appearance in the Greek world, on a frieze of terracotta revetment plaques from a palacelike building at Murlo (Poggio Civitate, near Siena) dated probably to the first quarter of the sixth century BC: pairs of figures recline on couches, holding drinking cups, one playing the lyre; tables with food stand before them; servants

bearing wine and a flute player attend them (Fig. 8). Although the exact
function of the building is not known, it is thought to have been in some
sense public, and the banquet scenes are believed to refer to events that may
have taken place in the courtyard of the building itself. They reflect the role
of luxurious banquets in the ceremonial life of an aristocratic society, as do
the slightly later friezes of similar type from several other Etruscan sites; the
most important, from Acquarossa near Viterbo, exceptionally shows three
figures rather than two reclining on each couch.[55] The more frequent scenes
from funerary contexts in turn show the central part played by the banquet
in Etruscan mortuary ritual.

It was once generally accepted that the Etruscans adopted the reclining
banquet as a direct borrowing from the Greeks, but more recently some
scholars have suggested that the part played by Near Eastern peoples, espe-
cially the Phoenicians, should not be ignored.[56] There is, however, no doubt
about the influence of Greek iconography upon the banqueting scenes,
which, from the mid-sixth century onwards, are so frequent in a wide va-
riety of Etruscan monuments in different media from the late archaic and
early classical periods. The most significant of these are the painted tombs
of Tarquinia and the relief friezes, themselves originally painted, of funerary
urns, *cippi*, bases, and a few sarcophagi from Chiusi. In some cases, exact
parallels for figures or motifs can be drawn with the decoration of Attic
red-figure pottery, which was imported into Etruria in vast quantities at
this time, and itself attests to the popularity and importance of the drinking
customs for which it was designed.[57] Nevertheless, the Etruscan images,
painted or carved, are far from a simple transposition of Greek models.
Both the dining practices themselves and the ideological role of the ban-
quet in society undoubtedly differed in fundamental ways from those of the
Greeks; the art at times draws attention to these distinctions, or introduces
identifiably local features, at others is closer to Greek prototypes. Thus most
recent commentators agree, on the basis of the archaeological finds, that
the banquet in Etruria combined both eating and drinking; and food can
be recognized on the tables in several of the representations, including the
Murlo plaques. It is, however, also evident that Greek drinking customs,
such as the practice of mixing wine with water in a special bowl, had been
adopted from an early date; mixing bowls are not only conspicuous among
the assemblages of banqueting equipment from the seventh century, but are
also represented prominently between the couches on the Murlo plaques.
Other renderings, notably almost all the Tarquinia paintings, lack any indica-
tion of food, and seem to show a Greek-style *symposion* with pure drinking.
In some tombs of the late archaic period, special emphasis is placed on the

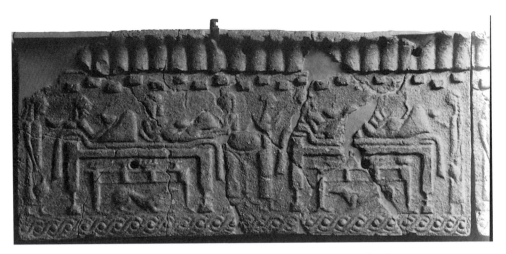

Figure 8 – Murlo, terracotta revetment plaque with banquet scene. First quarter of sixth century
BC. *Siena, Palazzo Comunale. DAI Rome 81.3654, photo Schwanke.*

krater, for instance in the Tomb of the Lionesses; here a huge *krater* appears in
the centre of the end wall, garlanded and flanked by musicians and dancers;
four male banqueters recline along the side walls. The prominence of the
krater suggests that the wine has a ritual or symbolic significance: not only,
as in Greece, emblematic of unity among the banqueters who partake of it,
but also perhaps as offering and sustenance for the dead.[58]

The most striking difference lies in the presence and position of women.
Although many scenes show all-male participants in the banquet, on others
women appear, reclining alongside the men on the same couch. In some late-
sixth-century tombs, such as the Tomb of Hunting and Fishing at Tarquinia,
a single couple is shown in this way, placed in a position of honour on the
end wall; they embrace affectionately, and are evidently the married owners
of the tomb (Fig. 9). Servants and attendants, male and female, wait on
them; an ostentatious display of elaborate wine vessels stands at the side; the
whole scene conveys the prestige and opulent lifestyle of the heads of the
household, represented as a couple. Similarly, two well-known terracotta
sarcophagi from Caere of the late sixth century place the deceased couple
together reclining upon a couch, simultaneously a dining couch and the
actual container for their remains.[59] Later, in some fifth-century tombs
such as the Tomb of the Leopards (Fig.10), the Tomb of the Triclinium,
or the Tomb of the Ship (Fig. 11), pairs of male and female guests are
shown reclining together, all participating alike in the banquet. Although
the scheme is sometimes reminiscent of the representations of *hetaerae* on
Greek pottery, the Etruscan women are never shown nude; they are fully,

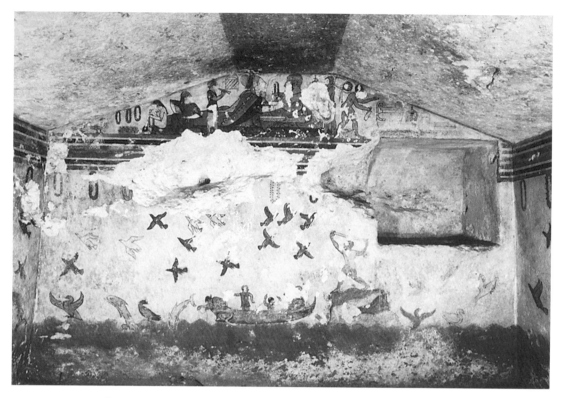

Figure 9 – Tarquinia, Tomb of Hunting and Fishing, rear wall of second chamber, banquet scene in pediment. Ca. 510 BC. DAI Rome 82.608, photo Schwanke.

indeed elegantly, dressed, and appear in attitudes of authority comparable to the men beside them. The decorous dress and behaviour of the women make it unlikely that they are meant to be seen as *hetaerae*; rather they seem to be the members of the family or the communal group participating in the funerary celebrations.[60] The freedom with which Etruscan women behaved was notorious among the Greeks, who use it as one of their standardized ways of reproaching what they saw as decadent foreign manners; the custom of Etruscan women attending banquets and reclining along with the men was precisely a point that was picked out for shocked (and malicious) criticism.[61] When the Etruscan painters decided to depart in this important respect from the iconography of the banquet that they found on the numerous Attic drinking vessels that they were importing, they were evidently responding to strong social directives. If reclining to dine was a mark of honour and privilege for aristocratic males, then the female members of that aristocracy had a claim also to comparable distinction, and some of them at least required that the artists convey this.[62]

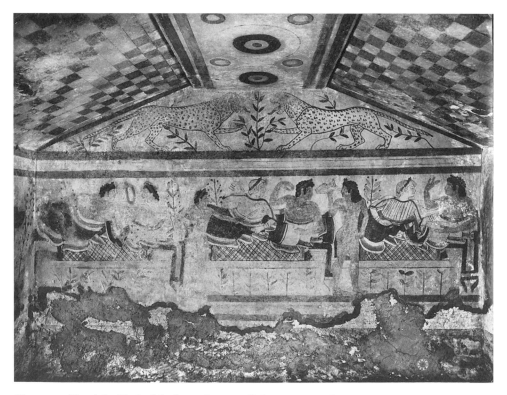

Figure 10 – Tarquinia, Tomb of the Leopards, rear wall, banquet scene. Ca. 480–470 BC. Copyright Alinari/Art Resource, NY (Anderson 41047).

The banquet also figures on a series of tombs from the fourth century BC, at Tarquinia and Orvieto, but much has changed in these representations. The banquet is sometimes shown explicitly as taking place in the next world, in the presence of the gods of the underworld, Hades and Persephone, or of underworld demons. Inscriptions give the names of the dead, male and female, and those of other banqueters, sometimes indicating the presence of several generations; they stress both the social role of the family in the city and the links between the dead and their ancestors, united in the banquet. The tables are usually laden with food, and in the fourth-century Golini Tomb I at Orvieto, along with the reclining diners (mostly male, but including at least one woman), further scenes show the preparation of food by numerous servants in the kitchen, and the carcasses of animals hung up, waiting to be prepared. Another detail shows the wine vessels elaborately displayed on a table. Such realistic details serve to glorify the wealth of the household in an unusually explicit manner; both food and drink, lavish, elaborately prepared, and splendidly served, contribute to the magnificence

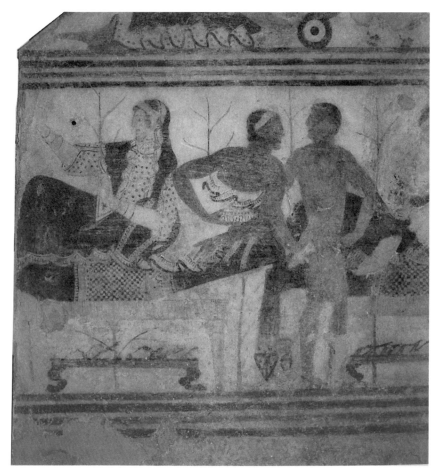

Figure 11 – Tarquinia, Tomb of the Ship, rear wall, detail of banquet scene. Later fifth century BC. *DAI Rome 82.2785, photo Schwanke.*

of the banquet. The emphasis on the social status of the family is reinforced by the inscriptions, which name almost all the figures, including the servants. But this is not a banquet of everyday life; the gods of the underworld are present, presiding over the proceedings.[63] Women are still shown reclining in some of these later scenes, but others adopt the scheme used on the Greek votive and funerary reliefs for showing a couple, where the woman is seated on the foot of the couch or on a separate chair, while the man reclines.[64] In the Tomb of the Shields at Tarquinia, of the later fourth century, two couples are represented in this way, identified by name as successive generations of members of a powerful local family (Fig. 12). Rather than seeing this as indicating a change of practice, it is better understood as an artistic fashion consciously imitating Greek models, and chosen

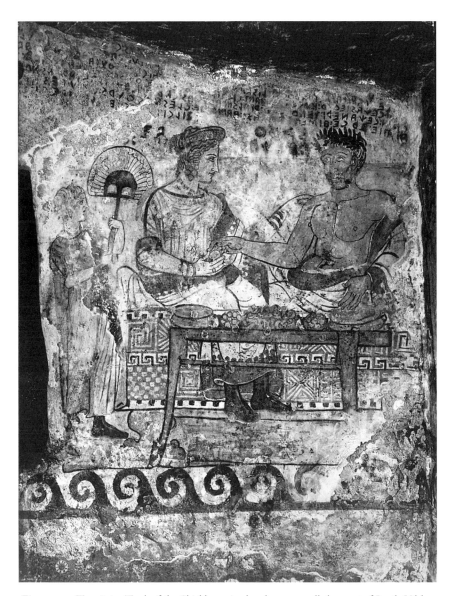

Figure 12 – Tarquinia, Tomb of the Shields, main chamber, rear wall, banquet of Larth Velcha and his wife Velia Seitithi. Ca. 350–300 BC. Copyright Alinari/Art Resource, NY (Anderson 41064).

to convey the specific connotations appropriate for an honorific funerary scene.[65]

Scenes of the banquet disappear from the painted tombs after the fourth century BC. The main use of the motif in the Hellenistic period is on the sarcophagi and cinerary urns that were produced in vast numbers in

many Etruscan cities; the main centres were Tarquinia, Chiusi, Perugia, and Volterra. Some of these, like the much earlier terracotta sarcophagi of Caere, have the form of a couch, on whose lid the deceased reclines. On most of the later examples, the assimilation of the monument to a couch is lost, and the chest of the urn or sarcophagus is decorated with elaborate scenes in relief. These occasionally represent the banquet, but much more often show unrelated mythological or funerary subjects (See Fig. 71, Chapter 4).[66] But the figures, both male and female, continue to recline in the standard position upon their lids. The direct allusion to the banquet, however, has become much weaker, and they frequently hold objects which have no reference to dining. The motif seems to have become conventional, an image of the dead in a position of honour and prestige which can be used to express various values, but which no longer necessarily evokes more than a faint shadow of the associations that the banquet once conveyed in Etruscan society.[67]

The relationship of Rome to this Etruscan tradition is often obscure, and certainly varied at different periods. At the height of Etruscan power in the seventh and sixth centuries BC, there was to a large extent a common culture throughout the centres of Latium, including Rome, which had much in common with that of Etruria. That this included lavish banqueting practices is evident from, for instance, the discovery of a banqueting service for more than thirty persons in a domestic context of the seventh century at Ficana in Latium. The consumption of wine was central to these banquets, and there is evidence that women played an important role at them.[68] It can hardly be doubted that in the sixth century, when traditionally the Etruscan kings, the Tarquins, ruled at Rome, the city would have partaken of an aristocratic way of life in which the reclining banquet, with women present, would have played a part.[69] The earliest surviving representation of the banquet in Rome is on a small fragment of a terracotta revetment plaque of the late sixth century from the Palatine Hill. It comes from the same mould as better-preserved examples from Velletri, a Latin city southeast of Rome; and they are related in type to those from Etruria discussed above (Fig. 13). They show the normal pattern of reclining banquet, with pairs of male and female figures together on couches at a drinking party, servants bringing wine, and a flute player. The workmanship is almost certainly Etruscan (from Veii, where other fragments have been found), but both the images and the ideology behind them must have been comprehensible and significant to the Romans and Latins who commissioned them.[70]

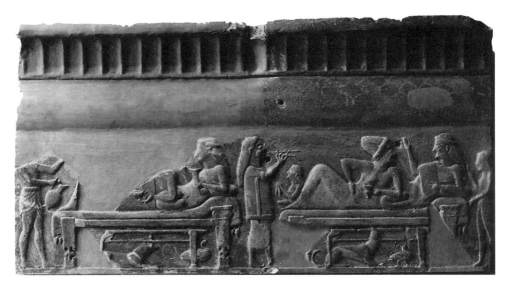

Figure 13 – Velletri, terracotta revetment plaque with banquet scene. Late sixth century BC.
Naples, Museo Nazionale 21600. DAI Rome 83.2207, photo Schwanke.

As seen earlier in this chapter, the Romans' own traditions were vague
and sometimes contradictory or tendentious. We lack evidence for convivial
behaviour in the early and mid-Republic; nor is it possible to distinguish
what the Romans took directly from the Greeks (including the Greek cities
of southern Italy), and what was filtered through Etruria. By the late Repub-
lican period, when our sources, written and visual, become more substantial,
the different elements were inextricably entangled: the Etruscan cities, now
subject to Rome, were strongly affected by the culture of their conquerors,
whereas the art of both the Etruscans and Rome itself had felt the irresistible
impact of Hellenistic models and styles. It does not seem possible, on our
present evidence, to distinguish any specific Etruscan contributions to the
Roman banqueting scenes that will be examined in the following chapters,
with one exception. Chapter 4 discusses a category of funerary sculpture
that represents the dead lying like banqueters upon a couch, which was
set over the grave itself. It seems clear that this type of monument, which
appears in the early first century AD, was derived from the common Etr-
uscan use of similar figures on the lids of urns and sarcophagi, which lasted
well into the first century BC. To what extent Etruscan models may also
have contributed to the spread of the banqueting iconography as a funer-
ary motif in northern Italy, and from there beyond the Alps, must remain
unclear.[71]

DIFFUSION: THE ROMAN EMPIRE

Banqueting scenes from all parts of the Roman empire illustrate their wide adoption among peoples originally of different backgrounds and cultures. Although many of them will be discussed in the later chapters of this book, the topic of their introduction and variation is too large to be examined here in any detail. To conclude this chapter, I discuss one specific type of monument from one region, the Roman Rhineland, which exemplifies both the diffusion of this imagery and some of the difficulties of interpreting it. Banquet scenes in relief appear on a substantial number of grave stelae from this region, from the Flavian period onwards. They contain familiar elements: a single man, formally dressed in civilian costume, reclines on an elegant couch; a table stands in front bearing drinking vessels, their forms rendered with considerable attention; a servant stands in attendance. Many have inscriptions, which identify their owners as soldiers in the Roman army, still serving or discharged.[72] One from Mainz, for example, identifies its owner as Silius son of Atto; another from Alt-Kalkar, near Xanten, as C. Iulius Primus son of Adarus from the Civitas Treverorum (Trier) (Fig. 14). Both men died while on active service in the auxiliary cavalry, which was recruited from noncitizen provincials. On both stelae, the panel below the inscription proudly shows their horse, the mark of their service, handsomely caparisoned and accompanied by a groom.[73] But did serving soldiers—common soldiers, not officers—really indulge in banquets of this sort? The auxiliary camps and forts of the Roman army on the frontier did not provide comfortable couches for the soldiers' messes; they lived in crowded conditions, and probably slept on pallets or in bunk beds. Only the upper levels of the officers might expect to have the space and the comfort needed for reclining banquets. Still less would the ordinary soldiers be likely to own the range of drinking vessels that we see here, certainly not in any numbers. Peter Noelke, who has studied these reliefs, has pointed out that they do not even correspond to the types of metal vessels usually found in the northwest provinces at this period; they appear to be intended to represent the sort of silver vessel found in contemporary Italy. Again the highest officers might possess expensive vessels of this type, which could be observed and envied by their inferiors, and reproduced by the sculptors.[74]

For Primus and Silius, therefore, and many others like them, the reclining banquet with all its trimmings was something all but unattainable in ordinary life, but glimpsed in the lifestyle of their officers of Roman or Italian origin. It is used on the stelae as a sign of all that they hoped to emulate in Roman life and culture, directly comparable to the adoption of a Latin name in

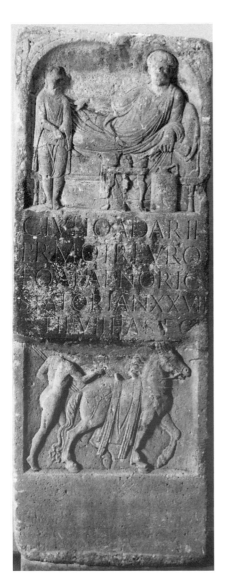

Figure 14 – Alt-Kalkar, grave stele of C. Iulius Primus. Early second century AD. *Bonn, Rheinisches Landesmuseum 38.436.*

place of the Germanic name of their fathers. If they had lived to serve out their time in the army, they would have become full Roman citizens, and might, if they were fortunate, have been able to afford some such luxuries as appear in these scenes. As it is, the scenes serve to convey to an alien world the continued attraction of an ideal which had appealed so irresistibly to the aristocracy of archaic Greece.[75]

Place Settings

GREEK AND ROMAN DINING ROOMS

Few things are more revealing of the significance that a society attaches to
the processes of communal eating and drinking than the physical layout of
the spaces used for that purpose. The size of the group that can readily
be accommodated, and the arrangement of the diners within that group,
profoundly affect their ability to communicate and their relationship to one
another; the whole atmosphere and character of the occasion are dependent
upon these factors. Certainly this is true of the spaces used for dining in the
Greek and Roman worlds, and their variations give a good indication of
the changing social role of conviviality in each society. Rooms designated
specifically for dining can be identified in the Greek world as early as the
sixth century BC, and are frequent in the fifth and fourth; in the Roman
world, they go back at least to the second century BC.[1] Numerous surviving
examples allow us to reconstruct the layout of these rooms, on the basis
sometimes of traces of actual fittings for couches or tables, more often of
features of design or construction that indicate where the furniture was
intended to be placed. It was of course possible at all times to dine elsewhere
than in a specially designated room, but the identifiable rooms in domestic
architecture provide a good starting point for the discussion. My focus here
will initially be on private dining in a domestic setting, but it must be stressed
that the boundaries between public and private were fluid, and that convivial
dining was in no sense a wholly private activity in ancient society.[2]

The typical Greek form, at least for private dining, is the *andron*, the
room of the men. It appears repeatedly in domestic architecture of the fifth
and fourth century BC, in almost identical form: approximately square, with

Figure 15 – Olynthos, plan of houses A VI 2, A VI 4, A VI 6, with androgens *shaded and position of couches indicated. After 432 BC. After Hoepfner, Schwandner 1994, fig. 61, courtesy of W. Hoepfner.*

off-centre door, and a slightly raised platform, the trottoir or *kline*-band, around three-and-a-half sides.[3] Frequently, as in numerous houses at Olynthos, it is placed at the outside corner of the house, to provide easy access for the guests from the courtyard without disturbing the rest of the household (Fig. 15).[4] The couches were set head to tail on the trottoir around the walls; each couch had a separate table (Fig. 16). Dimensions too recur closely;

Figure 16 – Athens, Agora, room in South Stoa I, reconstruction drawing. Ca. 430–420 BC. Photo American School of Classical Studies at Athens: Agora Excavations.

the normal domestic rooms held seven or, more rarely, eleven couches, each approximately 1.80 to 1.90 m long and 0.80 to 0.90 m wide; rooms suitable for three, five, or nine occur occasionally. In more lavish buildings there may be more than one such room, sometimes of varying sizes. Thus several wealthy fourth- and third-century houses at Eretria contain a suite with an eleven-couch and a seven-couch room side by side, an anteroom in front of the smaller; some even have additional dining rooms as well (Fig. 17).[5] In these rooms the guests would recline, one or two to a couch, exactly as they are shown in so many vase paintings; they form a continuous ring, interrupted only by the door. The arrangement both emphasizes and reinforces the unity of the group, the sense of common fellowship within a circle, which is so fundamental to the ethos of the Greek *symposion*.

The characteristic form of the Roman triclinium in the late Republic and early Empire is very different. The name means literally the three-couch room, and it is marked by an arrangement of three broad couches set in the form of the Greek letter Pi.[6] A single table stands between them and serves all the diners, who are close enough that all can reach it. The form can be identified at Pompeii on the basis of archaeological evidence, such as cuttings for the couches in the walls of some rooms, and markings on the pavements that distinguish the setting of couches and table. The rooms themselves are usually long and narrow, and often divided by structure or decoration into a forepart and a deeper inner zone; the couches were set up in the inner portion.[7] Confirmation of this layout is given by the couches and tables of masonry that survive at Pompeii out of doors in gardens and similar settings, or in half-enclosed rooms, as in the summer triclinium of the House of the Moralist (III 4.2–3) (Figs. 18, 19) or the House of the Cryptoporticus (I 6.2–4).[8] Indoors, movable couches of wood were normally used, in the grander houses with fittings of bronze or of even more expensive materials; these fittings have sometimes survived and permit their reconstruction. The most elegant type, of Hellenistic derivation, has a curving headrest or *fulcrum* at one end (Fig. 20); but a true triclinium evidently required a matching set of three fitted together, in which case the *fulcra* may have been confined to the head and foot, respectively, of the two outer couches.[9] A different type, with upright boards at the back and sides, became common from the first century AD. It is not always easy to distinguish the remains of dining couches (*lecti tricliniares*) from beds, which often had similar form, nor is it always clear how they were used in practice.[10] In general, the couches are longer and wider than the characteristic Greek form, averaging about 2.20/2.40 m by 1.20 m.[11]

ARTÈRE EST-OUEST

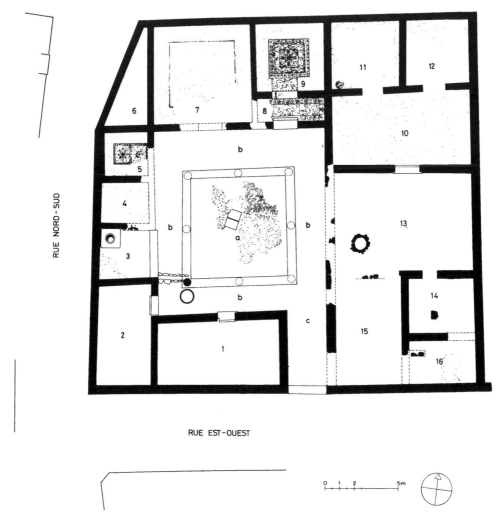

RUE NORD-SUD

RUE EST-OUEST

0 1 2 5m

Figure 17 – Eretria, House of the Mosaics, plan. Andrones *are rooms 5, 7, 8–9. Mid-fourth century* bc. *After Ducrey, Metzger, Reber 1993, fig. 25; courtesy of P. Ducrey, École suisse d'archéologie en Grèce.*

We know from literary sources that, in the first century bc and early first century ad, the normal pattern for a private dinner in Rome was no more than nine guests, arranged three per couch. The couches (Latin *lecti*) were designated *summus, medius,* and *imus* (highest, middle, lowest), the three places on each couch numbered in turn, and strict rules of precedence dictated the positions of the guests (Fig. 21). The traditional place of honour was No. 3 on the middle couch (*imus in medio*), sometimes referred to as the

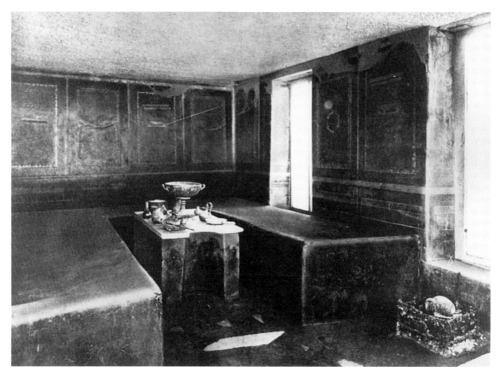

Figure 18 – Pompeii, House of the Moralist (III 4.2–3), summer triclinium, with masonry couches and table. After Spinazzola 1953, II, fig. 730.

locus consularis, the position of the consul or other high magistrate; next to it was the place of the host, No. 1 on the lowest couch (*summus in imo*).[12] All this would have the effect of producing a close-knit group, even closer than the Greek plan: to reach the common table, the guests must lie diagonally across the couches, almost in the lap of their neighbour. But the hierarchy of the placing, the emphasis on positions of honour and order of precedence, create a very different atmosphere; the appearance of fellowship and equality is hollow, as John D'Arms has rightly stressed. What the arrangement really encourages is networking, the complex exchange of favours and obligations that is so basic to the Roman social structure.[13]

Needless to say, the Roman pattern was not static and unchanging. Literary sources continue in the second century AD to quote proverbs to the effect that the ideal party should be no more than nine, the number of the Muses[14]; but already in the later years of Pompeii there is a tendency toward big dining rooms capable of holding more guests.[15] From the later first century onwards, changes in the architecture of private houses make it clear that those of any wealth wanted to be able to offer a banquet to

Figure 19 – Pompeii, House of the Moralist (III 4.2–3), plan in 79 AD. Triclinium (Tr) and summer triclinium (Tr.e) marked. After Spinazzola 1953, II, fig. 699.

much larger numbers. Across the western Mediterranean from this time on, houses were built with a basically similar plan: a central peristyle, off which opens a large and impressive room on the main axis, obviously the principal reception room. Often it is identified clearly as a dining room by a mosaic pavement laid out in a scheme known as the T + U plan: a plainer area around the three sides of the room where the couches are intended to be

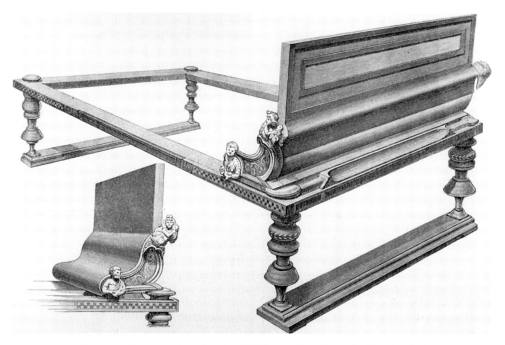

Figure 20 – Reconstruction of couch with fulcrum *from Pompeii. After Overbeck, Mau 1884 fig. 228.*

placed (the U), and a more highly decorated area in the centre and at the entrance, which would be left unimpeded, for service and entertainment. The arrangement is still the Pi shape of the triclinium, but on a much larger scale than the characteristic triclinia at Pompeii. The rooms are also usually much grander, with monumental entrances, often tripartite, and frequently look out on fountains in the garden of the peristyle.[16] The type is especially common in the prosperous towns of the African and Hispanic provinces in the second and third centuries AD; among numerous examples, many cited in earlier studies, two may be quoted here. At Thysdrus (El Djem) in Africa Proconsularis, a series of houses of this type contain triclinia with mosaics clearly demarcating the setting for the couches. One known, from the in-scription on one of its mosaics, as the Sollertiana Domus, has a large room (9.30 × 6.20 m) opening off the peristyle, with a fountain basin opposite its door (Fig. 22). The mosaic is divided into an elaborately decorated central area and figured panel at the entrance, together forming the T, and a much plainer ornamental surround on three sides for the couches.[17] The triclin-ium in another grand house, the House of the Fountains, at Conimbriga in Lusitania (now Coimbra in Portugal) was even larger, 11.70 × 7.25 m; at the back, limestone slabs covered the area on three sides for the couches,

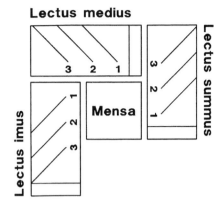

Figure 21 – Layout of typical Roman triclinium in the late Republic and early Empire. After H. Thédenat, Pompéi *(Paris 1910), fig. 44.*

surrounding a broad panel of mosaic, while half the room was left open in front to provide more extensive space for entertainment. It too opens off the peristyle through a wide entrance, with a view to a garden enlivened by fountains (Fig. 23).[18] Rooms of this type are large enough to accommodate many more than the traditional nine, perhaps a couple of dozen.

Again it is clear that the whole ethos and atmosphere of the meals held in rooms such as this would be different. There can be little direct contact or communication between most of the guests, and they no longer share a common table. Sometimes individual tables must have been provided; elsewhere there is evidence for a ledge running along the front of the couches, where cups and other items could be set down.[19] There would be even more emphasis in these rooms on hierarchical seating arrangements: the central couch will inevitably have greater prestige and must have accommodated the guests of honour, whereas those at the far ends are very remote from the centre. In contrast, there is a great increase in the space available for entertainment of various sorts, of which the guests would be largely passive spectators. For the host at such events, the banquet is an opportunity for the exhibition of status and the display of luxury and wealth; the whole affair comes to be treated as itself a spectacle, staged in a splendid setting, and often with the host as its focus.[20] Sometimes the house contains also a second smaller room laid out as a triclinium and designed for more intimate banquets, where the ideal of the small convivial group can survive; these rooms too are often elaborately decorated.[21]

Another development of the later centuries of the Roman Empire will be discussed more fully in Chapters 5 and 6, but should be mentioned briefly now. This is the appearance of another type of dining arrangement, the continuous semicircular couch known as the *stibadium* or *sigma*, the latter name from its resemblance to the form of the Greek letter (Figs. 99, 100,

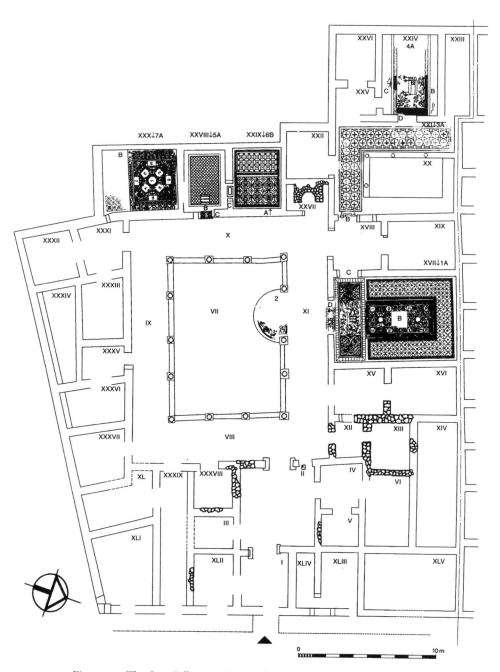

Figure 22 – Thysdrus, Sollertiana Domus, plan showing triclinium on right. Late second to early third century AD. *After Dulière, Slim 1996, plan 1.*

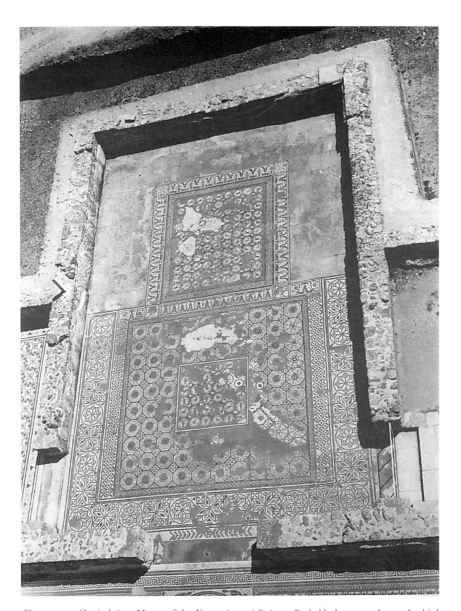

Figure 23 – Conimbriga, House of the Fountains, triclinium. Probably late second to early third century AD. *Photo Instituto Português de Museus, Archivo Nacional de Fotografia.*

Chapter 5). It is attested in literary sources already in the first century AD, in the poems of Martial, and there is archaeological evidence from the same period for the use of the form for outdoor dining, where it undoubt-edly originated. We cannot, however, at present identify examples of the type in internal domestic architecture earlier than perhaps the late second or third century AD.[22] The arrangement implies a return to a smaller and

originally more intimate manner of dining; examples show that it normally held about seven or eight guests, and there was a single table, semicircular or round, within reach of all. Rooms intended for such an arrangement were often built with an apse to hold the couch, leaving the front part of the room entirely free, again for service and entertainment. Here too, as will be seen later, the physical arrangements evidently brought with them the implications of a different atmosphere.

HELLENISTIC DINING ROOMS

The simple early form of the Roman triclinium, as a separate room set aside for dining, is standard in houses of the first centuries BC and AD. Its origins and introduction are more obscure, like the whole question of Roman convivial practice in the early and mid-Republic. Although it has been suggested in the past that triclinia (in this sense) were hardly known in domestic architecture before the late Republic, more recent authors have been inclined to push the origins of the Roman triclinium back earlier, at least to the second century BC.[23] The further question then arises, to what extent it can be identified as an authentically indigenous development, perhaps continuing early Italian traditions, and how far it was affected by the model of contemporary Greece. One theory has associated its introduction with the wave of convivial luxury, which later Roman authors attributed to the conquests of the second century BC.[24] This may be valid for the identification of a specific room in the house that was reserved for dining, but can hardly hold for the use of the characteristic triclinium arrangement of the couches, unless such an arrangement can be shown to have been normal practice in the Hellenistic world.

Our knowledge of the rooms used for dining in the Hellenistic period, and their relationship to the previous classical forms, is unfortunately patchy, although it is clear that various types existed alongside, and perhaps eventually replaced, the classical *andron*. None of them, however, seem well suited to provide a model for the triclinium. Rooms of the *andron* type certainly continued to be used and constructed quite late in the Hellenistic period; examples of such rooms, with recognizable raised bands for the couches around the edges, have indeed been identified in central Italy during this period. Thus three were found side by side close to the forum at Pompeii, in a context dating from the end of the fourth or beginning of the third century BC; their function is suggested to have been public or civic rather than domestic.[25] This would indicate that there was indeed influence of

Greek forms and Greek customs of dining in parts of the Italic world at this date, but it did not produce anything resembling the Roman triclinium. More problematic are the dining rooms in later Hellenistic domestic architecture. The best-known site for private domestic architecture in the late Hellenistic period is Delos, which was not necessarily typical. Here the *andron* has disappeared, and the main reception room in houses large and small is the so-called broad room, a room broader than it is long, opening off the peristyle usually on its central axis, and in the grander houses elaborately decorated (Fig. 24). Such rooms are believed to have been multifunctional rather than reserved exclusively for dining, and they too bear no relationship to the characteristic form of the triclinium. Smaller rooms sometimes found alongside them are suitable to hold three narrow couches for more intimate dining, but are much too small for the broad Roman couch holding three people.[26] There seems to be no evidence in the Hellenistic world of the arrangement of three broad couches each holding three people. Despite its Greek name, this characteristic Roman form of the triclinium appears on our present evidence to have indeed been an Italian development.[27]

More influence is likely to have been exercised on aristocratic Roman dining in the late Republic by the example of the palatial residences of Hellenistic potentates; here again, our evidence is lacunose. Recent studies have suggested that some of the great late classical and early Hellenistic palaces may have functioned essentially as gigantic banqueting houses. At Aigai (Vergina) in Macedonia, for instance, in the presumed palace of Philip II (or one of his successors), the main peristyle has been reconstructed as a continuous succession of large and small rooms for banquets. These are shaped like traditional *andrones*, but are much larger, capable of holding 15, 19, and even perhaps 30 couches; a recent calculation has suggested a total complement of 278 couches, appropriate for the royal banquets of the Macedonian kings.[28] We lack archaeological testimony for the great palaces of the later Hellenistic period, of the Ptolemies or the Seleucids; we have little concept even of the rich villas or townhouses of the aristocracy in the Hellenistic East at this time. Recent excavation, however, of the palaces of the Hasmonean kings and of Herod the Great at Jericho and elsewhere in Palestine, dating from the end of the second and the first century BC, has revealed that they were dominated by magnificent long halls, often columned around three sides and with the fourth, short side open, one of whose functions must surely have been that of banqueting hall (Fig. 25). In contrast both to the traditional *andron* and to the Hellenistic broad room of the Delos type, such long halls would be designed for hierarchical arrangements, with the ruler reclining in a central position at the end, on the axis of the room. It seems

Figure 24 – Delos, House of the Trident, plan. Broad room at top. Ca. 130–88 BC. After J. Chamonard, Délos 8, Le quartier du théâtre (Paris 1922), pl. XIII.

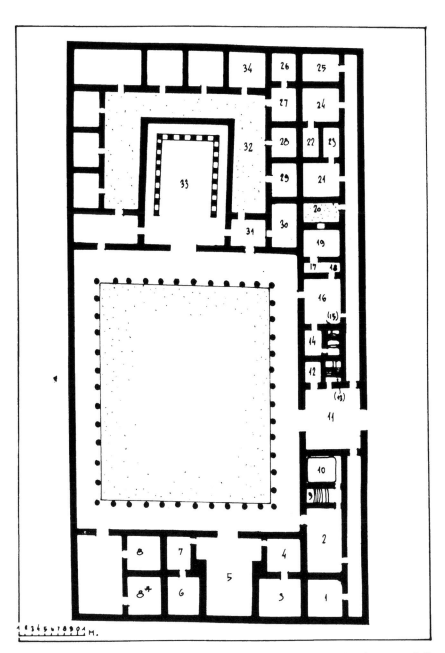

Figure 25 – Jericho, first Winter Palace of Herod the Great, reconstructed plan; banqueting hall at no. 33. Ca. 35 BC. After Netzer 1999, fig. 43, courtesy of E. Netzer.

safe to assume that halls of this type were current in the princely architecture of the late Hellenistic period, and that they led to the adoption of similar halls by the Roman aristocracy of the late Republic and early Empire. The later developments of the Roman triclinium in the Empire, with its growth from rooms designed for the traditional small group to a much more monumental and impressive arrangement, must, I believe, be seen against this background.[29]

DINING IN SANCTUARIES AND OUTDOOR DINING

In a study of the spatial setting of the convivial meal, it is convenient to start from the rooms designed for dining in private houses; yet a great deal of dining took place in other settings. Even within the house, it was always possible to use rooms that were not specially designated or readily identifiable. Many rooms, whether in the richer or more modest houses, must have been multifunctional; dining rooms certainly existed in upper storeys that are now lost; and much dining must have taken place out of doors, in peristyles and gardens, using movable facilities. However, private festivities in a domestic setting form only part of the total picture. There were feasts at the great religious sanctuaries; public banquets for huge numbers, sometimes for all the inhabitants of a city; and parties of all sizes in the open air. In some Greek sanctuaries, rooms of the same type as those in private houses were constructed for feasting. At the sanctuary of Artemis at Brauron, for example, a row of nine rooms opening off an L-shaped portico was constructed ca. 420 BC. They are the same shape as the characteristic private *androues* of the period, and each is able to hold eleven couches; the stone tables are still in place, and cuttings for the couches are visible in the stone slabs of the trottoir behind them.[30] In contrast, many sanctuaries contain rooms of different sizes and shapes that must have been used for cult banquets, some much larger, some with a longitudinal emphasis.[31] A special problem is posed in the Hellenistic and Roman periods by the impact of local religious traditions and their interaction with Graeco-Roman architectural forms. Thus one particular type of room is found in sanctuaries in the eastern Roman empire, for instance at the sanctuary of Apollo Hylates at Kourion on Cyprus, reconstructed in the early second century AD. These fair-sized rooms are laid out like a row of long, narrow triclinia; around three sides, where the couches might be expected to stand, are masonry podia about 2 metres wide and 1 metre high. A row of columns divides them from the centre, and a ledge suitable for cups or plates runs around the edge. The

participants must have reclined on mattresses upon these podia, which can be reached only by staircases at the ends, leaving the centre free. We have little idea what sort of cult banquets took place in these rooms, but their peculiar architectural disposition suggests some special ritual. Presumably, this continues local traditions, perhaps Semitic in origin, expressed now in monumental form, but the details currently remain a mystery.[32]

For large banquets, whether religious or civic, single rooms would not be enough, and we have to assume that the great majority of guests were accommodated outside, often probably under porticoes to provide shade, or with tents or temporary pavilions. These ephemeral arrangements might consist of nothing more than branches on the ground or wooden benches to lie on, and simple tents or awnings overhead.[33] At the opposite end of the scale, they could include the fantastic structures that were constructed for royal festivities. A lengthy passage of the historian Kallixeinos of Rhodes describes the pavilion designed for the grand banquet of Ptolemy Philadelphus in Alexandria, probably in the 270s BC; it was adorned with all the resources of art and capable of holding 130 couches.[34] As will be seen in Chapter 3, a great deal of Roman public feasting required temporary provision of one sort or another, often for very large numbers.[35] All these various arrangements will have had a different effect on the nature of the banquet that went on in them, and have encouraged a different atmosphere and different relations among the participants.

The extent to which these different occasions were recorded in art varied greatly. At all periods, scenes of the banquet, whatever the medium, show pronounced biases in their choice of what sorts of scene and what types of arrangement to represent. These biases can be seen most clearly in the numerous images on Attic red-figure pottery of the late sixth and fifth centuries BC. Many, of course, give no hint of the setting, but on the vast majority of these vases the guests are arrayed singly or in pairs on free-standing, mobile couches (cf. Figs. 4, 5, Chapter 1). This suggests an interior scene, the sort of event that would take place in a standard private *andron*. Others, often with a Dionysiac theme, place the scene out of doors with the banqueters reclining on the ground. An arrangement that might be appropriate for a larger-scale event, with a number of guests reclining in a row on what appears to be a continuous bench, is found occasionally on rather later pottery from the fourth century, or on that from other regions of the Greek world such as South Italian, but not on Attic during the main period. In other words, the private *symposion* has exercised so overwhelming a monopoly of the imagery used on the Athenian vases during this period that there is no room for the representation of any other form of banquet, although in

other contexts experiments were occasionally made to introduce or suggest variant types of setting.[36] In the absence of original Hellenistic scenes, we cannot judge the extent to which such experiments may have continued, especially in the pictorial arts, which offered much greater potential for the representation of setting and background. But the Roman paintings about to be discussed, which appear to be based on Hellenistic prototypes, also concentrate upon private and intimate occasions. It seems unlikely that there was any established tradition at any time in the Hellenistic period for the representation in art of large public banquets of the sort discussed above, whether in grandiose settings or in the open air. The *symposion* of a small group, as the focus of social conviviality and individual luxury, remained the ideal.[37]

PAINTINGS OF THE BANQUET IN POMPEII AND HERCULANEUM

Discussion of the development of the triclinium has shown how complex the relationships were between convivial fashions in the Hellenistic world and those of Roman Italy and later of the Empire. As seen in Chapter 1, Hellenistic luxury provided the models for the life of pleasure of the Roman upper class; in a town such as Pompeii, from which most of our evidence comes, the wealthier classes in turn imitated the fashions set by the rich and powerful in Rome.[38] The complexity becomes even greater when we look at the earliest Roman images of the banquet, and especially at the paintings that appear in the Campanian cities at the end of the first century BC and during the first century AD. Scenes of the banquet appear more than a dozen times among the panels that form the central feature of walls painted in the Third and Fourth Styles in the houses of Pompeii and Herculaneum. Although the original location of many of them is not known, they sometimes decorated a room that can be identified appropriately as a triclinium.[39] It is natural to assume that they are designed to convey to the assembled guests an ideal of convivial behaviour, or to glorify by implication and comparison the host who is offering the meal. Yet for the most part, these paintings seem to bear only limited relationship to actual Roman dining practices and to conjure up a very different set of associations, which look back to the Hellenistic world. The Roman artists, in this field as in much else, had inherited the Hellenistic iconographic tradition, and much of their work at this period was based more-or-less directly on Hellenistic prototypes. It is almost always problematic to distinguish the extent to which they modified and adapted

these prototypes, and the degree to which they were influenced by the contemporary world around them. It is noteworthy that a large number of these paintings show no sign of anything recognizable as referring to the layout of the Roman triclinium. The characters recline, singly or, more often, in couples, on individual couches, indoors or out of doors, just as they had much earlier in Greek vase painting or on the grave monuments with scenes of the reclining banqueter that were widespread throughout the Hellenistic world.[40] This in itself would suggest that the painters were drawing on earlier models; many other features of the paintings fully confirm this. Yet, as will be seen, it would be misleading to think that all details of these paintings were necessarily reproduced from an earlier source; the painters, here as elsewhere, seldom copy exactly. They vary the originals, and introduce new elements; it is often in the selection of these elements that they most clearly express their own specific tastes and ideologies.

The most informative paintings in this respect come from a recently excavated building in Pompeii known as the House of the Chaste Lovers (IX 12.6). It appears in fact to have been, not an ordinary house, but a bakery with an oven in its main court. One room in the complex has been identified, from its plan and decoration, as a triclinium; it was decorated in the late Third Style, probably around 35–45 AD, although one wall was restored later in the Fourth Style.[41] Banqueting scenes occupy the centre of each wall. Those on the two original walls both show pairs of elegant lovers reclining at ease at a drinking party (Pl. I, Fig. 26). The scene on the west wall is set indoors, that on the north wall out of doors under an embroidered awning; in each case, there are two couches strewn with rich cushions and hangings, and set at right angles. Between the couches stand three-legged tables laden with drinking vessels: two in the indoor scene, one beside each couch, and one only in the outdoor scene. The revellers hold drinking cups; the men are bare to the waist, and the women are, at the most, lightly draped. At one side of the outdoor scene is the small figure of a servant pouring liquid – evidently wine – from an amphora into a large bowl set in a wide basin on the ground. Each scene also contains subsidiary figures: in the indoor scene, there is a rather enigmatic group of an apparently drunken woman supported by a slave; in the outdoor scene, a flute player and another woman seated to one side, and what is probably a statue with a torch behind. Finally, barely to be made out in the indoor scene is the head and elbow of a third man on the left-hand couch, in shadow and apparently sunk in sleep. The third scene, from the restored east wall, is very different in style; it shows two couples of youths and their girlfriends in an advanced stage of drunkenness. The details are here much less distinct,

and it is not clear whether there is one couch or two; the single table holds various drinking vessels. One of the men drinks from a horn (with assistance from his companion), both men also hold cups. Awnings hang above, as if from a pillar or column; a maid behind holds a fan.

A second version is known of both the paintings on the two original walls, confirming that they were indeed based on earlier models. The out-door scene is repeated in a well-preserved painting from an unknown house at Pompeii (Pl. II).[42] It almost exactly reproduces the main group of figures and the setting, but introduces variants in some of the details. Principally, these affect the drinking apparatus. The vessels on the tables differ in the two versions, and their forms recall those characteristic of Roman silverware of the first century AD.[43] Another change is the servant who pours wine into the bowl in the House of the Chaste Lovers, although the bowl and basin set appear in both paintings, and may be presumed to have been taken from the original. A similar combination is found in other banquet scenes of the period and can be identified as showing the wine being cooled in iced water.[44] The other version of the indoor scene is lost, known only from two nineteenth-century drawings.[45] These differ in minor details, but give the main features of the scene. It showed only the left-hand couch with one pair of lovers on it, and the group of the drunken woman and her supporter behind it, but omitted the other lovers on the right-hand couch and the second table beside them. In their place, however, appeared a slave boy, apparently holding a ladle for the wine. There is no trace of the third sleeping figure on the couch behind the two lovers.

Both sets of paintings, we can safely assume, reproduced well-known prototypes; there may even be some story alluded to by the drunken woman in the indoor scene, which is now lost to us. The variants between the different versions cast valuable light on the intentions and working practices of the Pompeian painters. The central figures can be taken to have been handed down from the prototype; the omission of the right-hand couch and its occupants from the second version of the indoor scene may be caused by practical considerations such as lack of space. But the painters clearly had a free hand in their renderings of details such as the silverware on the tables; they evidently introduced elements familiar from their own surroundings, although of a quality which would not necessarily be part of the everyday experience of the average banqueter in the room itself. The servant pouring wine in the outdoor scene in the House of the Chaste Lovers also appears to be an addition of the Pompeian painter; it seems intended to draw attention to the expensive apparatus and the luxury of iced water, and perhaps to make its function clear to those viewers who might be unfamiliar with it.

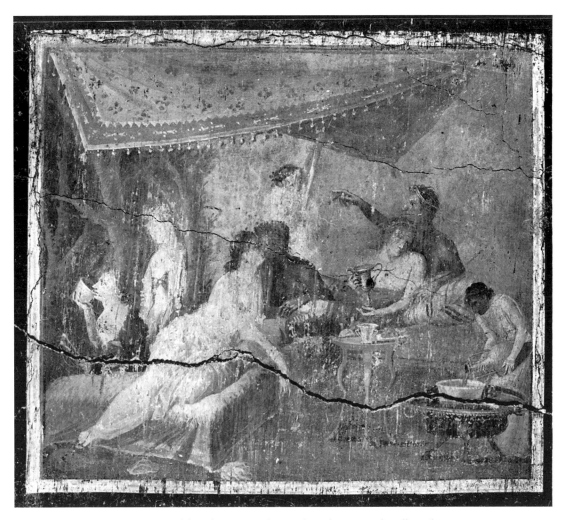

Figure 26 – Pompeii, House of the Chaste Lovers (IX 12.6), triclinium, north wall, outdoor banqueting scene. Ca. 35–45 AD. Photo Soprintendenza Archeologica di Pompei (neg. 55652), upon authorization of the Ministry for Cultural Heritage and Environment.

These additions may therefore be seen as designed to enhance the message of luxury by introducing the sort of detail that would speak directly to the viewers: objects and practices which they might have seen and envied at the banquets of the truly rich. More puzzling is the third sleeping figure who appears in the indoor scene in the House of the Chaste Lovers, but is omitted in the other version. The presence, here only, of three figures on the couch rather than two seems designed to conform to Roman custom rather than Greek; it is also incongruous with the erotic implications of the groups of two lovers, who should surely have a couch to themselves.

Tentatively, it may be suggested that the Pompeian painter may here have modified his original, perhaps following an unclear passage in his model, to make it conform to Roman practice, and to the expectations of the viewers.

A fine painting of the Fourth Style from Herculaneum, now in the Museo Nazionale in Naples, belongs in the same general category (Pl. III).[46] It shows a single couch on which a young man reclines, naked to the waist, his lower body and left arm wrapped in a purple cloak. His left hand holds a garland, with his right he holds up a silver drinking horn from which a stream of wine runs to his mouth. A woman sits beside him at the foot of the couch, her upper body covered only with a diaphanous veil, a golden net over her hair. Behind her a little maidservant offers a box, perhaps of jewellery. In front of the couch stands a small three-legged table covered with drinking silver: clearly to be distinguished are two differently shaped cups, a slightly larger cup or bowl, a small ladle, and a long-handled implement, almost certainly to stir the drink. An indoor setting is suggested by the plain wall behind. The elegant, and clearly expensive silverware again finds parallels, although not exact replicas, among real vessels of the first century BC to the first century AD. The silver horn from which the man drinks, however, does not seem to reflect normal practice, but rather to act as a symbol of exceptional luxury and indulgence.[47]

In most respects, these paintings make little reference to Roman practice, and even less to their actual context in Pompeii or Herculaneum. There is a vast distance between such scenes, with their atmosphere of luxurious artifice that recalls the world of Alexandrian epigrams, and any actual banquets that may have taken place in the decidedly modest room in a commercial establishment where they are painted. The elegant bronzed young men, torsos bare in Greek style, are as remote from Pompeian society as the expensive women who accompany them, and who are obviously to be understood as *hetaerae*. The paintings are clearly meant to evoke, for the guests who would recline immediately beneath them, an appropriate mood of festivity, to serve as a paradigm for a luxurious life; a life that was beyond the reach of middle-class inhabitants of small town Pompeii, except in their dreams or in their cups. This ability of the banquet scene to encapsulate such dreams should not be forgotten when, in other contexts, we attempt to look for the reality behind the image, or to disentangle the complex and interwoven strands of significance.

Some other scenes from Pompeii are better adapted to represent Roman practice, at least as far as the spatial layout is concerned. One of the earliest is no more than a sketch: it decorated a *lararium* or household shrine in the kitchen of the House of Obellius Firmus (IX 14.2/4) (Fig. 27).[48] The

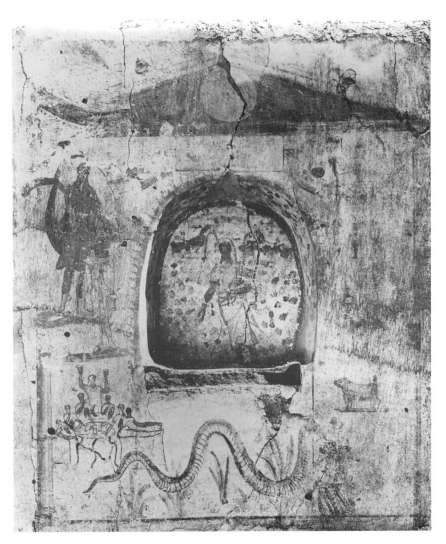

Figure 27 – Pompeii, House of Obellius Firmus (IX 14.2/4), lararium *painting, banquet scene below left. Late first century* BC. *Photo Soprintendenza Archeologica di Pompei AFS C 399 (neg. 80853), upon authorization of the Ministry for Cultural Heritage and Environment.*

three-sided triclinium arrangement is here clearly rendered, with the single table within reach of all participants. Six men are reclining, a seventh in the centre stands raising a cup in either hand, as if in a toast. The execution is summary and without pretensions, reflecting the low-status location of the painting. It has been taken to represent the members of the household, perhaps the slaves celebrating a festival at which they were permitted to recline like their betters; the reference to contemporary custom would be essential for such a purpose, and Greek luxury would have no place. But

for all its simplicity, it may be noted that here too the emphasis is entirely upon drinking, with no food visible; even the rapidity of the sketch does not prevent the representation on the table not only of various drinking vessels, but also of implements to serve them such as the ladle.

More substantial are three paintings from the House of the Triclinium (V 2.4), from a room decorated in the Fourth Style, probably before the earthquake of 62 AD.[49] These paintings show groups reclining on couches arranged approximately in the form of a Pi, although opened up in front to make the scenes more legible for the viewer. One is set indoors (Fig. 28), one probably out of doors, the third in a portico with awnings (Fig. 29). They are painted in a rather hasty, fluid style, and the condition, especially of the central one, is poor. In the first, it is possible to make out the forms of the three adjoining couches fairly distinctly; in the other two, the shape of the couches is not clear, but there is a single table in the centre designed for all participants. None shows the full nine guests of Roman convention; as far as can now be judged, the number varies between five and seven, distributed from one to three to a couch. Other details conform to Roman custom, especially in the first, indoor scene: one guest sits while a slave removes his shoes; a distinguished man seems to be in the position of honour at the central couch and is attended by a small servant boy, apparently black; and the hairstyles and clothing seem more Roman than Greek. The general atmosphere is still that of the untrammelled drinking bout. In the first scene, a drunken guest is supported by a servant as he vomits; in the second, another is slumped forward over the front of the couch. Servants offer cups or jugs of wine, wine vessels stand on the tables, and there is no food to be seen. The second scene includes the entertainers, a nude dancer and two flute players, on a smaller scale in the foreground; it also shows a bronze statue of a youth holding a tray, a token of luxury that may be compared to the real statue of a bronze ephebe holding torches in the summer triclinium of the House of the Ephebe.[50] No women appear among the guests in the first scene, although there may be one in the second. The third painting, however, shows couples of half-nude men and women, one drinking from a horn, in a scene of abandoned festivity comparable to those of Hellenistic inspiration discussed earlier. Above their heads, however, are written their words in Latin: one says 'Have a good time', another 'I am singing', a third 'That's it, cheers'.[51]

These scenes, in short, have taken the Greek ideal of the drinking party, and translated it into a Roman setting and Latin dress, in the process losing the elegance of the finer paintings in Hellenistic style. There is no doubt that the paintings set out to represent a banquet in recognizable contemporary

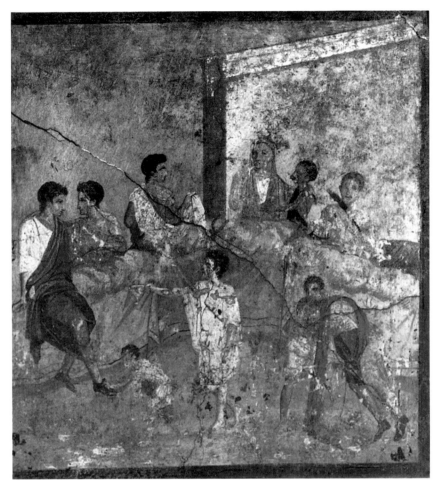

Figure 28 – Pompeii, House of Triclinium (V 2.4), indoor banquet. Naples, Museo Nazionale 120029. Mid-first century AD (before 62); 68 × 66 cm. Photo Soprintendenza Archeologica delle province di Napoli e Caserta.

fashion, a glorified version of feasts that might actually have taken place in the room. They imply, therefore, not only the desire to create an appropriate mood of festivity, but also the intention of self-representation by the owner who commissioned the paintings; in them, he advertises the pleasures of the feasts he can offer his guests, complete, at least ideally, with servants, entertainment, and unlimited wine. It is not clear, unfortunately, whether the comparatively modest house was privately owned or was an inn where the triclinium was available for hire.[52]

Sometimes the theme is treated quite explicitly as fantasy. A series of small paintings from the House of M. Lucretius at Pompeii (IX 3.5) shows

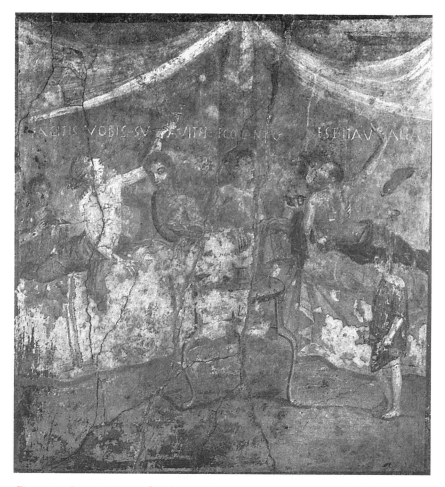

Figure 29 – Pompeii, House of Triclinium (V 2.4), banquet under portico. Naples, Museo Nazionale 120031. Mid-first century AD (before 62); 63 × 60 cm. Photo Soprintendenza Archeologica delle province di Napoli e Caserta.

Erotes and Psyches enjoying the pleasures of the banquet, music, and dance; the details are often direct imitations of motifs found with normal human actors. Two scenes show the banquet out of doors under an awning: in one, the participants are reclining on the couches of a triclinium, a table laden with drinking vessels between them; in the other, they are on a cushion set on the ground, the original form of the *stibadium*, while an Eros dances in front holding an amphora, to the music of a cithara (Pl. IV).[53] The *stibadium* cushion also appears for scenes of an outdoor picnic in a landscape setting, but these are never more than minor episodes in a frieze or larger painting, often very sketchy in style.[54] Two such scenes, episodes in a Nilotic landscape showing a group of diners reclining on a cushion under a pergola,

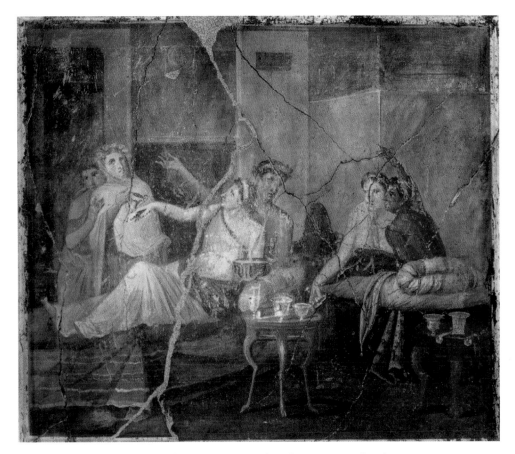

Plate I – Pompeii, House of the Chaste Lovers (IX 12.6), triclinium, west wall, indoor banqueting scene. Ca. 35–45 AD. Photo Soprintendenza Archeologica di Pompei, upon authorization of the Ministry for Cultural Heritage and Environment.

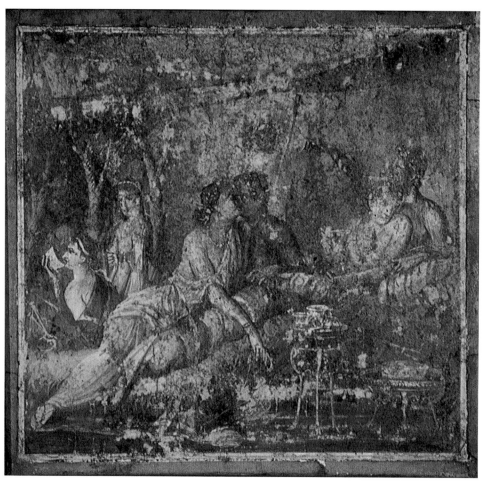

Plate II – Pompeii, outdoor banqueting scene, based on same original as Fig. 26. Naples, Museo Nazionale 9015. Mid-first century AD; 44 × 48 cm. Photo Soprintendenza Archeologica delle province di Napoli e Caserta.

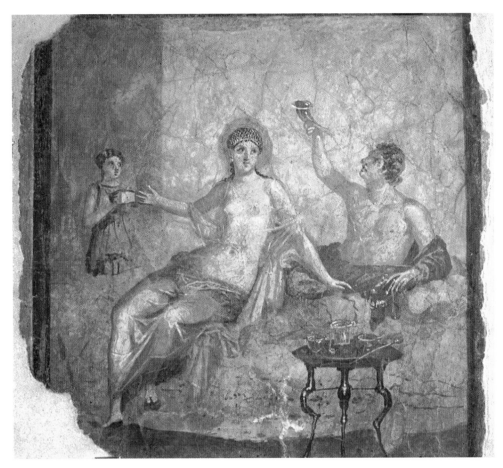

Plate III – Herculaneum, banquet of young man and hetaera. *Naples, Museo Nazionale 9024.*
Mid-first century AD; *59 × 53 cm. Photo Soprintendenza Archeologica delle province di Napoli*
e Caserta.

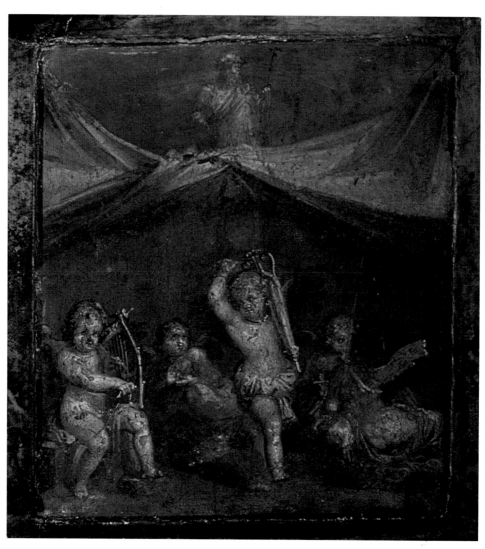

Plate IV – Pompeii, House of M. Lucretius (IX 3.5), banquet of Erotes and Psyches. Naples, Museo Nazionale 9207. Mid-first century AD; *45 × 40 cm. Photo S. Jashemski, courtesy of W. Jashemski.*

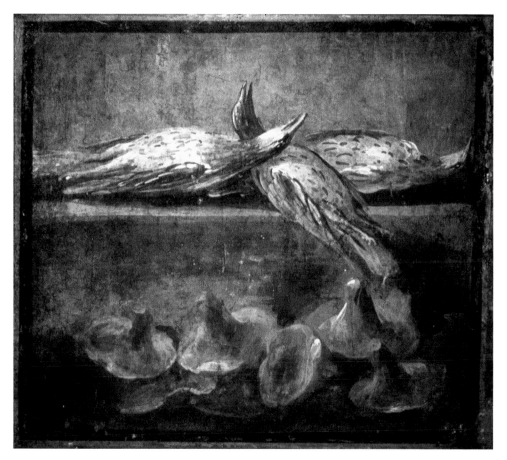

Plate V – Herculaneum, painted panel with still life (xenia). Naples, Museo Nazionale 8647c. Third quarter of first century AD *(Fourth Style). Photo Soprintendenza Archeologica delle province di Napoli e Caserta.*

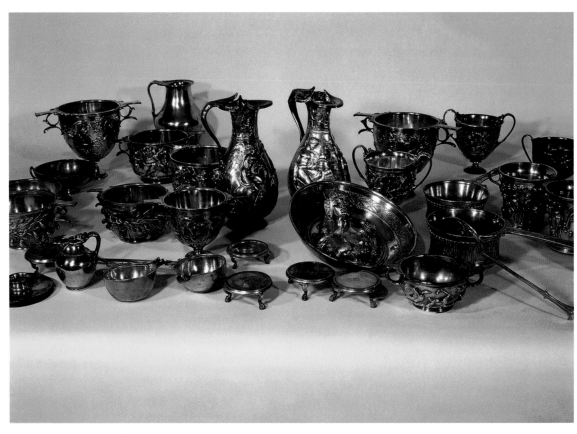

Plate VI – Boscoreale Treasure, selected silverware. Paris, Musée du Louvre. Copyright Réunion des Musées Nationaux (86EE 1899)/Art Resource, NY.

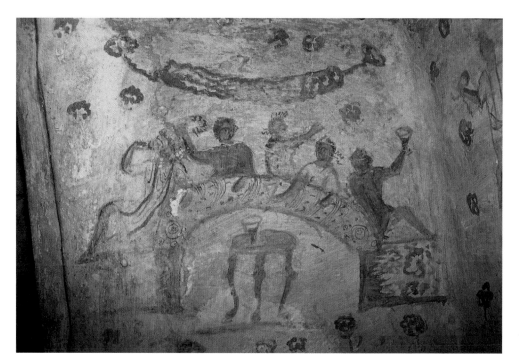

Plate VII – Lilybaeum, Hypogaeum of Crispia Salvia, painting of banquet scene. Second century AD. *Photo courtesy of R. Giglio and Soprintendenza per i Beni Culturali ed Ambientali, Trapani.*

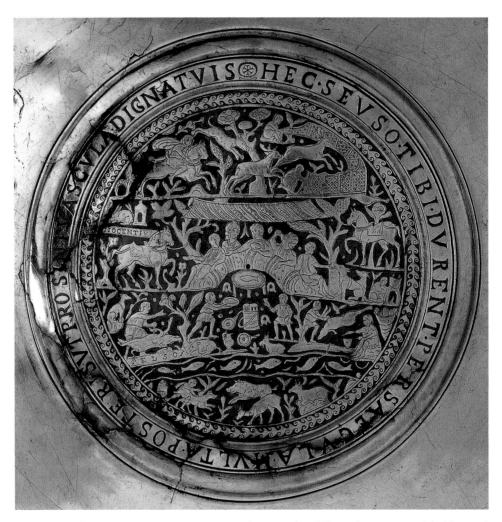

Plate VIII – Sevso Treasure, Hunting Plate, central medallion. Photo courtesy of the Trustee of the Marquess of Northampton 1987 settlement.

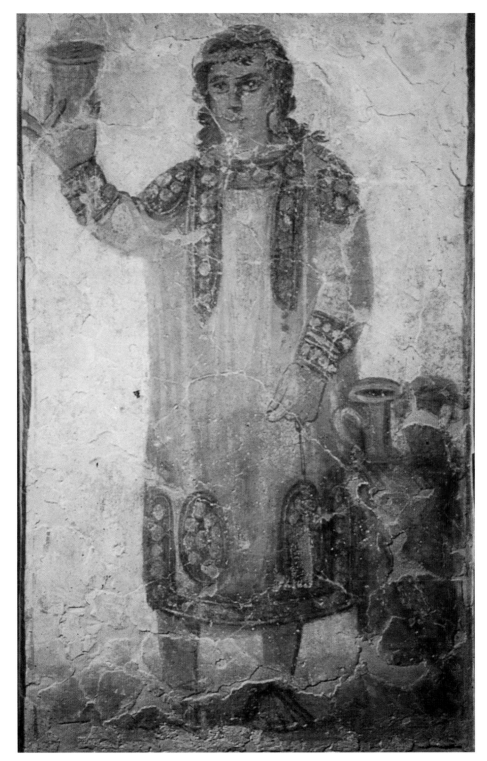

*Plate IX – Rome, building on Caelian Hill, painting of wine server. First half of fourth
century* AD. *Naples, Museo Nazionale 84284. Photo Soprintendenza Archeologica delle province
di Napoli e Caserta.*

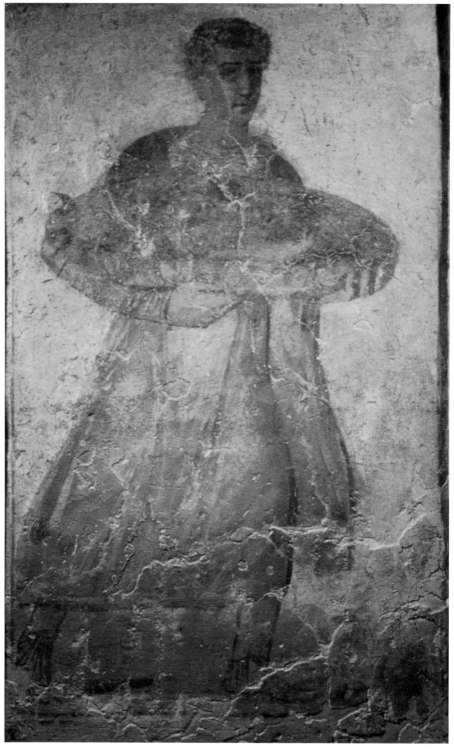

Plate X – Rome, building on Caelian Hill, painting of servant with plate of vegetables. First half of fourth century AD. *Naples, Museo Nazionale 84285. Photo Soprintendenza Archeologica delle province di Napoli e Caserta.*

Plate XI – Thysdrus, mosaic panels from triclinium with xenia. *Third century* AD. *Tunis, Musée du Bardo A 268. Photo courtesy of R. J. A. Wilson.*

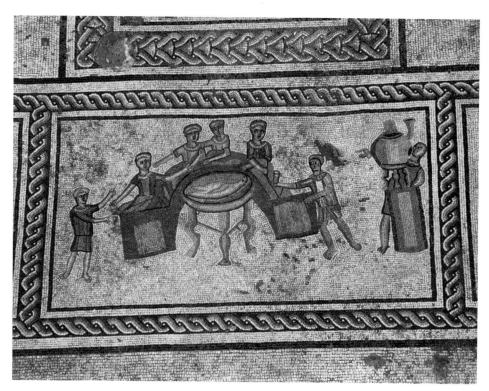

Plate XII – Sepphoris, House of Orpheus, triclinium, mosaic of banquet. Probably second half of third century AD. *Photo G. Laron, the Hebrew University Expedition at Sepphoris; courtesy of Z. Weiss.*

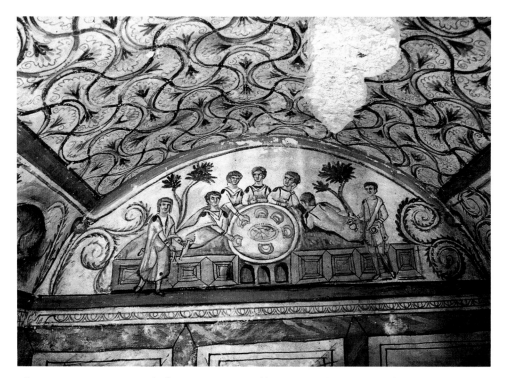

Plate XIII – Constanza, Tomb of Banquet, painting of banquet on stibadium. *Mid-fourth century* AD. *Photo courtesy of A. Barbet.*

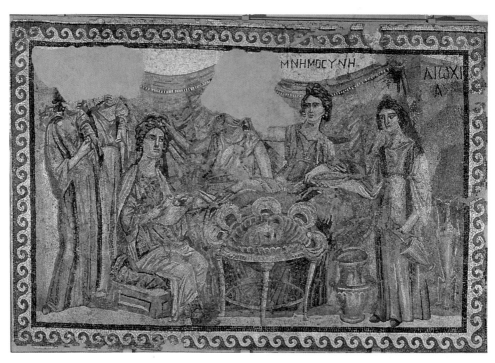

Plate XIV – Antioch, Tomb of Mnemosyne, mosaic of banqueting women. Late fourth century AD. *Worcester Museum of Art Inv. 1936.26. Photo Worcester Art Museum, Worcester, Massachusetts.*

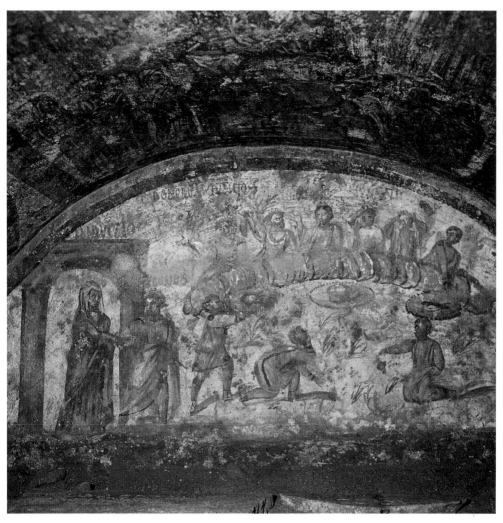

Plate XV – Rome, Hypogaeum of Vibia, arcosolium, *induction of Vibia and banquet of Vibia among the Blessed. Probably second half of fourth century* AD. *Photo Pontificia Commissione di Archeologia Sacra, Vib B1.*

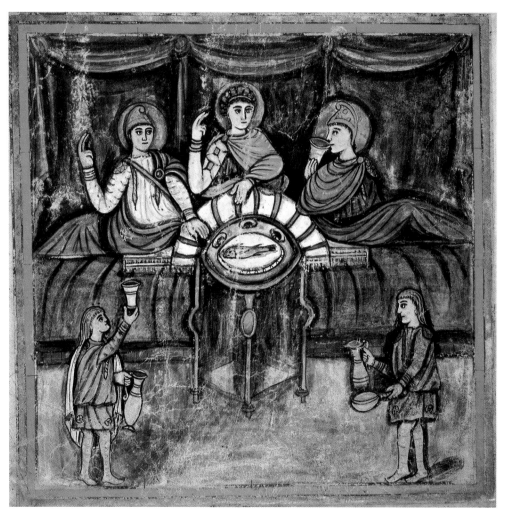

Plate XVI – Vergilius Romanus, Cod. Vat. Lat. 3867, fol. 100v, Dido's Feast. Probably late fifth century AD. © *Biblioteca Apostolica Vaticana (Vatican).*

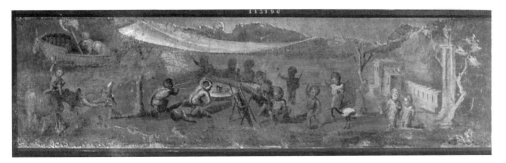

Figure 30 – Pompeii, House VIII 5.24, outdoor banquet of pygmies. Naples, Museo Nazionale 113196. Photo Soprintendenza Archeologica delle province di Napoli e Caserta.

decorate the sides of the outdoor triclinium in the House of the Ephebe at Pompeii (I 7.10–12); another adorns the garden side of the podium of the peristyle in Pompeii VIII 5.24 (Fig. 30). The actors in these and similar scenes are often grotesque little pygmylike figures, and the entertainment that they are shown enjoying can be crudely erotic. Often there are allusions to an Egyptian setting, with the typical Nilotic flora and fauna that for the Romans evoked an exotic and almost mythical land.[55] This setting makes evident the intention to allude to the pleasures and luxuries of Hellenistic Alexandria, the undoubted source of this fashion for outdoor dining. Already in the late second century BC a scene of a symposium out of doors under a pergola, beside the waters of the flooded Nile, had featured prominently in the foreground of the great Nile Mosaic at Praeneste (Palestrina) in Latium, which offers a panorama of the land of Egypt and its characteristic activities.[56] In their use at Pompeii, these paintings, like the outdoor triclinium itself, bring the world of these fantasies directly into the lives of the houseowners.

A clear representation of a triclinium banquet is found on a work in a different medium, a mosaic panel from Capua (Fig. 31). The style suggests a date slightly later than the Pompeian paintings, perhaps the late first to early second century AD.[57] The mosaic is fragmentary and the left side destroyed, but the Pi-shaped arrangement of the triclinium is very distinct; the couches appear to have a continuous structure, with a wooden end and legs visible at the right, and a red bolster placed on top. Six figures survive, at least in part, on the two remaining sides, suggesting the canonical number of nine guests. Nevertheless, this does not seem to be intended for the close-set triclinium familiar from the Pompeian examples in masonry. The couches appear to have opened out more widely; at least three little tripod tables occupy the space between them instead of the traditional one, and there is room for

the servant at the front to move into the central space. In other words, this small panel seems designed, not only to represent a scene in a specifically Roman setting, but also to reflect some of the changes in the archaeological record discussed above, where the rooms designed for dining grow larger and more spacious. The numerous little tables recall the passage in Petronius where Trimalchio orders his guests to be provided with individual tables.[58] The Capua mosaic also introduces respectably dressed women among the guests, evidently as full participants in the banquet; indeed, one woman is placed prominently in the centre of the middle couch in what is evidently a prestigious position, even if not the traditional position of honour. However, another woman on the right-hand couch appears to be half-nude (as indeed are two of the men), indicating that some elements of the scene are derived from the traditions of the hedonistic banquet, like those in the Pompeian paintings just discussed; and here too only drinking vessels are visible on the tables and in the hands of the guests.

It will be clear from the examples discussed that there is no easy division between 'Greek' and 'Roman' elements in the banquet paintings of the Campanian cities and others of similar date. We are fortunate to be able to identify common prototypes lying behind the paintings of the House of the Chaste Lovers and their replicas; we may likewise assume Hellenistic forerunners for most of the large panel paintings that show hedonistic banquets of youths and *hetaerae* like that from Herculaneum. Even with these, however, minor details seem to have been left to the painters' discretion, allowing the introduction of contemporary features. The appearance in a few scenes of a recognizable triclinium layout is a less ambiguous indication of Roman custom, but is compatible with the use of specific motifs taken directly from the Hellenistic tradition. There is a definite preference for scenes with an outdoor setting, whether the diners use individual couches, a triclinium arrangement, or a cushion placed directly on the ground.[59] The evocation of pleasure and luxury that is the principal object of these paintings does not depend for its force upon their closeness to actual contemporary practice; the banquet is an ideal that can be effectively conveyed by means that are largely conventional and traditional. Nevertheless, in some of these paintings, elements of advertisement are apparent that suggest the beginnings of a need for more direct reference to contemporary experience. In Chapter 3, some uses of the banqueting motifs in funerary contexts will be discussed, which show more clearly than those from domestic settings at this date the manner in which the theme could be adapted to the specific needs of self-representation. Only one will be mentioned here, the painting of the banquet scene from the Tomb of Vestorius Priscus at Pompeii (Fig. 43,

Figure 31 – Capua, banquet mosaic. Perhaps late first to early second century AD; 102 × 96 cm. Museo Campano, Capua. DAI Rome 64.661, photo Hutzel.

Chapter 3). Here the diners recline out of doors at a triclinium, a large table set with drinking vessels in the centre. The scene, like other paintings in the tomb, is undoubtedly designed to convey an impression of the status and wealth of Priscus and his family, and accordingly to refer recognizably to contemporary Roman practice. Yet even here there are details that recall the traditional scenes of the Hellenistic symposium: one man drinks from a horn, another is slumped drunkenly forward over the table. The sense of hedonistic luxury which such images conveyed was inextricably interwoven into the ideology of the banquet and its pleasures.[60]

FOOD, DRINK, AND THE ROLE OF WOMEN IN THE CAMPANIAN PAINTINGS

The exclusive concentration upon drinking in the Pompeian paintings is certainly inherited from the Greek tradition of the *symposion*, and seems at variance with Roman values, and with the importance of food and cooking

conveyed by the literary sources.[61] Representations of food do indeed appear in the paintings of the Campanian cities, but in very different format: in small panels that show different and often exotic types of fruit, fish and seafood, game and small birds, and so forth; they are represented as raw rather than cooked (indeed, sometimes as alive), waiting for preparation (Pl. V, Fig. 32).[62] Certainly, there is nothing in any way comparable to the extravagant dishes that we find in the moralists or in Apicius: no flamingoes' tongues or dormice in honey, let alone Petronius' fantastic imaginings such as the wild boar disguised as a sow with her piglets, who turns out to be stuffed with live thrushes.[63] However, although these dishes are simpler, they are often expensively presented, on elaborate silver plates or in elegant glass vases. These paintings are given the name of *xenia* by archaeologists and identified with the paintings described by Vitruvius as representing the gifts of food that Greek hosts sent to their guests; when they decorate triclinia, as they usually do, they are clearly intended to allude to the lavish banquets held there, and to convey an impression of the wealth and hospitality of the host.[64]

Occasionally, however, a different method is adopted of alluding to the wealth and variety of food served at a meal: through the representation of its debris. The type of mosaic known as *asarotos oikos*, or 'unswept room', goes back to a Hellenistic conceit devised, as Pliny tells us, by the mosaicist Sosos at Pergamon.[65] This original itself is lost, but a handful of later mosaics imitate or adapt the concept, the earliest of the first century BC. Best known is one from Rome, now in the Vatican, signed by its maker Heraklitos, and probably dating to the second century AD (Fig. 33).[66] Here a frieze in mosaic ran around three sides of a square, evidently in front of the couches of a triclinium; it was decorated with the debris of all sorts of food, shown with *trompe l'oeil* realism as though lying on the white ground. It includes the bones of fish and chicken, shells of seafood and lobster claws, snail shells, nuts, cherries, bits of vegetables, and even a tiny mouse gnawing a nut. To dispose of remains by dropping them on the floor was a natural practice when eating with one's fingers; the small tables used in the Roman triclinium served primarily for serving food, not to hold dishes for debris. In a real dinner, we must assume that the floor became littered with such objects, not to mention puddles of spilled wine (and sometimes worse); all to be swept up by the slaves. On the mosaic, these sordid remains are presented with virtuoso skill for the guests to admire before the meal begins, an amusing talking point and a promise of the good meal to come. It must be noted, however, that there is no visual indication of the actual consumption

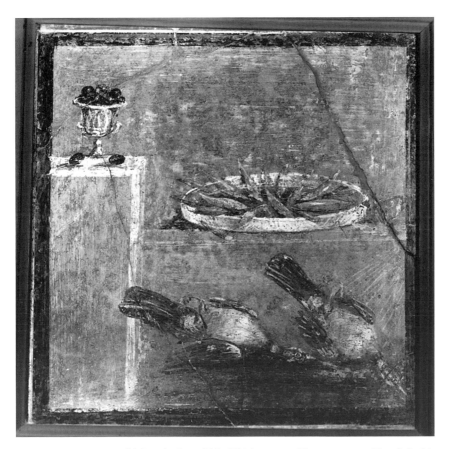

Figure 32 – Pompeii, still life with plate of fish. Third quarter of first century AD (Fourth Style); 37 × 37 cm. Naples, Museo Nazionale 8634. DAI Rome 60.2386, photo Sansaini.

of food; even in this context, the process of eating remains an inappropriate subject for art.

The conventions and rituals of drinking, however, are of central interest to the artists and their patrons. In all the banqueting scenes so far considered, the drinking apparatus invariably occupies a prominent place. The drinkers hold cups or bowls of silver, or even drink in unrestrained fashion from a horn; the servants hurry forward to offer full cups, or with a jug to fill an empty one; and meticulously rendered vessels are spread out on the tables. Many types of cup are often differentiated, and the equipment, also of silver, used to prepare and serve the wine is placed beside them; there is almost always the ladle or *cyathus* used to transfer the wine to the cups, and sometimes a long-handled instrument that probably served as a stirrer. Many literary sources convey the importance attached to the possession of

Figure 33 – Rome, mosaic of asarotos oikos, detail showing debris of food. Probably second century AD, based on Hellenistic original by Sosos of Pergamon. Museo Gregoriano Profano, Vatican Museums. Musei Vaticani, Archivio Fotografico Neg. N. XXXIV.32.32.

silverware in the late Republic and early Empire. Drinking silver in particular was highly prized, as a mark not only of its owners' wealth, but also of their culture. The great treasures of silver that have survived from this period, such as those from the House of the Menander at Pompeii and the villa della Pisanella at Boscoreale (Pl. VI, Fig. 34), contain as many as 100 objects.[67] Far the greatest number are drinking cups, in various shapes and sizes, usually richly decorated in relief, and often with extraordinary delicacy; the subjects vary from floral motifs, birds, and animals, to mythological and Dionysiac scenes, a pair of cups with figures of skeletons, and even a pair with historical scenes from the imperial repertory. The frequent appearance in these collections of cups designed as pairs – occasionally even in sets of four – suggests their use in sympotic rituals, probably in the drinking of toasts. More generally, it is clear that their decoration was intended to evoke admiration and discussion at the drinking party, and to invite exhibitions of culture and wit from the assembled guests. The selection of vessels that the artists chose to include in the paintings, and their careful portrayal, reflect their significance for their patrons and their viewers.

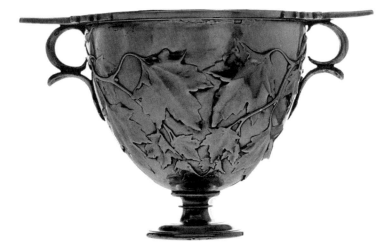

Figure 34 — Boscoreale, silver cup decorated with plane branches. H. 10.6 cm; first century AD. Paris, Musée du Louvre Bj 1910, photo Chr. Larrieu.

Conspicuously absent from these scenes is anything corresponding to the *krater* that plays such a prominent part in scenes of the Greek *symposion* on Attic vases: a large communal bowl where the wine would be mixed for the whole company. In several of the paintings, we see a smaller bowl standing on the table, which seems to have formed a standard part of a drinking set; this might have been used to mix a limited quantity for one or two persons.[68] There is no indication in any of these paintings of the use of hot or cold water for mixing, although the literature makes it clear that this was normal, fashionable practice at this date. A method of cooling the wine appears several times, with a large bowl – the only time vessels of this size appear – placed into a basin evidently of iced water.[69] Cooling one's wine by adding ice or snow, of which we hear much in the written sources, does not appear recognizably in the figured scenes, now or later. Nor is there any sign here of the use of a special apparatus to heat water for mixing, although some magnificent examples of these expensive machines were already in use in Pompeii as early as the first century BC; it will be seen in subsequent chapters that they came to play a prominent part in many later Roman banqueting scenes.[70]

Finally, the ambivalent position of women in these paintings should be noted. Several show all-male gatherings, as indeed can be found at all periods of Roman art; it can hardly be doubted that, in many circumstances, a dinner or drinking party remained a male prerogative. In many others, the women present are clearly marked by their state of undress and unrestrained behaviour as sexually available and belonging to the underworld; as in much sympotic poetry, erotic pleasures are implicitly or explicitly included among

the delights of the banquet.[71] We may wonder, if there were women among those dining in these rooms, whether they too saw such paintings as an expression of their own ideals of luxurious living. Yet the Capua mosaic, and one or two of the paintings, include women who to all appearances are portrayed in their dress and demeanour as respectable members of society, participating in the feast on equal terms with the men.[72] In this respect, there seems to have been a contradiction between the models available to the artists, with all the conventions that they carried with them, and the pressures exerted by contemporary social practice and the ideologies that it imposed. The contradiction, which perhaps was inherent in the whole Roman attitude to women's participation on equal terms in banquets and the question of their right to recline, was never entirely resolved. Its effects will be seen most clearly in the examination of banqueting scenes on funerary monuments in Chapter 4 because it was in such monuments that questions of self-representation and status were especially prominent, and that the ambiguities of status in Roman society were most acutely visible.[73]

HELLENISTIC INFLUENCE: THE EASTERN PROVINCES

In general, therefore, the appearance of banqueting scenes in Roman art of the Empire is long dominated by traditions and conventions that go back to the Hellenistic period. In many of the Pompeian paintings that form the main subject of this chapter, images of Hellenistic convivial luxury, utterly remote from the direct experience of the viewers themselves, are called upon to evoke the requisite mood of escapist enjoyment. Features taken from the contemporary world are used tentatively; they do not affect the main outlines of the scenes, but introduce a few elements that would have served to establish familiar connections. Other paintings do show a desire to set the banquet in a framework of recognizable contemporary practice; this concerns primarily the appearance of the triclinium layout, which must have been seen as one of the most striking indicators of specifically Roman convivial behaviour. Other changes, such as the presence of women as respectable participants, appear occasionally. Yet these developments remain compatible with the maintenance of many characteristics of the Hellenistic scenes, which prove very persistent. New formulae are only slowly worked out for the representation of aspects of the contemporary banquet, even of some that had the highest ideological value; many, indeed, become established only in the later Empire, and will be discussed in Chapters 5 and 6. In Chapters 3 and 4, the main focus will shift from domestic decoration to the

use of banqueting scenes in funerary contexts; it will be seen to what extent
the requirements of this use influenced the traditional banqueting motifs,
and led to the introduction of new elements and different emphases.

Before leaving the scenes from domestic contexts, we may turn for com-
parison briefly to the Greek-speaking regions of the Roman Empire. Ban-
queting scenes from these regions show that the dominance of Hellenistic
traditions here was even more powerful and explicit, and continued into
the second and third centuries AD. At Antioch, the great metropolitan city
of Syria, sympotic and banqueting scenes are used at this time to decorate
the mosaic pavements of private houses; the rooms they adorn are some-
times recognizable as triclinia from the layout of the pavements. There is no
suggestion that these show scenes from contemporary life; instead the char-
acters are identified by inscriptions as mythological or allegorical figures,
or occasionally as the great figures of classical literature. One shows diners
named as Agros and Opora, personifications of the productive field and
the fruitfulness of autumn, respectively; they are served wine by a Silenus
named as *Oinos*, wine himself (Fig. 35).[74] Another identifies its characters
as Aion, deity of eternal time who holds the wheel of the zodiac, and as the

*Figure 35 – Antioch, House of the Boat of Psyches, mosaic of banquet of Agros and Opora. Ca.
235–312 AD. Baltimore Museum of Art 1937.127. Photo Department of Art & Archaeology,
Princeton University, neg. 2277.*

personifications of the transient and fleeting times, past, present, and future, collectively named as the *Chronoi*.[75] In a third, Menander, the Athenian comic playwright of the fourth century BC, reclines along with a woman labelled Glykera, supposedly his mistress, while Comedy stands in attendance holding a mask.[76] Elsewhere we see Dionysus, victor of his drinking contest with Heracles, amid members of his thiasos.[77] These scenes would also serve to enhance the convivial spirit of the participants or to set a tone for banquets held in the rooms, but that tone is dramatically different from that of the Pompeian paintings. The theme of Aion and the Chronoi is manifestly intended to stimulate discussion of a philosophical nature among the guests before whom it is displayed; the more straightforward allegory of Agros and Opora would encourage appreciation of the bounties of nature provided at the feast. Menander, whose plays remained at this period a favourite source of after-dinner entertainment, would have asserted the host's tastes in literature or called for an exercise in literary allusion, whereas the presence of his female companion might be taken as a discreet reference to sexual adventure. The more general pleasures of sympotic indulgence are sufficiently evoked by the familiar figures of Dionysus and his followers. In this ambience, it is not surprising that the scenes are composed entirely in the traditional manner, the banqueters reclining upon individual couches, or in the case of Dionysus and Heracles, on cushions on the ground. Many of them will undoubtedly have repeated earlier prototypes; others have adapted motifs taken from stock though arranged in new form. At the most, contemporary reference is confined to a few minor details, just as in the paintings of the House of the Chaste Lovers. The wealthy houseowners of the Greek cities in the Imperial period were no more immune to change in their own dining habits than those of Italy or any other part of the Empire; the changes in the plans of their houses would be sufficient to demonstrate this.[78] But their art remained in this respect highly conservative, and images traditional in conception and content were sufficient to create the ethos that they desired; they seem to have felt no need at this stage for an art that would more closely reflect their own status and activities, at least in their domestic decoration.

In Italy, the eruption of Vesuvius in 79 AD puts an end to our series of paintings of banqueting scenes from domestic contexts. For more than a century, there is little to follow them. The Capua mosaic, if correctly dated, may extend the series slightly, but the theme of the banquet does not appear to have been widely adopted in the second century on the mosaics of Italy, nor those of the Western Empire. Nor indeed is it taken up in other surviving media in this period, with the exception of the funerary sculpture discussed in Chapter 4, which belongs to a very different tradition.

The Eastern Empire, as just seen in the case of Antioch, also followed its own traditions and conventions. Accidents of survival must of course be allowed for, and especially the disappearance of almost all domestic painted decoration. Yet on our present evidence, it looks as though the theme had gone somewhat out of fashion in domestic decoration in Rome and Italy, and had not yet been widely adopted in the Western provinces. It will be seen in Chapter 5 that it came back triumphantly in the third century and flourished especially in the fourth, in all sorts of contexts and in a wide variety of media, as well as over a wide geographic range. Only then, it will be suggested, had the artists freed themselves sufficiently from the restraints of a tradition that no longer spoke to current preoccupations, and mastered a repertory that conveyed adequately the ideological significance of banqueting in the contemporary world. As will be seen there, it was above all scenes of the *sigma* banquet that were chosen as appropriate for the new messages that were now required. Earlier in this chapter, I discussed the changes that transformed the architecture of triclinia throughout the Western Empire in the late first and second centuries AD, and the corresponding changes that these imply in the atmosphere and ethos of the banquets. Yet it must be noted that the surviving images do not show the huge events with masses of guests that the new and much larger rooms seemed designed to cater to. The Capua mosaic is the only example known to me of a scene that appears to be set in a large extended triclinium; even there, probably no more than nine guests were shown.[79] The technical difficulties of portraying such large numbers are undoubtedly in part responsible for their absence; ancient art was not good at crowd scenes. Yet it is also possible that such large numbers did not appear well suited to convey the desired convivial ethos; the small group remained the ideal. When the banqueting scene does come back into favour, it is indeed in the form of the small convivial assembly; other means were sought to express the required sense of status and display.[80]

Public Dining

MONUMENTS OF PUBLIC BANQUETS AT ESTE AND SENTINUM

In the Roman, world dining was often a public activity, conducted before an audience. It is of course an oversimplification to speak as though there were a clear dichotomy between public and private; the two were closely intertwined, and public concerns penetrated deep into what we would classify as private life. But the subject of this chapter is not the public aspect of the statesman or politician entertaining in his own home, but rather the occasions when groups assembled to feast in public, that is, in the public view. The integration of such occasions into the life of the community, the ways in which they were presented both to those who participated and to those who observed from outside, are an important aspect of the Roman attitude towards banqueting, and can tell us much about its social role.

In Rome itself, innumerable references from all periods make clear to us the importance of communal feasting in public life, to mark events ranging from religious ceremonies and triumphs to imperial anniversaries or the funerals of the great.[1] Many sources indicate the lavish scale of such events; thus Crassus in 70 BC is said to have feasted the people at 10,000 tables after his great sacrifice to Hercules; Julius Caesar to have feasted the entire Roman people after his multiple triumphs in 45 BC on 22,000 triclinia; Tiberius to have entertained the people – partly on the Capitol, partly elsewhere – while his mother and wife entertained the women.[2] On other occasions it was the Senate, or the senators and *equites* who feasted, often in front of a temple where all could see them. Feasting also played an important part in the lives of many professional and religious *collegia*; for instance, the guild of flute

Figure 36 – Rome, fragmentary relief from state monument showing banquet of Vestals. Rome, Museo Nuovo Capitolino Inv. 2391. 41–54 AD*; 0.48 cm × 0.52 m. DAI Rome 41.2675, photo Faraglia.*

players held a regular banquet in the temple of Jupiter. Such events were often notoriously lavish; Varro complains of the innumerable dinners of the *collegia*, which are sending the prices in the market through the roof.[3]

Events such as these must have attracted huge public attention, and played a large part in the self-presentation of public figures under both the Republic and the Empire. Yet, surprisingly, representations of the grand public banquet are almost entirely absent from surviving iconography in Rome. There seems to be only one exception: a small fragmentary relief from a state monument, one of the so-called Valle-Medici/Museo Nuovo reliefs, showing the banquet of the Vestals (Fig. 36).[4] The six Vestals, clearly identifiable by their characteristic headgear, the *suffibulum*, are reclining at a triclinium covered with drapery; one holds a large cup, another an object like a jar, a single plate bearing what seems to be a cake rests on the table in front. Several servants, apparently female, are visible in the background. The reliefs are now generally agreed to come from a state monument of the Claudian period, but it cannot be further identified.[5] A feast at which the Vestals attend

in formal costume must form part of a sacrificial ceremony, but there is no way of defining it more closely; we know of several occasions in the Roman religious calendar on which the Vestals were required to dine formally. A passage frequently quoted in comparison is that preserved in Macrobius, which records the banquet held for the inauguration of Cornelius Lentulus as *flamen* of Mars in 69 BC. There the *pontifices* reclined on two triclinia, while a third triclinium held four Vestal virgins and Lentulus' wife and mother-in-law.[6]

Our ignorance of the context of the Vestals relief is all the more regrettable in view of its uniqueness. Otherwise, it is remarkable that we do not find representations of public banquets in Rome to compare to the many accounts in literary sources, either in religious contexts or in those of the great public celebration. Needless to say, this does not necessarily mean that such representations never existed, especially in the more ephemeral media such as painting. As early as 214 BC, Livy records the painting dedicated in the temple of Libertas by Ti. Gracchus after his victory at Beneventum, which showed the feast celebrated by the army after the battle.[7] However, it seems clear that such scenes of mass communal feasting did not become established in the current iconographic tradition of public monuments.

In contrast, a small group of monuments of relief sculpture from towns in central and northern Italy have representations that may be identified as scenes of public feasting. None, unfortunately, comes from a known archaeological context or findspot, but their form leaves no doubt that they originally formed part of funerary monuments, and all are ascribed on the basis of style to the first half of the first century AD. Although in no case has an associated inscription survived to assist their interpretation, they may be compared with the large numbers of inscriptions found in the towns of Italy and the western provinces that record public and communal feasting. As will be seen, the figured monuments serve not only to complement the evidence of our written information, but also to illuminate aspects of behaviour and thought beyond what the written sources can tell us.[8]

The first is an altar now in the Museo Nazionale at Este; its origin is unknown, although Aquileia has been suggested (Figs. 37, 38).[9] At some point in its history it was reused as a well, and the lower part was cut down. On the front of the stone is carved a close-packed group of figures reclining on the three rectilinear couches of a triclinium, the inner outline of the couches clearly delineated. Between them stands a table laden with drinking vessels. Although some of the figures of the diners are very worn, there were probably thirteen of them.[10] Two servants attend at either side: the one to the left carrying a jug, the one to the right turning to look at a low stand with cups on it; and there are traces of an additional tiny figure,

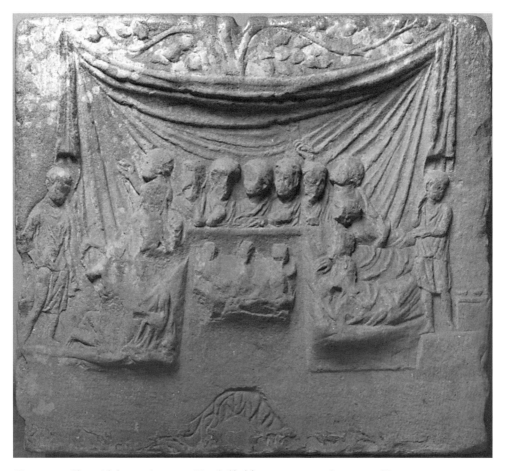

Figure 37 – Altar with banqueting scene. First half of first century AD; *86 × 93 cm. Este, Museo Nazionale Atestino Inv. 1547. DAI Rome 84.3100, photo Schwanke.*

perhaps a flute player. The scene is set against a backdrop composed of a large curtain hanging from a tree. Below is a more enigmatic item, which has been convincingly identified as the upper part of a wreath, cut off when the bottom of the stone was cut down.[11]

A similar scene, although simpler and rougher in execution, appears on a block from Sentinum in Umbria, now in Ancona (Fig. 39).[12] Here twelve figures are shown reclining on the three couches of a triclinium, around a circular table laden with drinking vessels. Again the sculptor has been careful to show the distinct edges of the couches and has added the carefully turned legs. The rest of the scene, with the twelve reclining figures, has proved rather too complicated for his evidently limited ability, but there is no doubt here of the number. Neither subsidiary figures nor backdrop are included; the image of the diners appears in isolation, sufficient in itself.

Figure 38 – Side of Este altar, smith's tools. DAI Rome 84.3104, photo Schwanke.

Traces on the other two sides of the block, before it was broken, show that an identical scene was represented there: on the left is visible the edge of one couch and the heads of three figures on it.

Roman funerary monuments, especially at this period, were designed to communicate to the passerby; they were set densely along the roads leading out of the cities where they would be readily seen. Their inscriptions record the status of the deceased, the offices that they have held in their city, and similar information that conveys their social position.[13] The images that decorate them may complement the inscriptions or even substitute for them. On one side of the Este altar, for instance, are carved the working tools of a smith, anvil, bellows, and tongs, in evident allusion to its owner's

Figure 39 – Sentinum, relief of banquet. Probably first half of first century AD. *Ancona, Museo Nazionale 123. DAI Rome 81.2247, photo Schwanke.*

occupation (Fig. 38); the other side shows spindle, distaff, shears, and wool-basket, the typical wool-working equipment, indicating that it is also the tomb of his wife.[14] The messages that such images conveyed to the contemporary viewer may be presumed to have been direct and unequivocal. However, when we try to recover the message of the main images on these two reliefs by the usual methods of comparison and analogy, we find that visual parallels are not plentiful. There is no connection between these dining scenes and the standard motif of the reclining banqueter used on innumerable grave monuments from the Hellenistic period onward, the so-called Totenmahl motif, which will be discussed in Chapter 4; nor do they resemble any of the domestic depictions of the convivial group discussed in Chapter 2. Both sculptors have set themselves carefully to portray, first, the three rectilinear couches set close around the central table, in the characteristic form of the Roman triclinium; and then, the twelve or thirteen tightly packed figures, a number that is unusual for this date and noteworthy. Given the challenge that the subject posed, especially evident in the case of the Sentinum relief, we should assume that these details were intended to have a special communicative force.

Some commentators have suggested that the banquets on our reliefs should be interpreted as part of the funerary ritual, perhaps the *Silicernium*, the feast celebrated by the mourners at the tomb after the burial, or the *Parentalia*, the annual rites in memory of the dead celebrated by the family in February. But there is not the slightest indication that would serve to evoke such a setting; in particular, one would expect to find a representation of the tomb itself if the viewer were expected to make such a connection. Much more plausibly, other commentators have seen them as representations of euergetistic banquets offered by the deceased to a group of their fellow citizens.[15] Large numbers of inscriptions from all over the Roman world, and especially from central Italy, record the custom whereby wealthy members of the elite donated a banquet or feast – the terms *cena* and *epulum* are those most commonly used – to members of their community. The recipients are most often the decurions, the city council, or the Augustales, the group of wealthy freedmen who were responsible for the imperial cult; they could also be the whole populace or all the citizens, or alternatively the members of one or more of the professional or religious *collegia*. The donors in turn are most often decurions or Augustales, but also include a certain number of individuals who had won distinction on the wider imperial stage, such as members of the senatorial or equestrian orders; women also constitute a small but significant segment of the benefactors. Such banquets might be given in the donors' lifetimes, to celebrate occasions such as their entry on a magistracy or the erection of a statue in their honour, or after death, set up in their testament or donated in their memory by a family member.[16] A fairly characteristic example, from Sinuessa in Campania, records that a certain M. Cacius Cerna, after an eminent political and military career, instituted a *cena* to be given on his birthday in public to the people of Sinuessa.[17] The inscriptions that record these events are carved in stone, sometimes at considerable length or with great pomp of presentation, to be set before the eyes of fellow citizens and their posterity; they may form part of grave monuments or be set up in public places such as the forum.

On the reliefs in Este and from Sentinum, the emphasis is on the coherence of the group and the formal dress that they are represented as wearing, both suggest that they are intended as the visual equivalent of these inscriptions; a lasting record of the generosity of the donors to their fellow councillors or citizens. They may be compared with the practice, found in a similar geographic range at much the same period, of representing scenes of gladiatorial combats on funerary reliefs, often undoubtedly as a record of a spectacle that the dead man has given in his lifetime.[18] Even the careful choice on our reliefs of the unusual number of twelve or thirteen guests, larger than was normally considered congenial for a social dinner party at this date, suggests

an intention either to allude to a specific body of known size or, perhaps more generally, to evoke a large number. If the groups were repeated on the sides of the Sentinum relief, this might be meant to suggest a banquet serving a substantial number.[19] The wreath at the bottom of the Este relief gives a further clue. A similar wreath appears on grave monuments above representations of the *bisellium*, a seat twice the usual size for use at public functions, which was decreed as a special honour to prominent men of both the decurion and the Augustales class, for especial benefits (normally munificence) to the city. It may be compared, for instance, with the representation of a wreath resting upon the *bisellium* on a funerary stele from Suasa, now also in the museum at Ancona; the inscription here identifies the dead man, whose portrait appears above, as a *sevir*, and two lictors bearing the *fasces* flank the seat. The banquet on the Este relief may then be taken to have been given by the *bisellarius*, the recipient of the award, in return for the honor of the *bisellium*.[20] The smith's tools carved on the side suggest that the male figure commemorated was someone who had made a great deal of money in the blacksmith's business, sufficient to be honoured by his city; given such a background, it is plausible also to suggest that he may have held the office of *sevir Augustalis* or *Augustalis*.[21]

Several of these inscriptions state explicitly that the dinner must be held in public; clearly the donor's munificence must be seen by the community to have its full effect. A woman named Cocceia Vera, from the old Sabine town of Cures, gave money for a banquet on her birthday, to be held in public, the decurions on ten triclinia, the *sevirales* on two. A similar provision is made on an inscription from Gabii, where the decurions and *seviri Augustales* are to feast in public on their triclinia. One from Beneventum records the donation of a portico with a service room for preparation (*apparatorium*) as well as a crossroads shrine, and prescribes that the inhabitants should hold here their annual feast on the donor's birthday.[22] The tree and the curtain on the Este altar acquire their significance in this context; they indicate that the meal is held out of doors, in a setting suitably prepared, with the curtain serving not only to provide shade for the diners, but also to frame them impressively for the observers.

THE AMITERNUM RELIEF

Another relief comparable to those from Este and Sentinum comes from Amiternum in central Italy (Fig. 40). It too shows a banquet scene, but with significant and informative differences. Once again the original context is unknown, but the long narrow slab must also have formed part of a

Figure 40 – Amiternum, relief with reclining and seated banqueters. Probably mid-first century
AD; *0.49 × 1.12 m. Pizzoli, church of Santo Stefano (Casa Parrocchiale). DAI Rome 84 VW*
935, photo Fittschen.

funerary monument. A drawing by an eighteenth-century antiquarian shows
an almost identical scene, but with the positions of the two main groups
reversed and enough difference in the details to show that it was based on
a distinct original. There must therefore have been two slabs, presumably
forming two sides of a rectangular monument, with similar scenes repeated
as on the Sentinum relief.[23]

Two separate groups are shown in both versions, each of six banqueters;
between them stands a table with the apparatus for serving drink, and two
servants busy around it. One group of diners reclines in the normal way, on
three couches around a single table. They are formally dressed, and there
can be little doubt that here too we are confronted with a public banquet
given by, or in honour of, the dead man whose tomb the relief adorned. The
second group is similarly dressed, but instead of reclining they are seated on
stools around a similar table. They hold cups, are served with wine, and are
undoubtedly also participating in a banquet. The obvious question therefore
arises why the two different schemes are adopted; what is the significance of
representing one group seated while the other reclines? Previous commen-
tators have not always attached a great deal of importance to this question,
sometimes speaking of the difference as simply 'iconographic'; in other
words, they appear to assume that the sculptor is following different models
for the portrayal of a meal without any particular reason for that choice.[24]
This is quite inadequate: the distinction, so prominently displayed, must be
significant – indeed, it should convey one of the central messages of the
relief.

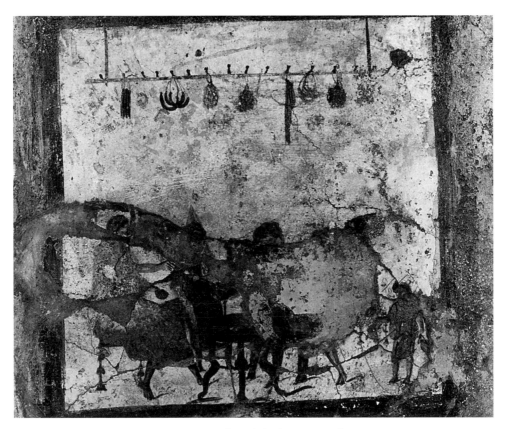

Figure 41 – Pompeii VI 10.1, caupona, *scene of seated drinkers in inn. Photo Ministero per i Beni Culturali e Ambientali, ICCD: GFN N 56106.*

Groups of seated diners and drinkers are by no means unknown in Roman art of the Early and Middle Empire; we are justified in assuming that they are intended to bear different connotations from scenes with reclining diners. Roman tradition looked on sitting to dine as a mark of old-fashioned simplicity; but apart from the special case of women (not relevant here), there is no suggestion of archaic custom discernible in such scenes.[25] They are usually taken as scenes of the *taberna* or *popina*, the lower-class drinking establishment; a setting appropriate for the more popular costume and sometimes the deportment of the figures. Thus two sets of paintings from Pompeii, which decorated the walls of actual taverns, include scenes of seated diners and drinkers. One set of thirteen panels from *caupona* VI 10.1 contains a scene showing four figures, two of them wearing what appears to be travelling costume (the typical hooded cape of a traveller), sitting on stools drinking around a table; above them, as though from the ceiling, hangs a string of foods, apparently vegetables and sausages (Fig. 41). Other scenes from the same series show seated and standing drinkers served wine by,

presumably, the host, while inscriptions above give their words. One asks, rather optimistically, for a glass of Setine wine, the favorite wine of the emperor Augustus.[26] The second set, from the *caupona* of Salvinus (VI 14.35/36), shows men playing dice and quarrelling, and a scene of two seated men served wine by the hostess, again with their words written above.[27] Similar scenes appear in sculpture; on the front of a third-century sarcophagus from the Isola Sacra near Ostia, a woman brings wine to two drinkers seated at a table. At the left is a counter of the type characteristic of taverns, from which the wine has evidently been drawn (Fig. 42).[28]

Seated dining and drinking (for males) may therefore be taken to indicate a lower status occasion or one in a more casual setting. But the seated group on the Amiternum relief is hardly to be seen as in a tavern. They are as formally dressed and behave with as much propriety as the reclining group, and they are served from a common, elaborate apparatus. The inscriptions once again suggest parallels that help in the interpretation. Numerous records of donations of food and meals distinguish by different terms the treatment of separate groups within the community. At Iuvanum, a *cena* is given to the decurions and their sons and to the Augustales *quinquennales* and their sons, an *epulum* to the plebs; a *cena* is obviously here the more prestigious event.[29] At Surrentum, the decurions receive a *magna cena*, whereas the populace on an earlier occasion had only *crustulum et mulsum* (mulled wine and crunchy cake).[30] It is clear that the scale of liberality that each group receives in such cases is directly related to its status. The same principle often determines donations of money on similar occasions: inscriptions frequently record that the higher social groups get more, sometimes substantially more, than the lower. The decurions get the most, the Augustales or similar groups somewhat less, the populace least of all; the need of the recipients plays no part in determining who gets what. The importance of the distinction for an understanding of the function of the distributions in the Roman community has been recognized by many recent historians. Primarily political in motivation, such distributions emphasize and strengthen the structure of the community and the status of its leading groups, to which the benefactors themselves of course belonged.[31]

However, it has not always been recognized in how visual a form such distinctions might be expressed. An especially telling inscription from Corfinium records the generosity of a munificent donor who has provided both banquets and cash: 'he delighted the most splendid city council, their children and wives, but also the populace as they feasted publicly with the greatest pleasure', and set up a substantial fund whose interest was to be distributed to the decurions and the entire populace on his birthday. It

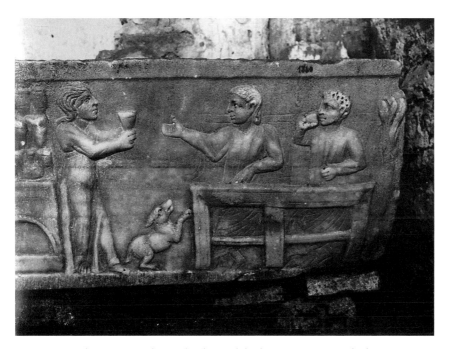

Figure 42 – Isola Sacra, sarcophagus, detail, seated drinkers in tavern. Late third century AD. Ostia, Museo delle Navi Inv. 1340. DAI Rome 69.750, photo Hutzel.

goes on to specify that a distribution was further made to three groups to whom three different terms are applied: the decurions, together with their children, were given 30 sesterces each as they reclined (*discumbentibus*), the *seviri Augustales* 20 sesterces as they dined (*vescentibus*), and the entire plebs 8 sesterces as they feasted (*epulantibus*).[32] The choice of terms is made very deliberately, and the distinction is evidently central. Although the difference between the last two, *vescentibus* and *epulantibus*, is obscure, it clearly involves status; the plebs may have received only a picnic basket, the Augustales a more substantial meal. But the important point is that only the decurions are distinguished as reclining. If one compares this with the Amiternum relief, I think there can be no doubt that this is the sense here; the highest status group reclines to eat (i.e. receives a *cena*), the lower sits. The distinction may be between reclining decurions and seated Augustales; however, because Augustales may recline in other contexts, it is perhaps more likely that the seated group represents the plebs, those reclining either decurions or Augustales.[33] As seen above, many of the inscriptions stress the public nature of such events and the importance of the privileged groups being seen to dine. More is involved than just the munificence of the benefactor, important though this is; dining in style is itself intended to be a public

spectacle, which reinforces the social hierarchy, and the less privileged act as spectators of the pleasures of their betters at the same time as they too partake in the celebration.[34]

The communicative potential of the Amiternum relief is not yet exhausted. Prominent in the centre between the two groups is the serving table, from which one attendant carries wine to the recumbent group. Another, who holds a ladle in his lowered hand, is busy behind it. The message is clearly that wine was plentifully available at the banquet: another aspect of the donor's generosity. But the servant with wine jug and the drinking cups in the guests' hands would have been sufficient to convey this; the serving table is an extra. It is shown as a handsome piece of furniture, almost certainly meant to be seen as marble, with a single leg in the shape of a herm, and bearing an elaborate set of implements, not easy to make out in its present condition; at either side are two objects shaped like drinking horns, with a pair of cups apparently placed under their spouts.[35] The prominence and detail with which all this is displayed may suggest that it too records part of the benefactor's donation. There are inscriptions which record the donation, not only of the meal itself, but also of some of the apparatus required for serving it. A notable example is one of the lengthy inscriptions from the mid-second century AD in honour of M'. Megonius Leo from Petelia, a small town in Bruttium. Among his numerous and substantial other donations, it records that in his lifetime he had given the Augustales two triclinia, and in his will (which the inscription quotes) left them candelabra and lamps for the furnishing of the triclinia, 'so that they can more easily attend at the public banquetings'.[36]

For any formal meal, it must have been necessary for the diners to be equipped with the requisite tableware – drinking cups, jugs, bowls, and all the rest; and the couches, cushions, and drapery must all have come from somewhere. Were they too all provided for the occasion by the donor, or were they the communal property of the decurions or the Augustales? Practice probably varied, but at least one story shows that it might be considered normal for the donor to provide them, although the setting and social context are different, and the date is earlier. Cicero and other authors tell the story of Q. Aelius Tubero, entrusted by his cousin Q. Fabius Maximus with the task of organizing the banquet he was giving to the Roman people in honor of his uncle Scipio Aemilianus. The Stoic Tubero, known for his austerity, provided goat skin covers for the couches and vessels of ordinary terracotta, to the great disgust of the people, with the result that he was defeated in an upcoming election for praetor.[37] The anonymous donor at Amiternum may have provided luxurious apparatus for his banquet,

perhaps even some special piece of wine-serving equipment, which he proudly caused to be recorded right in the centre of his relief.

THE TOMB OF VESTORIUS PRISCUS

Another monument, poorly preserved but much discussed, may refer to similar practice: the paintings of the tomb of Vestorius Priscus at Pompeii. Unlike the reliefs discussed above, here there is an inscription preserved in situ, which states that the tomb was erected by his mother for the young Priscus, who was aedile, perhaps in 70/71 AD, and died very shortly thereafter at the age of 22.[38] We can be certain therefore that we are dealing with an aspiring member of the municipal elite. The tomb consisted of a funerary altar within a walled precinct; paintings, now much faded, covered both the altar and the internal surfaces of the precinct walls. One of the paintings can be identified as the young magistrate seated on a tribunal and flanked by lictors, performing his duties as aedile; another with a pair of gladiators is likely to refer to a *munus*, a gladiatorial spectacle, which he organized as magistrate.[39] Another shows a banquet or drinking party; despite the poor state of preservation, it is possible to make out five figures reclining on couches around a big circular table, drinking vessels in hand (Fig. 43). An awning hangs above them, and peacocks stand on either side; the scene is set out of doors, probably in a garden. The most unusual feature is the representation, to the right of the diners, of a serving table laden with silver vessels, and another tray supported by a servant behind this. Further vessels stand, as might be expected, on the table between the diners, ready for use; the display is an extra, and as such must be intended to make a special point. Opinion has differed as to the interpretation of the scene; some have seen it as a funerary banquet, others as a public banquet of the type that I have been discussing, whereas the most recent commentators, Stephan Mols and Eric Moormann, see it as a private celebration in a domestic context, the sort of event in which Priscus would have participated during life, and whose role in the tomb is to illustrate the wealth and luxury of the family.[40]

The table with the display of silverware is repeated independently, and much more clearly, in the painting of a niche at the side of the tomb (Fig. 44).[41] The vessels are represented with considerable care, and a red hanging acts as backdrop. In the centre stands a big wine bowl; around it are four matched pairs of cups, in a range of sizes and shapes; two matched wine jugs; two drinking horns on stands; a row of four little measuring cups or ladles; and two spoon-shaped objects probably for stirring the drink. The

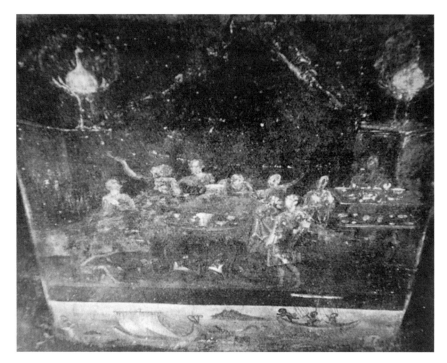

Figure 43 – Pompeii, Tomb of Vestorius Priscus, banquet scene. Shortly after 70/71 AD. *After Spano 1943, 278, fig. 11.*

larger vessels all bear a similar decoration of leaves, creating the impression that they form a matching service. Beneath the table stand a jug (whose colour suggests bronze, in contrast to the silver colouring of the other vessels) and a basin; this is the equipment for washing the guests' hands, as we learn from examples showing them in use, which will be discussed in Chapter 5.[42] Further vessels, now very faded, were shown on the side walls of the niche.

The practice of displaying table silver, especially drinking silver, on a special stand, the *abacus* or *mensa vasaria*, was a well-established form of ostentation among wealthy Romans. It had predecessors in the use of *kylikeia* for similar purposes in the Hellenistic world; Etruscan tomb paintings indicate that such displays were also familiar in Etruscan society.[43] In Priscus' tomb, the image is evidently designed to be read by the viewer together with the banqueting scene, repeating in more emphatic form the table represented in the scene itself; the paintings are arranged so that both can be seen simultaneously. The vessels themselves are portrayed with unusual care; several of them have more or less close equivalents in actual silver vessels from some of the first-century hoards of Roman silver.[44] It can hardly be

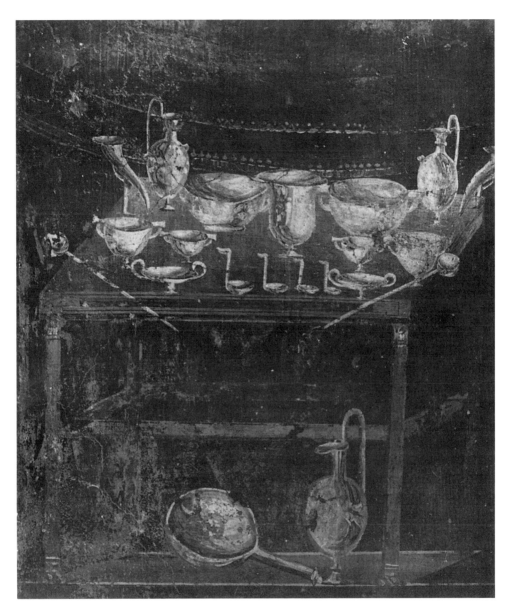

Figure 44 – Pompeii, Tomb of Vestorius Priscus, display of silverware. DAI Rome 31.2529.

doubted that the intention is to show, with fair veracity, the sort of array of drinking silver on which a wealthy provincial family might pride itself. Beneath the painting, a low base of masonry projected from the wall; it might have served to hold drink offerings for the deceased. However, although there is a link here between decoration and function, the vessels in the painting, as Mols and Moormann rightly saw, are not intended primarily

to evoke funerary ritual. With their display of status and luxury, they belong rather in the world of the living; an evocative symbol of the pleasures of a grand and lavish banquet. The emphasis given to them suggests that they serve an even more significant role, and move the banquet scene from the realm of private luxury to that of public representation. There may be an allusion to an occasion when the Vestorius' family silver had been displayed for the whole town to see, at a public banquet for the decurions or their representatives, or even to the donation of the vessels to the city or the *ordo* for public banquets. Such a gift would have been exceptionally lavish, but not impossible.[45]

Despite some ambivalence in details, the monuments in sculpture and painting can convey aspects of the significance of public banquets at which the inscriptions only hint. They remind us strongly that dining could be a spectacle, something to be displayed before the eyes of the populace. On the Amiternum relief, the contrast between reclining and seated diners makes it even clearer that reclining to dine was itself a recognised symbol of status. Even in domestic settings, the layout of Roman triclinia in the early and mid-Empire often contained an element of the spectacular: not only the view outwards from the triclinium for the diners themselves, but also the view into the triclinium from outside was taken into account, and the diners might be arrayed as if before a backdrop.[46] If this is true of the private domestic banquet, it would have been all the more so for one held in public. The sight of the town councillors (or other members of the elite), clad in their best, reclining on embroidered drapery and cushions under a rich awning, eating and drinking lavishly from splendid silver vessels, would not only have resounded to the credit of the donor; it would also have reinforced vividly the messages of status, privilege, and group solidarity that were essential to the social structure of the Italian towns.[47]

It was monuments such as these that Petronius must have had in mind when he makes his nouveau riche freedman, Trimalchio, give instructions to the stone-mason Habinnas for his funerary monument towards the end of his dinner.[48] After various specifications for the layout and decoration of the monument, Trimalchio directs that on it should be carved a representation of the highest point of his career, when he sits on the tribunal wearing the embroidered toga of the *sevir Augustalis* and five gold rings, pouring out coins for the public; 'for', he says, 'you know that I gave an *epulum* of two *denarii*'. Then, as if by an afterthought, he continues: 'make (i.e. carve on the tomb) triclinia, if you think fit, and make the whole populace enjoying themselves'.[49] It has rightly been seen that Petronius shows himself very familiar with the monuments that freedmen of the time were commissioning for themselves in Campania and central Italy, but as usual

he makes Trimalchio start with the familiar and the reasonable, and pile up the effect to ludicrous extremes. Representations on several tombs belonging to Augustales or municipal magistrates show the deceased seated in state on the tribunal, officiating at gladiatorial games or at a distribution, in a manner very similar to that Trimalchio describes.[50] It is clear from the sequence of thought that this scene goes closely with the *epulum* mentioned next; Trimalchio's hearers must be meant to understand this as involving an actual distribution of cash per head.[51] He then decides that he also wants triclinia, clearly still part of the decoration of the tomb. These are evidently comparable to those represented on the monuments at Amiternum, Este, and Sentinum; a visual record of a formal dinner, more lavish perhaps than the term *epulum* by itself need imply. But then he goes even further and wants to have the whole populace included: a task beyond the capacity of any actual sculptor to render.[52]

LATER REPRESENTATIONS OF PUBLIC BANQUETS

The group of monuments discussed here clusters in the first century AD in central and northern Italy.[53] They appear to have no successors, at least on our present evidence, and to leave no solid iconographic legacy. But the distinction between seated and reclining diners which is so important, in my view, on the Amiternum relief may cast some light on the interpretation of two very different later monuments. The first is a rather humble sarcophagus lid in the Vatican, dating from the later third century (Fig. 45).[54] The central group shows three figures reclining on the *stibadium* cushion, with a table in front, and servants approaching from either side with food and drink. It conforms to the pattern of *sigma* meals common on sarcophagus lids of this period, which will be discussed in Chapters 4 and 5. However, it is flanked on either side by scenes (damaged at the right, but evidently identical to that at the left) which are unique: each shows three figures seated behind a table, again with attendants hurrying towards them carrying a whole range of objects. Because the two dominant features of the scene on this lid are the contrast between seated and reclining diners, and the presence of an exceptional number of attendants (at least ten survive), it may be suggested that this scene also stems from the tradition of the representation of euergetistic banquets for different categories or classes of society; here, however, it is reduced to a barely recognizable size and form.

The final work to be discussed in this context is in a different medium, much later, and comes from a different region of the Empire: a mosaic from Carthage, to be dated in the later part of the fourth century AD

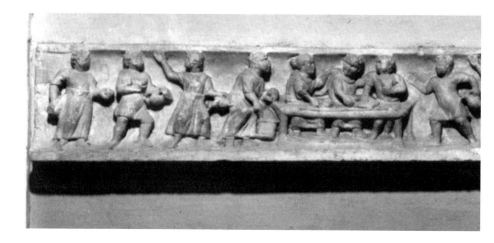

(Figs. 46, 47).[55] Little is known of its original setting, except that it formed the floor of a large room, presumably a reception room, in a private house. It is roughly oval in shape, with much of the centre and one long side destroyed. Here too a banquet is in progress; seven high-backed benches survive, whole or in part, spread in a ring around the circumference of the pavement, with one somewhat out of place in the middle. Each bench held three guests, who are all shown seated, with their upper bodies upright, their legs cut off short by the edge of the long tables in front. Cups, vessels, and plates rest on the tables; servants bustle among the guests with trays of food and drink. The space in the centre contained the entertainers: an old man playing the syrinx and women dancing with clappers. Here too it is likely that we see not just a lavish private festivity but a record of public munificence. Horst Blanck noted that one of the diners appears to have portraitlike features, and suggested that he may be meant to represent the host and donor, portrayed in the midst of the banquet that he has donated.[56] The practice of giving *epula* to one's fellow citizens, or selected categories of them, flourished in Africa during the High Empire, as it did in Italy. By the late fourth century, the inscriptions attesting to the practice have become much rarer, but it has been shown convincingly that it was still alive.[57]

Again it is the seated position of the diners that is the most remarkable and unusual feature of this scene. Blanck argues that this illustrates a change in fashion, as sitting to dine came to replace reclining in late antiquity; a change which I accepted in an earlier publication. However, the evidence does not in fact indicate that such a change was normal for upper-class meals in the fourth century, in Africa or elsewhere. Blanck quotes in

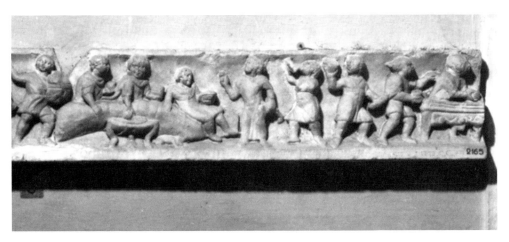

Figure 45 – Rome, sarcophagus lid with seated and reclining banquet. Late third century AD.
Vatican, Museo Chiaramonti Inv. 2165. Musei Vaticani, Archivio Fotografico Neg. XXX.1.86.

comparison representations from several late antique sources showing figures
seated on similar benches to dine, for example, the three angels entertained
by Abraham under the tree of Mamre in one of the nave mosaics in S. Maria
Maggiore in Rome, or the meal at the house of Circe, with four animal-
headed guests, in the manuscript of the Vergilius Vaticanus.[58] But these
are all renderings of extraordinary events, mythological or biblical; they
cannot be taken to reflect contemporary upper-class custom. An alternative
explanation therefore seems preferable. I would propose that the seated meal
is meant to be seen as an *epulum*, not just for the decurions or the elite of the
city, but for larger sections, perhaps the whole populace; the simpler, less
honorific form of dining is accordingly adopted. The mosaic, unparalleled
among all the vast number of mosaics known from Africa in this period,
makes full use of the resources of the medium to convey the atmosphere of
the occasion: the benches and tables set perhaps in a public space such as the
forum; the populace in their best clothes filling them; slaves hurrying among
them with delicacies; music and dancing in the centre. In the midst of it all,
the generous host exults in the admiration of his fellow citizens. If Blanck is
correct in identifying the host's own portrait, seated like the others in their
midst, then for once the emphasis is not upon social differentiation, but
upon the common and reciprocal ties that link donor and recipients. The
mosaic belongs in a domestic context, presumably the house of the donor in
question. Unlike the inscriptions or the grave monuments discussed earlier,
it is not designed to convey a message to the wider public in general, but to
impress upon all those received in the house the generosity and affability of
the host.

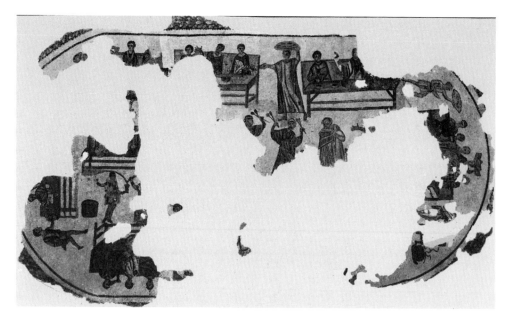

Figure 46 – Carthage, mosaic of seated banquet. Late fourth century AD; 3.5 × 5.9 m. Tunis, Musée du Bardo A 162. DAI Rome 63.356, photo Koppermann.

SETTINGS FOR PUBLIC DINING

Most of the public banquets must inevitably have been held in the open air, with movable equipment in temporary installations. The banquets for really large groups comprising the whole populace of a town, let alone that of Rome itself, could only have been accommodated in an open setting: the forum, the streets and squares or, in the case of Rome, the gardens and *horti* of the great aristocrats. Porticoes, ubiquitous in Roman urban architecture and adaptable to almost any function, will have provided a sheltered location for the more privileged.[59] There is also no doubt that the huge buildings designed for public assembly and spectacle, the theatre and amphitheatre, could on occasion be used for feasting. The great feast given by Domitian to the assembled people in the Colosseum is immortalized by Statius; even in municipal cities outside Rome, there is some evidence to suggest that the local theatre could be used in the same way. However, except where imperial resources allowed the provision of quite extraordinary facilities, we may suspect that such settings were better suited to the distribution of *sportulae* and other small-scale and portable handouts; a formal, reclining banquet could not have been accommodated.[60]

It is obvious that we cannot hope to find archaeological traces of such ephemeral provisions for dining. However, more permanent settings might

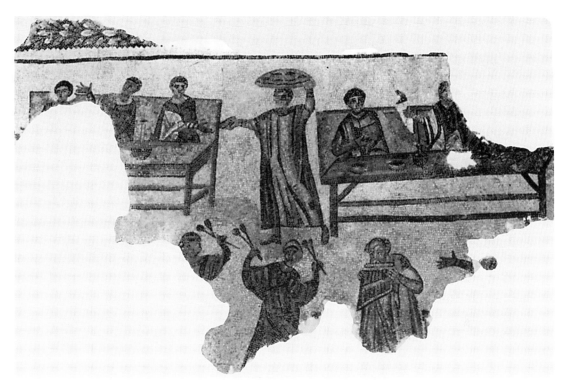

Figure 47 – Carthage, mosaic of seated banquet, detail. Photo KMDD.

be used for smaller-scale functions that can be classified as public or semipublic. Buildings identified as inns at Pompeii sometimes contain, in addition to space for clients to sit to eat and drink, a masonry triclinium where they can recline. The building known as the House of Julia Felix (II 4.7), for instance, contained a small *taberna* with a counter, and an inner room with both benches to sit on and a triclinium for reclining.[61] More often, such triclinia were out of doors in a garden or courtyard.[62] In view of the distinction observed earlier between seated and reclining dining, we should ask who the users of these triclinia would have been. Higher status travellers might expect to dine in style even when staying in an inn; but they may also have been rented out to groups such as *collegia* for their communal dinners. Also likely to have been rented are triclinia found in gardens and vineyards without buildings attached (Fig. 48); at Pompeii, a large vineyard which has been excavated near the amphitheatre contained two masonry triclinia, which might well have been used by visitors on the occasion of the games.[63] But these triclinia are all small structures, which would have held no more than the conventional nine in comfort, or about twelve at a

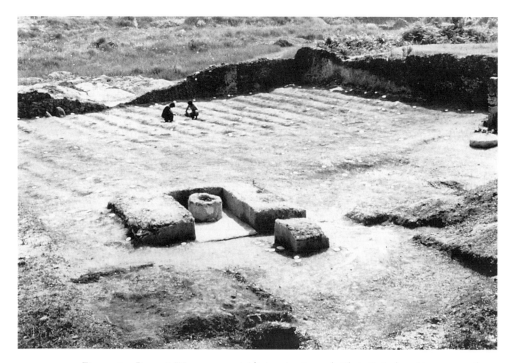

Figure 48 – Pompeii III 7, masonry triclinium in vineyard. Photo S. Jashemski, courtesy of W. Jashemski.

squeeze as on the Este and Sentinum reliefs; they are not intended for larger events.

Beate Bollmann has collected the buildings in Italy that can be identified, certainly or probably, as the seats of *collegia*, including those of the Augustales. There is no single architectural form for such buildings, which must be identified on the basis of inscriptions or contents; they include buildings with a central porticoed court, temple structures with a court in front, and simple halls. Inscriptions indicate that the most common Latin term for these seats was *schola*, but various other names are also found.[64] Communal dining was beyond doubt one of the primary functions of the majority of *collegia*, whatever their official *raison d'être*. One might therefore expect their buildings to contain provision for such activities. However, just as various building types could be adapted to the needs of the group, it is also clear that the space in them was, for the most part, multipurpose. They seldom had special designated dining areas; couches could be set out in the main hall, side rooms, the porticoes, or the court itself.[65]

There are, however, a few examples of buildings which contain rows of rooms furnished with permanent masonry triclinia, which were

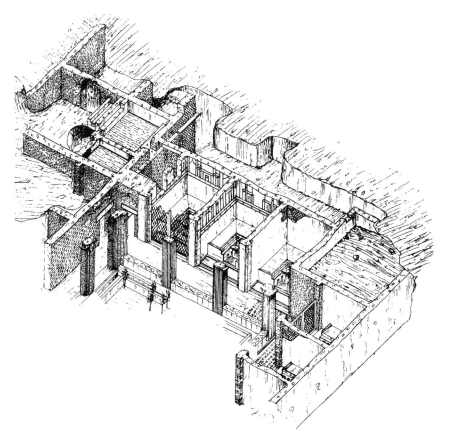

Figure 49 – Pompeii, Agro Murecine, building with multiple triclinia, reconstruction. Mid-first century AD. *After Elia 1961, 201 fig. 2.*

obviously designed for the frequent dining of quite large groups. One of the most interesting is a building discovered outside Pompeii in the area known as the Agro Murecine, in the maritime district (Fig. 49).[66] Only one side could be excavated; it contained a peristyle, off which open a row of identical triclinia, three on one side, two surviving on the other. The couches are faced with marble, and provision is made for the sort of water effects with which the Romans loved to accompany their parties: a central jet in the middle of each circular table and more jets of water playing into a channel around the edge of the couches. Paintings on the walls behind include mythological scenes and Dionysiac figures in an architectural setting. Wooden grills allow each room to be closed off individually. The triclinia are about the standard size for Pompeii, slightly under 5 metres square, each one therefore holding the canonical nine guests or a few more, if needed. For the five surviving, we might calculate a total complement of forty-five

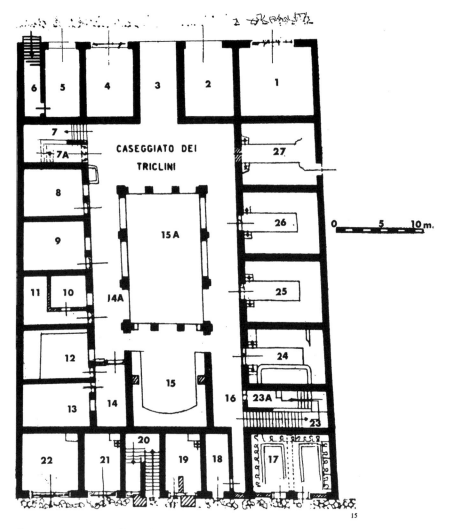

Figure 50 – Ostia, Building of the Triclinia (I 12.1), plan. Building ca. 120 AD; masonry triclinia installed later in second century. After Packer 1971, 157, plan 15.

to fifty. It is likely that the plan was repeated symmetrically on the other side of the peristyle, in which case the building would have held about 100 diners.

Who then might have used the building and on what sort of occasion? In one triclinium was found a store of wax tablets, packed in a wicker basket, and dumped there for storage, along with other incongruous material, while the building was undergoing reconstruction; they record the transactions of what seems to be a banking business at the nearby port of Puteoli. If we could be certain that they were connected with the activities in the

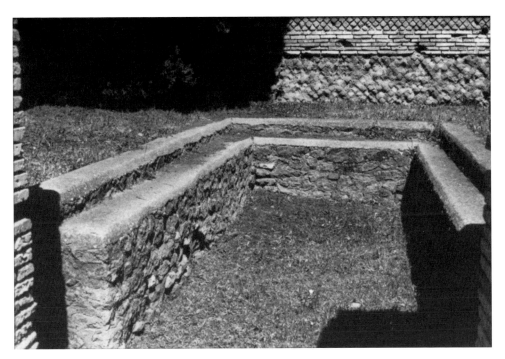

Figure 51 – Ostia, Building of the Triclinia, masonry couches in one triclinium. Photo KMDD.

building, we might think of a corporation of traders and financial dealers, but the tablets date to an earlier period, and we cannot safely conclude that there must be a direct link. Nevertheless, the social context is surely that of a wealthy association. Whatever their other activities, dining must have played a central role if they needed a special building for this purpose. The unusual water effects add an additional touch of conspicuous luxury. It is tempting to suggest that a donor determined to leave his mark in a memorable way might have provided the furnishings as a gift to the group; regrettably, no inscription records this.[67]

We are on firmer ground with the identification of a structure known as the Building of the Triclinia at Ostia (I 12.1), which has been convincingly identified as the seat of the wealthy and important *collegium* of the carpenters, or *fabri tignuarii*; an inscription records their dedication of a statue to Septimius Severus in 198 AD (Figs. 50, 51).[68] The building itself goes back to the reign of Hadrian, circa 120 AD. There is a central court with arcaded porticoes, flanked by side rooms, with a large open room on the central axis of the court that served, at least in its latest phase, as a cult room. One wing contains four triclinia with masonry couches; in their present form these couches are later insertions, presumably replacing movable fixtures.

The triclinia are larger than those at Pompeii and could have held a dozen or more each in comfort; they no longer have a communal table, which has been replaced by a ledge along the front of the couches. If space were needed for larger banquets, temporary structures could have been erected in the porticoes, but it was evidently expected that banquets for forty or fifty would be a regular and recurring feature. Once again it is clear that dining is one of the prime and principal activities of the group.

A building at Misenum can be identified by numerous inscriptions as the seat of the Augustales.[69] Although its origins probably go back to the Julio-Claudian period, the principal activity here can be placed in the late Flavian to Trajanic period, with further embellishment under the Antonines. It takes the form of a central templelike structure devoted to the imperial cult, flanked by two side rooms and set in a porticoed court. The eastern side room was identified as a triclinium by an inscription on the mosaic at the entrance; it records that the mosaic was laid and the work dedicated by Q. Baebius Natalis, who held the title of *Augustalis immunis*. The inscription, if the text is accurate, refers to the room itself under the name *triclinium constantiae*, an odd expression for which I know no parallel, although there are other examples of triclinia being given names.[70] The architectural decoration of the adjoining cult room, with a columned porch, was the work of a further donor – a priestess, Cassia Victoria – on behalf of her husband, L. Laecanius Primitivus. The busts which ornament the tympanon, with a priestly cap (*galerus*) carved on the background between them, can only be the pair concerned. To celebrate the dedication, Cassia also gave an *epulum* and a distribution of money.[71] Again the visual element is striking. We may visualize Cassia's banquet taking place in the adjoining triclinium; as the Augustales made their way to it, they would be confronted by the splendid new porch of the cult room and the images of its donors. Large numbers of other inscriptions would also have been visible on the statues of emperors (Vespasian, Titus, Nerva, adapted from Domitian, and Trajan were all found), deities, and honoured members of the *collegium* itself. Many of the inscriptions record not only the donors, but also the gifts they made for an *epulum*, a distribution, or a similar event. This would foster a lively and powerful sense of both community and continuity.

Outside Italy, various buildings are known whose plan or other features suggest identification as collegial buildings with dining facilities. Only one will be discussed here: the 'Building with benches' at Hadrumetum [Sousse] in Africa Proconsularis.[72] The plan of this interesting building (never excavated or published in detail) shows six rooms with masonry triclinia arranged three down each side, across a central space in which an even larger

triclinium was installed in one phase. In the best preserved of the rooms, the couches are 1.20 m wide, with a marble rim around the edge to hold the mattress and a ledge running in front that is suitable to hold cups or other small items. Mosaic covers the front of the couches and the central space. Even more clearly than the Building of the Triclinia at Ostia, that at Hadrumetum would have been suitable for no purpose except the regular holding of banquets, but no evidence survives that would help to identify those who used it.

The Augustales and wealthy *collegia*, like that of the carpenters at Ostia, could afford spacious and well-decorated buildings. Many *collegia* were much smaller and humbler bodies, sometimes including slaves among their members. They met in simpler structures and will have had to use whatever space was available for their feasts. It is also clear that not all meals were of the reclining variety; sometimes at least, the members sat to eat. But even in the case of comparatively small *collegia,* the inscriptions which set out their laws and constitutions often make clear the central importance of dining among their activities, with specifications of the dates and occasions on which they are to hold their feasts and of the provisions to be made for them.[73] Other inscriptions contain the gifts or bequests of wealthier members, which include provisions for dining or the supply of furnishings, equipment, and decoration to accompany their feasts.[74] The inscriptions also sometimes give an indication of the menus provided on such occasions, from exotic imported fruits for a rich association of businessmen in Rome who dealt in ivory and citrus wood, to bread, wine, and sardines for the worshippers of Diana and Antinous at Lanuvium.[75] Several of them make a special point of the hot water, *calda,* to be mixed with the wine, and of the equipment required to serve it; as seen already, this was an important ingredient of luxury and well-being.[76] Beyond the factual details, what emerges clearly from some of these inscriptions is the sense of conviviality that even such simple feasts could create. The worshippers of Diana and Antinous at Lanuvium included in their laws a prescription that anyone with a complaint or business to transact should keep it for the general assembly so 'that we may feast quietly and joyfully on the days of celebration'.[77] Other associations even defined themselves by the act of eating or drinking together, calling themselves by such names as 'Diners' (*comestores*) or 'Boon Companions whose custom is to eat a feast together' (*convictor(es) qui una epulo vesci solent*).[78]

This ideal of festivity and conviviality can also be conveyed by the decoration of the rooms, on the few occasions where this has survived. In Chapter 2, I discuss the paintings from the so-called House of the Chaste

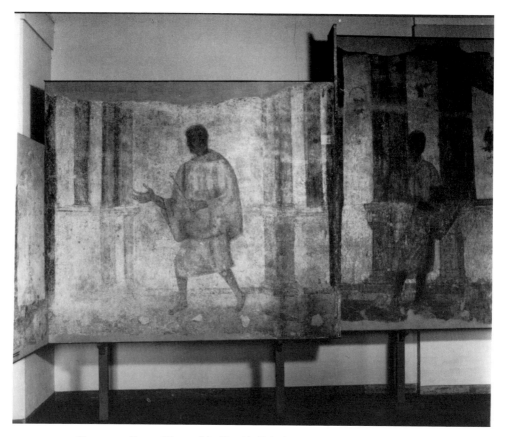

Figure 52 – Rome, House of the Heralds (Schola Praeconum), *wall painting with waiting servants, figure next to entrance. Ca. 220–40* AD. *DAI Rome 76.2357, photo Rossa.*

Lovers at Pompeii (IX 12.6), and comment on the distance between the world of luxurious elegance that the paintings evoke and the simplicity of the room that they decorate (Pl. I, Fig. 26). As seen there, the building from which they come does not appear to have been a private house, and has been identified as a bakery; it is plausibly suggested, although not proven, that the triclinium may have been the setting for the dinners of a *collegium*.[79] More certain is the identification of a building on the slopes of the Palatine in Rome as the *schola* of the *praecones*, the public heralds. The partially excavated building again had a porticoed courtyard, with three rooms opening off one side, the central one emphasized by its greater size and a niche in the end wall. The masonry is Severan, of the beginning of the third century AD.[80] At a slightly later date, the southern side room received a wall painting showing seven (originally eight) life-size male figures against an architectural

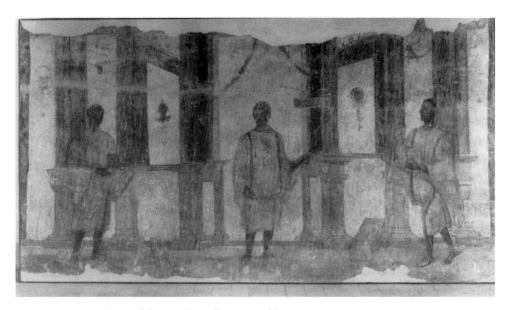

Figure 53 – Rome, House of the Heralds, wall painting of three servants. Rome, Istituto Centrale per il Restauro–Archivio Fotografico 740.

background (Figs. 52, 53). They wear short tunics and hold out objects that were offered to the guests arriving at a banquet: garlands of flowers, towels, a box of ointments or perfumes. Other objects lie on the ground at their feet, among them a fly whisk, another box, and a pair of light sandals. The figure closest to the entrance on one side advances as though to greet the guests, a staff of office in his hand. The iconography of these figures is that of the servants in attendance at the banquet; similar figures appear on domestic and funerary monuments in the later third and fourth centuries.[81] Slightly later still, the same room received a black-and-white mosaic pavement showing two processions, each of four men carrying standards (*vexilla*) and *caducei*, the emblems of the heralds, who appear here in the characteristic activity of their profession.[82]

Both monuments show how the banqueting iconography that was used in the private houses of the wealthy could be adopted to decorate the buildings where the members of comparatively humble groups assembled for their feasts. They provide an excellent illustration of the way in which the aspirations to luxury and conviviality trickled down in Roman urban society from the upper classes to those below them. The Pompeians dining next to the bakery could see themselves reflected in the world of aristocratic Hellenistic hedonism illustrated in their paintings; the Roman

heralds (a minor body of state officials) could imagine throngs of servants like those who waited on the rich standing ready to attend to their wants. The monuments discussed in the first part of this chapter stressed the role of the public banquet in reinforcing the distinctions of status and privilege; as these last examples show, it could also serve to provide the illusion of luxurious living for those who would otherwise have lacked it.

Drinking in the Tomb

THE MONUMENT OF FLAVIUS AGRICOLA AND THE TRADITION OF THE TOTENMAHL MOTIF

A statue now in Indianapolis shows a bearded man reclining on a couch, his upper torso bare; in his left hand he holds a drinking cup, his right is raised to the wreath on his head (Fig. 54). The figure acted as a funerary monument, with an opening at the foot of the couch for the urn that held the ashes of the deceased.[1] The identification of the same figure in a drawing in the collection of Cassiano dal Pozzo now in Windsor Castle revealed its history; it was discovered in Rome in 1626, in excavations beneath St. Peter's, in what we now call the Vatican Necropolis, when the foundations were being laid for Bernini's baldacchino.[2] For those who were hoping to find the tomb of St. Peter, our man was a grave disappointment; even more shocking, however, was the inscription originally written on the base of the couch.[3] The dead man, who gives his name as Flavius Agricola from Tibur, speaks in indifferent hexameters: 'I am reclining here, as you see me, just as I did among the living in the years which fate gave me, I nurtured my little soul and wine was never in short supply.' He goes on to speak of his wife of 30 happy years, Flavia Primitiva, who has died first, of her pious worship of the goddess Isis and of her beauty, and then apparently of the support of his stepson Aurelius Primitivus. Then he continues (l.12): 'Friends who read this, I advise you, mix up the wine and drink far away, binding your brows with flowers, and do not spurn the pleasures of Venery with beautiful girls; all the rest after death the earth consumes and fire'. This was too much for the Vatican; the Pope, Urban VIII, ordered the inscription first to be plastered over, then the whole base to be destroyed, and threatened with 'the most

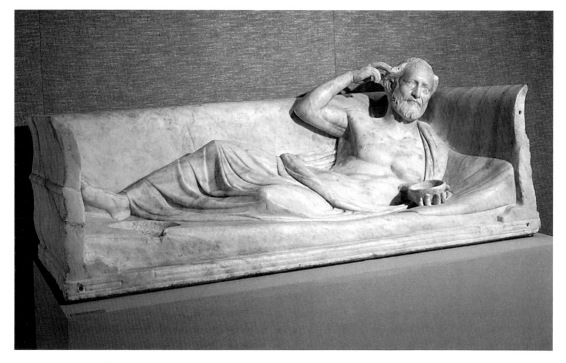

Figure 54 – Rome, Vatican Necropolis, kline *monument of Flavius Agricola. Ca. 160 AD; 0.67 × 1.78 × 0.69 m. Indianapolis Museum of Art, Gift of Alan Hartman (IMA72.148).*

rigorous excommunication and the most horrible threats' whoever divulged the verses. The statue, minus base, ended up decorating the garden of the Pope's nephew, Cardinal Francesco Barberini, whose attitude toward these matters was very different from that of his papal uncle.[4]

In both his image and the verses inscribed on it, Flavius Agricola chose to present himself on his tomb as a banqueter at a drinking party. In doing so, he drew on a long and widespread tradition. Reclining banqueters, dining or drinking, are ubiquitous on Greek and Roman funerary monuments and in the decoration of tombs. They appear in many forms, from elaborate scenes of convivial banquets with numerous participants to the isolated drinker. Far and away the most common scheme is that known as the Totenmahl, or meal of the dead, a convenient although not necessarily accurate label. The basic motif of the Totenmahl consists of a single male figure, wearing tunic and mantle or with his upper torso bare, reclining on a couch with a drinking vessel in his hand and a small table in front laden with food.[5] A woman often sits either in a separate chair or on the foot of the couch; a servant brings drink. The motif, which appears on a small number of Greek reliefs of the late archaic period, is used frequently in Attica in the second half of the fifth and the fourth century BC on votive reliefs dedicated to heroes, where it

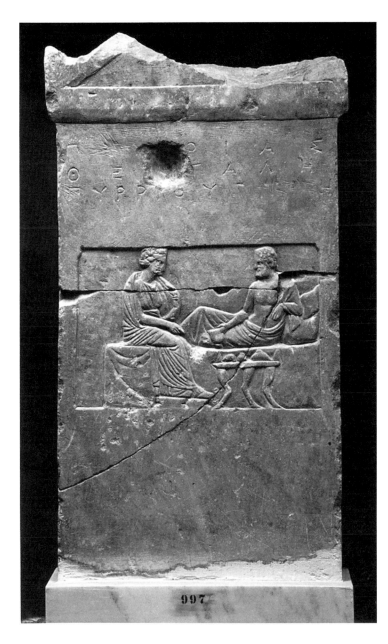

Figure 55 – Peiraeus,
grave stele with funerary
banquet, inscription of
Pyrrhias and his wife
Thettale. Fourth century
BC. Athens, National
Museum 997. DAI
Athens (Neg.
2001/655).

represents the hero relaxing at the *symposion* and accompanied by his seated
female consort; worshippers sometimes bring offerings, and heroic attributes
such as a snake and a horse's head are included. It appears less frequently as
a funerary monument on fourth-century Attic grave stelae, with the heroic
attributes omitted and in much more modest form (Fig. 55).[6] But the motif
was used earlier in a funerary context in Asia Minor, especially in regions

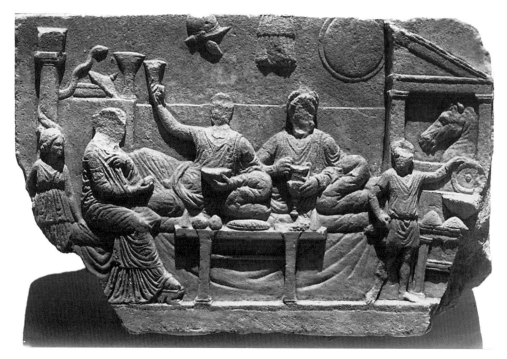

Figure 56 – Samos, Hellenistic Totenmahl relief. Pythagoreion-Tigani Museum. Last third of second century BC; H. 47 cm. DAI Athens Samos 7034.

on the fringes of the Greek world where Greek culture and art came into contact with those of non-Greek or semi-Hellenized peoples. It appears, for instance, on the stelae of Graeco-Persian style from Daskyleion in Mysia and its region, which begin probably at the turn of the sixth to the fifth century; the paintings in the tombs of Kızılbel and Karaburun II at Elmalı in Lycia attest to the use of the theme in this area in the late archaic period, and it appears on the rock-cut reliefs of Lycian tombs and sarcophagi from the end of the fifth and fourth centuries BC.[7] In the Hellenistic period, it becomes perhaps the single most common subject of funerary reliefs, repeated on hundreds of stelae from most areas of the Hellenistic world (Fig. 56).[8] Considerable variations are now found in the details, ranging from the addition of further figures to the central group (for instance, two, three, or even four figures may sometimes recline together on the couch, and more than one woman may be seated at the sides), or the inclusion of children, to the elaboration of attributes, furniture, or background. Analysis of its treatment in individual regions or cities can show very different associations and values expressed through the medium of the basic scene; nevertheless, the underlying motif remains unmistakable.[9]

Figure 57 – Totenmahl relief of the late Empire, apparently from Hierapolis. Ca. 300 AD; H. 76.5 cm. Karlsruhe, Badisches Landesmuseum Inv. 65/75.

It loses none of its popularity under the Roman Empire, although its dif-fusion is not uniform in all regions. From Hadrian's Wall and the Rhineland (e.g., Fig. 14), from Dacia and the Danube provinces, to Palmyra and Egypt, as well as many parts of Asia Minor (Fig. 57) and the Greek Islands, the Totenmahl, or variants derived from the original motif, constitute one of

the most favoured themes for funerary reliefs.[10] The motif also appears on paintings and, occasionally, on mosaics; recent publications of tomb paintings from regions as diverse as Cyrenaica and Jordan suggest that the apparent comparative rarity of the motif in this medium may be simply an accident of survival.[11] In many parts of the Graeco-Roman world, there is direct continuity from the Hellenistic series; elsewhere, especially in the Northwest provinces, the means of diffusion are more obscure and undoubtedly more complex. Needless to say, local traditions differ very greatly in the treatment of the theme; although some maintain the original motif very closely, others introduce substantial variations. For instance, some of the Egyptian stelae introduce the Anubis jackal and other symbols of Egyptian deities and cult, set protectively beside the central motif; many of the Palmyra reliefs display standing figures and busts of family members around the reclining banqueter dressed in elaborate Parthian costume. Even more idiosyncratic variants appear in the 'family meals' of the Rhineland, where the principal figures are seated in substantial chairs; and the 'Pannonian banquet', common in what is now Hungary, omits the reclining figures themselves, and shows only the table with vessels and food flanked by attendant servants, while a separate panel above contains the frontal busts of the deceased.[12]

The interpretation to be placed on these scenes has been the subject of discussion and controversy for more than two centuries. Many commentators have argued that the motif carries a single basic meaning; that the reclining banqueters should be seen *either* as a representation of the deceased during life, enjoying the worldly pleasures of the banquet, *or* in an eschatological sense, as a representation of the banquet in which they hope to participate in the next world. Others have seen it as primarily an allusion to funerary ritual, with the stress either upon the offering of food and drink to the dead or on the banquet celebrated by the survivors at the tomb. More recent commentators have recognized that the very longevity of the motif and its diffusion among peoples of diverse cultures and beliefs argue against any assumption of a single uniform significance. It is clear that by the Hellenistic period, and then in many parts of the Roman world, the image of the reclining banqueter had come to be recognized as a motif essentially appropriate for a funerary monument. Insofar as it served to evoke a common set of associations, they were surely those generally implicit in the reclining banquet itself: its role as a sign of status and privilege, of pleasure and luxury. More specific connotations might be given by the accompanying elements and attributes or by the variations in the treatment of the central theme; at different times and places, greater emphasis might be placed on the heroising aspects of the motif, on the trappings of luxury, on the representations of

Figure 58 – Rome, tomb near columbarium of Statilii, painting of banqueting couple. Parker 3312, courtesy of the British School at Rome, Archivio Fotografico.

the assembled family. Indeed, the motif's appeal may have been due, in no small part, precisely to its ambivalence and lack of a single, clearly definable content; it was open to observers to interpret it as they thought fit, according to their cultural predispositions or their own individual preferences.[13]

In Rome and Italy, which will be the main focus in this chapter, the motif is used on monuments of many different forms: in addition to stelae (where it is comparatively rare, except for special circumstances), it is used on funerary altars and urns, later on loculus slabs and sarcophagi, as well as a few paintings and mosaics (Fig. 58).[14] It is proportionately much less common, especially in the sculpture of the city of Rome itself, than in many other regions. However, this comparative rarity may be best explained as a consequence of the wide range of other subjects available for use in funerary contexts, and the greater choice that this permitted sculptor and patron alike. Not only is the motif applied to monuments of very different form, including the large-scale three-dimensional sculptures about to be considered, but there is great variety in its treatment: in the presentation of the principal figures, male and female, the numbers and roles of servants and other minor figures, the details of furniture, drinking vessels and food, and aspects of

the setting. It is clear that the motif in Roman funerary art has complex origins, in which the contribution of the Etruscan tradition must be taken into account as well as that of the Hellenistic East.[15] It also remains, over a period of several centuries, a vital and expressive image, which lent itself to variation and reinterpretation; in no way can it be considered a fossilized schema dependent upon earlier models. This chapter cannot aim to provide comprehensive coverage of these developments but will focus on a few of the most conspicuous.[16] My aim here is primarily to show how the expressive quality of the motif could be manipulated through variations in its handling and through the differing contexts in which it was used.

KLINE MONUMENTS

The monument of Flavius Agricola takes the central motif of the Totenmahl reliefs, the banqueter reclining on his couch holding a cup, and renders it in three dimensions, with the near life-size figure carved in the round on a free-standing couch. Thereby it transforms the comparatively modest scene of the reliefs into an altogether more substantial and impressive type of monument. It belongs to a category which has been given the name of *kline* monuments: free-standing sculptures showing the deceased lying on a couch, which were originally set over a grave or, as here, had the ash urn inserted into them. They were fashionable in Rome from the middle of the first century AD into the second; Agricola's monument has been dated to around 160 AD, making it one of the later examples.[17] An early example shows a certain C. Iulius Bathyllus, freedman of the Emperor Augustus and guardian of the Temple of the deified Augustus and Livia, who must have died sometime after 41 AD (Fig. 59).[18] He is more formally dressed than Agricola in tunic and toga, and his manner is more dignified, but he too reclines on his left elbow and holds a large drinking cup. We do not need an inscription like that of Agricola to identify the couch as a banqueting couch, on which the deceased reclines to drink as he did in life. However, sometimes the motif is more ambivalent.

Kline monuments of the same type are also used to commemorate women and young boys, but with an important difference. They do not hold drinking cups, nor recline in the pose of happy banqueters; instead they lie back on the cushions, sometimes as if in sleep or in the weakness of death. On a monument from the Via Laurentina in Rome, probably of the early first century AD, a young boy wearing only a mantle lies propped on the cushion; he is accompanied by a snake which approaches an egg held in his left

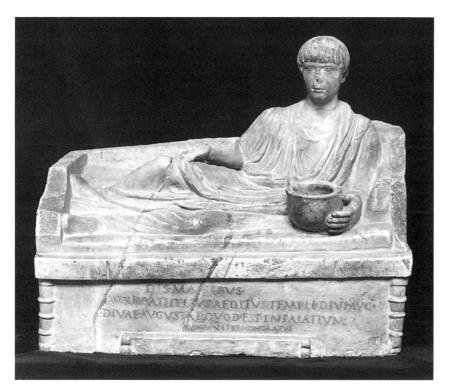

Figure 59 – Rome, kline *monument of C. Iulius Bathyllus. After 41 AD; the head is not original. Rome, Musei Capitolini Inv.n.211/S; photo Archivio Fotografico dei Musei Capitolini (MCD 22919).*

hand – both taken from the symbolism of funerary cult (Fig. 60).[19] *Kline* monuments of women appear in the Flavian period, slightly later than those of men and boys; some lie with closed eyes as if asleep, others support their heads on their hands, and hold garlands, pomegranates, poppies, or other funerary symbols.[20] Thus an Antonine woman in the Vatican rests her head on her right hand, her eyes open; in her left hand, she holds a poppy or a pomegranate (Fig. 61). Two tiny Erotes play around her, one holding out a garland; they appear frequently on the monuments of women and children to suggest their beauty and their charm.[21] The couch here is evidently no longer conceived as a banqueting couch, as with the men; instead, it is the couch on which one sleeps, lies in sickness, and dies, and which is used for the exposition of the body. Or rather, the couch can be all these things; the context and the viewers' sense of appropriateness determine which sense is uppermost.

The ambivalence can be traced to actual funerary practice. A well-known relief from Amiternum, usually dated in the mid- or late first century BC,

Figure 60 – Rome, Via Laurentina, kline *monument of boy. Probably early first century AD; L. 1.78 m. Museo Nazionale Romano Inv. 61586. DAI Rome 80.2718, photo Schwanke.*

shows a funeral procession with the dead man lying on his couch carried on a bier; he lies in a lively pose, propped on his elbow in the banqueting position (Fig. 62). The figure has been interpreted variously as the corpse itself, an image representing the dead, perhaps of wax, or an actor playing the role of the deceased.[22] But it may be that these distinctions would have been meaningless for the ancient observer, for whom the figure on the relief might represent both the image and the man. Descriptions of imperial funerals illustrate the role played by such images. In his account of the funeral of Augustus in 14 AD, Dio Cassius tells us that a couch of gold and ivory with purple hangings was carried in the procession. The body was hidden beneath it in a coffin, while a wax image of the emperor in triumphal dress was carried upon it; two further images followed, at least one of gold. A little later he tells us that, after the emperor's deification, his golden image on a couch was placed in the Temple of Mars and honoured as if it were a cult statue. We are not told in what sort of position these images appeared, whether lying supine as if in death or propped up in a more lifelike manner, but it is tempting to think that at least the golden image was more likely to be shown in a position taken from life.[23]

A further example of the semantic glide between the convivial and the funeral couch comes from Petronius' account of the end of Trimalchio's dinner, when he lays himself out on his couch in the triclinium – the same couch on which he has just been dining – propped up with cushions, and pretends to be dead.[24] The patrons who commissioned the *kline* monuments play on this same equation. Their social position may be relevant here; where they are identifiable, they come from the middle sections of Roman

Figure 61 – Rome, kline *monument of woman. Ca. 160–70 AD. Vatican, Museo Chiaramonti Inv. 1365; L. 1.70 m. DAI Rome 80.1578, photo Schwanke.*

society: they are freedmen (like Trimalchio himself), the descendants of freedmen, businessmen, and artisans.[25] It has often been remarked that the tomb monuments of such people, especially during the early Empire, show even more than the usual Roman attempt to establish status and position. Lacking ancestors, the wealthy freedmen were unable to exploit the ancestral images that had played so important a part in the upper-class Roman funeral; they had to find other methods to manifest their standing and prestige in both their funerals and their monuments.[26] The carved image on the couch would serve to perpetuate the display of the funeral, which doubtless for

Figure 62 – Amiternum, funerary relief. Mid- to late first century BC. L'Aquila, Museo Nazionale Abruzzese. Copyright Alinari/Art Resource, NY (Alinari 36101).

such men was as magnificent as it could be made; at the same time, it demonstrated to posterity the right to enjoy the pleasures of life which the freedmen had attained and the privilege of reclining to dine.

THE POSITION OF WOMEN: URNS, ALTARS, AND RELIEFS

The distinction that we see on the *kline* monuments between dining and drinking men and women sleeping or lying peacefully is evidently due to a sense of decorum that has deep roots. In the Greek tradition, there was a strong convention that respectable women should not be represented reclining at dinner; the typical Greek and Hellenistic Totenmahl reliefs portray the women seated beside their reclining husbands.[27] In Roman society, respectable married women could and did recline at meals in public, and representations of banquets in more general, nonfunerary contexts represent them accordingly.[28] Nevertheless, the traditional tabu continued to impose powerful inhibitions and evidently led to a sense, in some circles at least, that it was inappropriate for a woman to be represented on her grave monument as a reclining banqueter holding a wine cup. But women of these intermediate classes were also capable of attaining considerable wealth and power, and were anxious to lay claim to the visual language in which this was expressed. The commissioners of the *kline* monuments adopt a compromise, whereby the prestigious imagery of the couch is employed, but with emphasis on its other significance as the setting for sleep and death so the associations would be purely funerary. However, the distinction is by no means consistent, even within a narrow chronological span. Smaller funerary monuments from Rome, funerary urns, altars, and reliefs, dating to the first and early second centuries AD, display a remarkable mixture of conventions in the representation of women. Such monuments were obviously cheaper than large-scale sculpture in the round, and their commissioners often seem to have been willing to dispense with traditional decorum in favour of a more immediately expressive and honorific presentation.

Examples are not lacking which show the traditional scheme: the man reclining holding a cup and the woman seated at the foot of the couch or on a separate chair; for instance, an urn from Puteoli dedicated by Roscia Prepis to L. Roscius Prepon (Fig. 63).[29] Alongside this, however, appear variants where the man and woman both recline. On the handsome Flavian altar from Rome of Q. Socconius Felix, husband and wife lie together on the couch, both formally dressed; the man holds a cup, and the woman

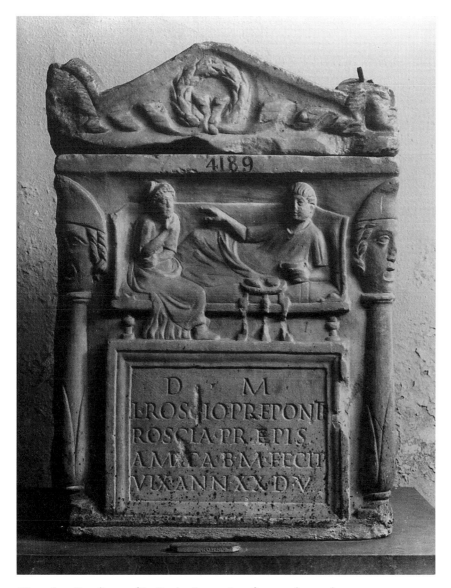

*Figure 63 – Puteoli, urn of L. Roscius Prepon. Late first to early second century AD; 0.44 ×
0.32 m. Naples, Museo Nazionale Inv. 4189. DAI Rome 71.419, photo Singer.*

probably holds a small incense box (Fig. 64). Two more cups stand on the
table in front, with three elegant young servants around it; an Eros flies
down towards the woman from above.[30] On others the woman reclines
alone, for instance, on the little funerary urn of Lorania Cypare now in
the Louvre, dedicated by her husband (and probably fellow freedman) C.
Loranius Adiutor (Fig. 65). Drinking cups stand on the table before her, but

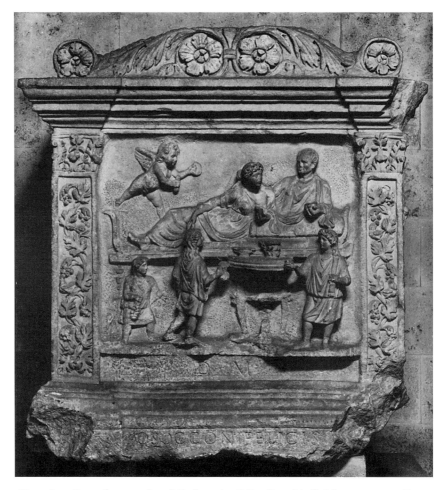

Figure 64 – Rome, funerary altar of Q. Socconius Felix. Second half of first century AD. Rome, Via Quattro Fontane 13–8. DAI Rome 63.755, photo Felbermeyer.

she does not touch them; instead she rests her head on her left hand as if in thought, like the women on some of the *kline* monuments. Once again an Eros with a mirror appears above her, over the top of the couch among garlands, but the two Eros-like figures who stand on bases at either side of the couch in fact represent the servants. They wear short tunics, and the one to the right holds a jug.[31] In contrast, Attia Agele on her funerary altar in the Vatican lies alone on her couch holding a cup, while other drinking vessels stand on the table before her.[32] More exceptional is the image on a funerary urn now in the Metropolitan Museum in New York (Fig. 66). Here the woman is shown reclining with all the apparatus of a drinking party, cups and a ladle on the table in front of her, a cup in her hand, and

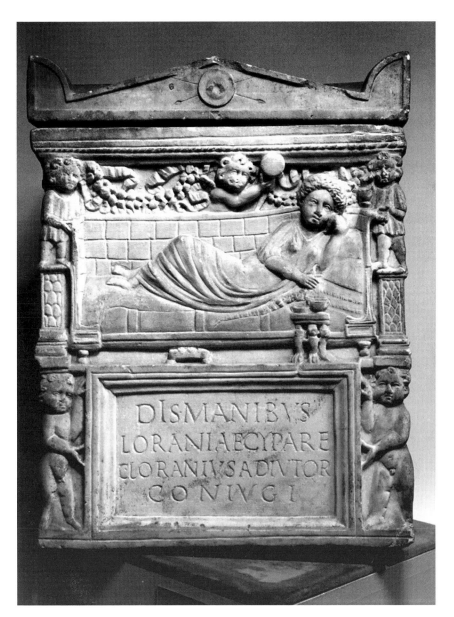

Figure 65 – Rome, Funerary urn of Lorania Cypare. End of first to beginning of second century
AD; 0.56 × 0.35 m. Paris, Musée du Louvre MA 2144; photo Chuzeville.

two little servant boys at either side – one holding two wine jugs, the other a
swag of fruit. Seated on the couch, in a pose that inescapably recalls the con-
ventional scheme of the seated woman, is a male figure, his hands held out to-
wards the woman. The inscription mentions only a man, M. Domitius Prim-
igenius, as the commissioner of the work, leaving unclear his relationship

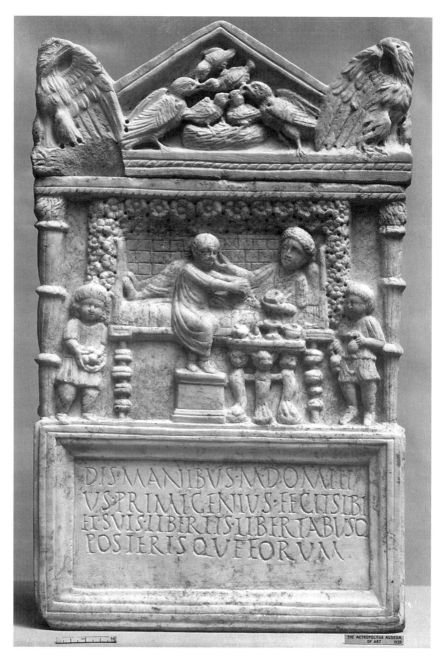

Figure 66 – Funerary urn of M. Domitius Primigenius. Probably late first century AD; 0.403 × 0.337 m. The Metropolitan Museum of Art, Fletcher Fund, 1927, 27.122.2a,b.

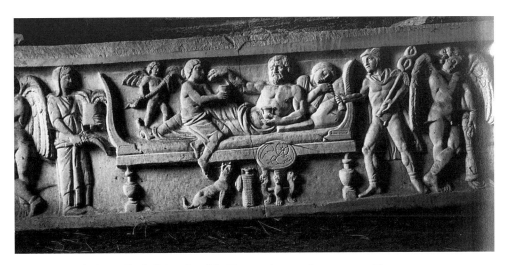

Figure 67 – Isola Sacra, Tomb II, loculus *slab. Ca. 152–60 AD; 0.61 × 2.13 m. Museo Ostiense Inv. 1333. DAI Rome 69.734, photo Hutzel.*

to the figures represented above it; whether he is to be seen as the man figured along with a wife (who presumably died first) in a complete reversal of expected roles, or whether a preexisting image, perhaps of mother and son, has been used inappropriately by a male purchaser, cannot now be decided.[33]

Even more curious is the mixture of concepts and conventions which must lie behind another relief, a *loculus* slab from the necropolis of the Isola Sacra at Ostia, dating from soon after 150 AD (Fig. 67).[34] The man, bearded, half-nude, and holding a cup like Flavius Agricola, reclines in the usual manner on the couch. In front is a small round table with elaborately carved legs, its top tilted toward the observer to show off the food which is incised into the surface (a chicken and a loaf of bread), a flask enclosed in a wicker case, and a dog that seems to wait for scraps from its master. Unexpectedly, however, two women accompany the man on the couch. Behind him one maintains the iconography of the woman who sleeps while the man drinks; on the other side, a second woman sits at the foot of the couch, half-nude like the man, and holds another cup towards him. All three main characters are shown with portrait features and contemporary hairstyles; that is, by Roman convention, they should represent the individuals buried in the grave. The half-nude woman is not, therefore, as we might take similar figures in Greek vase painting to be, a *hetaera*, but most probably the man's wife; her nudity, like his, carries an implication of heroization, or an assimilation to Venus.[35] The idealized atmosphere is enhanced by the presence of Mercury and

Ceres, evidently the patron deities of the dead man (presumably a dealer in grain), at either side of the couch, and of an Eros with a garland behind the seated woman. But the sleeping woman disturbs this atmosphere. We can only guess at her identity: a first wife, dead before her husband? A daughter, sister, or fellow freedwoman? Whoever she is, her sleeping pose appears to us inconsistent with the rest, a confused combination of two different conventions for the sense and implications of the figures on the couch. Perhaps this confusion occurs because we expect a clear distinction, where for the Roman observer the various senses merged imperceptibly into one another. Similarly, the two Erotes with downturned torches at the ends of the slab fit better with the iconography of the dead sleeping upon the couch than with that of the heroic banqueters, or indeed with the note of realism introduced by the details of the food and the flask.

SARCOPHAGI

In the course of the second century AD, the preferred burial practice in Rome changed from cremation to inhumation. The new practice led to the widespread adoption by wealthy Romans of the marble sarcophagus as a means of disposal of the body, and one which offered an even greater opportunity for representative display than the comparatively simpler monuments that I have been looking at so far. Representations taken from the traditional banqueting iconography appear on the sarcophagi produced in the city of Rome from the mid-third century onwards, although they are never common; they are used to decorate both sarcophagus fronts and lids. They show a single figure (male or female) or a couple reclining on a couch, surrounded by the panoply of the banquet, often in very elaborate form; the seated woman usually now sits in a substantial basket-chair playing a musical instrument known as the *pandurium*, numerous servants and attendants bring food and drink, children, putti, or Erotes often play around the couch.[36]

The most impressive of the sarcophagi is an elaborate one in the Vatican from around 270 AD. An inscription on the lid gives the name of its occupant, P. Caecilius Vallianus (Figs. 68, 69).[37] The whole front of the sarcophagus is occupied by the scene of the banquet, with a procession of servants at either side bringing food for the banqueter. The central group – reclining banqueter, seated woman in a chair playing a musical instrument – resembles the standard motif from the Totenmahl, but with differences. The main figure has a male portrait head, finely worked and undoubtedly meant for Caecilius Vallianus himself.[38] In front of the couch, a table bears a single

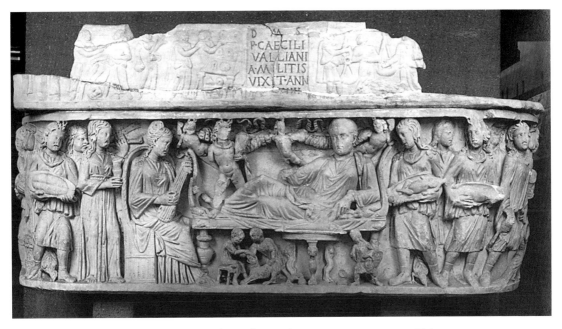

Figure 68 – Rome, sarcophagus of Caecilius Vallianus. Ca. 270 AD; 0.93 × 2.05 m. Vatican, Museo Gregoriano Profano Inv. 9538/9539. DAI Rome 90.413, photo Anger.

platter with a large fish upon it; the diner holds a garland, and Erotes or putti around the couch hold further garlands and baskets of flowers. But it is the procession of servants and the objects that they carry that are the most striking feature of the scene, setting it apart from the simpler earlier renderings. The maidservant behind the seated woman holds a vessel, either for wine or perfume. On either side are elegant young pages, with long hair flowing over their shoulders and long-sleeved tunics to their knees. Three carry rich-looking platters of food, a cake of some sort, a chicken, and probably a roasted piglet. Then comes one with apparatus for washing the diner's hands, a jug and a long-handled bowl.[39] Finally, the two at the outside edges, on the curving sides of the sarcophagus, hold what appear to be live animals, a peacock, and a hare: from the cooked food, we move to the raw. Baskets full of roses and trees stand behind them, setting the scene in the open air. Servants of this sort play an increasing role in the iconography of the banquet in the later centuries of the Empire; they make the whole image of the banquet far more luxurious and more obviously designed to impress than in most earlier representations. The food also plays a much more conspicuous part here than it did in earlier banqueting scenes, where it might be represented on the table or a basket of fruit or cakes might be offered, but without much emphasis; now it serves as a major vehicle for

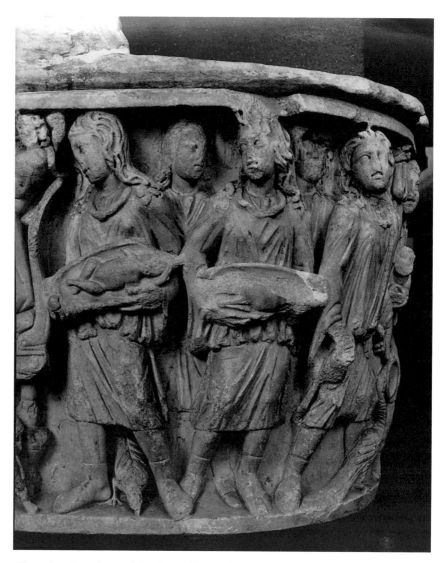

Figure 69 – Sarcophagus of Caecilius Vallianus, detail of servants. DAI Rome 90.414, photo Anger.

the visible expression of luxury. It is notable that all this is directed to the solitary figure on the couch alone. The apparatus is that characteristic of an elaborate meal with many guests, but there is no conviviality; it is left to the observer to be impressed with the signs of the status and wealth of the dead person.[40]

Much more common than sarcophagi where banqueting scenes are represented on the chest are those where the banqueters, carved as full figures in the round, recline on the lid; the chest bears unrelated decoration, often

Figure 70 – Rome, catacomb of Praetextatus, sarcophagus of Balbinus. Ca. 238 AD. DAI Rome 72.482, photo Singer.

mythological. Unlike the free-standing *kline* monuments discussed above, to which they are obviously related, here the sarcophagus itself becomes the funeral couch, and the chest containing the body physically supports the reclining figure. Sarcophagi with lids like these appear at Rome in the early to mid-second century AD, and somewhat later in both Athens and Asia Minor; they are especially common in the third century.[41] They are luxurious, expensive objects, for clients who could afford top models; identifiable owners sometimes come from the highest social classes. One particularly fine example from the pagan necropolis on the site of the catacomb of Praetextatus in Rome is usually identified as that of the emperor Balbinus and his wife, who reigned briefly in 238 AD (Fig. 70).[42] The reclining figures themselves show some of the same variations that we have already seen. The Roman examples at first show only a single figure; females and boys are usually shown resting or sleeping. In the third century, they normally represent a reclining couple; the man usually holds a drinking vessel, while the woman may hold a garland but does not otherwise participate in the meal. On the sarcophagi of Roman Greece and Asia Minor, explicit allusions to a meal are absent;

there are no drinking vessels or related objects, although the man may hold a book scroll. Even on a sarcophagus of Attic manufacture exported to Rome, such as a splendid example in the Capitoline Museum from the mid-third century AD whose chest is decorated with the scene of Achilles on Scyros, the figures on the lid simply recline side by side, with no direct reference to a meal.[43] In contrast, great attention is paid to the decorative details of the couch and mattress; the latter is often elaborately ornamented with vegetal scrolls and friezes of sea monsters or hunting scenes. The notion of reclining as a power position is very strong here; the mighty figures in their tomb are presented to the observer in the most impressive manner possible. Emphasis is on representative display and luxury; the banquet itself is less prominent.

The derivation of the motif in this form, and the relationship between its appearance in different regions of the Empire, are matters of some dispute. For the Roman examples, there can be little doubt that the idea goes back, beyond the *kline* monuments of the early empire, to late Etruscan traditions.[44] The Etruscans had represented themselves reclining on their own graves as early as the late sixth century BC, as in the famous terracotta sarcophagi from Caere.[45] In the Hellenistic period, such representations are almost monotonously frequent in Etruscan art, on the lids of both sarcophagi and cinerary urns (Fig. 71). Both males and females appear reclining, although most appear separately rather than as couples, and here too there is a distinction between the sexes. The most frequent attribute for men is the libation bowl, but they may also hold drinking vessels, or sometimes scrolls and writing implements. The women hold flowers, fruit such as pomegranates, or household and toilet implements such as fans or mirrors.[46] But the concept of the sarcophagus as itself a couch on which the deceased can be shown reclining also has roots in the Greek world. Sarcophagi in the form of couches, although without reclining figures, are common in Macedonia and several other parts of the Hellenistic world.[47] In the mausoleum of Belevi, near Ephesus, the massive sarcophagus of a local potentate was carved in the form of a couch, perhaps in the early third century BC; bench and footstool stand between the couch's legs. The lid, which some scholars believe to have been added in a second phase, perhaps in the mid-third century, shows a huge figure reclining on cushions and holding a bowl. The statue of a servant in oriental costume, found in the tomb chamber in front of the sarcophagus, may have been added at the same time. The effect is that the whole group is transformed into a three-dimensional Totenmahl; a truly prestigious monument, which has been attributed by many commentators to members of the Seleucid dynasty.[48] It does not seem, on our present knowledge, to have had any immediate successors or imitators; the origins

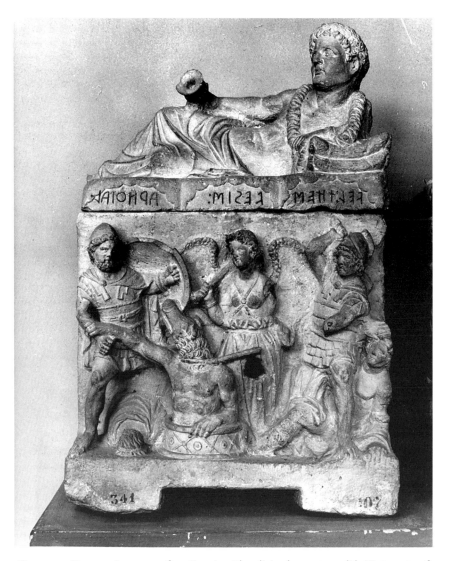

Figure 71 – Etruscan cinerary urn from Perugia with reclining banqueter on lid. First quarter of second century BC. Perugia, Museo Nazionale Inv. 341. DAI Rome 82.1758, photo Schwanke.

of the *kline*-sarcophagi of Asia Minor in the Roman Imperial period remain under discussion.

DINING AND DRINKING IN TOMBS

The monuments from Rome and its environs discussed above have given some notion of the multivalence of the motif of the reclining banqueter in Roman funerary art, and of its interweaving with the other associations

that the couch can evoke. Occasionally, the monuments themselves contain clues, visual or verbal, to how their owners wanted them to be read, but most of them give little indication whether those who commissioned them believed that they would remain still drinking in the tomb or that they would pass to an eternal banquet in the next world, or whether their attention was entirely fixed on the pleasures of this world, and they had no hope of any such enjoyment in the next. Over the centuries that I am considering, it was undoubtedly possible to find in Rome – to say nothing of the other parts of the empire – adherents of all these views. Indeed, given human inconsistency, many probably held more than one at the same time.

Other categories of material may help to illuminate, from other angles, the complex interconnections between dining, especially drinking, and death in Roman thought. The epitaph on the monument of Flavius Agricola quoted at the beginning of this chapter belongs of course in the world of popular Epicureanism of the *carpe diem* variety.[49] Similar attitudes find frequent expression in funerary inscriptions both in Rome itself and throughout the empire. On one epitaph from Ostia, a certain Primus speaks from his tumulus: 'I lived for Lucrini (that is, oysters) and often drank Falernian wine; baths, wine, and love grew old along with me through the years'.[50] An old soldier from Antioch in Pisidia echoes the sentiment: 'While I lived I drank gladly; do you drink, you who live'.[51] Better still for our purposes is the epitaph of L. Runnius Pollio from Narbonne: 'I stay drinking (*perpoto* – I drink continuously) all the more eagerly in this monument of mine because I must sleep and remain for ever here'.[52] Pollio's monument is not preserved, but must surely have shown him reclining with cup in hand. And in the inscription of Rubrius Urbanus with which the introduction opened, the 'merry image' of the banqueter is set against the foil of the dead man's self-denial in life, to return to the message that life must be enjoyed while it lasts.[53] Even more common in Greek are the inscriptions and epigrams that play with the familiar theme: one from Kios runs: 'Eat, drink, have a good time, and make love; all below here is darkness'; another from Kos tells the passerby to 'drink up, keep an eye on the end'.[54]

So far the emphasis is firmly upon this life. The highest pleasures of life in these epitaphs are those associated with the banquet and wine, and the opposition between these and the world of the tomb is expressed in as sharp a manner as possible. But there is nevertheless a certain ambiguity, if only in the fact that the dead man speaks, addressing himself to the passerby, and sometimes describes himself as still drinking in the tomb. Not all are as ready as Agricola to stress that what is seen is an image, and that earth and fire consume all the rest; indeed, Primus from Ostia combines his praise

Figure 72 – Pompeii, Tomb of Cn. Vibrius Saturninus, funerary triclinium. 63–79 AD. *After A. Mau,* Pompeii in Leben und Kunst *(Leipzig 1908), fig. 264.*

of oysters and Falernian with a hope that he may be regenerated like the Phoenix.[55]

The concept that the dead remain and dwell in the tomb is one of the most common of Roman funerary topoi; the tomb is *aeterna domus*, the eternal house.[56] Whatever ancient basis of belief lies behind this, by Roman times it is a cliché, and tells us little about the attitude to death of those who habitually use it. Nevertheless the influence of the underlying concept remains visible in many ways: in funerary practice, in the architecture of the tomb, and in the imagery of the monuments. The offering of food and drink to the dead is attested throughout the Roman Empire, persisting into the early Christian period, as is the provision of eating and drinking vessels within the tomb.[57] At least sometimes the link between this concept and the figured image is made explicit; when a reclining man of the Trajanic period on a *kline* monument from Ostia, now in Copenhagen, holds a cup bored through so that liquid can pass directly into the grave beneath, the sense that the dead man is drinking in the tomb is vivid.[58]

Moreover, many tombs throughout the Roman world contain real dining facilities.[59] A triclinium, with masonry couches and table, is attached to the tomb of Cn. Vibrius Saturninus at Pompeii (Fig. 72).[60] Several of the tombs

Figure 73 – Isola Sacra, biclinium *at entrance to tomb. Photo KMDD.*

at Ostia and the Isola Sacra have triclinia or biclinia of masonry inside or at their entrance, as well as tables and seats (Fig. 73); some even have hearths or other provision for cooking.[61] Inscriptions also sometimes speak of triclinia as part of tombs; one from Rome, for instance, specifies that the ownership of a columbarium carries with it the right to use the triclinium and the kitchen, and to draw water.[62] Indeed, the connection between dining and the tomb was believed to be so close that it could lead to a merging of categories, so that by a sort of metonymy triclinium and the related form *triclia*, technically a pavilion or bower such as is used for dining in a garden, came to be used as a term for the tomb itself.[63]

The tomb triclinia are of course provisions for the commemorative banquet: whether for the family holding the annual celebration of the feast of the Parentalia in February, or for a group meeting probably on the birthday of the dead man or woman in accordance with a bequest.[64] They are small-scale affairs, holding no more than a dozen at most, not designed for the big public festivities discussed in Chapter 3, but they would have been suitable for an association or small corporation. One of the Ostia tombs, columbarium 31 from the via Laurentina, contained both a masonry triclinium, inside the tomb underneath the rows of niches for the urns, and a painting of just such an occasion: five men dressed in white tunics and

Figure 74 – Ostia, Via Laurentina, columbarium 31, plan showing triclinium inside tomb. After Floriani Squarciapino 1958, fig. 61.

cloaks, holding up glasses in a toast (Figs. 74, 75). Although the lower part is destroyed, the banqueters are evidently gathered around a semicircular couch, the *sigma* or *stibadium*. Their names are written above them; simple names characteristic of the lower orders of society, such as Felix, Foebus, and Fortunatus.[65] Celebrations such as these introduce another aspect of the relationship between drinking and dining, and the tomb; their representation belongs in a different iconographic tradition, that of the convivial banquet.

SCENES OF THE CONVIVIAL BANQUET

Scenes of a group of banqueters reclining around the common table have a very different tradition in Roman art from that of the classic Totenmahl scene with the solitary banqueter on his couch, and are more closely related to representations of banquets in domestic or other nonfunerary contexts.

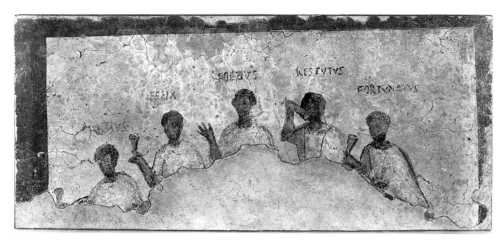

Figure 75 – Ostia, Via Laurentina, columbarium 31, painting of funerary banquet. Probably first half of third century AD. Vatican, Museo Gregoriano Profano Inv. 10786. Musei Vaticani, Arch. Fot. XXXV.32.21.

Communal banquets appear occasionally in funerary contexts in the early and mid-Imperial period, on the walls of tombs or on funerary monuments, although they are much less common than the various renderings of the banqueter on his couch, alone or with his spouse.[66] A recently discovered painting from the second-century hypogaeum of Crispia Salvia at Lilybaeum, modern Marsala in Sicily, shows a cheerful group of five men reclining at a *sigma* couch, wearing wreaths and brandishing cups (Pl. VII). A table with a cup of wine stands in the curve of the couch. A large garland hangs above their heads, while roses are scattered liberally over the background. On the adjacent wall amidst a similar background of roses, the same five men are seen in a joyful procession, accompanied by the music of a double flute played by a seated woman. More roses and garlands cover the other walls of the tomb, along with Erotes, peacocks, and other birds, and baskets of flowers.[67] The sense of festivity is clearly dominant here. Although the roses and birds may evoke a paradisal atmosphere, the banqueting group recalls the words of Flavius Agricola to his surviving friends: 'mix up the wine and drink far away, binding your brows with flowers...' A similar atmosphere prevails in a small panel from the Via Latina necropolis in Rome, now in the Louvre; it may date from the early third century.[68] Eleven guests are assembled around a curving bench or table under a vine pergola, their heads wreathed with ivy; a servant brings a dish, another rests on the table before them. The Dionysiac overtones of vine pergola and ivy seem more likely to indicate a general convivial ambience than to identify the group specifically as Dionysiac initiates.

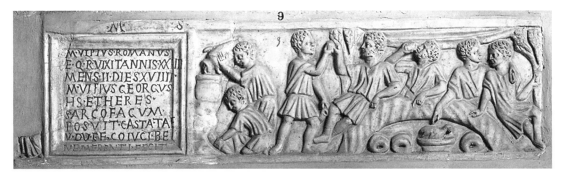

Figure 76 – Rome, sarcophagus lid with outdoor picnic at sigma. *Third quarter of third century* AD. *Vatican, Galleria Lapidaria, Inv. 160a. Musei Vaticani, Archivio Fotografico Neg. II.16.18.*

Scenes of this sort become more frequent from the third century onwards, and several examples will be considered in the following chapters.[69] In the present context, the most relevant are a series of sarcophagus lids from the later third century that show a group of banqueters – usually about four or five, all male – on the *stibadium* (Fig. 76).[70] Often the scene is set out of doors, with trees supporting an awning to shade the diners, who recline on a curving cushion, with the food placed on the ground before them. On others the setting is more ambiguous, with a regular table in the curve of the cushion. The diners themselves most often wear short tunics, appropriate for hunters or for dwellers on the land. Servants busy themselves preparing the drink and bring plates of food; wine cups and jugs are much in evidence. A common detail shows the wine (or more likely, the water to mix with the wine) being heated in a cauldron on a makeshift oven at the side; the boar's head or other game set before the diners further identifies the meal as the open-air picnic after the hunt. However, this atmosphere is not consistent on all the examples, and others show elements taken from the iconography of more formal meals: the diners are formally dressed, servants bring platters of different foods, and the wine stands in a big jug rather than an open bowl.[71]

A great deal has been written about these scenes, usually in an attempt to define the context of the banquet and to establish a clear distinction of significance between scenes of this type and those of the more traditional type, with a single banqueter or a married couple on a couch. Scholars have attempted to establish criteria by which to distinguish between scenes of the funerary banquet, whether that of the family at the tomb or of a wider group in commemoration of the dead, scenes which allude exclusively to the pleasures of this world and the banquet as a mark of luxurious life, and

those which represent the banquet in the next world as the hope for a happy afterlife. In particular, many scholars have distinguished clearly between representations of the so-called *kline*-meal, such as the sarcophagus of Caecilius Vallianus, with a single banqueter or a couple on a single couch, and those of the *sigma*-meal as seen on these lids, with a group on the semicircular couch or cushion. The former, they suggest, always retained a sense of the heroization of the dead, whereas the *sigma*-meal bore more reference to everyday life, as an image of bucolic happiness.[72]

I do not myself believe that it is possible to establish any clear set of criteria, nor a neat dichotomy between two iconographic types. However distinct their origins, in practice there is a great deal of mutual influence and contamination between them; the servants bearing food and drink, for instance, move freely from one type to the other. Once again, we are confronted by the interweaving of the various themes of the banquet and death; on most examples, we probably draw a false distinction if we ask whether the scene is meant to be read as the banquet at the tomb, as that in the next world, or as one from the deceased's past life. All these senses may be implicit together, or one or another may be emphasized; all are linked by the common idea of the banquet as the ideal metaphor for happy existence. There is of course no doubt that the representations of a single banqueter or a couple have a stronger honorific focus, designed to stress the prestige and status of the dead. What the group banquets add is just what was missing on the sarcophagus of Caecilius Vallianus: the sense of conviviality, without which the *convivium* loses much of its value.

DEATH AT THE FEAST OF THE LIVING

At this point, we should look at the other side of the coin, the *convivium* of the living. Here the idea of death was used repeatedly to enhance the pleasures of life. Convivial poetry plays constantly with the opposition, perhaps most vividly during the first centuries BC and AD, for instance, in the works of Horace or Martial.[73] One of the most striking examples occurs in the pseudo-Vergilian poem the *Copa*, where the song of the Syrian innkeeper inviting the listener to enjoy all the delights of the feast ends with the unforgettable image of death tweaking the ear of the reveller: 'live', he says, 'I am coming'.[74] When Petronius makes Trimalchio return constantly to the theme of death, whether ordering his tomb or laying himself out on his bier, he is only exaggerating a popular fashion for which we have extensive other evidence; it should not be taken to reflect a special morbid

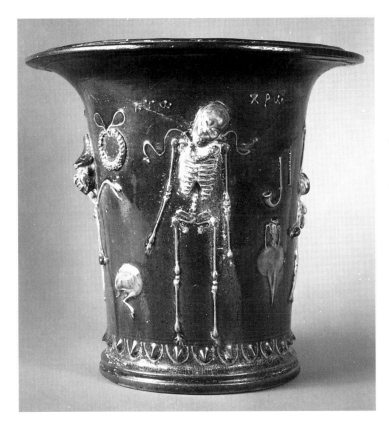

Figure 77 – Thrace, green-glazed cup (kalathos) with skeleton and banqueting paraphernalia. Probably second half of first century BC. Berlin, Antikenmuseum, Staatliche Museen Preussischer Kulturbesitz, Inv. V.1. 30141. Photo courtesy of Bildarchiv Preussischer Kulturbesitz.

preoccupation.[75] One of the clearest illustrations of this fashion may be found by examining the representations of the skeleton in Roman art, and the use made of them.[76] The great majority of such representations occur on objects connected in one way or another with drinking or the banquet, and they too date for the most part from the first centuries BC and AD. They range from little bronze or silver models of skeletons which could be passed from hand to hand among the guests, to drinking cups like the one from Thrace now in Berlin, where the skeleton is surrounded by paraphernalia of the banquet such as a garland, an amphora, and a haunch of meat, and accompanied by the motto 'get and use' (Fig. 77).[77] There are the famous silver cups from Boscoreale, where the skeletons are identified by inscriptions as some of the greatest of Greek poets and philosophers, revelling among flowers and music[78]; or the well known mosaic probably from the floor of a triclinium in Pompeii with the skeleton butler, jugs in hand (Fig. 78).[79] These reminders of mortality are of course intended to urge the living to all the greater enjoyment of their short-lived pleasures. As the guests gazed

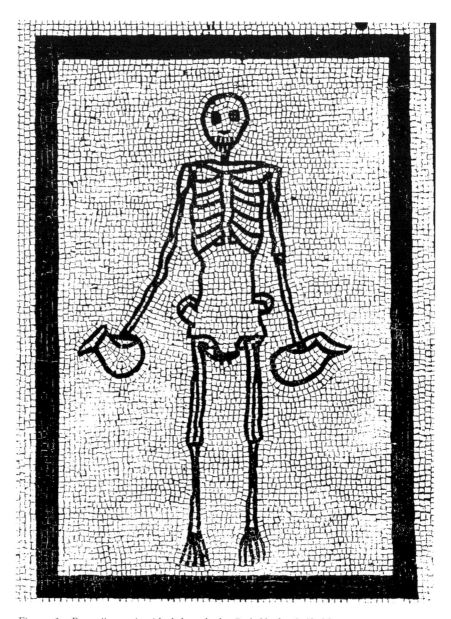

Figure 78 – Pompeii, mosaic with skeleton butler. Probably first half of first century AD. Naples Museo Nazionale Inv. 9978. Copyright Alinari/Art Resource, NY (Anderson 25788).

upon them, as they drank from the cups or passed them to their neighbours, they were undoubtedly intended to compose their own meditations upon the familiar theme. The verses and epigrams that appear upon tombs would often have had their counterparts in those actually uttered at the banquet itself, like those that Petronius puts into the mouth of Trimalchio as he plays with a little silver skeleton: 'What a nothing the whole of poor man is. This

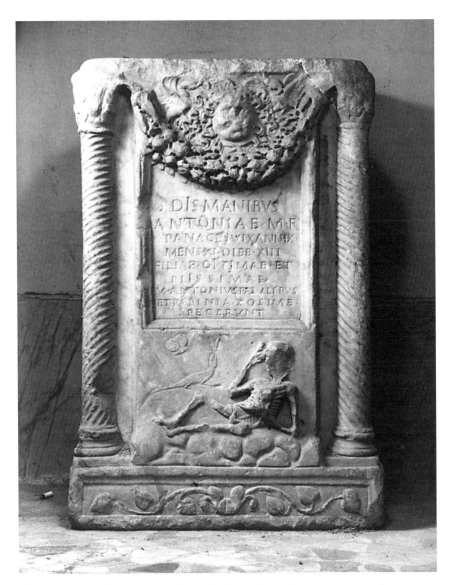

Figure 79 – Rome, funerary altar of Antonia Panace with reclining skeleton. Late first century AD. Naples Museo Nazionale 2803. DAI Rome 68.4103, photo Fittschen.

is what we shall all be, after fate takes us off. So let us live while we may enjoy it.'[80]

The motif is in a sense turned on its head in the comparatively few occasions when the skeleton appears where we might think it more natural to find it, on a tomb. On the little grave altar of Antonia Panace from Rome, now in Naples Museum, the area beneath the inscription frequently occupied by a banqueting scene contains a skeleton, reclining with drinking cup in hand, the other placing a wreath upon its head (Fig. 79).[81] The

*Figure 80 – Herakleion, sarcophagus, front showing skeleton beside table. Probably first century
AD. Herakleion Archaeological Museum. Photo KMDD.*

banqueting skeleton acts here as a sort of double quotation, picking up
from the living banquet the skeleton that parodies the gestures of the living.
However, whereas for the living it acts as a reminder of the inevitability of
death, on the tomb it alludes back to the pleasures of life. The epitaph tells us
that Antonia Panace was only 9 years, 11 months, and 13 days when she died,
surely too young to have taken much part in banquets. Nevertheless, the
theme must at least have seemed appropriate to the parents commemorating
their child; perhaps the intention was to allude forward to the pleasures
which she had no chance to experience.

More sophisticated self-quotation appears on an unusual sarcophagus
from Herakleion in Crete, probably to be dated to the first century AD
(Fig. 80).[82] It is itself in the form of a couch, with a cloth draped over
it. The objects carved along the front are those which would be found
on a Totenmahl relief: the table in front of the couch laden with food, a
basket beneath it, and attendants including a boy probably serving drink and
a flute player. Unique, however, in this context is the small skeleton that
stands beside the table. In this association, it forms part of the paraphernalia
of the party; that is, it is meant to evoke the model skeletons like the one
Trimalchio plays with. But here it is carved into permanent form for the
dead, who is himself in his sarcophagus now no more than a skeleton.

Some related themes show the same tendency to move between the
world of the living and that of dead, with constant reference from one to
the other. On one side of the Herakleion sarcophagus is carved a sundial, of
the typical bowl-shaped form used for ancient sundials, which had to regis-
ter hours whose length varied according to the season (Fig. 81).[83] Sundials
are used on occasion as tomb monuments, for instance, on an example from
the necropolis at Aquileia; and they are sometimes mentioned as part of the
decoration and equipment of tombs, as on an inscription from Centocelle

Figure 81 – Herakleion, sarcophagus, left end with sundial. Photo KMDD.

near Rome with a lengthy set of prescriptions for an elaborate tomb.[84] Trimalchio also ordered a sundial to be set on his tomb, giving the explanation that everyone who looked for the time would read his (that is, Trimalchio's) name, whether he wanted to or not. The reason may be typical of Trimalchio; on most tombs, the more obvious explanation for the presence of the sundial is the familiar theme of the brevity of human life and the ineluctable passage of time. Trimalchio also had a sundial in his triclinium, and here the explanation Petronius gives is that he wanted to be able to know at once how much he had lost from his life.[85] We find a similar play on a mosaic from the triclinium of a house at Antioch, where a well dressed man hurries past a sundial on a column (Fig. 82). The inscription above reads 'the ninth hour is past'; in other words, he is late for dinner. For observers used to the pattern of associations that we have been looking at, this would surely inspire a play on the interwoven themes of life and death, time and the banquet, pleasure and the end of all pleasure.[86]

In a paper entitled 'Death and the symposion', published in 1988, Oswyn Murray concluded that 'there existed in the Greek world a polarity, a more or less absolute distinction between the world of the symposion and the world of the dead'.[87] He was speaking of classical Greece, and above all Athens, and acknowledges that things may have changed in the postclassical

*Figure 82 – Antioch,
House of Sundial,
mosaic with man beside
sundial, inscription 'The
ninth hour is past'.
Probably mid- to late
third century AD.
Worcester Museum of
Art. Photo Department
of Art & Archaeology,
Princeton University,
neg. 2090.*

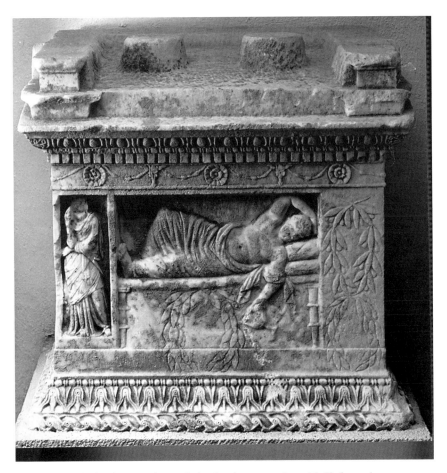

Figure 83 – Rhodes, funerary altar with drunken banqueter. Second half of second century BC. Rhodes Archaeological Museum Inv. 638. DAI Athens 71/1402.

age. Whether the distinction was indeed so absolute even in the period he was discussing may perhaps be questioned; at least by the Hellenistic period, it is evident both that the interrelationship of dining and death has become a cliché of funerary art, and that it was open to a wide range of different interpretations. In addition to all the variants on the standard Totenmahl motif, one exceptional monument may be quoted here which carries the association of death and drinking even further, in a sense to its logical conclusion. It is a funerary altar from the island of Rhodes, of the late Hellenistic period (Fig. 83). The dead man lies sprawled on his couch, one arm behind his head, the other dangling with an empty wine cup. Beside him stands a woman in the pose of grief. He himself clearly no longer participates in the banquet, nor is he shown in the decorous attitude of sleep; his position is unmistakably that used on vases for drunken

participants in the symposion. Are we being told that he has drained the cup of life to the full, or that he will experience eternal bliss or divine intoxication in the afterworld? The metaphor is left ambiguous; the viewer might take it in any or all these senses.[88]

In the Roman world, the confrontation between death and the symposium (or better, the *convivium*), which Murray defines as an attempt to come to terms with mortality, is undoubtedly still valid; it resulted in powerful and expressive imagery in both art and epigram. But that does not mean in any sense an absolute distinction. As we have seen, the two worlds are constantly interwoven; one serves to evoke the other, and motifs and attributes move freely between them. For Flavius Agricola, for Caecilius Vallianus, and many others like them, the two could not be separated; it must have seemed to them inevitable to choose to lie in death as they had lain so often and so happily in life.

Banqueting in Late Antiquity

THE HUNTING PLATE IN THE SEVSO TREASURE

The iconography of the banquet in its specifically Roman manifestations reached maturity in the later third and fourth centuries AD. Motifs derived from Greek and Hellenistic sources gave way to others which better reflected both contemporary customs and the values that lay behind them. Some scenes, treated in the earlier centuries of the Empire in ways that seem still tentative or experimental, appear now with increased frequency and are manipulated more effectively to convey the messages that the patrons wanted to express. Others are new, although frequently we have literary or artefactual evidence much earlier for the practices or attitudes that they illustrate. It is notable that this new iconography is spread widely throughout the provinces of the empire; the same repertory occurs in wealthy houses and tombs far outside Italy itself, from the Spanish provinces to Syria, from the coast of the Black Sea to North Africa. Regional differences would become apparent in many respects on closer view, but there can be little doubt that the diffusion of this repertory corresponds to a widespread uniformity in manner of life among the upper classes who commissioned these monuments. Across the empire, an elite had emerged who had enormous wealth and who were increasingly more inclined to invest that wealth in their own houses and estates, and all the furnishings of luxurious living, rather than in the public life of their cities. The art of Late Antiquity developed a style and an imagery supremely well designed to express power and status, and the magnificence with which the lives of the wealthy were conducted; its use, in widely separated regions, served to demonstrate and display membership of a class and participation in a shared culture.

Many of these new developments are illustrated on one of the most impressive objects of silverware from the late Roman Empire: the Hunting Plate from the Sevso treasure. The treasure itself became known to the public in the early 1990s; its ownership and origins were the subject of extensive legal dispute, and its provenance and the circumstances of its deposition may never be known. The hoard consists, to our present knowledge, of fourteen vessels of silver, all elaborately decorated, found buried in a large copper cauldron; they include four big plates, five jugs or ewers, a basin, an amphora, two buckets, and a casket for toilet items. In her publication of the treasure, Marlia Mundell Mango has concluded that the vessels were probably manufactured in different parts of the Roman Empire at various dates between around 350 and 450 AD, and assembled over a fairly long period before being buried in a location that remains unclear.[1]

The Hunting Plate is one of the earlier objects in the treasure, probably dating from the mid- to late fourth century AD (Pl. VIII, Fig. 84).[2] It is a spectacular piece of silver, 70.5 cm in diameter, partially gilt, with a central medallion 17.3 cm in diameter, surrounded by an inscription, and a frieze around the rim. Both medallion and frieze have figured decoration, the design incised into the surface, the background inlaid with niello (a black paste of silver sulphide), and patches of gilding picking out some details. The outer frieze has hunting scenes, with hunters on horseback and on foot chasing various animals large and small in a wooded setting, and bringing the game back toward a villa. Within the medallion we see again a number of hunting scenes, with deer and boar, while a fisherman holds his rod in a river full of fish. The whole centre is occupied by the scene of a picnic, held under an awning spread between two trees, to which two horses are also tied. Beneath this, five figures recline against a curving bolster: four men in short tunics and a woman. The little table in the curve of the bolster holds a plate with a fish, servants below bring more food and drink, and other vessels and containers stand in front. We also see two men cutting up the carcasses of game, a boar and a deer; a cauldron being heated; and the hunters' hounds waiting for a tidbit from their masters.

Around the medallion runs an inscription, containing in verse (more or less) a wish addressed to a certain Sevso: 'May these little vessels, Sevso, last you for many ages, so that they may serve your descendants worthily'. Sevso is evidently the owner for whom the plate is intended; the Germanic name suggests that he was one of the numerous men of barbarian extraction who rose to power and wealth in the late Roman Empire.[3] The inscription suggests that the plate itself and other unspecified vessels, deprecatingly referred to as *vascula*, little vessels, were meant as a gift. Similar inscriptions occur in

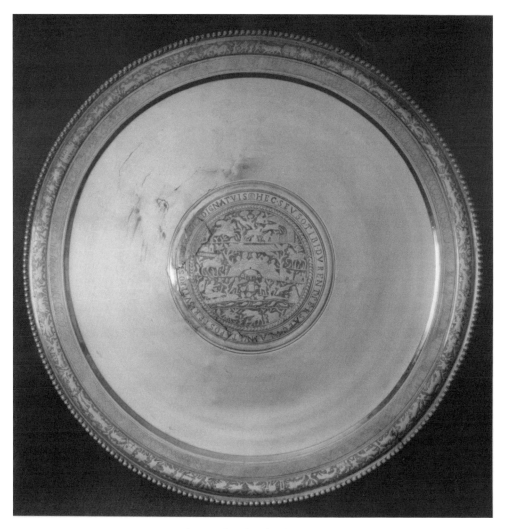

Figure 84 – Sevso Treasure, Hunting Plate. Mid- to late fourth century AD; D. 70.5 cm. Photo courtesy of the Trustee of the Marquess of Northampton 1987 Settlement.

late antiquity on a wide variety of objects, which were presented by and to notable or wealthy individuals, often to commemorate special events, public or private. Because this inscription does not include the donor's name but only that of the recipient, one may hypothesize that it was intended to commemorate an event in Sevso's family, possibly a wedding.[4] But inscriptions, often metrical, of this sort also served a purpose more closely linked with the function of the objects they decorated; they would be read, discussed, and the wishes they contain applied and perpetuated every time the object was used or displayed.[5]

A small detail at the start of the inscription provides information of a different sort: the Chi-Rho or monogram of Christ contained in a wreath. Sevso, it shows us, was at least nominally a Christian. Nothing else about the plate, nor indeed about any of the rest of the treasure, bears the slightest reference to Christianity; all is unashamedly secular. This is not in the least surprising at the date in question, when Christianity as the favoured religion of the emperors was exercising a strong attraction over many rich and powerful individuals, without necessarily entailing perceptible change in their luxurious lifestyle. It is in fact characteristic of the great treasures of fourth-century silver that they often contain one or two items with Christian reference alongside the greater part that is entirely secular, often indeed with mythological subject matter. The best-known example is the casket from the Esquiline Treasure from Rome, where the inscription immediately below an image of the triumph of marine Venus contains the wish 'Secundus and Proiecta may you live in Christ', preceded by a Chi-Rho monogram; it is likely that it was intended as a wedding present for the couple named in the inscription. In light of this, it is no wonder that we cannot always distinguish between Christian and non-Christian uses of the banquet theme, or identify the religious affiliation of those who use it.[6]

SCENES OF THE PICNIC

The Hunting Plate belongs in a category of huge display and serving plates, decorated often with ambitious figured scenes in relief, engraving or inlay, which are characteristic of the silver production of the fourth and fifth centuries.[7] Its closest parallel in both iconography and technique is the plate, also of silver gilt inlaid with niello, preserved at Cesena in northern Italy (Fig. 85).[8] This has an identical composition, with an outer frieze around the rim containing hunting and pastoral scenes between villas, and a large central medallion. The latter is divided into two halves; in the top is another scene of a picnic, with five guests reclining against a semicircular bolster beneath hangings, served by an attendant at either side. The lower half shows another complex set of buildings, a horse with its groom, and a duck pond.

On both plates, the picnic forms the focus of the whole decoration. Open-air dining had of course been practised since time immemorial, originally simply using branches or foliage to recline on, then mattresses or cushions called in Greek *stibades*. Wealthy Romans from the late Republic

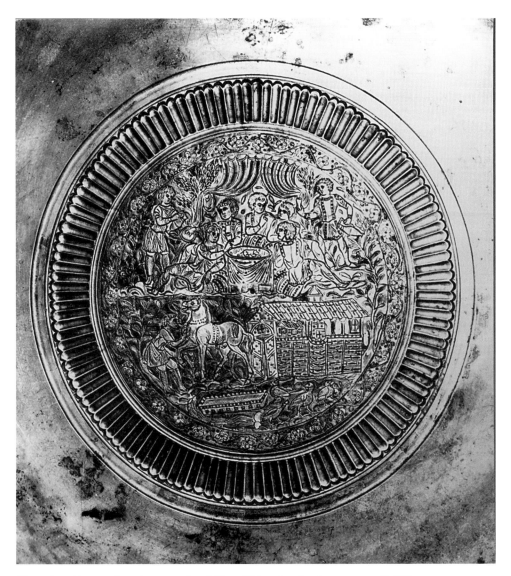

Figure 85 – Cesena, silver plate, central medallion. Mid- to late fourth century AD. DAI Rome 75.1140, photo Rossa.

onwards, undoubtedly following Hellenistic precedent, had developed such occasions as a grand opportunity for lavish hospitality and display, as we learn from the literary accounts of millionaires such as Lucullus or Hortensius entertaining in the midst of their aviaries or wild beast park.[9] Many installations for outdoor dining had permanent form. Numerous examples of masonry triclinium couches set beneath a pergola are found in Pompeii in the first century AD, as well as fixtures for wooden couches. Often they

have provision for fountains running through their midst or water splashing around them, like the elegant example in the House of the Ephebe (I 7.10–12).[10] They echo on a smaller scale the fashions set in the great villas of the aristocracy, or even those of the emperors themselves, the triclinia in grottoes or on islands found in the great imperial villas at Baiae and Sperlonga.[11] In more temporary settings, the guests would recline against a rich and elaborate bolster on the ground, with a low table or simply a plate set in its curve. This might be given permanent form as a semicircular couch of masonry, a basis on which the cushions and bolsters may be set: a monumental example occupies the curve of the apse of the so-called Serapeum of Hadrian's villa at Tivoli.[12] This is the origin of the semicircular couch known as the *stibadium* or *sigma*. Originating as an outdoor fashion, it migrated indoors by the later centuries of the Empire; numerous examples, discussed later in this chapter, show it as the normal arrangement for indoor dining in the fourth century AD, often with elaborate furniture.[13] But the arrangement also persisted in its earlier form for outdoor dining at picnics, with the *stibadium* bolster placed directly on the ground.

Scenes of outdoor festivities of this type, with the figures reclining on cushions on the ground, appear in paintings from Rome and Pompeii of the late first century BC and first AD. As seen in Chapter 2, many are small-scale sketches, often rather summary in execution; they form an episode in a frieze or occupy a subordinate position (Pl. IV, Fig. 30).[14] These paintings are designed to create the atmosphere of a festive outdoor celebration, but they play no part in the grand self-presentation of the host. There is no suggestion in these scenes from the early Empire that the outdoor feast has any connection with hunting, which indeed is not a common theme in Roman art at this period. It is not until much later, the third and fourth centuries, that hunting scenes began to play a major role in the decoration of rich Roman houses. At that time scenes of hunting, ranging from the pursuit of the small game of the local countryside to major expeditions after ferocious prey such as lions, bears, or leopards, came to be used widely, for mosaic pavements, for textiles, for decorated metal work: all objects that would be displayed before the sight of guests being entertained. It is clear that the ideology that lies behind these scenes has changed, and it has become an important part of the self-image of a wealthy Roman to display visibly the possession of estates, hounds, horses, and servants and, even more important, of the leisure necessary to engage in such activities, as well as the heroic courage required for confronting the larger game.[15] A natural corollary is then the combination of these scenes with the image that conveyed better than any other the ideal of a cultivated, rich,

and leisured lifestyle, the banquet or feast. We have literary testimony to the popularity of scenes of a picnic explicitly identified as that of the hunters after the hunt. The younger Philostratos, at some point in the third century AD, has a description of a painting with this theme, with five hunters reclining on their piled-up nets by a spring under the trees.[16] More than a century later, the orator Libanios describes more briefly a similar painting of a country picnic on the walls of the council house at Antioch. He does not call the diners hunters, but the mention of a dog and horse suggest the connection.[17]

No examples survive of paintings in public settings comparable to those described by Philostratos or Libanios, but their descriptions echo to a remarkable degree many details of similar representations in other media. The best known, offering perhaps the closest parallels, is the mosaic of the Small Hunt from the great villa at Piazza Armerina in Sicily, of about the third decade of the fourth century (Fig. 86).[18] Here the picnic is the central focus

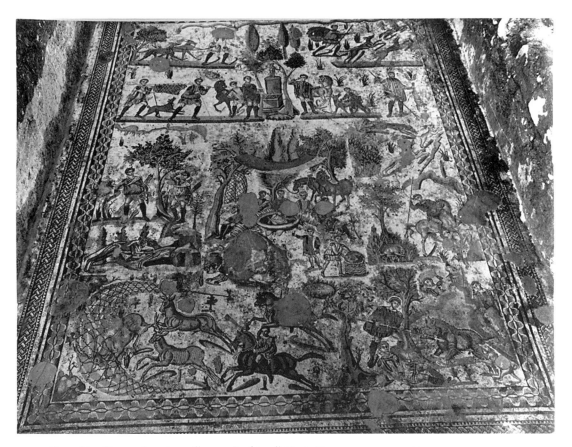

Figure 86 – Piazza Armerina, villa, mosaic of Small Hunt. Ca. 320–30 AD; 5.90 × 7.05 m. Photo Fototeca Unione no. 52285.

of a series of hunting scenes, similar to those on the Sevso plate but of much greater variety. They include the hunters' sacrifice to Diana in the register above, and the hunt of deer, boar, and smaller game all around. The five picnickers, all male, recline against a striped cushion, with an awning hanging from the trees above; a large dish bearing a fowl is set before them in the curve of the cushion. They are identified clearly as the hunters, wearing the same short tunics and leggings as the figures in the hunting scenes. The nets hang ready in the tree above, horses are tied to the trees behind, and a dog takes a tidbit from its master. In front of the group, three servants are busy with the preparation and serving of food and drink. The scene recurs again a few decades later on another Sicilian mosaic, from the villa on the Tellaro near Helorus.[19] Here the hunters' picnic appears at the bottom of a much more dramatic series of hunting scenes, with armed men fighting and capturing ferocious beasts in a wild landscape. Such scenes belong in the context, either of the heroic demonstration of courage and prowess, or of the capture of beasts for the amphitheatre games; the more peaceful episode of the hunters' picnic is less appropriate here than at Piazza Armerina, where the hunting scenes are all in place in the context of life on a country estate. Despite this, the ingredients of the scene are very similar: six hunters reclining on what at Tellaro are evidently the piled-up nets, as in the Philostratos description; a fowl on a plate before them; an awning suspended from the trees above; horses tied to the trees; and servants busy with the preparation and service.

As seen in Chapter 4, the picnic was also a popular theme on a series of late third-century sarcophagus lids from the city of Rome (Fig. 76).[20] Although some of these leave the nature of the meal and its setting ambivalent, others identify the participants as hunters by their short tunics and the plate of game before them, and set the scene in the open air beneath an awning. Moreover, on several of them actual hunting scenes are represented, either on the other side of the lid or on a larger scale on the chest of the sarcophagus so the association is clearly stressed. Thus one in the catacomb of S. Sebastiano in Rome shows a heroic lion hunt on the fragmentary chest, while the lid has five hunters in short tunics reclining on the *stibadium* cushion, a boar's head and two rolls of bread before them, an awning stretched behind; two servants attend them, one bearing a wine cup, two more are busy with a huge jug at the side. A second lid from S. Sebastiano, also with a lion hunt on the chest, shows a deer hunt on the other half of the lid and repeats many of the same elements in the scene of the picnic, including the boar's head. Yet even here there is an element of ambiguity because a servant also approaches bearing a plate with a fish.[21]

The Sevso plate evidently belongs in the same iconographic tradition as the works just discussed, and is most closely connected in general conception and detailed iconography to the Piazza Armerina mosaic. Nevertheless, it has ambiguities not present in the mosaic. It is perhaps surprising that the food lying on a plate on the table in front of the guests is a fish, as also appears to be that offered to them by the servants below. Fishing is not usually presented as a heroic or aristocratic activity comparable to hunting, and one would not expect a hunting party out with their hounds and horses to take time out to catch themselves some fish. It is surely the creatures whose carcasses are shown being prepared, the boar and the deer, that the viewer is intended to understand as the hunters' quarry; the baby boar and goat down below, apparently waiting to be eaten, may also be meant to be understood as products of the chase. But the figure sitting on a rock to the right who is catching fish with his rod and creel is a simple fisherman, not one of the aristocratic party. In other words, this is not a narrative of an actual hunting party where the hunters consume their own catch, but an image of a more formally staged occasion at which no delicacy should be conceived to be lacking; that is, the wild produce of land and water alike are at the disposal of the banqueters.[22] Even more telling is the presence of the female picnicker. In a real hunters' picnic, she would have no place; Roman women, even wealthy Roman women, did not normally ride to hounds.[23] Rather she and the man beside her in the middle, who is given more emphasis than the rest, are surely the owners, presumably Sevso himself and his wife, shown enjoying all the amenities of their estate.

In other respects too the picnic scenes on the Sevso plate and the Piazza Armerina mosaic are made to serve the purposes of the owners' self-presentation. A great deal of attention is paid to the apparatus of the meal, and its preparation and serving. The participants themselves wear rich clothes, especially clear on the mosaic where the colours are visible: the hunters' short tunics are evidently of rich materials, red and yellow and blue, and adorned with the embroidered patches and stripes characteristic of late antique costume. The cushions and hangings above are also elaborately ornamented.[24] In addition, the attendants too are richly dressed, and it is made clear that each has his own task. One offers a beaker of wine, a napkin over his shoulder; another brings a dish of food or (on the mosaic) seems to attend to the preparation of the food. A third attends to the heating of a vessel on the fire; on the mosaic this is a little black boy, who blows on the flames. On the plate, there are also the servants cutting up the carcasses of the game. The Tellaro mosaic also has the figure of the boy blowing on the flames, although here the vessel is suspended from the branch of a tree, with the

flames issuing from a hole in its side.[25] From another branch hangs a carcass, which a servant is dissecting, watched by two eager dogs. A new figure is added here to balance the attendant serving drink to the banqueters; on the opposite side, a man pours water into a basin in which a guest washes his hand. The Cesena plate, otherwise more limited, includes the same figure, also washing a guest's hand.[26] As well as this, we see the food on the plates, the containers for the wine (normally a pair of flasks in a wicker carrier), and various other vessels.

THE SERVANTS

This emphasis on rich and elaborate apparatus is of course nothing new. The paintings of banquet scenes from the first century AD had rendered carefully the shapes of different silver vessels and the decorated hangings on the couches; how important the display of silver could be at this period was made clear in the paintings of the tomb of Vestorius Priscus at Pompeii (Figs. 43, 44).[27] Earlier still, indeed, the Etruscan tombs had often included a display of handsome vases in their banquet scenes; and some of the Hellenistic Totenmahl reliefs had also paid attention to the detailed rendering of vessels and furniture (e.g. Fig. 56).[28] But the late antique renderings introduce some new features and place the emphasis rather differently.

First, the crowd of attendants. Here art seems to have followed a long way behind literature, and indeed behind real life. The banquets of wealthy Romans had always required the presence of great numbers of slaves.[29] Seneca, for instance, refers as a matter of course to the crowd of slaves who must stand around in silence while their master dines; many other sources fully confirm his account.[30] Seneca goes on to condemn the many specialized and often degrading tasks that the slaves are called on to perform: those who must mop up the spit or vomit, the carver, the wine server, the one who must watch the behaviour of the guests to decide who deserves to be invited back a second time, and those who must study their masters' tastes to know what food will tempt their weary appetites.[31] Although he writes with a moralising intent, the picture that he gives must be based on real practice to be effective. We have epitaphs for some real life attendants that give us the titles of their offices: there is the boy in charge of ladling out the wine (a cyatho), the one in charge of the wine jar (a laguna), or the one who served the wine cup (poculi minister).[32] Many of the inscriptions are those of members of the imperial household, who as freedmen went on to

distinguished careers in the imperial service; they sometimes give a list of the offices they have held as a veritable *cursus honorum*. One freedman of Trajan's, for example, records that he started serving the drink (*a potione*), moved on to the wine jar (*a laguna*), and then became tricliniarch, in charge of the whole organization of the feast; after that he progressed to higher office in the civil service, before dying at the age of 28.[33] Although the opportunities were undoubtedly greater in the imperial household, the service in households of the wealthy will have differed only in scale. Petronius, inevitably, carries the whole business to grotesque extremes with the innumerable slaves around Trimalchio's table and all the extraordinary tasks that they carry out, but as usual he exaggerates rather than invents.[34]

In contrast, in representations of the banquet from the earlier Empire, the servants do not usually appear especially prominent, and their role is mainly functional. There is almost always a boy, or much more rarely a woman, to serve the wine; and they sometimes perform other tasks such as bringing garlands or pouring wine into a bowl.[35] More exceptional is the painting from the House of the Triclinium at Pompeii (V 2.4), where we see attendants taking off the shoes of one guest and supporting another who is vomiting drunkenly (Fig. 28).[36] But it is not until the third and fourth centuries that we regularly find the servants, almost always young and male, occupying a major part of the scene, and a differentiated iconography developed to portray them. Sometimes indeed they become the primary subject. The third-century paintings of the *schola praeconum* in Rome, discussed in Chapter 3, simply show rows of servants against an architectural background, ready to greet and serve the entering guests (Figs. 52, 53).[37] Such figures become more common in the following century and a half, in varying contexts and in different media, and their role as vehicles to express luxury and hospitality is exploited much more effectively.[38]

This role can be seen clearly with a series of figures from a building on the Caelian Hill in Rome, to be dated in the first half of the fourth century.[39] Three, about two-thirds lifesize, survive whole or in part; drawings of the rest were done in the eighteenth century. They show a procession of seven young male servants, framed in separate panels with garlands and candelabra between; one serves the wine, the others carry large plates laden with food. The wine server is especially well dressed, his long curls falling to his shoulders, his tunic covered with *clavi* and *orbiculi* embroidered in red and gold (Pl. IX). In one hand he holds up a cup; slung from the finger of his other hand is an object that can be recognized as a sieve for the wine. Beside him is what appears to be a wicker case containing two large wine flasks.[40] The other servants are not quite so elaborately dressed, although

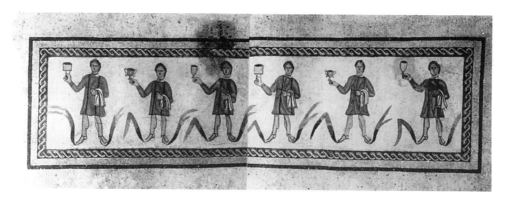

Figure 87 – Complutum, House of Bacchus, mosaic showing servants offering drink. Late fourth to early fifth century AD. *Photo courtesy of D. Fernández-Galiano.*

their long, sleeved tunics have ornamental patches on the shoulders; two of them have long flowing hair, the other three are short haired (Pl. X). They carry huge silver trays filled with a rich variety of foods, discussed further below. We do not know whether the banquet itself was represented on the missing walls of the room, or whether there may have been a portrayal of the master and mistress receiving the offerings. In either case, it is clear that the main weight of the image would have rested upon the servants with their offerings of food and drink.

We meet some of these servants again in other contexts and in widely scattered regions of the empire. A mosaic from a house at Complutum in Spain, of the late fourth or early fifth century, has a row of six servants holding out wine cups, a napkin over their other arm (Fig. 87).[41] They are less elegant than those at Rome; the designer appears to have had only one type of figure at his disposal, which he repeats with minimal variation. They do not form part of any more substantial banquet scene, rather they line the floor of the corridor leading to the dining room so it is clear that the wine they offer is intended to greet the guests as they arrive. A North African mosaicist from Thugga treated a similar theme with greater variety (Fig. 88).[42] Here two huge and powerful slaves carry on their shoulders amphoras from which they pour wine into bowls held by two younger and better groomed attendants. Two more, younger still and with the same flowing hair as the Caelian figures, stand at the sides; one has roses and a spray perhaps of myrtle, the other with a towel and jug is probably a water server. All these delights, then, are offered to the entering guest, and to reinforce the message the amphoras are inscribed with good wishes, *zêsês* ('long life') and *pie* ('drink') – fashionably in Greek, although this part of North Africa was Latin speaking.[43]

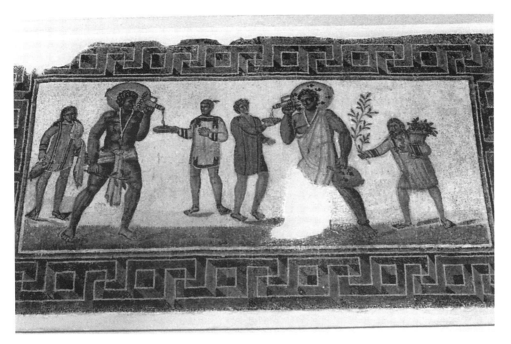

Figure 88 – Thugga, mosaic showing slaves serving wine and other attendants. Mid- to late third century AD. Tunis, Musée du Bardo A 382. Photo KMDD.

The rows of attendants bearing offerings appear at this period not only in domestic contexts but also in funerary, both as part of larger banqueting scenes and as autonomous motifs. On sarcophagi like that of Caecilius Vallianus, discussed in Chapter 4, the central figure on the couch is flanked on either side by rows of elegant long-haired youths with plates of food, drinking vessels, the apparatus for hand washing, and other equipment (Figs. 68, 69).[44] Similar rows of servants appear on other sarcophagi; there can be no doubt that they serve here to enhance the atmosphere of luxury and increase the honorific value of the scene (Fig. 89).[45] In a painted tomb from Sidon, known only from nineteenth-century drawings, figures of servants with trays of food were set in panels along the walls of the central chamber, while the end wall contained a standing figure, undoubtedly that of the owner of the tomb; two female figures, probably allegorical, appeared on either side of him (Fig. 90). Beside the servants were written their names, several of them clearly chosen for appropriate effect: Oinophilos, 'lover of wine'; Glykon, 'sweet one', perhaps bearing a cake; and Petenos, 'winged one', with a bird on his tray.[46]

Many of these servants are conspicuous for their elegant appearance, with long flowing hair and fine pleated tunics reaching to their knees. This

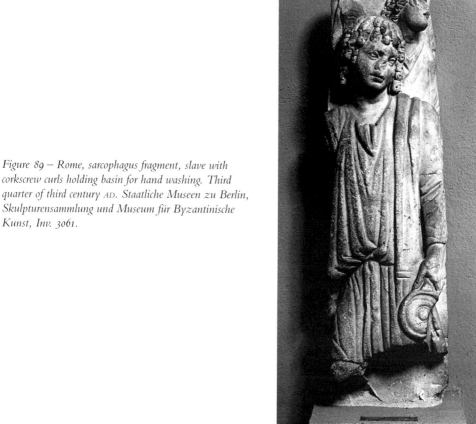

Figure 89 – Rome, sarcophagus fragment, slave with corkscrew curls holding basin for hand washing. Third quarter of third century AD. Staatliche Museen zu Berlin, Skulpturensammlung und Museum für Byzantinische Kunst, Inv. 3061.

reflects many literary descriptions of the attendants at the banquets of the rich, dating back to the early Empire. Traditionally it was the wine waiter, the *vini minister*, on whose appearance the greatest value was placed, and the moralists and satirists of the first and early second centuries give accounts which leave us in no doubt what was expected of such boys. Juvenal, for instance, describes such a boy as 'the flower of Asia, a boy bought for more than the entire fortune of the kings of Rome, but too expensive and too beautiful to pour wine for a poor man', while Seneca laments the misfortune of the slave who is adorned like a woman and must pluck out the beard he is beginning to grow.[47] Many sources relate that these boys were especially valued for their long, beautiful hair: indeed they are often referred to by

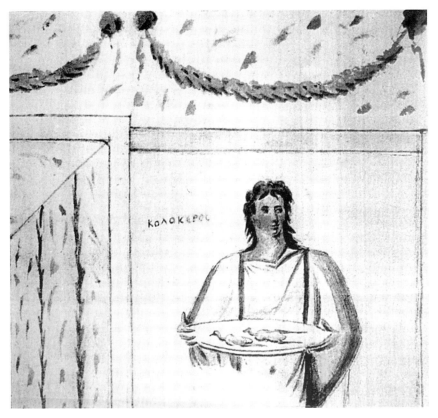

Figure 90 – Sidon, tomb painting of servant Kalokeros holding tray. Lost, after drawing by W. J. Bankes (1816). Photo A. Barbet, courtesy of the National Trust and the County Record Office of Dorchester.

terms such as *capillati* or *criniti*, which mean 'long-haired'. Seneca further describes the delicate complexions of such pages, carefully protected against the sun; while Philo of Alexandria, in an attack on the fashion for Italian-style banqueting, speaks at length of the beauty of the boys who pour the wine or carry water, their faces painted with cosmetics, their long hair skilfully trimmed or plaited, their tunics of the finest fabrics and elegantly arranged.[48] Seneca and others also make it clear that these youths might often be required to minister to the lusts of their masters, but it is worth noting that in Roman art the serving boys are almost never represented nude, as the wine servers regularly are in both Greek and Etruscan painting. Roman art had a very different sense of decorum.

An iconographic type that corresponds to these descriptions is used occasionally already in the first century AD. The late Flavian funerary altar of Q. Socconius Felix from Rome, discussed in Chapter 4, contains three

long-haired boys in flowing tunics attending the reclining couple: one holds a jug, another a towel and a missing attribute, the third and smallest a garland (Fig. 64).[49] In general, however, the servants appearing in banqueting scenes in the early Empire are short haired and comparatively simply dressed; the long-haired type seems to have been developed in the first place to represent attendants at sacrifices, and only subsequently taken over as an appropriate image for the luxury slaves of a fashionable banquet.[50] By the third and fourth centuries AD, the type of the beautiful long-haired boy has come to be used much more widely, not only in the context of the banquet, but also applied to luxury slaves in general.[51]

Attention is also paid to representing the varied roles of the attendants. Although the food bearers attract the greatest attention in many of the representations discussed in the preceding paragraphs, there may also be a figure to distribute flowers and garlands; another operating the heating apparatus, for the hot water to mix with the wine; and even a figure with a fan or fly-whisk.[52] One of the most frequent is the servant who carries the jug of water and basin to wash the guests' hands, who often appears balancing the wine server and may indeed be the only other servant to be represented. He appears in this role on the Tellaro mosaic and the Cesena plate (Fig. 85), as well as the painting from the Tomb of the Banquet at Constanza, to be discussed below (Pl. XIII). The provision of water had of course always been essential to comfort and good manners for those eating with their fingers, but in the late antique scenes it has evidently become one of the key elements of the luxurious banquet, and accordingly one of its most powerful and evocative images.[53] Another new type is the Black slave, again echoing earlier literary references to a fashion for exotic Aethiopian boys as attendants at the feast: they are represented most clearly on some of the mosaics with hunting picnics, such as Piazza Armerina or the Tellaro villa, but are also identifiable on some of the sarcophagi, such as a fragment in Berlin showing the water carrier (Fig. 89).[54] Women servants in long dresses also appear on some of the sarcophagi alongside the much more common page boys; they usually act as wine server while the males carry the dishes of food. Because the women attend male diners as well as female, their presence is also presumably to be ascribed to a desire for variation.[55]

FOOD AND TABLEWARE

The magnificent display of food that the servants carry or that lies on the tables in front of the diners again shows a new emphasis in these late antique scenes. On the plates carried by the Caelian servants, we see (if the drawings

can be trusted) a roast fowl, a suckling pig, and arrays of vegetables complete with sauce (Pl. X). Piglet and fowl appear again on the platters carried by the servants on the sarcophagus of Caecilius Vallianus, along with a cake, while a fish lies on the table before him; various fish and fowl, and again probably a cake, are carried in the paintings of the tomb at Sidon (Figs. 69, 90).[56] Some of the delicacies singled out for representation are rather surprising: for instance, a type of crescent-shaped roll appears in front of the guests on the Tellaro mosaic, surrounding a big platter with a fowl, in the Constanza paintings to be discussed shortly (Pl. XIII) and in other scenes, and was evidently highly prized.[57] The attention paid to food, as well as the importance attached to its variety, richness, and elaborate preparation, are clearly conveyed by all the ancient writers on the Roman banquet; it played an essential role in the displays of wealth, status, and culture for which the banquet was the occasion. As seen in Chapter 2, this importance is seldom reflected in representations of the banquet from the earlier Empire; the central focus for these rested on the wine. However, representations of food appeared from at least the first century BC in the form of small panels of painting or mosaic, known as *xenia* (Pl. V, Fig. 32).[58] The motifs assembled in these panels came then to be used on larger mosaic pavements, where they could be set individually into the grids formed by geometric patterns. Such pavements are found in Italy and especially in North Africa from the second century AD onwards. The items represented include live animals and birds, at liberty or trussed up for the kitchen, ranging from the familiar to the exotic (e.g. the flamingo), and by no means all edible; seafood, from fish and shellfish to lobster and squid; prepared dishes and baskets of fruit and vegetables, as varied as baskets of dates, bundles of asparagus, artichokes, mushrooms, cucumbers or zucchini; and baskets of snails (Pl. XI). Prosperity and trade had brought the wealthy access to an astonishing diversity of foodstuffs, deriving in origin not only from the Roman empire, but also from beyond its borders; the foods shown on the mosaics include not only objects that might suggest the produce of the hosts' own estates, but also others that must have been understood as brought from long distances, such as seafood, far inland.[59]

These mosaics are used to decorate reception rooms, frequently identified as triclinia by the layout of the pavement; displayed before the eyes of guests, they clearly convey a message of hospitality and the wealth of the goods available in the house. The reference to the banquet is sometimes reinforced by the inclusion among the motifs of nonedible objects such as drinking vessels and, on one pavement from Thysdrus, a little scene of three men at a gaming table (Fig. 91).[60] Another triclinium mosaic from a house at Thysdrus, with *xenia* motifs of this type and Dionysiac masks in the central

Figure 91 – Thysdrus, mosaic with xenia including scene of dice players. Third century AD. *Tunis, Musée du Bardo Inv. 3197. Photo KMDD.*

Figure 92 – Thysdrus, House of the Months, mosaic from triclinium with xenia *and* asarotos oikos *motif. Third century* AD. *Musée de Sousse. DAI Rome 64.311, photo Koppermann.*

area, has a separate strip running around the front of the area reserved for the couches, decorated with the debris of a meal in a design descended from the tradition of *asarotos oikos* mosaics discussed in Chapter 2; the intention is clearly to show these remains where they would most naturally be dropped at a meal (Fig. 92).[61]

The selection of items in these mosaics seems to be governed by a desire for the greatest possible profusion and variety; there does not appear to be any discernible order. Much more coherent is the display of food on the mosaic from a house at Antioch, probably of the early third century AD, named by its excavators after this mosaic the House of the Buffet Supper (Fig. 93).[62] The room itself was laid out for a *stibadium* couch, with a semicircular end. The strip of floor in front of the couch is decorated with a succession of rich silver vessels bearing food. First comes a dish with eggs, artichokes, and pigs' trotters, a little bowl for sauce at the centre, and a pair of egg spoons (Fig. 94); then a platter with a large fish; a ham; a roast fowl and perhaps some other meat or game; and finally what is probably a cake of some sort. Interspersed among the dishes are rolls of bread; garlands hang as if over the edge; and cups of wine and perhaps sauce dishes are placed at intervals. In the centre, a circle contains a scene of Ganymede giving a drink to the eagle of Zeus. This unusual emphasis on the sequence of fully prepared dishes ready to be eaten serves the same purpose as the *xenia* mosaics, to convey to the guests a message of the lavish elegance of the banquets held in the room, and of the wealth and hospitality of the host. But it may also have been designed to convey a more particular message. The order in which the food is displayed appears to represent the succession of dishes in a

Figure 93 – Antioch, House of the Buffet Supper, mosaic with display of food. Probably early third century AD. Antakya, Archaeological Museum Inv. 937. Photo Department of Art & Archaeology, Princeton University, neg. 4493.

well-organized meal, from the appetizers to the dessert. The mid-second-century satirist Lucian of Samosata, describing the ordeals undergone by the aspiring candidate to a post as tame philosopher in a great Roman household, relates his embarrassment when he first attends a formal dinner party: 'You do not know which of the dishes set before you in great variety and spread out in a definite order, you should put out your hand to take first or which second; so you will be obliged to watch your neighbour stealthily to copy him and learn the proper sequence of the dinner.'[63] Lucian makes it clear that it was an indispensable part of correct etiquette to know the right order in which to consume the components of an elaborate meal. We may suspect that the owner of the house at Antioch is concerned to impress upon his guests not only the lavishness of his hospitality, but also his familiarity with correct sequence and presentation. The meal you are about to enjoy, the message may run, will not be one of those disorderly and overindulgent

Figure 94 – Antioch, House of the Buffet Supper, detail with plate of appetizers. Photo Department of Art & Archaeology, Princeton University, neg. 4563.

dinners where a plethora of dishes is served without regard for good form. Rather, although all good things will be provided, each will be presented in the right place, to be enjoyed for its own sake.

As conspicuous as the food itself are the great plates and platters, evidently of silver, on which it is laid out, or those carried by the servants in the paintings from the Caelian or from Sidon and on the sarcophagi. Here a real change in customs and values is reflected, which can be seen in the study of the actual vessels themselves. Collections of Roman silverware from the first centuries BC and AD, such as those from Boscoreale or the House of the Menander at Pompeii, contain a high proportion of drinking cups, often richly and elaborately decorated (Pl. VI, Fig. 34). In late antique collections of silverware, however, either the cups have disappeared or they are confined to a few simple examples. Instead, the high point of the collections consists of bowls and plates, above all of huge platters and trays, decorated in relief or with inlay.[64] The Sevso treasure itself contains, in addition to the Hunting Plate (Fig. 84), two plates of comparable size decorated with mythological subjects, the Meleager and Achilles plates, and another with simpler but still elegant geometric decoration.[65] The even more magnificent treasure from

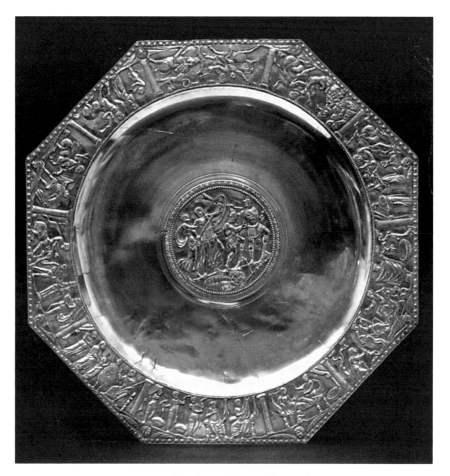

Figure 95 – Kaiseraugst Treasure, silver plate with scenes of story of Achilles. First half of fourth century AD; D. 53 cm. Römermuseum Augst; photo Gisela Fittschen; Neg. C348.

Kaiseraugst in Switzerland, buried probably in the middle of the fourth century, contains two big plates with figure decoration (one with Achilles again (Fig. 95), the other with a seascape and hunting scenes in niello inlay and gilding), at least seven simpler ones, and an elaborate rectangular tray, also decorated with niello and gilding, showing Dionysus and Ariadne.[66] It is quite clear that, whereas the wealthy of the first century had prided themselves on the precious drinking cups in which wine was served at the *convivium*, by the third and fourth centuries the plates have come to take pride of place. It is difficult to tell whether the most highly decorated objects were actually used to serve food or were designed purely for display, to be exhibited on a special stand in the dining room for the guests' admiration only, but the paintings and sarcophagi show us objects in use that are at least comparable in size if not necessarily in decoration.[67]

Figure 96 – Glass cage cup (diatreton) from grave at Köln-Braunsfeld. Probably first quarter of fourth century AD. Cologne, Römisch-Germanisches Museum Inv. 60.1. Römisch-Germanisches Museum der Stadt Köln / Rheinisches Bildarchiv.

Of course, this does not mean that the service of the wine had ceased to be an occasion for display. If silver wine cups had gone out of use, or at least declined in popularity, this was the result of a change in fashion and taste: their place had been taken by cups of glass. But glass was by no means necessarily a cheaper equivalent. The fourth century in particular is the great period of luxury glassware, and drinking glasses and bowls were often engraved or cut with rich decoration.[68] Most elaborate of all from this period are the cage cups (often known as *diatreta*), with their extraordinary outer shell of lattice tracery, each one of which will have required many months to make (Fig. 96). Although it is hard to imagine that objects so fragile can ever have been in regular use, the drinking mottoes set into their rims, 'drink and enjoy yourself' and the like, show they were indeed intended for

wine.[69] The servants in the paintings and on the sarcophagi hold jugs and cups of various shapes, some of which do indeed look more suitable for glass, although none are shown in such a way that they can be recognized as a luxury variety.[70]

CONVIVIALITY AT EPHESOS, SEPPHORIS, AND CONSTANZA

Most of the works from the late antique period discussed in the preceding sections have used the imagery of the banquet in the service of an ever-greater emphasis upon magnificent self-presentation. The display of luxury and extravagance had been fundamental to the ideology of the Roman private banquet ever since the late Republic, but it was the new iconography that developed in the third and fourth century that fully succeeded in giving visual expression to that ideology. At the same time, it conveys a new sense of ceremonial and formality, which undoubtedly reflects the role that the formal banquet played in wealthy society in the later empire. Even a scene such as the hunters' picnic can change from the small group of tunic-clad hunters relaxing casually under the trees, served wine by one or two servants, to the stately and splendidly dressed figures who are the focus of the whole composition on the Sevso and Cesena plates or the Piazza Armerina and Tellaro mosaics.[71]

Earlier representations of the *sigma* banquet have a very different atmosphere, whose emphasis is upon conviviality and festivity. This is true not only of the Nilotic picnics and similar scenes from Rome and Pompeii of the first centuries BC to AD, with their strongly hedonistic character, but also of later representations from a funerary setting such as the hypogaeum at Lilybaeum discussed in Chapter 4 (Pl. VII). This sense of relaxed conviviality is equally fundamental to the ideology of the Roman banquet, and it continues, not surprisingly, to characterize many images from the third and fourth centuries.[72] Several of the scenes on sarcophagus lids include figures who brandish cups or raise their arms in the conventional gestures of uninhibited relaxation.[73] There are also examples of mosaics from domestic contexts with banquet scenes of the hedonistic variety. One comes from a house at Ephesos and decorates an area likely to have been used for dining at the *stibadium* (Fig. 97).[74] It shows four figures, apparently two male and two female, reclining on a cushion on the *sigma* couch (probably of wood); they pass cups to one another and drink, or raise their hands to the wreaths on their heads. The pleasures of wine and convivial enjoyment

Figure 97 – Ephesos, mosaic of banquet at sigma. *Probably early fourth century* AD. *After* ÖJh *51 (1976–7), p. 78, fig. 22, courtesy of W. Jobst.*

are evoked here, in a manner directly comparable to some of the paintings from Pompeii; only the mise-en-scène and the details have been brought into line with contemporary custom. A big crater in the foreground reinforces the dominant theme of wine, but is joined by an additional and equally prominent vessel, recognizable as an *authepsa*, the container in which the hot water (*calda*) was heated to mix with the wine. The only servant shown is a boy, most unusually nude, who holds the hand-washing apparatus.

A recently discovered mosaic from Sepphoris in Israel shows even more clearly how the banqueting theme might be used at this period for its expressive value (Pl. XII).[75] It decorates a room laid out as an old-fashioned triclinium with a T + U pavement, whose central panel shows Orpheus and the beasts. The panel at the entrance, set to greet the guests as they arrived, shows four banqueters, all wreathed, reclining on a substantial wooden *sigma* couch. Two servants approach them, one with a cup of wine. The only other item in the scene is again a hot-water heater, prominently displayed on a stand with an attendant busy behind it. One of the panels at the side shows a pair of men playing dice, a scene that again conveys a message of relaxation and enjoyment.[76] At first sight it may seem surprising to find the scene of the *sigma* banquet used to decorate a traditional rectangular triclinium. It is conceivable that the original form of the room may have been older than the mosaic (stratigraphic details are not yet available), and that the owner, stuck with an intractable architectural form that was no longer the latest mode, wanted at least a new mosaic to express his awareness of more fashionable behaviour. But the *sigma* banquet may have been chosen for other reasons than simply fashion. The *sigma* couch seems to have been originally intended for a more intimate and less formal manner of dining than the traditional triclinium, and for a long time it apparently retained its association with the open air. It seemed therefore better suited to convey the message of conviviality, whose essence is a group of friends and associates assembled in relaxed comfort. That the entertainment in the room may in fact have been more formal, and perhaps more status oriented, does not contradict such a message, but reflects a basic ambivalence in the ideology of the banquet, to which I return below.

Hot-water heaters occupy a conspicuous position on both the Ephesos and Sepphoris mosaics. The vessels shown are of two different forms, both of which can be paralleled by actual examples dating back to the first century BC. Other examples range from the first century AD to the fourth; they are elaborate and complex vessels, with internal compartments to hold the fuel and various mechanisms for drawing off the liquid and releasing steam (Fig. 98). Literary sources make it clear that these were exotic and valuable luxury items. They do not appear in the banquet scenes of the early Empire; there is a substantial time lag between their attestation, both in the archaeological record and in literature, and their appearance in the artistic repertory. By the third and fourth centuries, however, it is clear that the hot-water heater had come to be treated as an indispensable item in the representation of a luxurious meal. Earlier in this chapter, the scene of

Figure 98 – Hot-water heater (authepsa) *from Kaiseraugst. Third century* AD. *Römermuseum Augst Inv. 1974.10376*

the water heating has been noted several times as an element in the hunters' picnic: at Piazza Armerina, the Tellaro villa, on the Sevso plate, or on several of the sarcophagi. The scenes of the indoor banquet show more elaborate apparatus comparable to several of the surviving vessels. Their prominent representation on both the Ephesos and the Sepphoris mosaics, in the latter to the exclusion of any other item of apparatus, makes it clear that they had acquired a great communicative force: if one feature was needed to express the message of happy and luxurious conviviality, beyond what could be

conveyed by the diners themselves, the hot-water heater had become the ideal symbol.[77]

One of the clearest illustrations of the characteristic late antique iconography of the *sigma* banquet appears on a recently discovered tomb at Constanza, the ancient Tomis, in Romania, constructed around the middle of the fourth century AD. It has decorative paintings along three of the walls, which include scenes of birds drinking from a basin, a hare eating grapes from a basket, and peacocks confronted across a basket of flowers. In the lunette on the end wall is the scene from which the tomb gets the name of the Tomb of the Banquet (Pl. XIII).[78] It shows, in remarkable detail, the *stibadium* couch with an embroidered cushion on it and a round table set into its curve. The trees suggest an outdoor scene, somewhat incongruously with the structure of the *stibadium*, which looks like indoor furniture; as will be seen below, such confusion between indoor and outdoor is not unusual at this date. Five men, all identically dressed in white tunics, recline upon it; two of them hold goblets, probably of glass. On the table in front of them are a series of crescent-shaped rolls (one for each guest and one extra at the front), and a dish perhaps with a cake. Servants approach from either side; at the left is the wine server in his long tunic, with a small jug and a mysterious object that perhaps is meant for a sieve. On the right, with short hair and a shorter tunic, is the water carrier ready to wash the guests' hands; he holds a jug, a handled basin, and a towel over his shoulder.[79]

As so often in funerary contexts, there are few clues to identify more precisely the occasion of the banquet. The mood appears restrained and dignified, without the uninhibited gestures seen, for instance, on the Ephesos mosaic; rather, it seems to be the integration of the group that is stressed. It is possible that the single crescent roll isolated at the front of the table is intended to be understood as destined for the dead, in which case the scene might be read as a commemorative funerary banquet. As seen in Chapter 4, the banquet in funerary contexts also serves as the ideal of human life, conveying on the one hand concepts of status and self-presentation, and on the other hand, of conviviality and good fellowship. Certainly there is nothing about the scene that would lead one to seek any specifically Christian interpretation, although at the date in question a Christian owner of the tomb would be not unlikely. The question has, however, now to be examined in the light of a second tomb found at Constanza, of similar date, the Tomb of the Orants.[80] Its paintings are closely related to those of the Tomb of the Banquet, but are badly damaged and can only be deciphered with difficulty and with numerous lacunae. Here banqueting scenes occupied the upper portions of the two long walls of the funerary chamber; the greater space

available allowed the introduction of more elements that enhance the luxury and status of the scenes presented. On both sides one panel contained a *stibadium* scene, with four or five diners reclining on a couch almost identical to that in the first tomb. On the left wall, a second panel contained the figure of a servant in a long tunic carrying a jug and towel, evidently the water carrier, and behind him a table with a display of vessels and perhaps food; there may be traces of another servant, and a destroyed third panel on the left may have held others. On the right wall, a similar panel contains the remains of three servants, one holding a jug, in front of an enigmatic structure that might possibly be interpreted as a dresser. Trees suggest an open air setting, as in the Tomb of the Banquet.

The difference between the two tombs comes on the end wall of the Tomb of the Orants. Here two figures stand among trees with hands raised in the typical gesture of prayer found in the Christian catacombs at Rome (and elsewhere), the so-called orant pose.[81] At least one wears a nimbus. No explicitly Christian symbols survive, and we cannot be certain of the religious affiliation of the owners of the tomb; both the orant pose and the nimbus could also be used by pagans. What we can safely conclude, I think, is the overwhelming emphasis on secular matters, on the banquet as an aspect of pleasure and display that is rooted very firmly in this world; the praying figures, although they introduce allusions to the next world, cannot eradicate this primary emphasis.

ROOMS FOR STIBADIUM DINING

Triclinia designed and laid out for the traditional style of dining, with couches set in a Pi-shape around three sides of a rectangular room, continued to be constructed or decorated in the third and early fourth centuries, as the mosaic from Sepphoris shows, but they become very rare in the fourth century. Increasingly common, however, are rooms designed to accommodate the *sigma* banquet indoors as well as outdoors.[82] Occasionally, a room contains masonry base for the *stibadium*, directly comparable to the fixtures for outdoor dining. One of the best examples is a recently published villa from El Ruedo (Almedinilla) in Baetica, where a room originally laid out as a rectilinear triclinium had a masonry *stibadium* inserted into it in a later phase, probably at the end of the third or beginning of the fourth century (Fig. 99). The effect was enhanced by the play of water: a *nymphaeum* in the back wall of the room behind the couch, with water running to a basin in the centre of the couch and from there to a basin in the peristyle beyond.[83]

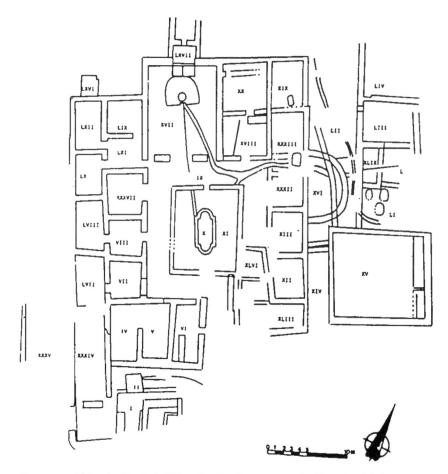

Figure 99 – El Ruedo (Baetica), Villa, plan showing masonry stibadium *in triclinium room XVII, inserted probably at end of third or beginning of fourth century AD. After Vaquerizo Gil, Carrillo Diaz-Pines 1995, fig. 9, courtesy of D. Vaquerizo Gil.*

A similar combination of masonry *stibadium* and fountain is found in Rome itself, in a building at the end of the forum near the Arch of Titus, converted into a private house probably in the second half of the fourth century; here the *stibadium* base is set into a raised apse opening off one side of a cruciform room.[84] In other examples, the area reserved for the couch is indicated on the pavement of the room. This is especially clear in the so-called Villa of the Falconer at Argos, where a nearly square room has a semicircular area marked out on the mosaic, divided into seven segments, presumably indicating the sections of which the *stibadium* couch was composed; a *sigma*-shaped table is set in the curve, bearing a plate with two fish (Fig. 100).[85]

Although rectangular rooms could be used in this way, as the examples from El Ruedo and Argos demonstrate, much more suitable was an apse or

Figure 100 – Argos, Villa of Falconer, mosaic with area marked out for stibadium. *Probably early sixth century* AD. *Drawing O. Söndergard, courtesy of G. Åkerström-Hougen.*

alcove into which the couch could be set, leaving the main part of the room open. Apsidal rooms recur constantly in wealthy domestic architecture in both townhouse and villa in late antiquity, in almost all parts of the empire. Frequently these are the most impressive rooms of the house, opening off the peristyle on its main axis and receiving the most elaborate decoration. They are clearly to be identified as the principal reception room, corresponding to the setting of the traditional triclinium in the domestic architecture of much of the Mediterranean during the High Empire. By analogy with the examples where the presence of the *stibadium* is attested directly or indirectly, we are surely correct in identifying most of such rooms as designed primarily for *stibadium* dining, although it should not be forgotten that the shape could serve various purposes, and the rooms may often have been

multifunctional.[86] The apses vary substantially in size. Some would offer room for a couch capable of holding seven or eight guests in comfort, with space for service behind, whereas in others the couch would have had to be placed right against the wall and could have held perhaps no more than five.[87] Larger numbers could be served by the triple-apsed triconchs, of which nearly two dozen are known from domestic architecture, both urban and rural; they date from the fourth to the sixth century, and the majority come from the western provinces of the empire. These allowed a couch to be placed in each apse, if required, while the central space was again left open. They too vary considerably in size. The grandest, such as those at Piazza Armerina or the great villas at Patti Marina in Sicily, Desenzano in northern Italy (Fig. 101), or Loupian in Gallia Narbonensis, are truly monumental structures with apses each capable of holding a couch for seven or eight, elaborate figured mosaics, and anterooms or columned courts in front of them. Others are much smaller and could have held only small couches crammed into the apses; their owners seem to be imitating the fashion set by the truly rich, without the resources to achieve the effects for which they were designed.[88]

These architectural settings for dining suggest two conclusions that are relevant for the images examined in this chapter, as well as for social be- haviour more generally. First, some of them illustrate the continuing ten- dency for outdoor and indoor customs to merge. This is most apparent with the *sigma* fountains at El Ruedo and Rome, where a fashion devised for outdoor dining is simply imported into an interior room, but many other examples show water used in less sensational ways, with fountains in the front of the room or outside the doors in the peristyle. Many rooms open their full width through a triple doorway onto the peristyle, offering views of the gardens and pools beyond. Literary sources of the period make it clear that these effects were often consciously sought; in the fifth century, for instance, Sidonius Apollinaris describes in one poem a cascade running through the dining room of a friend's rich villa, and in a letter praises the view from one of the dining rooms of his own country estate at Avitacum. This is nothing new; a taste can be traced right back to the great villas of the Republic for integrating the pleasures of a civilized lifestyle, of which the *convivium* was the highest, into a natural setting – but a Nature controlled and managed by artifice.[89] In light of this, it is easier to understand the conflation of elements suggesting outdoor and indoor settings that has been seen in the Tomb of the Banquet at Constanza or on the Cesena plate. Indeed, the picnic scenes themselves on the plates and on the mosaics at Piazza Armerina and Tellaro may also be seen as part of the same process,

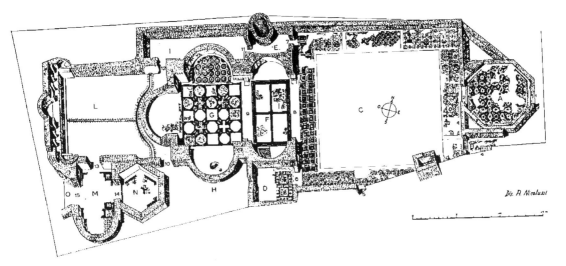

Figure 101 – Desenzano, plan of villa with triconch. Probably mid-fourth century AD. *After* G. Ghislanzoni, La villa romana di Desenzano *(1962).*

introducing the scene of outdoor dining, and the associated hunting themes, into the context of a formal and magnificent setting for an indoor meal. They carry further, and give additional point to, the fashion for using subjects that evoke the natural world and its products as decoration for dining rooms.[90]

However, in many of the larger *stibadium* rooms, the most conspicuous architectural features reinforce the atmosphere of ceremonial formality. The grand columned entrances, the open expanse of the room within, dominated by an apse often raised on a dais, inevitably created an effect of theatricality; lighting may have enhanced this further. Again, this is nothing new; the notion of dining as a spectacle has been noted in previous chapters at much earlier periods. At one moment, as several scholars have seen, the view to the outside for the diners from inside appears to have precedence in the design and layout of the triclinium, at others and in differing contexts, the view into the triclinium from outside has precedence.[91] Although the evidence considered in the previous paragraph shows that the concept of the view to the outside was still alive in late antiquity, there can be little doubt that the main emphasis was now on the internal spectacle. This too, however, worked in two directions. For the assembled diners, the spectacle was composed of the crowds of well-dressed attendants, the display of food and drink, the vessels in which it was served – all of which, as this chapter shows, could be reflected in the actual decoration of the room and the apparatus for the meal – as well as by the entertainment offered: all these would occupy the forepart of the room, the open space in front of the couch or between

the three apses of a triconch. At the same time, the diners packed closely on their semicircular couch were themselves set as though on a stage, and themselves constituted a spectacle as the focus of the whole. A banquet held in such conditions is a highly codified ceremony, leaving little room for relaxation or diversion.[92]

The contradiction, it may be suggested, is inherent within the Roman concept of the banquet and its ideology from a much earlier date. Status and display were fundamental ingredients of Roman elite dining from the late Republic onwards. Much of the iconography whose development has been followed in this chapter was designed to emphasize more clearly the spectacular aspects of the banquet; by the fourth century, art was serving these aims with extraordinary success. Nevertheless, the ideal of the *convivium* was something different: the small group, relaxed and enjoying the atmosphere of convivial fellowship. Even in the grandest and most status-oriented banquet, this ideal prevailed, at least to the extent of being paid lip service. The artist's task was to balance these conflicting aims, to re-create the convivial atmosphere within the context of magnificent display.

The Last Banqueters

DINING IN THE CATACOMBS

One group of late antique banquet scenes is much more homogeneous in
origins and context than the monuments considered in the last chapter:
the paintings from the catacombs in Rome. Representations of the banquet
occur more than 20 times among the paintings of the Christian catacombs
from the third to the early fourth century.[1] A few of these contain variants
of the standard funerary motif of one or two figures reclining on a free-
standing couch, attended by servants.[2] The rest show the convivial banquet
with several figures at the *stibadium* cushion or on a more substantial *sigma*
couch. The largest group comes from one single catacomb, SS. Peter and
Marcellinus; they include some scenes with very individual features and will
be considered later in this chapter. A more standard scheme occurs four times
with only minor variations in *cubicula* A2, A3, A5, and A6 in the catacomb
of Callixtus, and in similar form in the so-called *cappella greca* at Priscilla
(Figs. 102, 103); other versions are known from the Coemeterium Maius.[3] In
these scenes, seven figures are shown reclining against the *stibadium* cushion;
at Callixtus all are male, whereas in the Priscilla painting a woman appears
in the middle of the group. In front of the cushion are set a couple of
plates bearing fish and/or bread. The figures appear to be dressed alike, in
whitish tunics; they stretch out their hands towards the food. None holds
a drinking vessel, although at Priscilla a cup stands on the ground in front
of the cushion. In almost all these scenes, there is a conspicuous row of
tall baskets full of loaves of bread; between five and ten stand either in the
foreground in front of the cushion or spread out at either side, depending
on the nature of the space available.

Figure 102 – Rome, catacomb of Callixtus, cubiculum *A3, banquet scene at* sigma. *Probably second quarter of third century* AD. *Photo Pontificia Commissione di Archeologia Sacra.*

In several respects, these scenes are directly comparable to many of those from secular contexts or pagan tombs discussed in the previous chapters. Earlier commentators, unaware of the pagan precedents and considering them in isolation, often regarded both the *stibadium* cushion and the presence of fish as specifically Christian features; both, however, may be extensively paralleled on non-Christian monuments. Other aspects need more comment. First, the absence from these scenes of the servants bearing food and drink who figure prominently in many of the banquets discussed in Chapter 5 (including most of the *sigma* meals on sarcophagus lids that have Christian associations); there is no sign here of the conspicuous display that characterizes so many late antique banqueting scenes.[4] More striking is the apparent absence of drinking vessels in the diners' hands, although the cup in the Priscilla scene shows that this element of conviviality is not entirely missing. Undoubtedly, however, there is a greater sense of decorum and sobriety here than in many comparable scenes. The baskets full of loaves are also an exceptional feature, whose prominence suggests that they were intended to bear particular significance. Similar baskets appear on sarcophagi, where they serve various functions. Two are filled with flowers on the ends of the sarcophagus of Caecilius Vallianus, whereas several sarcophagus lids show a basket standing at the side full of bread, from which the servants are taking the loaves. On a fragmentary lid which also has a scene of the baptism of Christ, seven basket of loaves are arrayed before the diners in the same way as in some of the Callixtus paintings.[5] Similar baskets are also used in catacomb paintings and on Christian sarcophagi showing the miracles of Christ, for scenes of the Multiplication of the Loaves and Fishes, with Christ touching them with his miraculous rod.[6]

Controversy has raged even more fiercely over the significance and interpretation to be ascribed to the banquet paintings in the catacombs than it

Figure 103 – Rome, catacomb of Priscilla, cappella greca, *banquet scene at* sigma. *Probably late third to early fourth century* AD. *Photo Pontificia Commissione di Archeologia Sacra.*

has over those from pagan graves. Earlier commentators tended to see them either as allusions to the Eucharist or as illustrations of biblical scenes, such as the Multiplication of the Loaves and Fishes; for others, they represented the celestial banquet in the next world or the Christian communal feast, the *agape*.[7] Most recent commentators have rejected both the eucharistic interpretations and the identification as biblical scenes, in the absence of any figure clearly distinguished as Christ and of other specific identifying features. Rather, many have seen them as representations of the funerary banquet celebrated near the grave in honour of the deceased, in direct continuation of similar customs among the pagans. In particular, the rows of baskets full of loaves have been seen, by Jastrzebowska and others, as allusions to the charitable distributions that accompanied such funerary banquets, comparable to the euergetistic tradition of the pagans.[8] Although the interpretation as the funerary banquet has won most support in recent discussions, others have argued more cautiously for a variable range of significance, covering both the commemorative banquet in this world and the hope for the happiness of the dead in the next. Given the polysemy that is normal in early Christian painting, these meanings might in fact be present simultaneously.[9]

THE CATACOMB OF PETER AND MARCELLINUS

Much more varied are the numerous paintings in the catacomb of SS. Peter and Marcellinus. At least seventeen scenes here show subjects taken from the banqueting repertory, although many are fragmentary or known only

from earlier reproductions.[10] They range from a single figure reclining or
seated beside a table bearing food, or a couple reclining on a huge cushion
served by two attendants, to convivial scenes of six or seven reclining around
the *stibadium* cushion. In all but the simplest or most fragmentary scenes,
servants are present holding drinking vessels or plates and at least some of
the diners usually hold drinking cups.[11] Eight well-preserved scenes of the
convivial banquet, from two different regions (A and I) of the catacomb,
appear to form a special group, linked by the inscriptions that appear on
them, which are discussed below.[12] All come from the lunettes of *arcosolia*,
either in separate burial chambers (*cubicula*) or in galleries. Their chronology
has been much disputed, but recent studies of the catacomb have suggested
that they should all be dated between the late third and early fourth century;
they belong therefore either to the period of the Tetrarchy or to the years
immediately following the victory of Constantine and his Edict of Toleration
of the Christians.[13] They vary in the number of guests shown reclining at
the *sigma*, from two to five; most are male but a woman appears among
them at least once, and another includes two young children between three
men. In two scenes, a woman is seated in a separate chair at the end of the
sigma. Other women appear standing, usually holding out a drinking cup,
sometimes also a jug. At least three times a boy is also shown as a servant
with drinking vessel or plate of food. On all but one a fish lies on the
small tripod table in front of the cushion, which twice is covered with a
cloth.[14]

Two of these scenes will be examined here in greater detail. One (no. 75)
comes from an *arcosolium* in a gallery and fills the whole lunette (Fig. 104).
Four men recline on the couch, here a built-up *stibadium*; one drinks, the
others make lively gestures. The usual table stands in the curve of the couch,
bearing among other objects a plate with a chicken, rather than the usual
fish. To one side of the table stands the jug-and-basin set for washing hands,
on the other a pair of flasks in a wicker container. From the left approaches
a girl, wearing a short dress and holding a cup and a jug, in the pose typical
of the wine server. Behind her is a complicated container on a tripod stand
with a hole in its side from which flames issue; it gives an excellent picture
of a hot-water heater or *authepsa*, containing the hot water or *calda* to be
mixed with the wine. Written above, as if addressed to the girl by the man at
the end of the couch, are the words *Sabina misce*, 'Sabina, mix the wine'.[15]

A neighbouring chamber (no. 76) contains paintings in the *arcosolium* in
its end wall. In the lunette, a pair of peacocks flank a square central panel,
damaged by the later insertion of a *loculus* in its lower half (Fig. 105). A man
and a young boy recline together at the *stibadium*; to the right a woman

Figure 104 – Rome, catacomb of Peter and Marcellinus, arcosolium *75, banquet scene with hot-water heater, inscription* Sabina misce *('Sabina, mix the wine'). Probably end of third to early fourth century* AD. *Photo Pontificia Commissione di Archeologia Sacra, Lau L45.*

is seated in a separate high-backed chair. A large fish lies on the tripod table, which has elegant curved legs ending in animal heads. Both man and woman appear to have their hands stretched out towards another woman who stands in front of the *stibadium* at the left, holding out a cup, with a towel or napkin over her arm. Above her is written *misce mi Irene*, 'Irene, mix the wine for me'. The theme is picked up in one of the panels of the vault over the *arcosolium*: a female servant, similar to the standing figure in the main panel and wearing a short dress, stands with a jug in her hand beside yet another type of *authepsa*, this one egg-shaped with a pointed lid, on a triangular stand (Fig. 106). The corresponding panel on the opposite side of the vault contains a male orant figure, while in the medallion overhead stands a shepherd bearing a sheep on his shoulders.[16]

Inscriptions similar to the two just discussed accompany all the scenes of this group, and give them their exceptional character. Except for the one addressed to Sabina (no. 75), all are addressed to the same pair of female names: Agape and Irene, together or separately. These are followed by instructions to mix the wine or to bring the hot water: *Agape, misce nobis, Irene, porge calda(m)*, and so forth.[17] The form recalls that of everyday drinking expressions; in secular contexts elsewhere, we find similar phrases addressed to wine servers or tavern keepers, sometimes painted on actual

Figure 105 – Rome, catacomb of Peter and Marcellinus, cubiculum *76,* arcosolium *with banquet scene, inscription* misce mi Irene *('Irene, mix the wine for me'). Probably end of third to early fourth century* AD. *Photo Pontificia Commissione di Archeologia Sacra, Lau H34.*

drinking cups, such as 'mix', 'innkeeper, fill me with wine', or 'easy on the water'.[18] Although Sabina appears to be an ordinary female name, used to address the serving girl standing below, Agape and Irene, which mean love and peace, can be taken also in a symbolic sense. The phrases have normally been taken as addressed to the women represented in the scenes, but there has been much dispute whether they are meant to be seen as real women (both names were indeed used by Christians) or whether the reference is to allegorical virtues.[19]

Two interrelated problems are involved here. First, the role(s) of the women who are represented in the scenes. The women who bring wine in nos. 75 and 76.2 are clearly servants, quite simply dressed and playing a similar role to the boy servant in no. 39. However, in some of the other scenes women appear standing and holding out a cup of wine; these women are more impressively dressed and have been thought to play a much more significant role than simply that of a serving maid. For instance, in the two scenes nos. 78.2 and 78.3, which decorate the same *cubiculum*, a woman stands at the right end of the *sigma* cushion, holding in one scene a jug and cup, in the other a bowl and (apparently) a napkin; both wear sumptuous

Figure 106 – Rome, catacomb of Peter and Marcellinus, cubiculum 76, panel with hot-water heater in vault of arcosolium. Photo Pontificia Commissione di Archeologia Sacra, Lau L37.

dresses with full sleeves decorated with stripes. Above the first is written *Irene*, above the other *Agape misce* (Figs. 107, 108).[20] Although some commentators have also seen these women as servants, others have associated them with the women seated at one end of the *sigma* in nos. 39 and 76.2, who wear a similar (but not identical) costume, and have assumed that both groups of women play a similar role, as participants in some sense in the meal. The further assumption has usually followed, that both seated and standing women are to be connected with the Irene and Agape of the inscriptions.[21] P. Dückers for instance, in his detailed study of the paintings, claims that the similarities in the representation of these women are so strong that their identification cannot depend upon whether they are shown seated or standing, and concludes that they are all best to be interpreted as serving an intermediate role between those sharing in the meal and the simple serving personnel.[22] Yet distinctions such as these are crucial in the language of Roman art. A standing woman bearing a jug and cup can hardly have been seen by an audience familiar with similar representations in secular art as anything other than an attendant bringing the wine for the assorted

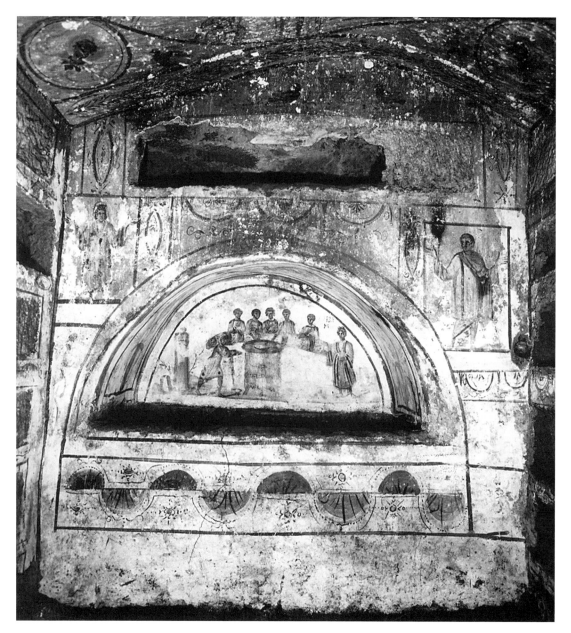

Figure 107 – Rome, catacomb of Peter and Marcellinus, cubiculum 78 ('of the two agapai'), end wall with Orants, arcosolium with banquet scene, inscription addressing Irene. Probably end of third to early fourth century AD. *Photo Pontificia Commissione di Archeologia Sacra.*

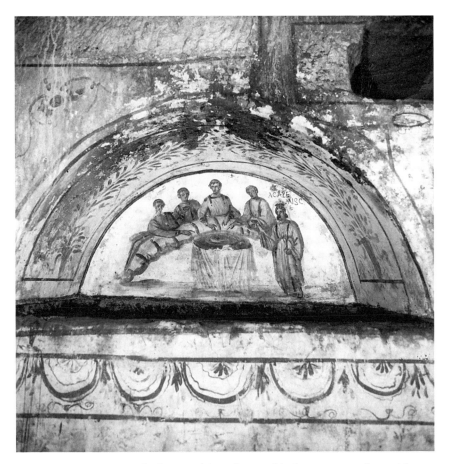

Figure 108 – Rome, catacomb of Peter and Marcellinus, cubiculum *78,* arcosolium *with banquet scene, inscription* Agape misce *('Agape, mix the wine'). Probably end of third to early fourth century* AD. *Photo Pontificia Commissione di Archeologia Sacra.*

company; whereas the woman in no. 76.2, seated in a stately chair and holding out her hands, either towards the fish on the table, or, more probably, towards the maidservant with the cup, appears as an honoured participant in the meal together with the man and boy at the *sigma*. Her seated position is a continuation of the old tradition, going back to the traditional Totenmahl scenes, of representing the woman seated in a separate chair: a mark of status appropriate to women.

A comparison with banqueting scenes from non-Christian funerary contexts confirms the contrasting roles of standing and seated women. Female servants appear in attendance on a deceased couple, who recline on a traditional couch, in the paintings from the tombs near the columbarium of the Statilii and on the Via Portuense in Rome; in the former, the maid holds

out a drinking cup towards her mistress (Fig. 58).[23] The sarcophagi showing the deceased reclining on a couch, which are only a few decades earlier than the probable date of the Peter and Marcellinus frescoes, frequently include a standing woman, often elegantly dressed, who brings the wine cup or jug. One appears, for instance, on the sarcophagus of Caecilius Vallianus (Fig. 68), another on two comparable sarcophagi known only from drawings. These women are clearly to be taken as servants and appear in the midst of the rows of other attendants; they may be seen as high-status attendants, comparable to the elegant male wine-waiters.[24] The seated woman in a high-backed chair appears on the sarcophagi in the form of the *pandurium* player, sometimes shown with portrait features that make it clear that her role in the scene is prestigious, even when she does not actively partake of the banquet. On an ivory pyxis in Baltimore, discussed below, the goddess Hera sits in a separate chair while the other gods and goddesses recline on the *stibadium* (Fig. 116).[25]

The second question concerns the relationship between the names in the inscriptions and the women represented. In some scenes (nos. 76.2, 78.2, 78.3) the inscription addressing Irene or Agape is written immediately above the figure of a woman who serves the wine and can plausibly be taken as addressed to her by the diners, as can the anomalous address to Sabina in no. 75. However, in other scenes there is no correlation between the number of names and the figures represented; thus both names appear in no. 50.2, although here a male servant appears alongside a woman holding a wine cup.[26] It is not therefore possible to take the inscriptions in every case as addressed to the women, even if the distinction between seated and standing women is ignored. Moreover, it is most unlikely that the same pair of names would be used to refer to real individuals in six different burial places, coming from two separate regions of the catacomb. It is therefore more plausible to suppose that the names have been chosen specifically for their allegorical significance; that they imply a wish that the banquets portrayed may take place in a spirit of love and peace.[27] In some of the paintings the artists, and presumably their viewers also, appear to have identified these allegories with the women pouring wine; others simply inserted the phrases into the paintings without specific reference. Sabina, however, in no. 75 remains obstinately secular.

An interesting parallel for this use of allegorical names can be found in a non-Christian context outside Rome on the mosaic from the late fourth-century Tomb of Mnemosyne at Antioch (Pl. XIV).[28] This shows three women at a banquet; two recline on a cushioned couch, and a third sits on a stool. They are served by a woman standing to the right with jug and bowl,

and dressed in a similar way to the two in scenes no. 78.2 and 78.3 at Peter and Marcellinus. Two more women similarly dressed stand to the left; they hold bundles over their shoulders, which perhaps contain flowers for the dead. The inscriptions at the top of the scene read Mnemosyne ('memory' or 'remembrance') and Aiochia, the latter apparently a misspelling of *Euochia*, meaning a banquet or the good cheer that characterizes it. It is left ambivalent whether these are to be read as titles for the entire scene or as identifying the figures closest to them, that is, the standing servant at the right (Aiochia) and the first of the reclining women (Mnemosyne).

Taken together, the banqueting scenes in SS. Peter and Marcellinus illustrate a remarkably broad range of motifs, much broader than usually recognized. It is clear that the image of the banquet bore great significance for the Christian individuals and families buried in the catacomb, but given the various ways in which they chose to represent it, it is unlikely that this significance was the same in all cases. The figures of the single banqueter or the couple descend directly from the traditional Totenmahl representations, which had been used, for example, on the tombstones of the *equites singulares* whose cemetery until recently had occupied the area where the Constantinian basilica of SS. Peter and Marcellinus subsequently rose.[29] They surely conveyed a similar concept of the banquet as the ideal of happy existence in this world or in the next. The communal meals sometimes introduce individualized elements that suggest an emphasis on the life of a specific family or community: the two small children who appear at the *sigma* in no. 45.2, or the man and boy together in no. 76.2. In many respects, however, these scenes conform fully to the normal iconography of secular banquet scenes of the period. This is true especially of scene no. 75, which includes all the trappings of material luxury: the wine flasks, the hand-washing apparatus, the dish of food, the servant with wine, and above all, prominent in the corner, the hot-water heater – a rare and expensive object, and therefore all the better adapted to convey a message of luxurious elegance. Others are less elaborate, but still include most of the traditional ingredients of a convivial banquet. It is also noteworthy that, however allegorical the appeals to Irene and Agape, they are expressed in a very material form: they are instructed not only to mix the wine, but also to bring the essential ingredient of an agreeable meal, the *calda*.

The problem is therefore similar to that which arose with the scenes of pagan funerary banquets: the absence of clues allowing the viewer to distinguish the specific occasion of the banquet. It may be questioned whether modern commentators are justified in trying to make too precise distinctions; the banquet seems to have been an essentially multivalent image, which

served to summon the range of associations inherent in it for Christians, as it had done for many centuries for pagans. In a tomb, an association with the funerary memorial meal celebrated nearby in honour of the dead seems indeed to be most naturally present.[30] But this does not also automatically rule out association with the normal convivial meals of the living: for the Christians, there was the habitual celebration of their communal meal, the *agape*, and all that it implied as an expression of fraternal charity and good fellowship.[31] Allusions to the status and material luxury of the deceased, or of the family that owned the *cubiculum*, are also, as has just been seen, not absent. Finally, there is the question of reference to the banquet in the next world. Many scholars have argued that the dead man or woman is never shown as present at these banquets, and therefore that there can be no allusion to the banquet of the blessed in Paradise; the same argument has been used of the representations of the convivial *sigma* banquet on sarcophagi, pagan or Christian.[32] Josef Engemann, however, has convincingly shown that on occasion the central figure in these scenes is indeed marked out with special emphasis, and at least once on a sarcophagus lid that figure's head is left in boss for a portrait.[33] This is of course compatible with the use of a banqueting scene to allude to the ideal meal in this world, as a sign of happiness and/or of status, but it may equally well imply the persistence of such qualities in the next.

In the last analysis, the paintings of the banquet at Peter and Marcellinus, as in the other catacombs, can be separated neither from their antecedents nor from their actual context. On the one hand, the painters provided scenes that were indistinguishable in many respects from those of the standard secular repertory, and undoubtedly carried with them a similar package of associations. On the other hand, they were commissioned by the Christian families buried in the *cubiculum* as part of an overall decorative ensemble intended to be seen and understood as a whole. One of the *cubicula* in Peter and Marcellinus whose decoration is unusually well preserved makes this especially clear: no. 78, the so-called '*cubiculum* of the two *agapai*'.[34] The *arcosolia* in two walls contain the two banqueting scenes nos. 78.2 and 78.3, each with a standing female figure and inscriptions addressed to Irene and Agape, respectively (Figs. 107, 108). In the first there is also a boy with a plate of food, and a vase on a column amid foliage suggests an open-air setting. On the wall above the first arcosolium, two richly dressed orants, male and female, hold up their hands in prayer. The remainder of the walls has mainly ornamental and vegetal patterns framing the numerous *loculi*. The vault is elaborately decorated. At the centre a panel, framed in a laurel wreath, contains a shepherd bearing a sheep on his shoulders and flanked

by three more. The scene evokes not only a bucolic idyll of peace and happiness, but also the image of Christ as the good shepherd who will save his flock and bring them to that peace. An outer ring is divided into eight semicircular segments containing a series of Old and New Testament scenes: Noah in his boxlike ark, Daniel and the lions, Moses striking the rock, Job, a baptism, the multiplication of the loaves, the healed paralytic carrying his bed, and the raising of Lazarus. The scenes form an extensive selection of those used in the catacombs from the later third century onward to convey the message of the Christian hope for salvation through the examples of the miraculous intervention of their god to save the biblical heroes, and the even more wondrous miracles of Christ culminating with the raising of Lazarus from the dead. The orant figures on the walls below similarly evoke the power of prayer to save the Christian soul. In this context, while the two banquet scenes may indeed refer to the meals celebrated by the living in memory of the dead, it seems likely that they also evoke simultaneously the happiness of the souls of the dead in the paradise that they hope to attain through prayer.[35]

FUNERARY FEASTS, CHRISTIAN AND PAGAN

That Christian funerary feasts differed little from the traditional feasts of their pagan contemporaries is indeed apparent from the strictures of many of the church fathers. Augustine in Africa several times thunders against the drunken excesses of feasts in honour of the martyrs or in commemoration of the dead; he is forced to tolerate them as long as they are carried out in private, in domestic luxury and vice.[36] In Milan, as we learn again from Augustine, St. Ambrose forbade all such feasts and offerings to the martyrs, as encouragements for drunkenness and too close to the funeral feasts, the Parentalia of the pagans.[37] Installations for banqueting, in the form of masonry couches, *stibadia*, or tables (*mensae*) resembling those in pagan necropoleis, have been found in Christian cemeteries of the fourth or early fifth century in various parts of the Roman world, principally in Spain and North Africa.[38] At Tipasa in Mauretania, two such installations were found in close proximity, one decorated in the area of the table with a mosaic bearing the inscription 'may peace and concord be upon our *convivium*' (Fig. 109). Naturally, funerary customs and behaviour were not necessarily the same in Rome and in Mauretania, but it is clear that similar concepts of the Christian banquet, funerary or otherwise, were widespread in many regions of the empire.[39]

Figure 109 – Tipasa, Christian necropolis, funerary enclosure with two stibadia, *one with mosaic inscription. After Bouchenaki 1974, p. 305, fig. 2.*

The Roman catacombs also contain numerous installations which might have been used for funerary meals, but which are less clearly identified than those just discussed: benches that might have been used for sitting (not re-clining), bases that might have served as supports for tables, and in places, regular chairs, the so-called *cathedrae*, carved from the tufa.[40] Their use, how-ever, has been much disputed; and recent studies have tended to see them as designed for offerings, or symbolically for the use of the dead themselves, rather than for actual meals. The funerary meals are better located in struc-tures above ground, which have seldom survived: the best example is the so-called Triclia-complex in the Basilica ad Catacumbas under the church of St. Sebastian, used by Christians in the second half of the third century.[41] The paintings of banquets at the graves themselves, it is proposed, serve

Figure 110 – Funerary inscription of Ianuaria from catacomb of Callixtus. After G. B. de Rossi, La Roma sotterranea cristiana III (Rome 1877), pl. XXVIII–IX, no. 22.

to present before the dead the image of the feasts held in their memory above ground.[42] But this in no way also excludes reference to the feast as the hoped-for reward of the blessed in the next world. The word *refrigerium*, which is used in the graffiti on the walls of the Triclia-complex to describe the memorial feast, appears also on innumerable inscriptions with reference to the refreshment of paradise. One addressed to the dead girl Ianuaria wishes her good refreshment and tells her to pray for us; images of a jug, a goblet, and what is probably a lamp illustrate the text (Fig. 110).[43] The two senses are inextricably interwoven and gain their force through their mutual reference. It was surely just this multivalence, the ability to link life and death and to exemplify all that was seen as desirable in life and that might be hoped for in death, that caused the banquet theme to enjoy such extraordinary favour for Christian tombs, exactly as it had for so many centuries for pagans.

It is a pagan monument of the fourth century that most explicitly represents the convivial meal at a *sigma* as taking place in the next world. The small Catacomb (better hypogaeum) of Vibia beside the Via Appia in Rome contains an *arcosolium* painted with scenes which relate to the two persons buried there, Vibia and her husband, Vincentius; the date is probably sometime after 350 AD.[44] Two of the scenes in the vault of the *arcosolium* draw on the traditional imagery of Graeco-Roman eschatology, with the sense clarified by inscriptions: Vibia is shown carried off by Pluto in his chariot and brought by Mercury before the judges of the underworld (named here as Dispater and Aeracura) and the Fates. Alcestis, whose devotion to her husband led to her being rescued from death by Hercules, accompanies her before the judgement seat. In the lunette at the back, Vibia is led by a 'Good Angel' through an archway to the meadow where a banquet takes

place (Pl. XV). Six figures, with Vibia herself identified in their midst, re-
cline at the *stibadium* cushion; they wear wreaths, and raise their hands in
lively gestures. A servant brings a plate of poultry, two other plates before
the diners hold fish and perhaps a cake; a tall amphora stands at the side. In
the foreground, two kneeling figures are playing a game of dice or some-
thing similar. The atmosphere is relaxed and full of the spirit of worldly
pleasure, but the inscriptions leave no doubt that this is to be seen as a meal
in paradise. Above the scene of Vibia led through the arch is written 'the
induction of Vibia', while over the banqueting group the inscription runs
'those judged by the judgement of the righteous'.[45]

The banquet theme is repeated in the third scene at the right of the
vault, but the central figure here is Vibia's husband, Vincentius (Fig. III).
Seven men recline at the *stibadium* cushion, several holding cups; plates
of food and loaves of bread are placed before them. Three of them wear
pointed Phrygian bonnets and voluminous cloaks. The inscription above
identifies them as the Seven Pious Priests.[46] The nature of this priesthood
is revealed by the much longer inscription painted across the top of the
arcosolium, which describes Vincentius as priest of the god Sabazius, a deity
of eastern origin related to Dionysus, and whose cult enjoyed a certain
popularity in the syncretistic paganism of the fourth century. The rest of
the inscription, however, introduces common themes of Roman funerary
epigraphy, including the familiar 'eat, drink, play, and come to me...'[47]
The banquet of the seven priests seems to lack the relaxed atmosphere
of that of Vibia and her companions; the figures are more upright, and
there are fewer lively gestures. Some scholars have taken this more hieratic
atmosphere as a sign that this should be seen as the funerary meal celebrated
on earth by Vincentius and his fellow priests in honour of the dead Vibia,
rather than another celestial banquet. However, because the main inscription
clearly identifies Vincentius as dead, there seems no reason not to locate his
banquet also in the next world, among the other worshippers of his god.[48]
Inscriptions apart, there is nothing intrinsic to either banquet that would
lead an observer to distinguish it from the representations of terrestrial feasts,
funerary or otherwise.

The catacomb appears to have been occupied by a remarkably diverse
group of adherents of different religions. A neighbouring *arcosolium* con-
tains scenes which apparently refer to some unidentifiable mystery religion;
inscriptions mark the graves of several priests of the Unconquered Sun
Mithras; other burials are almost certainly to be identified as Christian. As
elsewhere in Rome, it appears that Christians and pagans at this period
could coexist and bury their dead side by side.[49] Although each group drew
upon its own iconographic tradition to express its eschatological vision of

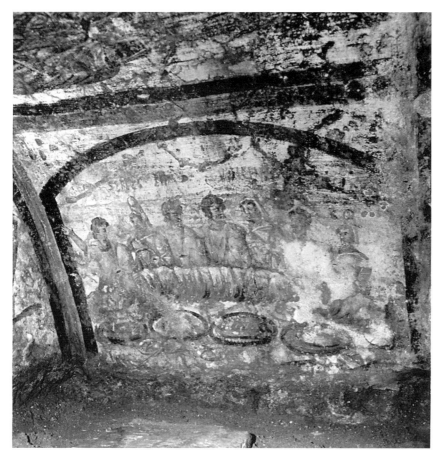

Figure 111 – Rome, Hypogaeum of Vibia, arcosolium, *banquet of Vincentius and Seven Pious Priests. Probably second half of fourth century* AD. *Photo Pontificia Commissione di Archeologia Sacra, Vib B3.*

death, judgement and salvation, the banquet spoke with equal force and clarity to pagans and Christians alike. Both for Vibia and Vincentius and for the families buried in the Peter and Marcellinus *cubicula*, the banquet scenes which fill the *arcosolia* dominate the rest of the decoration; we can hardly doubt that the message they conveyed, however differently interpreted by its various viewers, was seen as the most essential element of the funerary imagery.

THE LAST CENTURIES OF THE ANCIENT WORLD

Around the turn of the fourth to fifth century, images of banqueters in a funerary context seem to disappear and those in a secular context become much rarer or change their nature. In Rome itself, indeed, the paintings

of Vibia and Vincentius seem to be our latest examples, although there may be later ones in the provinces.[50] The reasons are assuredly complex. For Christian funerary images, the disapproval of the church authorities for the whole practice of funerary banquets must have played a decisive part, along with the intrinsically ambiguous nature of the banquet representations and their inescapably material associations. Identifiable pagan scenes, meanwhile, vanish from the record under the threat of Christian repression.[51] The disappearance of secular banqueting scenes is harder to explain, except insofar as we possess a much smaller quantity of secular art generally from this period than we do for the foregoing one. Certainly, the actual social practice of reclining to dine did not disappear or lose its significance among the upper classes in the fifth century or even later, although it may have become rarer in the tottering Western Empire.[52] The letters and poems of Sidonius Apollinaris, the wealthy landowner and later bishop in mid–fifth-century Gaul, contain numerous references to dining with his friends and associates; they make it clear both that a luxurious meal was as much the central ritual of social relations as it had ever been and that in his society it was inconceivable in any other form than that of formal reclining. His account, for instance, of his villa at Avitacum in the Auvergne includes a description of a small dining room overlooking the lake; reclining on the *stibadium* there, he says, you are engrossed by the pleasures of the view.[53] He also provides one of our most detailed accounts of the physical organization of a *stibadium* banquet, in the letter describing the banquet to which he was invited by the short-lived emperor Majorian in 461 AD.[54] Here he recounts, in laborious detail, the exact order of precedence in which the guests (the emperor and seven others) reclined on the *sigma* couch: the emperor in the place of honour on the right horn of the couch (i.e. the extreme left for the viewer), the consul in the next place at the opposite end, the left horn, and the others in due order with Sidonius himself in the lowest position, immediately next to (and therefore behind the shoulder of) the emperor himself, or as he puts it 'where the left side of the purple-clad one was spread out on the right edge'. The emperor began by addressing the guest of honour, the consul, and then worked his way through the others in order of precedence, until his passing over one of them exposed the tensions that were latent in the company. Later Sidonius recounts how, to win himself some time at an awkward moment, he turns round and calls for water to wash his hands, thereby delaying while the servants hurry around the back of the *stibadium*.[55] The whole passage makes eminently clear the degree of ceremonial and formality that was still inseparable from such an occasion, and the way the *stibadium* banquet, once designed for more informal dining,

had in turn become governed by hierarchy and precedence. Indeed we may suspect that, precisely as the presence of the barbarians became more inescapable in what had been the Western Roman Empire, those who clung to the old ways believed it all the more necessary to maintain what for them was the hallmark of civilized behaviour, and to assert the privileges of their traditions.

Elsewhere things were changing. Other sources emphasize the humility of the holy man who sits while others recline, like Saint Martin of Tours at the banquet of the emperor Maximus in 385/6: a different set of values was competing with the traditional ways.[56] As the barbarian courts became established, some barbarian kings adopted Roman fashions, including reclining to dine on formal occasions, but others undoubtedly retained their ancestral practices; their followers, and those of the Roman population who were assimilated into the conquerors' society, are likely to have followed suit. It is difficult to estimate the speed with which customs changed, but even in Italy or southern Gaul the archaeological evidence indicates that new buildings with rooms designed for the traditional reclining banquet were at least rare by the end of the fifth century, and that new styles of halls for entertainment were appearing, more suited for sitting at a table.[57] There is no sign, however, of a new iconography of the banquet appearing at this date; the rare scenes of seated dining that are found, for instance occasionally in biblical scenes, are isolated occurrences that do not establish a pattern.[58]

In the more tranquil eastern part of the empire, both the written sources and the remains of many houses demonstrate that the upper classes retained their traditional habits of dining well into the sixth century. Rooms designed for the *stibadium* banquet can frequently be identified from their plans, their fittings, or their decoration; one of the clearest is the so-called villa of the Falconer at Argos in Greece, probably from the beginning of the sixth century, where the layout for the couch and table is marked on the mosaic floor (Fig. 100).[59] At Apamea in Syria, a series of grand houses have been excavated, characterized by the presence of huge reception rooms with an alcove or apsidal end to hold the *sigma*. Although their original construction may go back to an earlier date, they continued to be used, restored, and redecorated in the fifth and sixth centuries; not until the early seventh century is any major change perceptible in their style of occupation.[60] In one, the House of the Triclinos, two grand apsidal rooms more than 13 m long open on adjacent sides of the peristyle; an inscription at the entrance to one refers to it as a *triclinos*, and records its restoration in the year 539 (Fig. 112).[61] In the House of the Stag, perhaps equally grand, the main reception room was rectangular in plan; adjoining it across an antechamber

Figure 112 – Apamea, House of the Triclinos, plan. After Balty 1984, p. 475, fig. 2b.

to the side was a much smaller and more intimate apsidal room. That both these rooms were used for dining still at the time of their destruction was shown by the discovery in each of them of their marble *sigma*-shaped tables, resembling that marked on the mosaic of the villa of the Falconer; in the main hall it was a huge slab of green Larissa marble, still in place in the centre of the room above the calcined remains of its wooden base, in the apsidal room a smaller slab of white marble (Fig. 113).[62] Fragments of similar tables were found in most of the other houses at Apamea; in the House of the Triclinos one was leaning against the wall of a small room, perhaps a storeroom or pantry, adjacent to one of the great apsidal halls. These tables were movable, but extraordinarily heavy, and would require several men to shift, another sidelight on the infrastructure that was necessary to organize a banquet.[63]

For all the splendour of these rooms, the tables are still designed to accommodate only comparatively small numbers, perhaps the traditional seven to nine guests; the ideal of an intimate grouping still prevails. Triconches presumably continued to be used, and at least occasionally constructed, although there are not many that can be attributed to this period.[64] In the grandest circles, there were multiconch rooms which allowed *stibadia* to be aligned in rows on either side and at the end; not surprisingly, they seem for the most part to have been a feature of palace architecture. In

Figure 113 – Apamea, House of the Stag, sigma *table of green marble from main reception room. Fifth to sixth century* AD; *1.54 × 1.53 m. Photo courtesy of J. Balty.*

Constantinople, the Great Palace of the Emperors contained a hall known as the Triclinium of the Nineteen Couches, the Decaenneacubita, which was used, as late as the tenth century, for state banquets. It can be reconstructed with nine *stibadia* set in apses down each side, and the high table for the imperial party at the end; each couch held twelve guests, except the imperial couch, which held thirteen. It seems to be already attested under Leo I in 457; tradition ascribed it to Constantine the Great.[65] It evidently served as a model for slightly smaller versions; in Constantinople, there is a great hall that may have formed part of the Palace of Antiochus, a powerful eunuch at the court of Theodosius II (Fig. 114). Built in the fifth century as an immensely long apsidal hall, it was transformed, probably in the sixth century, by the addition of three apses in each of the side walls, to hold a total of seven *stibadia*.[66] Much more surprising is the example in the remote town of Cuicul (Djemila) in Numidia. Here the enormous House of Bacchus, which already contained an impressive reception suite, received a room with seven apses, three down each side and one at the end, in all

Figure 114 – Constantinople, plan of Great Hall (part of Palace of Antiochus?); apses along side added probably in sixth century AD. After Lassus 1971, p.196, fig. 3.

26.80 m long (Fig. 115). It cannot be precisely dated, although the mid-fifth century has been suggested on the basis of the style of its mosaics. There is nothing to indicate whether the owners who needed to entertain in such style held any official position, or whether they were simply exceptionally wealthy aristocrats, perhaps driven out of the proconsular province of Africa by the Vandal conquest; however, their insistence on the traditions of formal dining, whatever the turmoil or disasters in the wider political scene, is unmistakable.[67]

In view of the importance evidently still attached to the banquet in such circles, its apparent disappearance from secular art may be due to the vagaries of our surviving evidence. But an interesting development is that the banqueting scenes we do possess from this period show, in place of the human banquet, a scene with a mythological setting. For instance, an ivory pyxis now in Baltimore, probably of the sixth century, shows the gods dining on the *stibadium* at the feast where the Apple of Discord was thrown among them, the event that led to the Judgement of Paris (Fig. 116).[68] We see Zeus, Aphrodite, and Athena reclining, while Hera sits in a separate chair at the side. It is noteworthy that in previous Graeco-Roman art the gods had not, with rare exceptions, been shown reclining; only now, with paganism irrevocably in decline, do the gods appear in the traditional position of honourable ceremony. Similarly, when the painter of the probably late fifth-century manuscript of Vergil known as the Vergilius Romanus painted Dido entertaining Aeneas and a companion, he showed it as a typical aristocratic banquet of the period (Pl. XVI). The guests, Dido in the centre, recline on the *stibadium*, amid rich cushions and hangings; the table

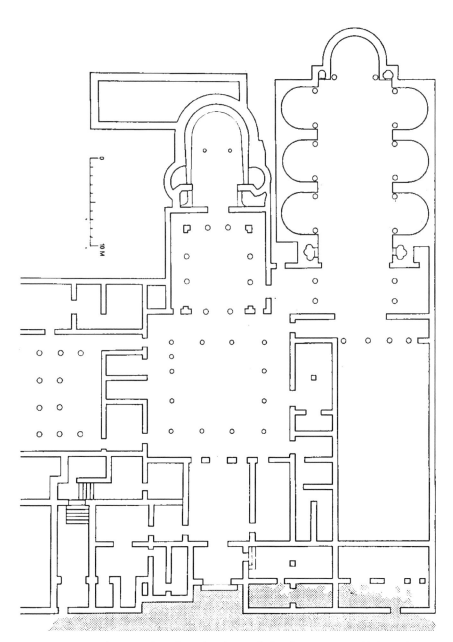

Figure 115 – Cuicul, House of Bacchus, plan showing hall with seven apses, added probably in mid-fifth century AD (or mid-sixth?). After Lassus 1971, p. 197, fig. 4.

bears a plate of fish, and three crescent-shaped rolls; long-haired pages, of a type seen in Chapter 5, bring a jug and cup of wine, and the water for hand-washing, respectively.[69] In the sixth-century manuscript of the Iliad, the Ilias Ambrosiana, two miniatures show Greeks and Trojans picnicking in

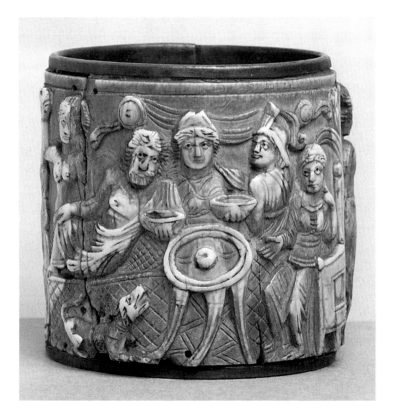

Figure 116 – Ivory pyxis with banquet of gods from Egypt. Early sixth century AD; H. 8.5 cm. Baltimore, Walters Art Museum 71.64. Courtesy of The Walters Art Museum, Baltimore.

their camps at a series of *stibadium* cushions placed on the ground, between three and five at each *stibadium*. Helmeted servants hurry forward with big plates of food; jars and flasks of wine stand waiting, some in the familiar wicker containers; and each scene contains at the side a servant busy at a pot heated on a makeshift stove. The wine jar behind identifies this as the heating of water for the wine.[70]

Biblical banquets are also represented in similar format. A miniature in the Vienna Genesis, of the sixth century, shows Pharaoh's feast (from Genesis 40.20–3), with his chief butler restored to favour serving him drink in the foreground, while his baker is hanged from a stake at the right of the scene: a good example of the use of death to emphasize by contrast the pleasures of the banquet (Fig. 117).[71] Pharaoh and his guests recline on the *stibadium* couch, shown very unusually from the side so that we see its structure and the way the guests position themselves; Pharaoh occupies the right horn, exactly as Sidonius describes Majorian. Beside the butler stands the water carrier, smaller in size to suit his inferior position, and another attendant with jug and towel stands ready behind the couch. In the background, two

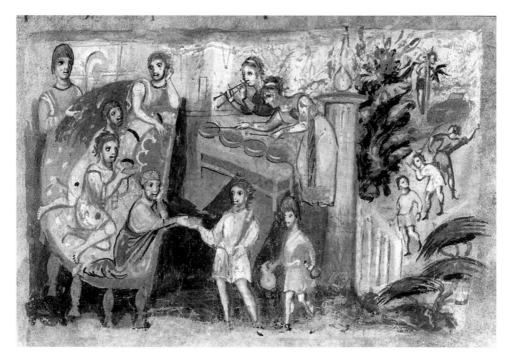

Figure 117 – Vienna Genesis, Cod. Vindob. theol. gr. fol. 17, Pharaoh's feast. Probably first half of sixth century AD. Courtesy of Österreichische Nationalbibliothek, Vienna (Bildarchiv ÖNB).

women entertain the guests with music, one playing the double pipes, the other bent over to strike a row of musical bowls.[72] The painting goes far beyond any information contained in the text of Genesis, to give a vivid impression of a luxurious banquet appropriate to convey Pharaoh's royal status. Similarly, the Codex Sinopensis, another luxury manuscript of the sixth century, shows King Herod's feast on the *stibadium*, Herod again at the right horn, with three guests; a servant brings the head of John the Baptist to Salome on a platter, similar to the great platters used as more conventional serving dishes in the paintings from the Caelian of the fourth century (Fig. 118).[73]

More influential for the future was the adoption of the scheme for representations of the Last Supper of Christ and the disciples. Christ appears with three disciples at the *stibadium* in a panel on an ivory diptych now in Milan, probably of the second half of the fifth century. A plate with a fish and a series of rolls lie on the table before them.[74] The full twelve disciples are found in another sixth-century manuscript, the Rossano Gospels, crowded together on the *stibadium*, with Christ wearing a golden cloak on the right horn (Fig. 119). On the semicircular table stands a bowl

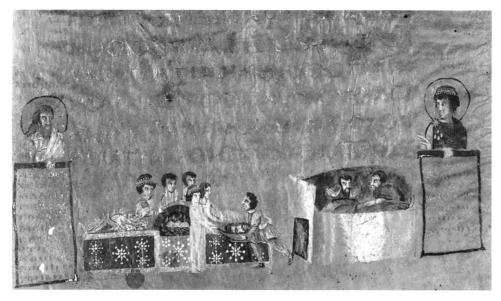

Figure 118 – Codex Sinopensis, fol. 10v, Herod's feast, with the head of John the Baptist brought to Salome. Sixth century AD. Paris, Bibliothèque Nationale, Suppl. Gr. 1286. Photo Bibliothèque nationale de France, Paris.

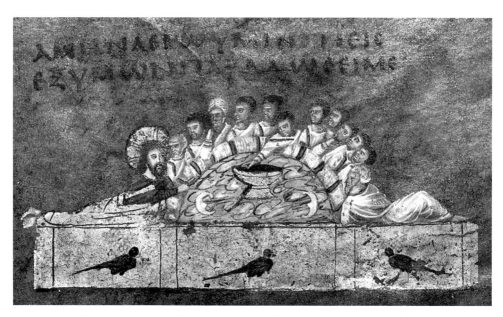

Figure 119 – Rossano Gospels, Last Supper. Sixth century AD. Rossano, Palazzo Arcivescovile, Museo Diocesano fol.3. Photo Hirmer no. 571.1017.

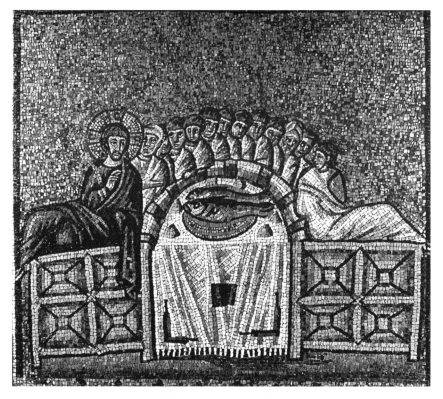

Figure 120 – Ravenna, Sant' Apollinare Nuovo, mosaic of Last Supper. Ca. 500 AD. *DAI Rome 58.740, photo Bartl.*

containing a dark substance, into which one of the disciples in the middle of the group, evidently Judas, dips his hand; two crescent-shaped rolls lie on the surface of the table.[75] The most famous version is the mosaic of Sant' Apollinare Nuovo in Ravenna of ca. 500 AD (Fig. 120).[76] Here, too, it is the scheme suitable for royalty that is adopted, with Christ in purple and gold in the place of honour on the right of the *stibadium* couch, the twelve disciples close-packed around its curve. At Ravenna, as on the Milan diptych, there are two large fish in a plate on the draped table, contrary to the biblical narrative. Around them are seven pyramidal loaves, but there is no cup. Although fish in Christian art have a manifold symbolic meaning, they also recall the many banquets where fish was represented as the prestige food par excellence.[77] Later Byzantine representations of the Last Supper continued for many centuries to show Christ and the disciples grouped around a *sigma*-shaped table. Occasionally they are represented as reclining in the old style, but for the most part the mediaeval artists, unfamiliar with the custom of reclining, no longer understood the scheme reflected in their

models, and the figures sit somewhat uncomfortably around the table; once or twice Christ alone reclines on a separate couch, while the rest sit.[78] The pose perhaps came to be seen as reserved in art either for Christ alone, or for Christ and his apostles; to represent ordinary humans in this way might have seemed impious.

In a sense, the wheel has come full circle. The image of the reclining banqueter, like the practice itself, started as the appanage of the great – of Assyrian kings and Persian satraps, then of the Greek aristocrats who strove to emulate their style of life. Over the centuries that followed, an extraordinary process of trickling down took place, as citizens and magistrates, freedmen and soldiers adopted the same image to express their dreams of a privileged life or a happy death, while continuing to stress that they did not think it appropriate for those of inferior or different social status to share the privilege. In the end, however, it passed beyond the reach of all but a very few, and once again the image of the reclining banquet came to be reserved only for the grandest figures: kings, queens, emperors, or gods, and their closest associates. The final image of the reclining banquet comes only from written sources. For many centuries, the Byzantine Emperors of Constantinople continued to celebrate the great feasts of Christmas with their guests in the hall of the Great Palace known as the Triclinium of Nineteen Couches, the Decaenneacubita; on these occasions, contrary to the usual practice, both Emperor and guests reclined.[79] But for the Western visitor to the Byzantine court in the tenth century, the envoy Luitprand of Cremona, who records the event, this is a strange and alien procedure, whose point he can no longer understand.[80]

Conclusion

The monuments discussed in this book can only rarely be appreciated today in their original environment. Many of the paintings and mosaics, especially those from domestic contexts, appear now as isolated panels or fragments in museums, bereft of their surroundings and deprived of reference to their architectural setting; they often appear to the modern observer more as independent pictures than as elements in the overall decoration of a wall, floor, room, or building. Many of them represent complete scenes, and can on one level be seen and read individually, yet they were also designed to interact with other elements of the decoration and gained force from their careful location in the space of a room or building. Those that remain in situ allow a better understanding of their original location and relationship to other elements of the decoration; nevertheless, this is at best partial.

Some examples may illustrate the importance of location and juxtaposition, and the limits of our appreciation of them. Several of the more recently discovered mosaic pavements have been preserved or recorded in situ and allow the layout of complete rooms, and even of major sections of a house, to be recovered from their floor plan. In the House of Bacchus at Complutum in Spain, the procession of servants holding up wine cups (discussed in Chapter 5) lines the corridor leading to a triclinium, which itself is decorated with Dionysiac figures, scenes of the vintage, and busts of the four Seasons.[1] The cup bearers, accordingly, act as a prologue to the pleasures implied by the decoration of the triclinium; they were not meant to be read independently. Similarly, the mosaic of the *sigma* banquet at the entrance to a triclinium at Sepphoris in Israel introduces the guests to a room decorated with Orpheus and the Beasts; music and culture are presented here as part of

the ideal convivial atmosphere, as much as the drinking and merry-making of the entrance panels.[2] Mosaics such as these make it clear that the images on adjacent pavements were frequently designed to enhance and complement one another; we can only guess at the potential contribution in these rooms of lost wall paintings or marble inlay, of decorated ceilings, of textiles and furnishings, not to mention such ephemeral effects as lighting, vegetation, or the play of water.[3] Unlike the mosaics, few domestic paintings of banquet scenes survive in situ; most of those from Pompeii and Herculaneum, in particular, were discovered at a period when it was normal archaeological practice to transport figured scenes of any quality or interest to the museum. Of those whose context is preserved, the most important are those from the triclinium of the House of the Chaste Lovers at Pompeii (IX 12.6). The three figured panels with banqueting scenes were set in the centre of simple red walls and flanked by winged figures floating in space, who hold baskets of fruit and other offerings of food. Although the effect of the whole can be described, in the words of the excavator, as a hymn to the joy of the banquet, the comparative modesty of the room itself, and the commercial establishment to which it is attached, serve as a valuable reminder that we should not automatically assume that all such scenes derive from settings of great material luxury.[4]

Tombs often preserve both architecture and decoration more completely than domestic buildings, and tomb paintings can more often be seen in their setting. Thus the paintings of the Tomb of the Banquet at Constanza, or of a *cubiculum* in the catacomb of Peter and Marcellinus in Rome, can be recovered more or less completely, and the banquets seen in their relation to the rest of the decoration.[5] Yet much that made up the original funerary environment is lost. Sculptured funerary monuments such as sarcophagi and grave reliefs are almost invariably removed from the tombs and cemeteries where they originally stood. Some of the grave monuments were displayed to the public view in open-air cemeteries or lined the streets leading out of town; in the forest of memorials to the dead, many will have repeated similar motifs with monotonous emphasis, amid which a few endeavoured to make their own monument stand out distinctively. In contrast, sarcophagi, urns, and similar objects were normally displayed within individual tombs, of limited access, and often belonging to a single family. Here they might contribute to a general message of that family's status and traditions, but they could also accumulate without any coherence over quite a lengthy period or be crammed into an inadequate space, perhaps in a tomb designed for another burial rite. They were also not infrequently reused at a later date, sometimes in quite different circumstances.[6]

Frequently, there is the further loss of the inscriptions that accompanied and identified the grave monuments. Such inscriptions may contain no more than a name and a bare formula of dedication, but they may also provide essential clues to the interpretation of the accompanying image. Thus not only do we know nothing of the monument that the Amiternum banquet relief and its lost brother originally decorated, but also we can only regret the absence of an inscription in which its commissioner might have publicized his generosity verbally as well as visually.[7] How intimately words and image might be interwoven, and how much each can contribute to the comprehension of the other, are well illustrated by the funerary relief of Rubrius Urbanus discussed at the beginning of the introduction or by the monument of Flavius Agricola.[8]

Such lacunae are a constant feature of the study of ancient art, as of the study of antiquity in general. The material is fragmentary, and our primary evidence is inevitably constituted by what survives, however much we must try to be aware of its shortcomings and to explore as best we can the areas of darkness. It is necessary to admit that the conditions under which ancient observers would have perceived most of these works are almost entirely beyond recovery. Other problems arise if we try to reconstruct their audience; even, sometimes, the extent to which there was an audience at all. We may question how closely the guests entering a triclinium would have studied the decoration of a mosaic beneath their feet or, once they had reclined, would have examined the paintings on the walls behind their backs. Nor may it seem to us likely that many travellers along the great cemetery roads spent much time contemplating the grave monuments or deciphering their inscriptions, assuming that they were able to read them. Inside the tombs themselves, visibility must often have been very limited; visitors to the tomb, on the occasion of burials or of subsequent feasts of the dead, will have been dependent on torches or small oil lamps that would have given at best a faint and flickering light. The modern scholar may make out associations between one element of the decoration and another, but these may never have been visible simultaneously under ancient conditions.

Yet it is also often clear that many images were indeed intended to speak to an audience. Regardless of who actually saw them, the patrons who ordered them, or the craftsmen who made them, did so in anticipation of certain reactions from those who were expected to see them. These expectations of what we may call the presumed or imagined spectators must be taken into account in our attempts today to interpret, even though we cannot reconstruct the response of any single individual in antiquity. Such expectations can be reflected in the careful selection and telling combination

of themes, and in designs that are orientated and motifs that are located with an eye to the angle from which they were to be seen. We may safely assume that sometimes at least it was hoped that guests at a banquet would use the images before them, on walls, drinking vessels, or floor, as a starting point for conversation, whether learned and philosophical, elegantly witty, or vulgar and banal. Petronius, as so often, offers a parody of the practice with Trimalchio's lugubrious reflections inspired by his little silver skeleton, but behind the parody must lie a familiar phenomenon.[9] Inscriptions raise similar questions concerning the extent to which they were, and even could be, read; yet there can be no doubt that they too were meant to communicate to an imagined audience. The combination of image and inscription illuminates this desire to communicate with special clarity when there is mutual reference between them, as on the relief of Rubrius Urbanus; in extreme cases, each would be incomprehensible without the other.

The degree to which individual monuments reflected this desire for communication varied enormously. The patrons who commissioned or selected these works came from diverse backgrounds and origins. The aristocrats of the Late Empire commissioning a mosaic for their palatial townhouse or villa, or ordering a piece of gilded silver plate, clearly had different interests and aims from those of the freedmen, wealthy or otherwise, in first-century Rome or Pompeii, or the Augustales for whom the grave monuments of Este and Sentinum may have been intended. It has been suggested many times in this book that part of the reason for the lasting appeal of the banquet theme lay in its flexibility and multivalence, its adaptability to diverse conditions of use while retaining a basic core of significance. Many of those who used it are unlikely to have examined this significance too closely; a grave monument will have been ordered from stock because it was available and appropriate, a theme for a mosaic or painting commissioned from the range that the craftsman had to offer, without great concern about the precise details to be included. Yet other monuments, as we have seen, seem to indicate patrons (or perhaps their agents?), not only investing much thought in the precise treatment of a selected subject, but also anxious that it be understood in the way they want. There may be few examples among the monuments we have been discussing of explanatory inscriptions that can illustrate this process with certainty, but even in the absence of inscriptions, it is the only way to account for some unparalleled combinations. Thus we saw in examining the Amiternum relief that the unique juxtaposition of seated and reclining diners is no casual accumulation of iconographic variants, but corresponds to a hierarchical distinction of great importance in euergetistic behaviour; it is safe to conclude that the combination was dictated as part

of the commission for the monument.[10] Similarly, the display of prepared foods on the mosaic from the House of the Buffet Supper at Antioch, laid out in an order that corresponds to their typical presentation at a Roman dinner, can hardly have been interpreted as anything other than a deliberate evocation of a well-conducted meal.[11]

The interaction between patron and craftsman which lies behind the production of these works could take very different forms. Most Roman craftsmen were fundamentally conservative, working with a store of material handed down by tradition, often over many centuries, and re-elaborated and varied as called for. If the patron was content with a standard scene or motif, reference to any specific requirements of the commission might be minimal. At other times, it must have been the patrons who took the initiative in demanding the inclusion of certain features that accorded better with their aims. It seems likely, for example, that the variations in the representation of women on the funerary monuments, reclining or seated, were dictated in the first place by the desires of the patrons. Those commissioning a monument will have been the first to require a departure from a long-established pattern, such as that which showed the woman seated while the man reclined. Subsequently, new motifs will have become more widely established in the repertory of the workshops, as the craftsmen saw new opportunities for a sale. But even when stock scenes were repeated with little variation, as with many of the simpler funerary reliefs, their creators must have judged that they would be seen as appropriate by their intended purchasers.

For the study of banquet scenes, questions of communication and response, of the workings of patronage and of craftsmen's traditions, are facilitated by two favorable circumstances. The first is the sheer number of such scenes, which permits the necessary comparison and establishment of types, together with their longevity, which lets us see changes over time. We can distinguish, with as much certainty as is ever possible in dealing with ancient art, between the stock scene and the exception; we can recognize norms and variants; and we can be reasonably sure of the date at which new subjects, or new ways of treating old subjects, appear. Despite all that I have said earlier in this chapter about the lack of context, a sufficient number do possess at least basic information about their place of origin, their approximate date of production, and the nature of the building or monument from which they came. Even more important is the possibility to draw on the mass of information about the banquet offered by other sources, literary and epigraphic, as well as the evidence for material culture. I have stressed repeatedly in the course of this study that the banquet scenes in no way act as illustrations of

the literary sources, any more than either are to be seen simply as reflections of real life. The distance between the picture offered by the literary sources and that of the visual images has in fact emerged on various occasions in this discussion, for instance, in the very different emphasis that they place upon the consumption of elaborately prepared food, or the much later appearance in art of the theme of the crowds of servants as a mark of luxury. Nevertheless, both clearly offer the opportunity for mutual illumination, if sometimes by contrast. The epigraphic sources, although obviously narrower in content, have the great advantage that they derive from a similar social milieu as many of the figured monuments; funerary images and inscriptions in particular show related concerns and preoccupations, and the inscriptions have frequently served as indispensable points of reference for the interpretation of the images. Finally, the archaeological material, for all its own lacunae and biases, takes us into the 'real' contemporary world, and provides a background against which to test and contrast evidence drawn from the other sources.

Overall, the banquet scenes offer us an image in microcosm of some of the most important developments in Roman art, and of the social forces that helped to shape them. The paintings of the Hellenistic-style symposium from Pompeii and Herculaneum exemplify the strand of Roman art in the first centuries BC and AD that was most indebted to Hellenistic traditions, copying, adapting, or recreating well-known masterpieces. But at much the same date, works such as the funerary monuments discussed in Chapter 3 represent a different element, the so-called Italic tradition found above all in provincial towns, and designed to convey a clear message in terms that may appear visually unsophisticated if judged by the standards of Hellenistic naturalism.[12] By the late second and third century AD a more distinctively Roman iconography has emerged; it is notable that themes which become established at this date had often appeared much earlier in the literature. In the later Empire, this iconography is combined with a style and manner of presentation that could effectively express the hierarchical language of power and status that dominated Late Antique society. There are, it may be suggested, few other common subjects that provide so good an opportunity to follow the interplay of these forces over the course of Roman art: on the one hand, the enduring traditions, on the other hand, the impact of changing contemporary practice and ideologies.

Notes

INTRODUCTION

1. Rome, Palazzo Barberini: Matz–Duhn III (1882) 3885. A drawing of the stone in the Cassiano dal Pozzo collection (London, BM Franks 364) is published in W. Stenhouse, *The Paper Museum of Cassiano dal Pozzo A. VII, Ancient Inscriptions* (London, forthcoming), 302–3, no. 179, along with a photograph of its present state; the heads of both father and son are now missing. I am very grateful to Amanda Claridge for a copy of these pages before publication and for information about the relief.

2. Buecheler *CLE* 1106 = *CIL* 6.25531, Rome:

 Qui dum vita datast, semper vivebat avarus,
 heredi parcens, invidus ipse sibi,
 hic accumbentem sculpi genialiter arte
 se iussit docta post sua fata manu,
 ut saltem recubans in morte quiescere posset
 securaque iacens ille quiete frui.
 filius a dextra resident, qui castra secutus
 occidit ante patris funera maesta sui.
 sed quid defunctis prodest genialis imago?
 hoc potius ritu vivere debuerant. (My translation).

3. Ch. 4, 'The Monument of Flavius Agricola and the Tradition of the Totenmahl Motif'; for definition see ibid, n. 5. For the sentiment, see ch. 4, nn. 49–54, 73.

4. For a good introduction to the social roles of Roman banquets, see D'Arms 1984; Garnsey 1999, esp. 134–8, part of a much wider discussion of food in Greek and Roman society, with useful bibliography.

5. For the treatment of the banquet and related subjects in Roman literature, see (inter alia) Gowers 1993, who studies the use of food as metaphor; Murray 1985; Griffin 1985, chs. 1, 4; Leary 1996; Leary 2001; Stein-Hölkeskamp 2001; Courtney 2001, 72–126; and cf. Introduction, n. 8. For Athenaeus, see the essays in Braund, Wilkins 2000.

6. For the custom of reclining to dine, see ch. 1, 'The Reclining Banquet'; for exceptions, see ch. 1, n. 42, ch. 3, nn. 25, 28. For the ideology of the *convivium*, see the passage of Cicero quoted in ch. 1, n. 12. For the role of the drinking party in Rome, and the distinction between the Greek *symposion* and Roman practice, see ch. 1, nn. 33–7.

7. For example, G. Mercuriale, 'De accubitu in cena antiquorum', in his *De arte gymnastica* (4th ed. 1601); P. Chacon, *De Triclinio, sive de modo convivandi apud priscos Romanos*, with appendix *De Triclinio* by Fulvio Orsini (1588); J. Stucky, *Antiquitatum convivialium libri tres* (2nd ed., 1597). See also Vagenheim 1992; Herklotz 1999, 217–9.

8. For example, Marquardt 1886, 297–340; Blümner 1911, 386–412; Friedländer 1922, II, 285–315 (part of his disquisition on 'Roman luxury'). More recently, Salza Prina Ricotti 1983 is a basically text-based study, focusing mainly upon food, and ending with an impressive series of recipes (see the review of J. D'Arms, *Gnomon* 58, 1986, 64–7); Dosi, Schnell 1990 is also predominantly concerned with food, although archaeology plays a larger role among their sources. See also the works quoted in ch. 1, nn. 33–4.

9. For the history of research into the *symposion*, see Murray 1990a. Colloquia: Murray 1990; Slater 1991; Murray, Tecuşan 1995; Nielsen, Sigismund Nielsen 1998.

10. Thus, the relief in Este, discussed in ch. 3, 'Monuments of public banquets at Este and Sentinum,' is illustrated in the works of Mercuriale and Chacon (Introduction, n. 7; cf. ch. 3, nn. 9–10. I am grateful to J.-M. Agasse for a discussion of these representations). Cf. Vagenheim 1992, for further examples. For Cassiano's interest in banquet scenes, see Herklotz 1999, e.g. 154, 254, 278–9.

11. Banquet of Vestals: ch.3, nn. 4–5.

12. The possible identification of a sarcophagus with a couple of banqueting figures reclining on its lid as that of the short-lived emperor Balbinus (ch. 4, n. 42) does not constitute an exception; it belongs to a standard type and contains no imperial features.

13. *Lectisternium*: ch. 1, n. 7.

14. Dionysus: cf. ch. 1, n. 21; ch. 2, n. 77. For Dionysiac scenes and related subjects in triclinia, see e.g. Kondoleon 1994, ch. 4–5, but contrast also Ling 1995, who shows that Dionysiac imagery is by no means so common as sometimes supposed in the triclinia of Pompeii. For Hercules, see Amedick 1994.

15. Mithras: Kane 1975. Danubian rider gods: Tudor 1976, 194–9, 255–62.

16. Thysdrus: Dunbabin 1978, 78–9, pl. 69. Grave monuments of Igel and Neumagen: Noelke 1998, 412–4, with references. See ch. 1, 'Diffusion: The Roman Empire,' for some monuments from the Roman Rhineland with more traditional banqueting imagery.

CHAPTER 1

1. On the origins of the custom, the Near Eastern background, especially in Phoenicia and North Syria, and its adoption in the Greek world, see Fehr 1971, esp. 3–25, 128–30; Dentzer 1971, esp. 215–31, 244–7; Dentzer 1982, esp. 51–8; Burkert 1991; Reade 1995; summary and bibliography in Matthäus 1999. The earliest literary reference to the custom comes from the prophet Amos (6.4–7), in the mid-eighth century.

2. Among the vast literature on the *symposion*, see Murray 1983; Lombardo 1989; Murray 1990a; and the extensive bibliographies in Murray 1990; also the essays in Slater 1991; Murray, Tecuşan 1995. For the civic or religious banquet, see Schmitt Pantel 1992 and ch. 1, n. 29.

3. Ar. *Vesp.* 1208–18.

4. Murray 1990a, 6. For Italy and the Etruscans, see ch. 1, 'Etruscan Banquets and Early Rome,' and n. 56; it may well have been the Phoenicians who were responsible for the original introduction of the reclining banquet here.

5. For the traditions of sitting to eat, see Marquardt 1886, 300; Blümner 1911, 386. Both refer to Isidor. *Orig.* 20.11.9, quoting Varro, *De vita populi Romani* F 30 Riposati: *apud*

veteres Romanos non erat usus adcumbendi, unde et consedere dicebantur; Serv. *Aen.* 1.79, 214, 708 (but the reference here is to heroic times); 7.176, again quoting Varro, *De gente populi Romani*: see Riposati 1939, 46, 140.

6. For the banquet in Rome of the Republic down to the third century BC, see Landolfi 1990, 15–49; the earliest references have a predominantly religious or cultual context. For archaic Rome, see ch. 1, nn. 68–70. Coarelli 1995, 207–8, assumes that the reclining banquet was known in archaic Rome, but does not quote sources. Several sources referring to the customs of the *maiores* in the good old days take reclining for granted: e.g. Cic. *Tusc.Disp.*4.3 (quoting Cato); Val.Max. 2.1.2; 2.1.9. A detailed study of the archaic Roman banquet and its relationship to Etruscan practices is announced as forthcoming: A. Zaccaria Ruggiu, *More Regio vivere. Il banchetto aristocratico e la casa romana di età arcaica* (Rome 2003/4).

7. *Lectisternium*: Liv. 5.13.6; Dion.Hal. *Exc.* 12.9; cf. Ogilvie 1965, 655–7. For goddesses the rite was later called *sellisternium*; that is, they were seated in chairs (*sellae*). Landolfi 1990, 22–8, thinks that the rite may rather have been of Etruscan derivation; Cèbe 1985 thinks that it combines Greek, Etruscan, and native Roman features.

8. See Landolfi 1990, 38, on the Hellenization of Roman table rituals in the fourth to third centuries BC (although he does not suggest that reclining was part of this process). Bek 1983, 84, states that 'this mode of reclining on the three couches during [a] meal had superseded the older Italic habit of sitting at table in the 3rd and 2nd centuries B.C., as a result of Greek influence', but quotes no evidence. Zaccaria Ruggiu 1995, 146–9, accepts that the practice of reclining on three couches ('il costume tricliniare') was known in Rome as a religious practice by the fourth century, but hesitates to see it as part of regular private practice much before the end of the third century, when it is attested in Plautus (see ch. 1, n. 9). Cf. also Liv. 24.16.16–19: after Ti. Gracchus' victory at Beneventum in 214 BC, the army is feasted publicly by the inhabitants of that city; the slave volunteers who had acquitted themselves well are described as dining *accubantes* (ch. 3, n. 7). The date of the appearance of a distinct room used only for dining is a separate problem: see ch. 2, n. 1.

9. For example, *Asin.* 828; *Bacch.* 720, 753–5 (where the reference is to a *biclinium*, serving the two young men and their girlfriends); *Trin.* 468–73. See Zaccaria Ruggiu 1995, 148, who points out that, although Plautus' comedies have a Greek setting, they presuppose that the Roman audience is familiar with the custom (although this does not necessarily imply that they followed it themselves).

10. Liv. 39.6.7–9; the spoils included the first triclinium couches inlaid with bronze to be seen in Rome. The same information in Plin. *HN* 34.8.14; 37.1.12. See Landolfi 1990, 51–73; Zaccaria Ruggiu 1995, 148–9.

11. On the political role of banquets in the late Republic, see Landolfi 1990, 75–110, and ch. 3; more generally on the social functions of Roman dining, see D'Arms 1984.

12. Cic. *Sen.* 13.45: *bene enim maiores accubitionem epularem amicorum, quia vitae coniunctionem haberet, 'convivium' nominaverunt*; the sentiment is repeated in *Ad Fam.* 9.24.3 (362 Shackleton Bailey). Cf. Stein-Hölkeskamp 2001, 364–5.

13. See ch. 3, nn. 1–3. Note that in the incident of Q. Aelius Tubero (129 BC), quoted in ch. 3, n. 37, it is an essential part of the story that couches are provided for the whole populace. Naturally, only the richest could afford munificence on this scale.

14. Many sources refer to the privilege of slaves being permitted to dine with their masters at the Saturnalia, or being waited on, as they dined, by their master or the latter's children; cf. M. Nilsson, *RE* IIA (1923), 205–6 s.v. Saturnalia. Although it is not stated that the slaves reclined on such occasions, that seems to be implicit in the custom. Columella

11.1.19, in the mid-first century AD, prescribes that a good *villicus* (overseer) should eat with his farmhands, and should not recline except on feast days, when however he should invite the best of the men to join him at table: presumably they too are then to recline. When Trimalchio towards the end of his dinner invites selected slaves to recline with the company, this seems to reflect a similar mark of favour, although characteristically it turns to farce as the whole *familia* crowds onto the couches (Petr. *Sat.* 70).

15. Cf., for instance, Lucian's description of the parasite, who earns his livelihood by flattery at dinners: his art is the most royal, because while other men work sitting or standing as if they were slaves to their art, the parasite exercises his art 'reclining like a king' (*Par.* 23).

16. Tac. *Agr.* 21.3. For the architectural form of rooms designed for reclining dining, see references in ch. 2, 'Greek and Roman dining rooms'; ch. 5, 'Rooms for Stibadium Dining.' See also ch. 1, 'Diffusion: The Roman Empire,' nn. 72–5, and ch. 4, nn. 10–12, for banquets in the Rhineland.

17. Possibly earlier is a Phoenician bronze bowl from Cyprus (Cesnola 4555), showing a formal banquet with the king reclining on a couch, his courtiers reclining on mattresses on the ground, while the queen's party sits apart: see Culican 1982; Matthäus 1999, proposing a date between the late eighth century and the mid-seventh century. For possible representations of banqueting couches on fragments of Cretan votive shields from the eighth century BC, see Matthäus 1999, 258.

18. British Museum 124920, 124922; Fehr 1971, 7–18, no. 1, pl. 1; Dentzer 1982, 51, 58–69, figs. 89–91; Barnett 1985; Reade 1995.

19. On the earliest appearances of the motif in Corinthian pottery, see Fehr 1971, 26–38; Dentzer 1982, 76–87.

20. For vase painting generally, see Fehr 1971, 26–106; Dentzer 1982, 76–153. On the theme in Attic vase painting, see Lissarrague 1990; Vierneisel, Kaeser 1990; and Klinger 1997; for South Italian, Hurschmann 1985.

21. For divine and mythological figures, see Dentzer 1982, 116–23; Carpenter 1995; for 'monoposiasts', see Steinhart, Slater 1997, with references.

22. Karaburun tomb II: Mellink 1972, 263–8, pls. 58–9; Mellink 1973, 297–301, pl. 44; ch. 4, n. 7. On the Greek reliefs, and the so-called Totenmahl motif, see Thönges-Stringaris 1965; Dentzer 1982, 223–557; Fabricius 1999; and ch. 4, nn. 5–10.

23. Friezes: Dentzer 1982, 230–40. Terracottas: Dentzer 1982, 163–216.

24. The literature is enormous: see the extensive bibliographies in Fehr 1971; Dentzer 1982; Murray 1990, 325–7; the review of Dentzer 1982 in Fehr 1984; and the works cited in ch. 1, nn. 20–2, especially Lissarrague 1990, and ch. 1, n. 29. For entertainment, see Schäfer 1997; for *hetaerae*, see ch. 1, n. 39.

25. Fabricius 1999, with bibliography; ch. 4, nn. 5–8.

26. To be published by M. Tsibidou-Avloniti, who has given lectures on this important discovery at colloquia of the Association Internationale pour l'Étude de la Peinture Murale Antique in Vienne, 1998, and at Somerville College, Oxford, in 2001. For brief preliminary accounts, see Tsibidou-Avloniti 1994; ead. 2002.

27. Ch. 2, 'Paintings of the Banquet in Pompeii and Herculaneum.'

28. For a fragmentary terracotta plaque with a banquet scene from the archaic period see ch. 1, n. 70. The sympotic scene on the Nile mosaic from Palestrina of the late second century BC is of pure Hellenistic derivation: Meyboom 1995, 33–4, 70, figs. 20–1. See also ch. 3, n. 7, for Livy's account of a painting of a banquet from 214 BC.

29. On the relationship between the sacrificial meal and the *symposion*, and their representation in the archaic period, see Schmitt Pantel 1990; on the transformation in the imagery at the end of the sixth century, see Schmitt, Schnapp 1982.

30. Assos: Dentzer 1982, 235–7, no. R 66, fig. 330. Tomb of the Diver: Napoli 1970; Rouveret 1974; Dentzer 1982, 245–8, no. R 342bis, figs. 584–6. Similar focus on drinking in the grave reliefs discussed in ch. 4, nn. 5–6.

31. Ar. *Eq.* 1187. Numerous passages from other comic poets are collected in Athenaeus 10.426–31; see further Wilkins 2000, 216–18. On the practice of mixing, as well as the proportions recommended, see Villard 1988.

32. For the interpretation of the *krater*, see especially Lissarrague 1990, 19–46; Lissarrague 1990a.

33. Marquardt 1886, 331–40; Blümner 1911, 400–19; A. Mau, *RE* IV.1 (1901), 610–19, s.v. *comissatio*, all with extensive sources but little attempt to distinguish between Greek and Roman custom: see further Dunbabin 1993, 128–9. On drunkenness and the *comissatio* as a 'culturally protective device to legitimize upper-class drinking', see D'Arms 1995.

34. For Roman food and cooking, see André 1981; Dosi, Schnell 1990; Salza Prina Ricotti 1983, esp. 204–34 on Apicius; for the role of food in Latin literature, see Gower 1993. On sumptuary laws, see Landolfi 1990, 52–67.

35. For Roman wine, see Tchernia 1986, especially 9–39 for its consumption; on the *grands crus* and their role as a mark of social discrimination, see Tchernia 1995.

36. Marquardt 1886, 331–6, with references.

37. I discuss this subject at length in Dunbabin 1993, esp. 127–9, with references. For hot water heaters (*authepsae*, also called *miliaria*,), see ch. 5, n. 77; for the use of ice and snow, see Turcan-Deleani 1964.

38. Cf. Bookidis 1990.

39. See Peschel 1987; Vierneisel, Kaeser 1990, 228–34; Schäfer 1997, 64–5.

40. Thönges-Stringaris 1965, 10, 16–18, 54–5; Dentzer 1982, 286–7, 316–22; Fabricius 1999, 22–3; ch. 4, nn. 5–8, 27.

41. Cic. *Verr.* 2.1.26.66. Cf. also Corn. Nepos *Praef.* 6–7: *quem enim Romanorum pudet uxorem ducere in convivium?*, in contrast to the behaviour of Greek women.

42. Cf. Marquardt 1886, 66, 300–1, 339. The classic sources for women sitting to dine in the good old days are Val. Max. 2.1.2: *feminae cum viris cubantibus sedentes cenitabant*; and the passage of Varro quoted by Isidorus (*Orig.* 20.11.9, ch. 1, n. 5), which continues: *postea, ut ait Varro de vita populi Romani, viri discumbere coeperunt, mulieres sedere, quia turpis visus est in muliere accubitus.*

43. Cf. Griffin 1985, chs. 1–6.

44. Dio 55.2.4; 55.8.2, at the dedication of the Portico of Livia in 7 BC; 57.12.5, when Livia dedicated an image to Augustus after his death in 14 AD: Dio records that Livia had wanted to give a banquet for the Senate and *equites* together with their wives, but Tiberius had insisted on entertaining the men himself and limiting her to the women. On other occasions, however, the senators and their wives were indeed entertained together at banquets; for example, by Gaius in 37 AD: Dio 59.7.1. See also ch. 3, nn. 2, 6.

45. See Bradley 1998, 47–8, but none of the sources that he quotes can be taken as reliable for normal contemporary practice, still less can the evidence of the funerary reliefs to which he refers be taken uncritically at face value (see ch. 1, n. 46). Nevertheless, it is likely to be true that conventions varied according to date, class, region, and occasion.

46. For example, ch. 2, 'Food, Drink, and the Role of women in the Campanian Paintings'; ch. 4, 'The position of women: Urns, Altars, and Reliefs'; ch. 6, nn. 22, 25.

47. Drinking '*graeco more*': Cic. *Verr.* 2.1.26.66, on which see Dunbabin 1998, 81 with n. 1; none of the proposed explanations is convincing.

48. See Rotroff 1996, especially her conclusions 25–7.

49. For Greek gastronomy, see Dalby 1996; for Roman reception of Greek cooking, see André 1981, 216–25, and ch. 1, n. 34.

50. See Griffin 1985, esp. ch. 1; also Murray 1985, for the relationship between Greek and Roman in the sympotic poems of Horace. For the importation of Hellenistic convivial luxury into Rome, see ch. 1, n. 10. For the view of banquets and drinking as characteristically Greek, cf. also the explanation in Festus (p. 235 Lindsay): *pergraecari est epulis et potationibus inservire*. For the architectural relationship between Hellenistic and Roman dining rooms, see ch. 2, 'Hellenistic Dining Rooms.'

51. Ch. 1, n. 41.

52. For the extent of participation of women in public banquets, see Van Bremen 1996, 155, revising the more negative conclusions of Schmitt Pantel 1992, 397–8. Cleopatra: e.g. Plut. *Ant.* 26.3–4; 58.5; 59.4; Ath. 4.147f–148b.

53. The role of the banquet in Etruria and central Italy has attracted much attention recently. For a summary and bibliography, see Cristofani 1987, and the works cited in ch. 1, nn. 55–58. Only a few aspects can be indicated here; in any longer treatment, more account would need to be taken of chronological and regional variations.

54. Tuck 1994, who compares the terracotta figures seated on rock-cut thrones behind tables in the Tomb of the Five Chairs at Caere from the last third of the seventh century BC, and the custom found in the area of Chiusi of placing bronze or terracotta cinerary urns on thrones with banqueting equipment before them, as a way of representing the dead partaking of a funerary meal. For banqueting equipment in graves in Etruria and other parts of central Italy, see references in Cristofani 1987; and see ch. 1, n. 68. A reclining figure of a man on the lid of a terracotta ash urn dating from 630–20 BC is mentioned by S. Haynes, *JRS* 92, 2002, 211. This becomes the earliest known representation in Etruscan art of feasting while reclining, and may even be slightly earlier than the earliest known representations in Greece.

55. Small 1971; Rathje 1994; Rathje 1995. At Murlo, the banqueters are shown reclining from left to right, the reverse of the normal direction; this is the result of the craftsmen's inexperience with the use of the mould for motifs of the sort, and is corrected on the later series of plaques. Acquarossa plaques: Small 1971, 42–3, pl. 21a; Stopponi 1985, 57–9, nos. 1.33, 1.34. See also ch. 1, n. 70, on the further group from Latium.

56. See especially Rathje 1994; Rathje 1995; on the Phoenician forerunners, see Rathje 1991; Culican 1982, esp. 20–1.

57. For the archaic monuments generally, see De Marinis 1961, who draws attention to many specific parallels in Attic and East Greek art. For the Tarquinian painted tombs, see Weber-Lehmann 1985; Stopponi 1983, 42–65; for the Chiusine reliefs, Jannot 1984, esp. 362–8. On the interpretation of the imagery, see D'Agostino 1989.

58. On the problem of the banquet with food as opposed to the *symposion*, see Rathje 1995. Small 1994 argues strongly that the representations should not be interpreted as a Greek-style *symposion*; but she tends to read some of the images too literally as portraying a specific moment in time. For the absence of food in the Tarquinia paintings, see Weber-Lehmann 1985, 33–6. Tomb of the Lionesses: Steingräber 1986, 316–7, no. 77, pls. 97–104; Weber-Lehmann 1985, 38–9; ca. 520 BC. The eggs held by some of the diners here and in some other tombs have been interpreted in various ways, realistic or symbolic; they cannot necessarily be taken as indications of an actual meal. For the role of wine and the 'exaltation of the *krater*', see D'Agostino 1989, 6–7; Briguet 1989, 229–30.

59. Tomb of Hunting and Fishing: Steingräber 1986, 293–4, no. 50, pls. 41, 46; Weber-Lehmann 1985, 24–5, 32, pls. 5.4, 12; ca. 510 BC. Caere sarcophagi in the Louvre and Villa Giulia: Briguet 1989, esp. 105–45, 227–39. See ch. 4, n. 45.

60. Tomb of Leopards: Steingräber 1986, 319, no. 81, pls. 105–9; ca. 480/70. Tomb of Triclinium: Steingräber 1986, 352, no. 121, ca. 470. Tomb of the Ship: Steingräber

1986, 327–8, no. 91, pls. 118–20, dated there to the end of the fifth century. On the identification of the women, see Small 1994, 87–9, with references to earlier arguments, and the conclusion that the women diners in, for instance, the Tomb of the Leopards are most probably not mistresses of the men but members of the extended family. For a group of women reclining separately from the men, see the unusual scene of funeral cult in the Tomb of the Funeral Couch: Steingräber 1986, 319–20, no. 82; Weber-Lehmann 1985, 40–1, pls. 28.2–29.

61. Aristotle Fr.704 Gigon = Ath.1.23d describes the Etruscan women banqueting with their men reclining under the same mantle; Theopompos, *FGH* 115 F204 = Ath.12.517d speaks of them dining with men who are not their husbands, and drinking toasts to whomsoever they choose. Both passages belong in the context of Greek denunciation of the Etruscans for luxury and immorality.

62. The difference between Greek and Etruscan behaviour in this respect is clearly recognized on a group of Attic black-figure *stamnoi* of the late sixth century known as the Perizoma Group, which were designed for the Etruscan market; they show men and women, respectably dressed, reclining together on mattresses on the ground. See Shapiro 2000, 330–3.

63. Orvieto, Golini Tomb I: Steingräber 1986, 278, no. 32, pls. 3–7; mid-third quarter of fourth century BC.

64. Greek reliefs: ch. 1, n. 40. For the rare earlier Etruscan representations of the scheme, see Weber-Lehmann 1985, 42–4; for its use on stone cinerary urns from the region of Chiusi in the late fifth and early fourth centuries, see Cristofani 1987.

65. Tomb of Shields, Larth Velcha with his wife, Velia Seitithi, and his parents, Velthur Velcha and Ravnthu Aprnthai: Steingräber 1986, 341–3, no. 109, pls. 145–9; third to fourth quarter of fourth century BC.

66. See Nielsen, M. 1993, 336. The banqueting scenes on the chests of funerary urns need further study; they include Ulysses and the suitors, and a scene normally but perhaps erroneously identified as Melanippe the Wise: see van der Meer 1977–8, 72, 79.

67. Nielsen, M. 1975; see further ch. 4, n. 46.

68. Rathje 1983; Gras 1983.

69. Later Roman tradition represented the young Tarquin princes as indulging in banquets and drinking sessions, *conviviis comisationibusque*, while the king's daughters-in-law (unlike the virtuous Lucretia) were discovered, in the absence of their husbands, passing their time *in convivio luxuque* (Liv. 1.57.5–9). See Landolfi 1990, 42–5.

70. Small 1971, 43–5, pls. 21.b, 22.c; Gantz 1974, figs. 5, 10, 40, 42; compare ch. 1, n. 55. On archaic Rome, see also Coarelli 1995, and see ch. 1, nn. 5–6.

71. Ch. 4, nn. 15, 44–6. It has also been suggested that the reliefs with scenes of feasting discussed in ch. 3, 'Monuments of Public Banquets at Este and Sentinum' and 'The Amiternum Relief,' are influenced by Etruscan models, but this is not convincing: see Felletti Maj 1977, 303–4, against Giuliano 1963–4, 37.

72. For the banqueting type on military gravestones of the first century to second century AD and its later development in the civilian sphere, see Noelke 1998, with earlier references. For the general scheme (the so-called Totenmahl), see ch. 4, nn. 10–12.

73. Mainz, LM S 50: Boppert 1992, 158–61, no. 52, pl. 45; early Flavian. Alt-Kalkar, now in Bonn, RLM 38.436: Bauchhenss 1978, 44–6, no. 29, pl. 30; Trajanic.

74. See references in Noelke 1998, 409–11.

75. Noelke 1998, 416–18, following many previous German scholars, argues that the motif reached the Rhineland from the Hellenized East, and most probably from Thrace and neighbouring regions, carried by auxiliary soldiers from these areas. It has also frequently

been assumed that the motif automatically carried with it associations of heroization in the next world; but see ch. 4, 'The Monument of Flavius Agricola and the Tradition of the Totenmahl Motif' and 'Dining and Drinking in Tombs,' for the difficulties of interpretation of the motif and the dangers of assuming any one single underlying significance.

CHAPTER 2

1. For dining rooms of the archaic period in sanctuaries in Greece, see Bergquist 1990; Hoepfner 1999, 143–8, believes that *andromes* can be identified in domestic architecture in Ionia as early as the seventh century. See also ch. 2, nn. 3–5. On the appearance of the triclinium in Roman domestic architecture, see ch. 2, nn. 23–4; cf. also ch. 1, n. 8.

2. I discuss many of these changes in earlier studies: Dunbabin 1991; Dunbabin 1996; Dunbabin 1998; here I summarize those arguments more briefly.

3. For the typical Greek *andron* of the classical period, see Bergquist 1990, 37–8, 44, with references; Dunbabin 1991, 121–2; Hoepfner, Schwandner 1994, 327–8; Dunbabin 1998, 82–3.

4. Olynthos: Hoepfner, Schwandner 1994, 98–9, 108–10.

5. Eretria: Ducrey, Metzger, Reber 1993, 46–7 (House of the Mosaics, rooms 5, 7, 8–9); Reber 1998, 134–6 (West district).

6. *Triclinium* (cf. *OLD* s.v.) is used both for the arrangement of the three couches and for the room capable of containing such an arrangement; the former is evidently the primary sense. In later Latin, it comes to mean simply the room in which one dined, regardless of the nature of the couch arrangement. For the sense of an arrangement of three couches, see e.g. Varr. *LL* 9.4.9; other sources in Dickmann 1999, 30–3. Leach 1997, 67–8, discusses briefly the literary sources for *triclinium* (= dining room) and the other main Latin term for a dining room, *cenatio*, which she believes usually designates a large and grandiose room. The relationship of the term to the Greek *triklinos*, etc., needs closer analysis; cf. also Dunbabin 1998, 88–9. Zaccaria Ruggiu 1995, 151, n. 65, claims that 'Il nome al triclinio viene dalla presenza del letto a tre posti'; I know of nothing to support this. In what follows, I use *triclinium* to refer primarily to the three-couch arrangement, and secondarily to rooms identifiable as designed for such an arrangement.

7. Zaccaria Ruggiu 1995; Dickmann 1999, 95–7, 215–19, with references. Cuttings in the wall for couches: e.g. Mau 1885, 69–71; Richardson 1955, 46–8 (House of the Dioscuri); cuttings and feet of couches: Maiuri 1927, 45–9, 79–80 (House of the Ephebe); remains of continuous couch around three sides, with wooden feet faced with silver fixed in the floor: Overbeck, Mau 1884, 317 (House of M. Lucretius). In the dining room of a villa at Boscoreale, the remains of three couches were found, with traces on the floor that indicated their position: Pernice 1900, 178–80. Pavements: see Dunbabin 1991, 123–4, with n. 17.

8. House of the Moralist: Spinazzola 1953, II, 750–6, figs. 731–2. House of the Crypto-porticus: Spinazzola 1953, I, 121–2, 442–5, figs. 149, 499; this may have belonged to a commercial establishment such as an inn rather than a private house, but the basic form is the same. For a list of masonry triclinia at Pompeii, see Soprano 1950, updated by Jashemski 1979, 346, n. 1.

9. For couches with *fulcra*, see Faust 1989; Pirzio Biroli Stefanelli 1990, 68–79; Mols 1999, 100–4. Remains of three couches with *fulcra* from the triclinium of the House of C. Vibius at Pompeii (VII 2.18): Faust 1989, 186–7, nos. 223–224A, now in Naples, Museo Nazionale Inv. 78614–78616. For their arrangement to make up the set of three, see Mau 1896, 76–80, who argues that the *fulcra* were confined to the two outer ends

of the set, and served to hold the mattress in place, not to support the head and arm of those reclining in the highest positions.

10. See discussion in Mols 1999, 35–43; 124–7. The only wooden furniture to survive in any quantity is that from Herculaneum, which Mols publishes; the beds/couches found there are almost entirely the type with boards. This type is frequently represented on the Roman funerary reliefs of the first and second centuries AD with banqueting figures; see ch. 4, n. 16. It is difficult to see how they could have been used in a formal triclinium, because the boards would seem to make it impossible for several diners to recline in comfort on one couch. Two examples are found at Herculaneum of apparent *biclinia*, i.e. two couches adjoining at right angles: a style of dining presumably used in simpler circumstances or where there was less space. However, the remains of bronze fittings from couches attest to the existence in Herculaneum of the more elaborate type of couch with *fulcrum*; although only once, in the House of the Corinthian Atrium, was there clear evidence of the three couches of a triclinium (ibid. 125, 251). Numerous problems arise over the use of these various types of furniture in practice, and their relationship to representations in art; I hope to return to some of them in more detail later.

11. Mau 1885, 69–71, gives a range between 2.25 and 2.80 m for the length of cuttings and other traces in the walls at Pompeii and between 1.20 and 1.50 m for the breadth; the couches themselves would be a little less. See also Mols 1999, 37–8, with slightly smaller dimensions for preserved beds and couches at Herculaneum, but many of these are beds rather than dining couches. In the masonry triclinia at Pompeii, the couches are often substantially longer; in the House of the Cryptoporticus, for instance, the maximum length is 4.68 m for the two side couches, 4.41 m for the central. They still have only one small table and do not normally provide space for a larger number around it. See the dimensions given in the list of Soprano 1950.

12. Marquardt 1886, 302–6; Blümner 1911, 387–9; A. Hug, *RE* VII A (1948), 92–101, s.v. *triclinium*. Needless to say, these norms were not always observed, and there was more flexibility and change than the handbooks indicate; but it is evident from the sources that this general pattern was considered the ideal. Trimalchio's dinner diverges from the norm in both the number of guests (at least 14) and in their placing (Petr. *Sat.* 31.8: the first place is reserved for Trimalchio in the new fashion, *novo more*); the attempts of some commentators nevertheless to indicate their distribution in a traditional triclinium of nine are surely misconceived (e.g. M. Smith *ad loc.*). Maiuri 1945, 159–60, saw that the numbers are more appropriate for the sort of big triclinium that appears in Pompeii in the Neronian period (cf. ch. 2, n. 15), and which must have brought with it changes in the order of reclining. At the same time, Petronius is undoubtedly also implying that Trimalchio has yet again got it wrong.

13. D'Arms 1990; see further my discussion in Dunbabin 1998, 89. Dickmann 1999, 291–6, stresses the fluidity of etiquette over the course of the banquet. For lying in the lap of one's neighbour, cf. Plin. *Ep.* 4.22.4: when the Emperor Nerva was dining with a few friends, Fabricius Veiento *proximus atque etiam in sinu recumbebat*.

14. For example, Gell. 13.11.2: no fewer than three, the number of the Graces, no more than nine, the number of the Muses; but he is quoting a saying of Varro (Fr. 333 Bücheler) from the first century BC. Cf. also *SHA Ver.* 5.1, with another maxim claiming seven as the ideal number rather than nine: *septem convivium, novem vero convicium* (note that the passage makes the improbable claim that Verus was the first to have twelve guests recline together).

15. Dickmann 1999, 320–2; Mau 1883, 80, mentions a triclinium, identified as such by its pavement design, with room for at least twelve guests. There can be little doubt that in the late Republic the houses and villas of the Roman nobility contained magnificent

halls which could be used for dining and which were capable of holding much larger numbers, but such rooms seem to have been multifunctional; the rooms which are marked out specifically to hold dining couches at this earlier period are designed only for the traditional small group, even the grand colonnaded *oeci* found in a few houses. See further Dunbabin 1996, 68–70.

16. On peristyle houses, see Meyer 1999, esp. 113–15, with earlier references. For the changes and the potentially much larger numbers that the dining rooms of the High Empire would hold, see Dunbabin 1991, 125–8; Dunbabin 1996, 72–4; for North Africa, see esp. Rebuffat, Hallier 1970, 290–301, 317–27, 334–5; Thébert 1987, 364–78.

17. Dulière, Slim et al. 1996, 4, 10–18: no. 1, plan 1, pls. I–VIII, LIX–LXIII; late second century to early third century AD. The bands for the couches measure 6.85 × 1.60 m at the sides and 5.87 × 1.43 m at the back.

18. Casa dos Repuxos: Bairrão Oleiro 1992, 19–20, 110–16, no. 10, pls. 39–43; end of second century to beginning of third century AD. The couch bands here are 1.70 m wide.

19. Individual tables: cf. ch. 2, nn. 57–8. Ledges along the front of couches: e.g. those along the masonry couches in the Caseggiato dei Triclinii at Ostia (ch. 3, n. 68) and the sanctuary of Apollo Hylates at Kourion (ch. 2, n. 32); cf. Dunbabin 1991, 127–8. They occur already on some of the outdoor masonry couches at Pompeii, e.g. in the House of the Cryptoporticus (ch. 2, n. 8), but are combined there with a small central table.

20. The design of the mosaic pavements not infrequently takes account of the placement of the most honoured guests on the central couch, with figured motifs or panels set to be seen from this viewpoint: e.g. Dunbabin 1991, 126; J. Dobbins, in Kondoleon 2000, 51–61, who shows that vistas toward fountains and other decorative features beyond the triclinium are also often calculated to be seen best from the places of honour. Two contrasting methods of planning triclinia are distinguished by Bek 1983, one stressing the view outward, the other that inward to the spectacle of the banquet itself. The second she believes to be especially characteristic of imperial banquets, but it is also applicable to the typical domestic triclinium of the mid-Empire; the two approaches can coexist.

21. For instance, the House of the Triumph of Neptune at Acholla in Africa Proconsularis contains a small triclinium (4.50 × 5.15 m) alongside a huge colonnaded triclinium-*oecus*, both clearly marked out by their pavements: Gozlan 1992, 93–113, 175–208.

22. On the origins and early development of *stibadium* dining, and the architecture that accompanied it, see Dunbabin 1991, 128–36; Morvillez 1996; see further ch. 5, 'The Hunting Plate in the Sevso Treasure' and 'Rooms for Stibadium Dining.' Martial, 10.48.6, and 14.87 describes *sigma* couches holding, respectively, seven and eight diners. See also ch. 2, nn. 54–5, for scenes of outdoor dining on a *stibadium* cushion. I use the term *stibadium*, like *sigma*, to refer to the semicircular couch, or to the cushion used outdoors on the ground by itself, despite the arguments of Amedick (1993, 1994, 112–5) that the term should be applied to all outdoor installations for dining regardless of shape, and even to the big T + U triclinia of the High Empire, which she sees, mistakenly in my view, as an extension indoors of the outdoor fashions: for arguments against this, see Dunbabin 1996, 70, n. 22; 1998, 100, n. 33.

23. The older view is represented by Bek 1983, who believes that there were no identifiable triclinia in the oldest Pompeian houses, 'for the reason probably that at this remote age the atrium or the tablinum still functioned as the representative backdrop for the festive meal' (84). The information concerning the *tablinum* comes from Varro (*De vita populi Romani* F 29 Riposati), talking about a time of unspecified antiquity, and in a passage whose terminology is somewhat problematic (see Riposati 1939, 137–40); while Servius, *Aen* I.726, quotes Cato as saying that the ancients (*antiqui*) used to dine in the atrium, also clearly referring to the distant past. On the whole question and the origins

of the triclinium in Roman domestic architecture, see Lafon 1989; Zaccaria Ruggiu
1995, who agree that triclinia of this form are identifiable at least by the second century
BC.

24. Bek 1983, 84; Zaccaria Ruggiu 1995, 146–9.

25. D'Ambrosio, De Caro 1989, 190, 194–7, fig. 36.

26. On the problems of the Delian broad rooms, also known as *oeci maiores*, see Dunbabin
1998, 82–9; Trümper 1998, 17–8, 146–50. Hoepfner 1999, 518–20, identifies many of
them as the Cyzicene *oeci* of Vitruvius 6.3.10, with space for two triclinia (i.e. arrange-
ments of three couches, of the regular Roman type) side by side, or a single central
triclinium. He believes the triclinium with three broad couches close packed around
a single table to have been a Hellenistic invention, developed by Hellenistic kings and
adopted subsequently by the Romans. But the feasts of Antiochos IV Epiphanes in 166/5
BC with 1000 and 1500 *triklina*, which he quotes in support of this theory (Ath. 5.195d =
Polyb. 31.4.3 [30.26.3]), are remarkable as an example of the philo-Roman tendencies of
that monarch and cannot be used as evidence for the Hellenistic origins of the practice.

27. Like the question of the date at which the Romans adopted the practice of reclining to
dine (see ch. 1, nn. 6–9), this subject needs further investigation, especially in light of
recent excavations of domestic architecture from many towns in central Italy, for which
see the summary in Pesando 1997, 255–305. The exceptional representation of three on
a couch on the revetment plaques from Acquarossa (ch. 1, n. 55) appears to show that
this aspect of the custom at least may be known in Etruria in the sixth century BC.

28. Hoepfner 1996, 11–7, fig. 5, with attribution to Philip II; ibid. 24–5, 29–31, on the
provisions for banqueting in the palaces at Pergamon and Pella. See also Nielsen, I.
1994, 81–99.

29. See Dunbabin 1998, 96–8; Nielsen, I. 1998, 116–19. Jericho: Nielsen, I. 1994, 155–63;
181–208, with references; Netzer 1999, esp. 25–7, 32–3, 45–7; cf. also the promontory
palace at Caesarea: Gleason 1998, 29–48.

30. Börker 1983; Brauron: ibid. 17–18, fig. 19, with references in nn. 72–3; Bergquist 1990,
37–8.

31. Bergquist 1990.

32. For the type, see Will 1976; sanctuary of Apollo Hylates, ibid. 361–2, fig. 5. For other
examples from Semitic contexts related to this type, although varying in specific plan
and dating to the Hellenistic or early Roman periods, see e.g. Will 1985, 114–19 (Delos,
sanctuary of Syrian goddess); Will 1997 (Palmyra, sanctuary of Bel).

33. For the setting of Greek public banquets, see Schmitt Pantel 1992, 304–33.

34. For tents, see Salza Prina Ricotti 1989. Pavilion of Ptolemy Philadelphus: Ath. 5.196a–
197c; Studniczka 1914.

35. Ch. 3, 'Settings for Public Dining.'

36. Cf. ch. 1, nn. 24, 29, and see Klinger 1997, for figures reclining on the ground. For
South Italian scenes with more than two diners apparently on a single couch or bench,
see Hurschmann 1985, e.g. K 14, pl. 4.1; A 54, pl. 15; K 39, pl. 25.

37. For late Hellenistic relief sculpture showing a numerous banqueters on a continuous
bench, evidently participating in a cult banquet, see Dentzer 1982, 517, figs. 727–8; also
Ghedini 1988, on an earlier relief (perhaps fourth to third century BC) from Golgoi on
Cyprus, with banqueters reclining on the rocky ground, which she interprets as a scene
of the cult of Apollo Magirios.

38. See ch. 1, 'Hellenistic Practice'; for the trickle-down effect in Pompeii, see Zanker 1979.

39. In addition to the paintings discussed in ch. 2, nn. 41–52, the following may be noted:
Naples, MN 9016, allegedly from Pompeii I 3.18 (but see Varone 1997, 149, for problems
with an attribution to this house), Ward-Perkins, Claridge 1976, no. 262. Naples, MN

9254, from Pompeii VI 9.2, *PPM* IV (1993), 689, fig. 61. Naples, MN 111209, from Pompeii VI 14.28–33, Pozzi et al. 1986, 170, no. 341; *PPM* V (1994), 357, fig. 21. Naples, MN 8968, from Pompeii VIII 2.39, Pozzi et al. 1986, 136, no. 89 (not the death of Sophonisba but a convivial scene: see O. Brendel, *AA* 1935, 563–5); *PPM* VIII (1998), 354–6, fig. 92.

40. On these grave monuments, see ch. 1, n. 22; ch. 4, 'The Monument of Flavius Agricola and the Tradition of the Totenmahl Motif'; as will be seen in ch. 4, the motif continues to be used for several centuries in the Roman world in funerary contexts, but does not necessarily represent contemporary practice.

41. Casa dei Casti Amanti: Varone 1993, esp. 622–9; Varone 1997. For the identification of the building as a bakery, see Varone 1989, 231–7, with the suggestion that the triclinium may have been rented out for public use; Varone 1990, 202–8. Cf. ch. 3, n. 79, for further discussion.

42. Naples, MN 9015 (Helbig 1868, no. 1445): Varone 1993, 627–8, pl. CLVIII; Varone 1997, correcting the origin from house I 3.18 given in his earlier article (see ch. 2, n. 39); its real provenance is not known.

43. For the role of silverware in these paintings, and its relationship to surviving examples of Roman silver, see Tamm 2001; the similarities to actual vessels are those of general configuration rather than exact imitation. I have benefited from many discussions with John Tamm concerning these questions, and in general from his work on these paintings.

44. See Tamm 2001, 69–71. This method of cooling is found also in Etruscan banquet scenes, for example, on the archaic reliefs from Chiusi: see Wiel Marin 1997.

45. Helbig 1868, no. 1447, from house IX 1.22, now lost: Varone 1993, pl. CLVI, 1–2.

46. Naples, MN 9024: Pozzi et al. 1986, 170, no. 340, pl. p. 65.

47. For the silverware, see Tamm 2001, 168–9, with parallels for the individual pieces drawn from various points over the previous 150 years; for horns, ibid. 107–8, 179–86. Glass drinking horns survive from the relevant period, but no silver examples are known; their appearance in these paintings seems to have special connotations of extravagance and excess.

48. Fröhlich 1991, 33, 179–81, 299 Cat. LIII, pl. 48.1; R. Tybout, review of Fröhlich 1991, *JRA* 9, 1996, 372, suggesting that the occasion is the festival of the Lares, rather than the Saturnalia as proposed by Fröhlich. Early Augustan; now destroyed.

49. Naples, MN 120029, 120030, 120031; Fröhlich 1991, 222–9, pls. 20.2, 21; *PPM* III (1991), 813–18, figs. 38, 41, 47. 120030 is badly preserved and the details especially unclear.

50. Pozzi et al. 1989, 146, no. 252; cf. also nos. 250, 251; Jashemski 1979, 92–3, 113, figs. 148–9, 184; for a similar statue holding a tray found in the House of Julius Polybius, see *PPM* III (1991), 798.

51. *CIL* 4.3442: *facitis vobis suaviter; ego canto; est ita valeas.* The first scene contains similar words as graffiti above the characters: *scio, bibo,* and *valetis* (CIL 4.4123).

52. On the identification of the building, see Fröhlich 1991, 227–8; Eschebach 1993, 130–1, with references.

53. Naples, MN 9193, 9207 (Helbig 1868, nos. 757, 759); Jashemski 1979, 97, 177, figs. 153, 262, 263; Varone 1997, 150, figs. 4–5; Pozzi et al. 1986, 160, no. 267. No. 9193 is badly preserved, but the edges of the couches are just visible, suggesting that they are to be understood as the rectilinear couches of a triclinium (as they are portrayed in the Helbig drawing), rather than a built-up *stibadium*. Here and elsewhere, however, the distinction is far from clear; the painter is concerned to get the impression of the group reclining in an approximately horseshoe or semicircular arrangement, rather than with the exact structure of the couches.

54. On all these, see Dunbabin 1991, 133–4, with nn. 88–93; Ghedini 1990, 48–51, figs. 26–8.

55. House of the Ephebe: Maiuri 1938, 24–5, pls. IV.1, V.2; *PPM* I (1990), 722–3, nos. 179b, 181. House VIII 5.24: Schefold 1962, 151, pl. 144; Varone 1997, 151, fig. 6; *PPM* VIII (1998), 606–7, no. 5.

56. Meyboom 1995, 33–4, with nn. 127–39, fig. 21, quoting references for Canopus and its pleasure houses as a symbol of Alexandrian licentiousness.

57. Museo Campano, Capua: Robotti 1974, 100–3 (dating it much too early to the late Republic); Johannowsky 1989, fig. p. 263, with a more plausible dating to the Flavian period. Nothing, regrettably, is known of its original location, but it looks as though it were intended as the centrepiece of a larger floor, and might very well have occupied this place in a triclinium.

58. Petr. *Sat.* 34.5: *itaque iussi suam cuique mensam assignari.*

59. A regular *stibadium* couch, rather than simply a bolster on the ground, is often identified in a lost painting from Pompeii (*bottega* on the Via Nolana), known only from a nineteenth-century engraving, which shows the guests reclining under a pergola: Åkerström-Hougen 1974, 116–17, fig. 73; cf. Dunbabin 1991, 133–4, with n. 87. I believe that the outline of the front of the couches suggests that a triclinium rather than the semicircular *stibadium* is meant, but in the absence of the original painting, certainty is obviously impossible.

60. See ch. 3, 'Monuments of Public Banquets at Este and Sentinum' and 'The Amiternum Relief,' for reliefs showing triclinia from Este, Sentinum, and Amiternum. Tomb of Vestorius Priscus: ch. 3, nn. 38–42.

61. See ch. 1, 'Wine and Women in Greece and Rome.'

62. Croisille 1965; Pozzi et al. 1986, 164–5, nos. 290–9. Pl. V shows one of a series of four panels from Herculaneum, with various foodstuffs including gamebirds and poultry, a hare, and a pile of eels, as well as fruit and mushrooms: Naples MN 8647, Pozzi et al. 1986, no. 295. Fig. 32 shows a panel from Pompeii, unusual in including a prepared dish of small fish: Naples MN 8634, ibid. no. 297.

63. Plin. *HN* 10.133 records that Apicius introduced the taste for flamingoes' tongue, and the dish remained an example of spendthrift luxury for the moralists. A recipe for flamingo (applicable also to parrot) is preserved in Apicius 6.232–3; see the note of J. André in the Budé edition ad loc. (1974). Dormice: Petr. *Sat.* 31.10; Plin. *HN* 29.118, 135 (medicinal uses); Varr. *RR* 3.15.2 (on *gliraria*); Apicius 8.397; cf. André 1981, 119–20. Trimalchio's boar/sow: Petr. *Sat.* 40.

64. Vitr. 6.7.4; see R. Hanoune, in Balmelle et al. 1990, 7–13.

65. Plin. *HN* 36.184.

66. Vatican, Museo Gregoriano Profano. See Dunbabin 1999, 26–7; Moormann 2000, 80–94, with full references and discussion of the theme.

67. See Pirzio Biroli Stefanelli 1991, esp. 62–77; Baratte 1986; Baratte 1998. Boscoreale, skeleton cups: ch. 4, n. 78. For the silverware in the paintings, the extent to which it appears to represent real objects and practices, and the conclusions can be drawn from its portrayal, see Tamm 2001.

68. For example, a bowl of this type stands on the table, accompanied by smaller drinking cups and by implements such as a ladle, on the two earlier paintings from the House of the Chaste Lovers at Pompeii and the replica of the outdoor scene (ch. 2, nn. 41–2; Pls. I, II, Fig. 26), and on the painting from Herculaneum (ch. 2, n. 46; Pl. III). See Tamm 2001, 67–8, 189–90; ch. 1, n. 48, for Hellenistic practice. Contrast ch. 3, n. 44, for the big crater painted in the Tomb of Vestorius Priscus at Pompeii (ch. 3, Fig. 44).

69. Ch. 2, n. 44.

70. See Dunbabin 1993, 120–7; ch. 1, n. 37; ch. 5, n. 77.
71. For the ambivalent position of the heroines of Latin love poetry and the character of the Roman demimonde, see e.g. Griffin 1985, ch. 1, 6; the Pompeian paintings just discussed refer in similar fashion to the ideal of a hellenized 'life of love'.
72. Capua mosaic: ch. 2, n. 57. See also one of the paintings from the House of the Triclinium (no. 120030), ch. 2, n. 49. More enigmatic is the painting Naples, MN 9016 (ch. 2, n. 39), which shows four or five women at a drinking party, one playing the double flute, another standing and brandishing a ladle.
73. See ch. 1, 'Wine and Women in Greece and Rome'; ch. 4, 'The Position of Women: Urns, Altars, and Reliefs'. The relief showing the Vestal Virgins at a banquet, discussed in ch. 3, nn. 4–6, belongs to a different tradition, but is important in showing that representations of such a scene could exist.
74. Levi 1947, 186–90, pl. XLIIa–b, from the House of the Boat of Psyches, ascribed to the period 235–312; Kondoleon 2000, 71–4, fig. 7. Now in Baltimore Museum of Art, 1937.127. The room it came from does not have a triclinium plan and looks more like an elegant *cubiculum*.
75. Levi 1947, 197–8, pl. XLIIId; Levi 1944; also ascribed to 235–312. The house from which it came was not further excavated and the mosaic was not preserved. The three *Chronoi* are labelled *Parōchê̄menos*, *Enestōs*, and *Mellōn*; they share a single couch, which may reflect current practice but is also dictated by the theme because the three together form a unit. The table in front is replaced by an incense burner.
76. Levi 1947, 201–3, pl. XLVc, from the House of Menander; Kondoleon 2000, 156 no. 40, proposing a date ca. 250–75. The room is small, but might have served as a private dining room for an intimate group. For Menander and Glykera, see Friend 1941.
77. Atrium House, triclinium: Levi 1947, 21–4, pl. Ia, probably early second century AD; Kondoleon 2000, 62, 66–71, 168–75 nos. 55–60. House of the Drinking Contest, triclinium: Levi 1947, 156–9, pl. XXX, probably early third century. For other Dionysiac banquets on mosaics in the Eastern Empire, especially Dionysus and Ariadne, see P. Canivet, J.-P. Darmon, 'Dionysos et Ariane', *MonPiot* 70, 1989, 10–28; add the magnificent mosaic discovered at Zeugma on the Euphrates: S. Campbell, R. Ergeç, 'New Mosaics', in: D. Kennedy ed., *The Twin Towns of Zeugma on the Euphrates. Rescue work and historical studies* (Portsmouth RI, 1998), 109–17.
78. On house plans at Antioch, see Stillwell 1961 (but note that he classifies many rooms as triclinia that seem too small for any but the most intimate gathering and whose layout does not conform to the standard plan); J. Dobbins, in Kondoleon 2000, 51–61; see also Dunbabin 1991, 126, with n. 35.
79. Ch. 2, n. 57; cf. ch. 3, 'Monuments of public banquets at Este and Sentinum' and 'The Amiternum relief,' for a different tradition.
80. See ch. 5.

CHAPTER 3

1. For public dining during the Republic, see Landolfi 1990; under the Principate, Donahue 1996; for banquets as part of religious ceremonies, Scheid 1985; for the distribution of meat (*visceratio*), Kajava 1998.
2. Crassus: Plut. *Crass.* 12.2. Caesar: Plut. *Caes.* 55.2. Tiberius: Dio 55.2.4. Cf. D'Arms 1998, with other examples; Donahue 1996, 44–5; also D'Arms 2000a. Although the actual numbers given in the sources may not be reliable, D'Arms (1998) shows that there is no need to question the general order of magnitude indicated and discusses possible locations for such huge events.

3. Varro, *RR* 3.2.16. Banquets of *collegia*: Donahue 1996, 45–7. Livy 9.30.5–10, repeated by Valerius Maximus 2.5.4, describes the flute players, forbidden in 312 BC by the censors from holding their regular feast, going on strike and migrating to Tibur, where they got thoroughly drunk and were brought back to Rome in wagons and dumped in the forum with appalling hangovers; regardless of whether it is true, it shows what the expectations were of such occasions. See also ch. 3, nn. 65, 73–8.

4. Ryberg 1955, 71–3, pl. XXII, fig. 36f; Felletti Maj 1977, 291–2; Koeppel 1983, 72–6, 114–16, no. 23, fig. 28 (with earlier bibliography); Fless 1995, 40, 107 Kat.22 III, pl. 19.1. Museo Nuovo Capitolino Inv. 2391 (on display in the Museo Montemartini). Felletti Maj 1977, 291, describes the couches as a semicircular *sigma*, but in fact the right angle formed by the central and right-hand couch is rendered clearly; the left-hand couch is set at a wider angle, evidently for compositional reasons.

5. See Koeppel 1982, 453–5, for the monument and the nonexistence of the 'Ara Pietatis Augustae' with which it has traditionally been identified. Torelli 1982, 66–82, proposes an identification as the *ara gentis Iuliae*; he does not discuss the fragment with the banqueting Vestals.

6. Macr. *Sat.* 3.13.11–12. Felletti Maj 1977, 291, suggests that the scene on the relief is a *lectisternium*, perhaps on the occasion of the *consecratio* of the altar, but the essence of a *lectisternium* was that the god or gods reclined, and there is no basis for seeing one here. Ryberg 1955, 72–3, thinks that it may be part of the ceremony of installation of Claudius as *Flamen Augustalis*.

7. Livy 24.16.16–19. The feast, offered by the people of Beneventum, was notable for the presence of the slave-volunteers who had fought in Gracchus' army and been given their freedom in consequence; however, those who had behaved in a cowardly fashion were condemned by Gracchus to take their dinner standing rather than reclining. Cf. D'Arms 1999, 305, with n. 19; Koortbojian 2002; ch. 1, n. 8.

8. For the monuments as a group, see especially the article of Compostella 1992, complementing and revising previous studies.

9. Fogolari 1956; Ghedini 1990, 38, fig. 2; Schäfer 1990, 342–4, no. 20, pl. 99; Compostella 1992, 666–70, figs. 6–8, with further bibliography. For the earlier history of the altar, which was represented in the work of the sixteenth-century antiquarian G. Mercuriale, see Agasse 2001; it is first heard of in Padua, and there is no direct evidence to connect it with Aquileia. Este, Museo Nazionale Atestino, Inv. 1547.

10. Modern commentators have differed over the numbers: Compostella 1992, 668, believes that she can identify thirteen figures, with the central figure at the back a woman; Fogolari 1956, 46, also identified the central figure as female, but hesitated between twelve and thirteen in total; Ghedini 1990, 38, sees twelve, with two women. The condition of the relief, especially of the diners on the left-hand couch, is so worn as to make its reading very uncertain; however, the engraving of Mercuriale, which shows it in slightly better condition, has thirteen, three down each side, seven along the back (see Agasse 2001). I am not convinced that the central figure is differentiated from its neighbours sufficiently to be identified as female.

11. Schäfer 1990, 343.

12. Felletti Maj 1977, 374–5, fig. 193; Ghedini 1990, 38, fig. 6; Compostella 1992, 673–5, figs. 14–16. Ancona, Museo Nazionale 123.

13. Many recent studies have stressed this aspect of Roman funerary monuments, with special attention being paid to the monuments of the Italian towns and to the classes responsible for erecting them, whether the municipal elite or the newly rich from the libertine classes. See especially the articles in von Hesberg and Zanker 1987; also von Hesberg 1992, chs. 3, 5; Zanker 1992; Compostella 1996.

14. Fogolari 1956, 46, figs. 4–5, who does not recognize the smith's tools but thinks they are also part of the woman's equipment, and believes the banquet to be held in honour of the dead woman; Compostella 1992, 668, figs. 7–8, who believes that the woman is identified as the donor of the feast, perhaps in honour of her husband.

15. The argument is made strongly by Compostella 1992, esp. 670–9. Ghedini 1990, 38–9, accepts the interpretation as euergetistic banquets for the reliefs from Amiternum, discussed below, and Sentinum, but sees the Este scene as a funerary ceremony for the family beside the tomb, to which she thinks the tree and curtain allude. Fogolari 1956, 46, assumes without question that the Este relief shows 'un pranzo funebre', perhaps in front of the funerary monument. For the *Silicernium* and other funerary feasts, see F. Weissbach, *RE* III A (1927) 59–60 s.v. *Silicernium*; Harmon 1978, 1600–3; Scheid 1984, 128–34.

16. These formal public feasts belong in a wider category of benefactions, which include distributions of money (*sportulae*) and of a range of foodstuffs consumed less formally. The feasts are studied by Donahue 1996, esp. 59–116; Slater 2000; and cf. D'Arms 2000a. For the wider range of distributions in Italy, see Mrozek 1987; also Andreau 1977; Duncan-Jones 1982, 80–2, 102–4 (for Africa), 138–44, 184–203 (for Italy); Pudliszewski 1992 (for Spain); Kajava 1998. For commemorative banquets and distributions in the Greek East in the Hellenistic and Roman periods, see especially Schmitt Pantel 1992, 255–420; also Schmitt Pantel 1982; van Nijf 1997, 149–88.

17. *CIL* 10.4736: *M. Cacius C. f. Cerna, / (duo)vir, trib(unus) mil(itum), praef(ectus) fabr(um), / natali suo cenam / publice populo Sinuess(suano) / dare instituit / III id. Sept.* Donahue 1996, appendix 1, provides a list of relevant inscriptions.

18. For example, the frieze of fighting gladiators from the monument set up by the *sevir* Lusius Storax at Chieti: Coarelli 1963–4; Felletti Maj 1977, 367–9; or the stucco reliefs with gladiators and *venationes* on the so-called tomb of Umbricius Scaurus (in fact of N. Festius Ampliatus) at Pompeii: Kockel 1983, 75–85, pls. 18–21. Cf. also Franchi 1963–4, 29–31, pls. XI–XII; Faccenna 1949–50; Faccenna 1956–8.

19. See further ch. 3, n. 33; the thirteen at Este perhaps represent twelve plus a donor. For the conventional numbers of guests, see ch. 2, nn. 12, 14; the numbers portrayed in the ordinary domestic banquet scenes are usually much smaller.

20. See Schäfer 1990, 320–1, 343, for this identification; for the Suasa relief, the gravestone of Sex. Titius Primus, ibid. 338–40, no. 17, pl. 98, with references.

21. For the social role and the organization of the Augustales, see Duthoy 1974; Duthoy 1978, with earlier references; Kneissl 1980; Ostrow 1985; Abramenko 1993. The disputed problems of the terminology, and the distinction between *seviri, seviri Augustales*, and *Augustales*, discussed by Duthoy 1978, do not affect the present issue.

22. Cures: *CIL* 9.4971: *Cocceia L. f. Vera [—] / ita ut ex usura eius summa[e —] / III non. Mar. die natali eiu[s decuriones] / in publico decem trichilini[s] / et sevirales duobus trichili[nis epulentur / —].* Gabii: *CIL* 14.2793: *...ita ut ex usuris eiusdem... decur(iones) et (se)vir(i) Aug(ustales) publice in triclinis suis epulentur...* Beneventum: *CIL* 9.1618 = *ILS* 6507: *...paganis communib(us) pagi Lucul(lani) / porticum cum apparatorio et compitum a solo pecun(ia) / sua fecerunt et in perpetuum VI id. Iun. die natale / Sabini epulantib(us) hic paganis annuos / (denarios centum viginti quinque) dari / iusserunt....* On this public aspect, see Slater 2000, 114–15.

23. Giuliano 1963–4, pls. XIII–XIV, suggesting a date of the mid-first century AD, which has been generally accepted by other commentators; Felletti Maj 1977, 360–1, fig. 187; Ghedini 1990, 38, fig. 5; Compostella 1992, 670–5, figs. 9–13. The relief is now in the church of Santo Stefano in Pizzoli, near L'Aquila. Giuliano quotes the observation of A. La Regina that three drawings by A. L. Antinori in the Biblioteca Provinciale

of L'Aquila represent both the surviving relief and another that is almost but not quite identical, which must have come from the same monument (35, pl. XV).

24. Thus, Giuliano 1963–4, 37, 'la scena é ottenuta giustapponendo due iconografie di banchetto, senza creare un preciso nesso figurativo tra i due gruppi'; Compostella 1992, 673, the groups are disposed 'secondo le due varianti iconografiche del soggetto'; cf. Felletti Maj 1977, 360.

25. For Roman tradition and the significance of seated dining, see ch. 1, nn. 5–8.

26. Fröhlich 1991, 214–22, pls. 18–20,1; the seated group is his no. 3, pl. 19,1. The paintings belong to the period of the Fourth Style. Cf. also Packer 1978, 33–7; 46–7; Kleberg 1957, 114–17.

27. Fröhlich 1991, 211–14, pls. 62–3; again from the Fourth Style.

28. Ostia, Museo delle Navi, Inv. 1340: Amedick 1991, 112–13, 138, no. 97, pl. 109,1; cf. also 136, no. 87, pl. 109,2.

29. *CIL* 9.2962: *[—] / cuius dedicatione diem / ludorum et cenam / decurionibus et filis / item quinq(uennalibus) Aug(ustalibus) et filis et / plebi epulum dedit.*

30. *CIL* 10.688: *...hic togae vir[ilis die] / crustulum et mulsum populo [dedit]; / aedilitate spectaculum gladia[torium et] / circensium edidit; ob honor[em —] / decurionib(us) magnam cenam d[edit...]...* For *crustulum et mulsum*, see Mrozek 1972; Criniti 1973.

31. Cf. Duncan-Jones 1982, 141–3; Mrozek 1987, 83–102, 105; Mrozek 1992; Patterson 1994, 229–32; van Nijf 1997, 152–6.

32. *CIL* 9.3160 = *ILS* 6530: *... qui ... statim / splendidissimum ordinem liberosq(ue) et coniuges eorum sed et populum public(e) / epulantes maximo cum gaudio exhilaravit. // ... obtulit decurionibus et universo populo HS L mil. nummum / quae Mammiana vocentur, ex cuius summae usuris die natalis eius VII idus Febrar. / divisionem percipere possint. //... Item dedit / decurionibus discumbentibus et liberis eorum singul(is) HS XXX nummos, sevir(is) Augustal(ibus) / vescent(ibus) singul(is) HS XX numm(os), plebei universae epulantibus singulis HS VIII nummos....;* cf. Slater 2000, 114. Donahue 1996, 111, n. 8, on no. 176, recognizes that the use of three different verbs underscores 'the essential disparity in the gifts received according to the social status', but does not appreciate the specific significance of *discumbentibus*.

33. Giuliano 1963–4, 36, attempts to explain the groups of six and twelve diners represented on the reliefs by establishing a connection with the number of *seviri*; he suggests, for instance, that the number twelve represents the outgoing and incoming colleges of *seviri*, or the *seviri* and Augustales together, and that at Amiternum it is the older members of the *ordo* who are represented as reclining. As he admits, however, *seviri* are not attested at Amiternum, nor does this proposal take account of the repetition of the scenes at Amiternum and Sentinum. More recent studies have left no doubt that when Augustales are named as beneficiaries of these euergetistic meals, the reference is to the whole college of Augustales, not just to the current year's officers; see Duthoy 1978, 1284–5; Mrozek 1987, 87–90; Duncan-Jones 1982, 139–43, 283–6. However, Duncan-Jones' attempt to calculate the numbers of Augustales on the basis of the inscriptions from Cures and Petelia (cited ch. 3, n. 22, 36), where the numbers of triclinia are mentioned in the inscription, is based on the false assumption that there were always nine places in the Roman triclinium. The groups of twelve/thirteen represented on the Sentinum and Este reliefs show clearly that numbers larger than nine per triclinium were possible and acceptable at public feasts.

34. Ch. 3, n. 22; further examples in Slater 2000, 113–18.

35. Giuliano 1963–4, 34, quotes the description given by N. Persichetti in *RM* 23, 1908, 22, who suggests that the objects shaped like drinking horns have a taplike device at the ends for distributing wine, or perhaps wine and water, into the cups placed under their spouts. The details cannot now be clearly made out.

36. *CIL* 10.114 = *ILS* 6469: *M'. Megonio M'. f. Cor. Leoni... / ... / volo... / ...comparari Augus-
/talium loci n(ostri) ad instrumentum tricliniorum du/um, quod eis me vibo tradidi, candelabra
et lucerna[s]/bilychnes arbitrio Augustalium, quo facilius strati[o]/nibus publicis obire possint...*
For Megonius Leo and his benefactions, which include the gift of a vineyard to provide
wine for the Augustales at their public banquets, see Bossu 1982.

37. Cic. *Pro Mur.*36.75; Val. Max.7.5; Sen. *Ep.* 95.72–3. On this incident, see Landolfi 1990,
66–7; Purcell 1994, 685; D'Arms 1998, 35–6.

38. Recent discussion by Mols, Moormann 1993–4, with full earlier bibliography. For the
date, see ibid. 38, with arguments for rejecting the normally accepted date of 75–76 AD
(proposed by Castrén 1975, 120, 238–9), as well as previous proposals.

39. Mols, Moormann 1993–4, 29–30, 43–4, fig. 21; 33–5, 45, fig. 30.

40. Mols, Moormann 1993–4, 27–8, 41–2, fig. 20a–c, with survey of earlier interpretations;
see especially Spano 1943, 278–85, fig. 11; Dentzer 1962, 542–9; Ghedini 1990, 37–8;
Compostella 1992, 679–81. Cf. ch. 2, n. 60. The painting is now badly faded and worn;
Fig. 43 is taken from the photograph in Spano 1943.

41. Mols, Moormann 1993–4, 30–2, 44, figs. 22–3; Spano 1943, 266–8, fig. 8; Pirzio Biroli
Stefanelli 1991, 113, fig. 1.

42. See ch. 5, n. 53, and cf. ch. 4, n. 39.

43. For the use of such display tables for drinking silver in Rome, see Marquardt 1886,
319–21; for the importance of silver in Roman society, see ch. 2, n. 67. For Hellenistic
kylikeia, see Studniczka 1914, 162–7; Zimmer 1996, 133–4; Fabricius 1999, 88–9; for
Etruscan, see van der Meer 1984.

44. For the most part, the vessel forms reproduce approximate types rather than actual
models, but there is an unusually close resemblance between the big wine bowl (itself
exceptional in Pompeian banquet scenes: ch. 2, n. 68) and the *crater* from the Hildesheim
Treasure of Augustan date: Pirzio Biroli Stefanelli 1991, 271–5 figs. 45–7. See Tamm
2001, 135–43, 149–51, and ch. 2, n. 43.

45. This interpretation of both banquet scene and silver is proposed by Schäfer 1990, 330,
n. 98; Compostella 1992, 681; Giuliano 1963–4, 36, n. 7, had already made the same
proposal for the silver. For the base to support offerings of drink for libations, see Mols,
Moormann 1993–4, 17–18, 39, 44, fig. 22; Spano 1943, 265–6.

46. Cf. ch. 2, n. 20.

47. Cf. D'Arms 1999, who quotes examples from early modern Europe of banquets as public
spectacles.

48. Among recent discussions of this passage, see Whitehead 1993; Donahue 1999. Still
useful is the commentary of Friedländer 1906, ad loc.

49. Petr. *Sat.*71.9–10.

50. See especially the funerary relief of the *sevir* Anteros Asiaticus at Brescia: Gabelmann
1984, 200–1, no. 97; Compostella 1989; Schäfer 1989, 54, 219–20, 403–4, no. C 69, pl.
121; the tympanon of the monument of Lusius Storax at Chieti (ch. 3, n. 18): Torelli
1963–4; Gabelmann 1984, 201–2, no. 98; Schäfer 1989, 54, 398–9, no. C 53, pls. 106.1,
122; also an urn from Ascoli Piceno showing a distribution of money, apparently by a
private individual: Veyne 1959; Gabelmann 1984, 163–4, no. 72, pl. 22; and a fragmentary
relief from Capua, ibid. 199–200, no. 96, pl. 33. A similar composition on the tomb of
Vestorius Priscus at Pompeii, shown in his role as aedile, ch. 3, n. 39: Schäfer 1989, 53,
218, 389, no. C 14, pl. 95.3. See also Ronke 1987, 138–46.

51. The interpretation of *epulum binos denarios*, here and in the comparable passage at
*Sat.*45.10, has been much discussed; see most recently Donahue 1999, with refs. 70,
n. 2. A substantial number of the inscriptions recording public feasts and distributions
make a similar use of *epulum* followed by an indication of an amount in cash. These have

been interpreted variously as an indication of the cost of the meal, as a cash gift made in addition to the banquet, or simply as a distribution in cash as a substitute for the meal. See Duncan-Jones 1982, 139–40, who thinks that the Petronius passages refer to the cost of the meal per head; Mrozek 1987, 34, who believes that *epulum* in these contexts comes to mean simply a distribution of money; Donahue 1996, 14–16, reviewing the ambiguity of usage of the term, with the possibility of 'a shift in the meaning of *epulum* from a meal granted outright to funds dispersed for the purchase of a meal'. In the Petronius passage, it seems to me from the context that the reference must be to an actual cash handout, not just the cost of the banquet, but also not a substitute for the banquet itself, given the mention of triclinia that follows.

52. The significance of *triclinia* here has also been much discussed; see Donahue 1999, 73, with n. 15. Again the archaeological parallels confirm that the reference must be to the usual arrangement of three couches ('dining tables', which Donahue prefers, is a misleading modern usage), and not to 'dining halls', which could hardly have been carved in any comprehensible form; Trimalchio is still giving instructions for the sculptural decoration of the tomb, as the repeated *facias, faciatur* make clear. The existence in some tombs of actual triclinia (i.e. masonry couches), attested by archaeological remains and inscriptions and discussed in ch. 4, 'Dining and Drinking in Tombs,' nn. 59–62, is not relevant here; these are provisions for funerary banquets for small groups, not for the sort of event that Trimalchio has in mind.

53. Part of a similar scene has been identified on a fragmentary relief from Saturnia in Etruria, with three men apparently reclining at a banquet; other details are unclear. Pollard 1998 has plausibly associated this with another fragment from Saturnia showing a gladiator, and suggested that both may have originally decorated the tomb of a member of the local elite. A relief from Apollonia in Illyricum also preserves part of a similar banquet scene, with the diners (seven men survive) reclining on the rectilinear couches of a triclinium around a small central table. Here, however, the main figures are two musicians, an *auletes* and a lyre player, shown on a much larger scale. There is no sign of any vessels on the table, nor do any of the men appear to hold cups. Undoubtedly, the representation of the banquet belongs in the same iconographic tradition as the group of Italian reliefs just discussed, but there is no clue to indicate the context more precisely. See *L' Arte Albanese nei secoli. Museo Nazionale Preistorico Etnografico 'Luigi Pigorini', Roma 1985* (Rome 1985), no. 362, fig. p. 84; quoted by Schäfer 1990, 343, n. 162.

54. Amedick 1991, 31, 166–7, no. 280, pl. 32,1–5: Vatican, Museo Chiaramonti Inv. 2165. For the *sigma*-meal on sarcophagus lids generally, see Amedick 1991, 29–32; Himmelmann 1973, 24–8, 57–66; and ch. 4, nn. 70–2, ch. 5, nn. 20–1.

55. Blanck 1981, with earlier bibliography. Tunis, Musée du Bardo A 162. For the date, see Dunbabin 1991, 136, 147, n. 100.

56. Blanck 1981, 342–4, pl. 145.

57. For records of *epula* in Africa in the second to third centuries, see Duncan-Jones 1982, 82, 104; Wesch-Klein 1990, 34–7; for the later empire, Lepelley 1979, I, 298–318.

58. Blanck 1981, 332–5, pl. 148; Blanck rightly rejects the suggestion made by some earlier commentators that the figures were sitting cross-legged. For S. Maria Maggiore and the other parallels, see Brenk 1975, 59–60, n. 41. See also Dunbabin 1991, 136, 148, n. 104, but I am no longer convinced that the mosaic can be taken to show that reclining 'was ceasing to be regarded as a necessity for an occasion such as this'. See also ch. 6, n. 58.

59. Cf. D'Arms 1998, on the probable settings for the great triumphal banquets of Pompey, Lucullus, and Julius Caesar; Donahue 1996, 127–9; ch. 3, n. 22.

60. Stat. *Silv.* 1.6.29–50; cf. Suet. *Dom.* 4.5; Dio 67.4.4; see Jones 1991, 194–6. Donahue 1996, 129–33, argues that theatres, amphitheatres, and even circuses were quite frequently

used as the setting for banquets in the western provinces, but the evidence he quotes is not conclusive; on the basis of inscriptions that mention the donation of *ludi scaenici* or *venationes* and *epula* on the same occasion, he argues that it is likely that all the festivities took place in the buildings concerned. At least in one case that he quotes (132, from Arles), the inscription is clearly talking about a formal meal with triclinia that could hardly have been accommodated in the amphitheatre.

61. Maiuri 1954, 295, fig. 1; Salza Prina Ricotti 1978–80, 270, fig. 30; Parslow 1995–6, 123, fig. 6 (plan).

62. See Packer 1978, 12–24, figs. 5, 8; Jashemski 1979, 167–80; Spinazzola 1953, I, 121–2, 442–5, figs. 149, 499; cf. Dunbabin 1991, 123–5. Cf. also *CIL* 4.807 = *ILS* 6036: *hospitium hic locatur, / triclinium cum tribus lectis*, from Pompeii VII 1.44/45, a small inn with the sign of an elephant and the name of the presumed owner Sittius at the entrance: Kleberg 1957, 31–2; Fröhlich 1991, 324.

63. Vineyard, Pompeii II 5: Jashemski 1979, 202–18; Jashemski 1993, 89–90.

64. Bollmann 1998.

65. Bollmann 1998, 37–8, 47–57, 133–4. For dining as one of the principal activities of *collegia*, see Ausbüttel 1982, 55–9; Flambard 1987; also Patterson 1994, 232–8; Zanker 1994, 273–7; and ch. 3, nn. 73–8.

66. Bollmann 1998, 79, 368–71 A 52, fig. 12, with previous bibliography; Pagano 1983. The building was discovered during the construction of the Pompeii–Salerno autostrada, which ran over the south side of the peristyle. Excavations were reopened in 1999–2000; see Nappo 1999; De Simone, Nappo 2000, esp. 62–70, 79–117. The triclinia on the north side measure 4.60 × 4.80 m, on the east 4.30 × 4.40 m. Richardson 1988, 309–10, may be correct in seeing the arrangements as better suited for drinking than for eating, given the presence of the jets of water and the distance of the table from the couches, but small portions of food could certainly have been brought to the diners individually by attendants.

67. Bollmann 1998, 371; Pagano 1983, 347–52, with references to earlier discussion. For the chronology, see now De Simone, Nappo 2000, with a date for the triclinia and their paintings shortly before 62 AD; the building was out of use, and the adjoining baths under construction, in 79. They suggest an identification as a *hospitium* or guest house/inn serving wealthy businessmen (72, 113).

68. Caseggiato dei Triclinii: Bollmann 1998, 51, 58, 284–8 A 30, fig. 1, pl. 1–2,1, with previous bibliography; Packer 1971, 157–60, plan 15, figs. 104–14; Hermansen 1981, 62–3. Inscription, with *album* of the *collegium*: *CIL* 14.4569. The masonry triclinia were probably installed in the course of the second century, some years after the original construction of the building: H. Bloch, *BullCom* 65, 1937, 92–4.

69. The building as a whole, with the numerous inscriptions found therein, was for long available only in the unsatisfactory posthumous publication of the excavator, de Franciscis (1991); see now Miniero 2000; Adamo Muscettola 2000. Recent studies have appeared of two of the most important of the inscribed bases, with full commentary: Camodeca 1996; D'Arms 2000. See also the discussion in Bollmann 1998, 83, 356–63, A 50, fig. 29, pl. 8; for the chronology, see ibid. 362; Miniero 2000, 25.

70. *AE* 1993, 478: *Q. Baebius Natalis, August(alis) / immun(is), triclin(ium) constantiae / sua peq(unia) stravit et / dedicavit*; de Franciscis 1991, 45, fig. 66, which shows only the left portion of the inscription; the whole text as given by de Franciscis could not subsequently be confirmed (cf. ibid. 85, no. XVII). It is not clear whether *constantia* is to be taken as a proper name or an abstract term. Bollmann 1998, 362, thinks there is no secure evidence for the identification of the east room as a triclinium; she mentions Baebius' inscription earlier but does not cite the text. Remains of food (boar and seafood)

were found on the floor of the cult room. The eastern room measures 6.40 × 7.20 m; a banquet of any size would have needed to use all the space available in the building.

71. De Franciscis 1991, 41–3, figs. 53–7; *AE* 1993, 477; Miniero 2000, 38–42; Adamo Muscettola 2000, 91–101. L. Laecanius Primitivus is known from another inscription found at Misenum dated to 165 AD: *CIL* 10.1881 (and another supposedly found at Puteoli: *CIL* 10.1880). See also *AE* 1993, 470, dated to 161 AD; and F. Zevi, in Miniero 2000, 47–62, on the inscribed bases from the building in general.

72. Published only in a brief report concerned primarily with the mosaics: Ennabli 1975. The mosaics suggest a date in the second century AD, perhaps the first half; various alterations affected particularly the layout of the central area. See also Gros 1997, for suggested identification of several buildings in southern Gaul as possible seats of *collegia*.

73. For the composition of the *collegia*, see Ausbüttel 1982, 34–48, who rightly stresses that their members did not in general belong to the very poorest classes of Roman society; nevertheless, there were substantial differences in size, social status, and economic standing between the various bodies. For the inscriptions, see ibid. 55–9; Flambard 1987.

74. For example, Flambard 1987, 224–5 (*CIL* 6.10237 = *ILS* 7870); 234–6 (*CIL* 6.10234 = *ILS* 7213, 3–4). Cf. also Calza 1939, an inscription from Ostia giving a list of donations to a *statio* (not further identified): along with statues of members of the Imperial house, they include *scamna, mensae*, and *scabilla; miliarium cum caldario*; candelabra; and *emitylia* and *illae* (mattresses and cushions): Herz 1980–1, 153–7 (Bollmann C 35).

75. *Negotiatores eborarii et citrarii, CIL* 6.33885 = *ILS* 7214; *cultores Dianae et Antinoi, CIL* 14.2112 = *ILS* 7212; Ausbüttel 1982, 56–7; Flambard 1987, 225–34; Bollmann 1998, 38. The precise reading and interpretation of *CIL* 14.2112, col.II, 14–16, are problematic: see A. E. Gordon, *Album of dated Latin Inscriptions* II (Los Angeles 1964), 68, no. 196.

76. For example, *CIL* 14.2112, col.II, 16:... *caldam cum ministerio; CIL* 6.33885:.... *pan(em) et vin(um) et caldam*. The equipment for heating the water, *miliarium cum caldario*, is listed among the donations in the inscription from Ostia quoted ch. 3, n. 74. Cf. Dunbabin 1993; ch. 1, n. 37; ch. 5, n. 77.

77. *CIL* 14.2112, col.II, 23–4:... *ut quieti et hilares diebus sollemnibus epulemur.*

78. Ausbüttel 1982, 55; *CIL* 9.3815, from Ortona; *CIL* 11.6244, from Fanum Fortunae.

79. See ch. 2, n. 41; for the building, Varone 1989, 231–6; Varone 1990, 202–8.

80. Bollmann 1998, 261–5, A18, fig. 7, with full earlier bibliography; *LTUR* 4, 1999, 254–5 (E. Papi). For the *praecones*, their status and aspirations, see Purcell 1983, 147–8.

81. For the paintings, see Marchetti 1892, 44–8; Cagiano de Azevedo 1947–9; Helbig(4) II, no. 2076 (B. Andreae). They are usually dated ca. 220–40, not much later than the original construction, although Strocka 1995, 87, n. 40, believes they are Tetrarchic. For the iconographic type of the servants at the banquet, see ch. 5, 'The Servants.'

82. Morricone Matini 1967, 103–5, no. 93, pls. XXIII–V.

CHAPTER 4

1. Wrede 1981, 101–9, figs. 19–20, 22, with earlier bibliography. Indianapolis Museum of Art, Inv. 1972.148.

2. For a full account of the history of statue and inscription, see Pucci 1968–9, 173–7, pl. LXXV; Vermeule 1966, 37, Fol.64: no. 8548, figs. 136, 136a; for the location of the sculpture's findspot, in Mausoleum R of the Vatican Necropolis, see Apollonj Ghetti et al. 1951, 86–7; Toynbee, Ward Perkins 1956, 30–2, 58. The identification of the statue in the Indianapolis Museum is made in Wrede 1981, 102, n. 44.

3. Buecheler, *CLE* no. 856 = *CIL* 6.17985a:

 Tibur mihi patria, Agricola sum vocitatus,
 Flavius idem, ego sum discumbens ut me videtis.
 sic et aput superos annis quibus fata dedere
 animulam colui, nec defuit umqua Lyaeus.
 praecessitque prior Primitiva gratissima coniuncxs,
 Flavia et ipsa, cultrix deae Phariaes casta
 sedulaque et forma decore repleta,
 cum qua ter denos dulcissimos egerim annos.
 solaciumque sui generis Aurelium Primitivum
 tradidit qui pietate sua coleret fastigia nostra
 hospitiumque mihi secura servavit in aevum.
 amici qui legitis, moneo, miscete Lyaeum
 et potate procul redimiti tempora flore
 et Venereos coitus formosis ne denegate puellis:
 cetera post obitum terra consumit et ignis.

4. Pucci 1968–9, 174–6.

5. See Thönges-Stringaris 1965; Dentzer 1970; Dentzer 1982, 223–557; Fabricius 1999, 21–30. There is in origin a clear distinction between the representations of the single banqueter and those of the convivial banquet, although a tendency to contamination between the two types can sometimes be observed. The term Totenmahl is best kept for the solitary banqueter of the canonical type; for a definition, see Fabricius 1999, 16, n. 6. Despite the potentially misleading implications of the term (which implies that those represented are always to be understood as dead, thereby begging the question of the theme's significance), I continue to use it to refer to the standard motif of the single banqueter as here defined.

6. Fig. 55 shows a fourth-century grave stele from the Peiraeus, with the inscription of Pyrrhias and his wife Thettale: Dentzer 1982, R 479. H. R. Goette, to whom I am grateful for photographs of the stele, tells me that the head of the woman has been reworked at a later date, but the inscription and the figure of the man are original.

7. Thönges-Stringaris 1965, 37–41; Dentzer 1969; Dentzer 1982, 224–30, 265–95; Pfuhl, Möbius 1977–9, 5; Fabricius 1999, 30–8 (for the controversial chronology of the Graeco-Persian stelae, see ibid. 33, n. 79). Elmalı, Kızılbel: Mellink 1998, 24–5, 51–2, 59–60, pls. 29, XII; Karaburun II: Mellink 1972, 263–8, pls. 58–9; Mellink 1973, 297–301, pl. 44; ch. 1, n. 22.

8. The thorough study of Fabricius 1999 gives full bibliographies for different cities and regions, and detailed analysis of the treatment of the motif in Samos, Rhodes, Byzantion, and Kyzikos. See also Pfuhl, Möbius 1977–9, esp. 393– 494; Schmidt 1991, esp. 103–16; Cremer 1991; Cremer 1992.

9. Fig. 56 shows a relief from Samos of the later second century BC, with two men reclining on the couch, a seated woman, and male and female servants: Horn 1972, 184–5, no. 159a. The heroic attributes – horse's head, weapons hanging on the wall, snake, and the drinking horn in one man's hand – are typical of the Samian reliefs, as are the elaborate furniture, the food on the tables, and the variety of vessels: Fabricius 1999, 111–63, pl. 6a.

10. The bibliography is enormous, and only a selection can be quoted here. For the Greek East (in addition to the works cited in the previous notes), see Dentzer 1978; for the Cyclades, Mercky 1995, 53–66; Zaphiropoulou 1991. Egypt: Parlasca 1970; Parlasca 1975. Rhineland: Noelke 1998, with earlier references; ch. 1, nn. 72–4. Britain: Mattern

1989, 721–8. Moesia: Alexandrescu-Vianu 1977. Dacia: Bianchi 1985, 98–104. Palmyra: Parlasca 1984; Parlasca 1998. Fig. 57 shows a late example apparently from Hierapolis in Asia Minor, ca. 300 AD: Pfuhl, Möbius 1977–9, no. 1787, pl. 258.

11. Paintings: Bacchielli, Falivene 1995, fig. 3, pls. I, II (Asgafa El Abiar, Cyrenaica, probably fourth century); Smith, Mare 1997 (Abila, Jordan, perhaps third century); also Russell 1984, 20–4, figs. 10, 15 (Anemurium). One from Sabratha is described, without illustration, by Di Vita 1983, who ascribes it to the third quarter of the first century AD. Cf. also one of the scenes painted on the inside of a sarcophagus from Panticapeaum (Kertch, in the Crimea), probably of the end of the 1st to beginning of the second centuries AD: M. Nowicka in Blanc 1998, 66–70. Mosaics include the series of funerary panels from the necropolis at Thaenae (Thina) in Africa Proconsularis, probably of the third to early fourth centuries AD: Dunbabin 1978, 139, 273, no. 6, with refs.; Blanchard-Lemée et al. 1995, 80–1, fig. 50; and the third-century examples from Edessa, Dunbabin 1999, 172–3, with refs.

12. See ch. 4, n. 10; for the 'Pannonian banquet', see Diez 1959–61; Bianchi 1975.

13. For a review of the various interpretations proposed for the motif, see Dentzer 1982, 1–20, and the review in Fehr 1984; Fabricius 1999, 13–19. No comprehensive survey of the uses of the theme in the Roman period has ever been made; many individual publications have favoured one or another of the interpretations listed above. Similar arguments have been used in the attempt to establish the significance of scenes of the convivial banquet in funerary art; see ch. 4, n. 72.

14. The theme is found occasionally on stelae in northern Italy: e.g. Mercando, Paci 1998, 123–37, nos. 60–4, pls. 74–7; Rebecchi 1986, 908–9, fig. 16. In Rome, the motif appears frequently on one distinctive group of stelae, the grave monuments of the *equites singulares Augusti*, where it forms the most common single motif, in a very standardised form, and is probably derived from the military gravestones of the Rhineland: Speidel 1994, 4–8. Altars: Boschung 1987, 15, n. 28; 18; 27, nn. 356, 375; 34, n. 509; 51, n. 747. Urns: Sinn 1987, 66–7. Sarcophagi: Amedick 1991, 11–45; Himmelmann 1973, 15–28, 47–66; and see ch. 4, n. 36. Paintings: Rome, tomb near columbarium of Statilii, Nash II, 359, 369, fig. 1152 (Fig. 58); tomb on Via Portuense, Felletti Maj 1953, 54, fig. 13. Ostia, Via Laurentina tomb 17: Bedello Tata 1999; Isola Sacra, painting and stucco: Baldassarre *et al.* 1996, 101–3, 173–4, fig. 67; mosaic: ibid. 69–71.

15. Etruscans: see ch. 1, 'Etruscan Banquets and Early Rome'; ch. 4, nn. 45–8.

16. One development is the frequent replacement of the traditional dining couch with *fulcrum* by the bed/couch with boards at the back and sides, which became common from the first century AD onward (cf. ch. 2, nn. 10, 11). This type, which could only really accommodate one person reclining in comfort, serves to accentuate the focus on the figure thus honoured, but thereby increases the ambivalence between the dining couch and the bed, discussed below.

17. The basic study of these monuments is Wrede 1977; also Wrede 1981; Berczelly 1978, esp. 49–53; Koch, Sichtermann 1982, 58–61; Wrede 1990, 26–8. For a date for Flavius Agricola shortly before or after 160 AD, on the basis of style, the type of beard, and nomenclature, see Wrede 1981, 104–7. Isolated examples of *kline* monuments are found in the third century, but their main period of production is in the second half of the first century and the first half of the second century AD. I retain the term '*kline* monument' in this discussion, despite the potentially misleading connotations of the Greek term *kline* for what are essentially Roman monuments; the Latin *lectus* would be more appropriate.

18. Wrede 1977, 400–2, figs. 73–4; Stuart Jones 1912, 72, no. 2, pl. 15. The present head does not belong, and the left end of the couch is restored. Inscription: *CIL* 6.4222. Palazzo dei Conservatori, Inv. 1999.

19. Wrede 1977, 402, figs. 69, 70; S. Dayan, L. Musso, in Giuliano 1981, 177–8, no. II, 64, with bibliography. Traces remain of an Eros behind the boy. The portrait head has been dated variously between the late Augustan and the Neronian periods (refs. in Musso, ibid. 178), but seems unlikely to be as late as the mid-first century AD. Museo Nazionale Romano, Inv. 61586.

20. See Wrede 1977, 409–12, 424–6; Wrede 1981, 89–96; also Wrede 1971, 131–3, pl. 78.2 (*kline* monument of Claudia Semne); D'Ambra 1989 (relief of Ulpia Epigone).

21. Wrede 1977, 413, fig. 102; Andreae 1995, 822–3, with a date of 160–70 AD; Amelung 1908, II, 3–4, no. 1. Museo Chiaramonti, Inv. 1365.

22. Franchi 1963–4, 23–32, pls. V–X, proposing a date in the mid-first century BC; Felletti Maj 1977, 121–5, fig. 34. For the interpretations, see Drerup 1980, 114–15, with n. 140. For funerals, see Flower 1996, 91–127; Bodel 1999.

23. Dio Cass. 56.34.1; 56.46.4. Compare also Tacitus' account of the complaints about Germanicus' funeral: *ubi illa veterum instituta, propositam toro effigiem ...* (*Ann.*3.5, quoted by Wrede 1977, 407). On imperial funerals, see Arce 1988, esp. 46–53.

24. Petr. *Sat.* 78.

25. On the social status of the commissioners of *kline* monuments and their relationship to traditional funerary practices, see Wrede 1977, 404–9.

26. Cf. especially Zanker 1975; Kleiner 1977, 180–91; Zanker 1992; v. Hesberg 1992, 239–40.

27. Ch. 4, nn. 5–8; cf. ch. 1, n. 40. Quite exceptional, however, is a group of funerary reliefs from Rhodes dating from the end of the third and second centuries BC, which show reclining women, some alone, some together with their husbands on the couch; a few even hold drinking vessels. See Fabricius 1999, 165–224, esp. 183–90. In the Imperial period, reclining women appear regularly, with their husbands or alone, on the monuments of some parts of the Greek world, such as the Cyclades: Mercky 1995, 57–8.

28. See ch. 1, nn. 42–6.

29. Sinn 1987, 201, no. 457, pl. 71a. Naples, Museo Archeologico Nazionale Inv. 4189; found in Puteoli, but not distinguishable from Roman work. Late Flavian to early Trajanic.

30. Goethert 1969; Boschung 1987, 108, no. 852, pl. 45. Found beside the Via Triumphalis west of the Tiber; now in the Via Quattro Fontane 13–18. See further ch. 5, n. 49.

31. Sinn 1987, 202, no. 462, pl. 72c. Paris, Louvre MA 2144; end of first century or beginning of second century AD.

32. Boschung 1987, 79, no. 8, pl. 1; Andreae 1995, 422–3 (322 F/XVIII 26). Vatican, Museo Chiaramonti Inv. 1471. Late Neronian/early Flavian.

33. Sinn 1987, 201, no. 458, pl. 71c,d. New York, Metropolitan Museum of Art, Inv. 27.122.2; unknown provenance. Probably Flavian. A fragmentary urn from the Vigna Codini on the Via Appia also shows a reclining woman with a fragmentary seated figure, possibly male: Sinn 1987, 160, no. 275, pl. 50a. Fabricius 1999, 173, pl. 20b, identifies a similar reversal of roles on one of the Hellenistic reliefs from Rhodes (ch. 4, n. 27), although Pfuhl, Möbius 1977–9, 487, no. 2026, describe the seated figure as female. A reclining woman with a seated young man appears on a stele from Herakleia Pontike, attributed to the second century AD: Pfuhl, Möbius 1977–9, 486, no. 2024, pl. 292 (the inscription mentions a woman and a 15-year-old male, presumably mother and son); one from Tomi, probably second to third centuries AD, has reclining woman and seated older man: ibid. 487, no. 1410b, pl. 205 (the inscription records that the man set it up in his lifetime for himself and his wife; the man appears in a separate panel as a mounted hunter: ibid. 336).

34. Amedick 1991, 12–13, 136, no. *84, pls. 3.2, 4.1–2, dated to 152–60; Agnoli 1998, pl. 69.5. Museo Ostiense, Inv. 1333, found *in situ* in Tomb II, Isola Sacra. Another fragmentary

loculus slab from Ostia (Inv. 47824, found reused in the Christian basilica at Pianabella) shows three figures reclining together, an elderly woman between an older and a younger man, presumably a family group; the younger man is half nude, the other two figures fully clad. Both men hold drinking cups, the woman a garland. The rendering of the tables and food, the wine flask, and the dog, is similar to that on the Isola Sacra slab: Agnoli 1998, 135–6, pl. 71.

35. For the use of nudity or seminudity in female funerary images and its significance as an assimilation to Venus, see Wrede 1971, 131, 136–66; Wrede 1981a, 72, 110, 306–23; Kleiner 1981; D'Ambra 1989, 396–7.

36. See Amedick 1991, 11–24 ('Klinen-Mahl'); Himmelmann 1973, 15–28, 47–55; Wrede 1981, 109–18; Bozzini 1975–6. Amedick lists 51 examples, but many of these are quite small fragments. They also include several now lost, including two evidently lavish examples known from Dal Pozzo drawings, Amedick's nos. 306, 308. The latest is the fragmentary lid of the sarcophagus of Junius Bassus in the Vatican, who died in 359 AD (Amedick no. 300, discussed at length by Himmelmann, loc. cit.).

37. Amedick 1991, 17–21, 167–8, no. 286, pls. 15.2–4, 16–17, 108, with earlier bibliography. Vatican, Museo Gregoriano Profano Inv. 9538/9539.

38. Amedick 1991, 18, following earlier scholars, argues that the figure was originally designed as female, and that the head was recarved as a male portrait when the sarcophagus was purchased, presumably to suit the purchaser. The female-seeming forms of the body are not conclusive, because they are shared with other, indubitably male, figures of the period, including the male servants on the same sarcophagus; the clothing, long-sleeved tunic, and mantle, is common to both male and female. Amedick claims that signs of reworking can be seen in the head; again, it is not clear wheather this means more than that a head originally left as a boss was carved down into a portrait. She further argues that the absence of a drinking vessel in the figure's hand, and the accompanying Erotes and children playing beneath the couch, are more appropriate for a female occupant; these arguments too seem less than compelling, given the small number of other full-scale versions and the variety of details that appear on them. The reclining figure on the lost sarcophagus shown in the Dal Pozzo drawing (Amedick no. 306), who does hold a drinking cup, appears to be male, but is similarly surrounded by Erotes and playing children. The lid with the inscription of Caecilius Vallianus does not fit on the chest, and may not belong. In general, it seems to me better to reserve judgement on the question of the gender of the figure as originally designed.

39. See ch. 5, n. 53; cf. Nuber 1972, 83–90, 117–25.

40. For the increased attention given to both servants and food in late antique banqueting scenes, see ch. 5, 'The Servants' and 'Food and Tableware'.

41. Cf. Wrede 1977, 415–31; Wrede 1984; Wrede 1990; Strocka 1971; Wiegartz 1965, 14–15, 24–5; Wiegartz 1974, 362, 378; Koch, Sichtermann 1982, 371–3 (Attic, introduced ca. 180 AD); 505–6 (Asia Minor, 'Hauptgruppe', appearing ca. 160/70); see also Goette 1991, on the Attic 'Klinen-Riefel' sarcophagi.

42. Gütschow 1938, 77–106, pls. X–XV; Wiggers, Wegner 1971, 242–3, 249, pl. 79, with earlier bibliography; Wrede 1990, 38 no. 3, fig. 18, with arguments for attributing it to a Roman workshop rather than one from Asia Minor. Against the identification as the sarcophagus of Balbinus, see Wrede 2001, 64–5, who sees it as intended for a high military officer of the equestrian class.

43. Rogge 1995, 136–8, no. 24, pls. 44–7, with earlier bibliography.

44. Wrede 1977, 395–9.

45. Cf. ch. 1, n. 59; Briguet 1989, who reconstructs the gestures of the missing hands to show the woman pouring perfume from a flask onto her husband's hand. She also has no

doubt that the body of the couch in the Louvre group was indeed used as a sarcophagus; this has been questioned in the past both for this group and for that in the Villa Giulia (e.g. Helbig(4) 3, 2582 (T. Dohrn), who sees it as an urn on a monumental scale).

46. Cf. Herbig 1952, 110–11; Thimme 1954; Thimme 1957; Gentili 1994, 13–14, 123–51; Nielsen, M. 1975, esp. 379- -82; Dareggi 1972; ch. 1, nn. 66–7. Fig. 71 shows an urn from Perugia (Mus. Naz. Inv. 341), with a male figure on the lid garlanded and holding a *kantharos*; the chest shows the enigmatic scene of the 'Wolf-demon in the well': *LIMC* VII (1994) 35–7 s.v. Olta no. 6 (J. G. Szilágyi).

47. Vollmoeller 1901, 345–8, 369–74; Miller 1993, 14–15, n. 81 (on stone *klinai* in Macedonian tombs); Fabricius 1999, 87 n. 27. *Kline*-sarcophagi are also common in Alexandrian tombs (e.g. Adriani 1963–6, 30–1, and 283, refs. s.v. *sarcophagi-kline*), and in many parts of southern Italy (e.g. Baldassarre 1998, 107, 123, 128, 135); cf. Dentzer 1982, 536.

48. Praschniker, Theuer 1979, 99–104; R. Fleischer, ibid. 146–60, who proposes that the mausoleum was originally erected for Lysimachos between 301 and 281 BC, and that the lid and the servant statue were added in a second phase for Antiochos II in 246 BC. See also Hoepfner 1993, who argues for a single building phase for the mausoleum, which he is inclined to ascribe to Lysimachos, but does not discuss the sarcophagus; Ridgway 1990, 187–96, concluding cautiously that the majority of the evidence points to a date ca. 290/80 BC, that the question of one or two construction phases cannot be answered, nor can the identity of the owner(s) of the tomb be securely established. The sarcophagus, now in Selçuk Museum (Inv. 1610), is 2.57 m long, the lid 2.67 m.

49. ch. 4, n. 3. For discussion and numerous parallels, cf. Kajanto 1969; Amelung 1985; Brelich 1937, 49–53.

50. *CIL* 14.914 = *CLE* no. 1318 (Ostia): D. M. / C. Domiti Primi. /
 Hoc ego su(m) in tumulo Primus notissi/mus ille.
 vixi Lucrinis potabi saepe Fa/lernum,
 balnia vina Venus mecum / senuere per annos.
 hec ego si potui / sit mihi terra lebis.
 set tamen ad Ma/nes foenix me serbat in ara
 qui me/cum properat se reparare sibi. /
 l. d. fun[e]ri C. Domiti Primi a tribus Messis Hermerote Pia et Pio.

51. *CIL* 3.6825 = *ILS* 2238 (Antioch in Pisidia), playing on the equivalence of b and v in popular Latin: *T. Cissonius Q. f. Ser(gia), vet(eranus) / leg(ionis) V Gall(icae). Dum vixi / bibi libenter: bibite vos / qui vivitis. / P. Cissonius Q. f. Ser., frater, / fecit.*

52. *CIL* 12.5102 = *ILS* 8154 (Narbo): *L. Runnius Pa[p.?] / Cn. f. Pollio / [Eo] cupidius perpoto in monumento meo, / quod dormiendum et permanendum / heic est mihi.*

53. Introduction, n. 1.

54. T. Corsten, *Die Inschriften von Kios* (I.K. 29, Bonn 1985), 138–9, no. 78 (with parallels): πίε, φάγε, τρύφησον, ἀφροδισίασον, τὰ δὲ ὧδε κάτω σκότος; R. Herzog, *Koische Forschungen und Funde* (Leipzig 1899) no. 163 = *GVI* 378 (Kos):...Χρυσόγονος Ν<υμ>φῶν λάτρις ἐνθάδε κεῖτα[ι] παντὶ λέγων παρόδωι· πεῖνε, βλέπ' ἰς τὸ τέλος.

55. ch. 4, n. 50.

56. For example, *CIL* 6.9583 = *ILS* 8341 (Rome): *haec est domus aeterna, hic est / fundus, heis sunt horti, hoc / est monumentum nostrum.* Cf. Brelich 1937, 10, with numerous further references.

57. Cf. Toynbee 1971, 37, 51–3, 62, with refs. Even more telling than the deposition in graves of single vessels or small groups is the complete service of miniature silver vessels placed apparently in the grave of a child or young girl in the vicinity of Rome in the

early first century AD: Zahn 1950–1, 282–5. See also Jastrzebowska 1981, 129–30, on the provision of libation tubes in graves in Rome.

58. Wrede 1977, 415–17, fig. 108, identified there as one of the earliest examples of a sarcophagus lid of the *kline*-type; later (Wrede 1990, 28) he corrects this opinion, identifying it as a *kline* monument, following Berczelly 1978, 52, who suggests that it was originally associated with a cinerary urn placed underneath the cup. See also Calza 1964, 70, no. 112, pl. LXV. Ny Carlsberg Glyptotek Inv. 777; L. 1.45 m.

59. Cf. Février 1978, 220–6, on such facilities in pagan and Christian necropoleis throughout the Mediterranean, with special reference to North Africa. For an interesting pagan complex of the fourth century at Sabratha with four masonry *stibadia* adjoining a hypogaeum, see Di Vita 1980–2. See also ch. 6, 'Funerary feasts, Christian and pagan', nn. 38–41, on Christian necropoleis.

60. Kockel 1983, 109–11, pl. 31.

61. Ostia, inside tombs of the first to early second centuries AD: Floriani Squarciapino 1958, 93–7, 117–27; Boschung 1987a, 120–2, figs. 23–5 (who points out that in the smaller tombs the triclinia are so narrow as to be of little practical use for a meal). Isola Sacra: Calza 1940, 56, fig. 16; 69, fig. 21; Bragantini 1990, 62–70; dated predominantly to the second century. See also Jastrzebowska 1981, 116–27.

62. *CIL* 6.14614 = *ILS* 7931 (Rome): .../*Ad hanc aediculam ollarum n. VI, et columbar. / iuxcta (sic) aedicul. n. VI ollar. n. XII, et angul. parietis / columb. n. III ollar. n. VI, itus aditus ambitus, tricl. / culinae usus aquae hauriend. concessus est / Q. Caulio Carpo ab Sex. Horatio Diadumeno.*

63. For example, *CIL* 8.21269 = *ILS* 8118 (Caesarea Mauretaniae): *Trichlia / Marciae Martialis.*

64. Cf. Toynbee 1971, 61–4; ch. 3, nn. 15–17.

65. Floriani Squarciapino 1958, 125–7; Donati 1998, 290, no. 62, pl. 62; the painting is probably of the first half of the third century, although Mielsch 1978, 172, places it in the early fourth century. Vatican, Museo Gregoriano Profano Inv. 10786.

66. Ghedini 1990, esp. 48–53, on the picnic scenes in the columbarium of the Villa Doria Pamphilj in Rome and the hypogaeum at Caivano near Naples; Jastrzebowska 1979, 42–6. See also ch. 3, 'Monuments of Public Banquets at Este and Sentinum'; the monuments discussed there belong to a distinct group with different conventions.

67. Giglio 1996, 10–13, figs. 8, 14–19; Giglio 1996a.

68. Tran Tam Tinh 1974, 71–2, no. 50; Ghedini 1990, 41, fig. 11; Ghedini, Salvadori 1999, 84–5, fig. 2. Louvre P 36.

69. See ch. 5, esp. 'Conviviality at Ephesos, Sepphoris, and Constanza'; ch. 6, esp. 'Dining in the Catacombs,' 'The Catacombs of Peter and Marcellinus,' and 'Funerary Feasts, Christian and Pagan.'

70. Amedick 1991, 29–45, pls. 26–37; Himmelmann 1973, 24–8, 57–66; Jastrzebowska 1979, 46–54; van der Meer 1983; Ghedini 1990, 43–4. See further ch. 5, nn. 20–1; ch. 6, n. 4.

71. For the wine-heating scenes, see Dunbabin 1993, esp. 136–8, and ch. 5, n. 77.

72. For example, Himmelmann 1973, 24–8; Amedick 1991, 30–2 (who acknowledges that there are exceptions, as elements of the '*kline*-meal' come to be used also in the *sigma*-meal to display the wealth of the deceased). The supposed absence of any clear identification of the deceased in the group banquets is also used as an argument against seeing these as alluding to the next world, but for exceptions see Engemann 1982, and ch. 6, n. 33.

73. For example, Hor. *Carm.* 1.4; 1.11; 2.3; 2.14; Mart. *Ep.* 2.59; 5.64. Cf. Dunbabin 1986, 194–5; Grottanelli 1995, 66–74.

74. *Copa* 38: *mors aurem vellens 'vivite' ait 'venio'.*

75. Cf. Grottanelli 1995, 74–6, with references.

76. I discuss this subject in detail in Dunbabin 1986, which I summarize briefly here.
77. Skeleton statuettes: see references in Dunbabin 1986, 196–9, figs. 1, 2–6. Berlin, green-glazed *kalathos* from Thrace with inscription *kto chro*, probably second half of the first century BC, Berlin, Antikenmuseum, SMPK, Inv. 30141: ibid. 199, figs. 7–8; Zahn 1923.
78. Boscoreale cups, Paris, Louvre Bj 1923, 1924: Dunbabin 1986, 224–31, figs. 37–42, with refs., nn. 151, 172; Baratte 1986, 65–7.
79. Naples, Museo Archeologico Nazionale Inv. 9978, probably first half of first century AD: Dunbabin 1986, 215–6, fig. 25, with refs., n. 120.
80. Petr. *Sat.* 34.10:
 Eheu nos miseros, quam totus homuncio nil est.
 Sic erimus cuncti, postquam nos auferet Orcus.
 Ergo vivamus, dum licet esse bene. Cf. Grottanelli 1995, 74–5.
81. Boschung 1987, 51, 106, no. 815, pl. 40; Domitianic. Naples, Museo Archeologico Nazionale Inv. 2803. In Dunbabin 1986, 242, I described this as 'a rather tired survival of an earlier idea' (accepting there a date in the second half of the second century AD, which Boschung's typological studies have shown to be much too late). I now think the use of the skeleton motif here shows considerably more ingenuity that I then acknowledged.
82. Koch, Sichtermann 1982, 365, fig. 404 (described as without parallel); Dunbabin 1986, 206–8, with refs. In Herakleion Archaeological Museum, the lid is missing.
83. Dunbabin 1986, 206–8, fig. 19.
84. For sundials in a funerary context, see most recently Wiemer 1998, with earlier references, nn. 5–8; for the forms of sundials, Gibbs 1976. Aquileia: Bracchi 1960, fig. 1; ibid. fig. 7 is also clearly a tomb monument, although apparently without provenance. Inscription from Centocelle, *CIL* 6.10237 = *ILS* 7870: *T. T. Cocceii Gaa et / Patiens, quaest(ores) III, / mensam quadratam in trichil(inio), / abacum cum basi, horologium, /... d(e) d(ecurionum) s(ententia) posuerunt /....*
85. Petr. *Sat.* 71.11; 26.9.
86. Levi 1947, 219–21, pl. 49b; from the House of the Sundial. Probably mid- to late third century; Worcester Museum of Art. For the ninth hour (midafternoon) as the customary hour for dining, see Marquardt 1886, 298.
87. Murray 1988, 254.
88. Pfuhl, Möbius 1977–9, 369, no. 421b, pl. 216; Fabricius 1999, 168–70, pl. 15a. Archaeological Museum, Rhodes no. 638; second half of second century BC.

CHAPTER 5

1. The basic publication of the treasure is Mundell Mango, Bennett 1994, which contains an introduction, descriptive catalogue, and technical analysis. Part 2 of the work, which will contain iconographic, stylistic, and comparative discussion, has not yet appeared. Attempts to establish claims for a findspot for the treasure in Lebanon, Croatia, and Hungary were all unsuccessful before the New York Supreme Court. See also Mundell Mango 1990; Pirzio Biroli Stefanelli 1991, 309–11, nos. 198–211, figs. 249–61; Cahn et al. 1991.
2. Mundell Mango, Bennett 1994, 55–97.
3. Mundell Mango, Bennett 1994, 38, Table 3, A; 77: *h(a)ec Sevso tibi durent per saecula multa / posteris ut prosint vascula digna tuis.* Two further inscriptions occur within the central medallion: IN(N)OCENTIUS, perhaps the name of a horse, and PELSO. The latter appears above the band of water underneath the picnic scene, and it has been suggested that it identifies it as Lake Pelso, the Latin name of Lake Balaton in Hungary (thereby

possibly providing some support for the arguments for a Hungarian origin for the treasure, although naturally there is no necessary connection between the origin of the plate itself and findspot of the treasure). Mundell Mango believes that the water shown must be a river rather than a lake, and suggests that Pelso may be the name of the dog seated above (ibid. 78). For Sevso, see Mundell Mango 1990, 6–7.

4. On the role of such gift exchange in the distribution of silver, see the dispute between Cameron 1992 and Painter 1993. Although they disagree over the extent and importance of such exchange, both acknowledge that silver objects were used for presentations of this sort by private notables as well as the emperors. In the Sevso inscription, Cameron points out that 'the reference to the use that his posterity will make of it is certainly consistent with a wedding' (1992, 185). The prominent representation of the woman in the picnic scene, discussed ch. 5, n. 23, would also be appropriate in a wedding gift.

5. On this role see Baratte 1992, 13–14.

6. Esquiline casket: Shelton 1981, 31–5; also Cameron 1985; Shelton 1985. For objects with Christian inscriptions in the Mildenhall treasure, see Painter 1977, 18–23. On the problems of distinguishing Christian uses of the banquet theme, see further ch. 5, nn. 80–1, and ch. 6, esp. 'Funerary Feasts, Christian and Pagan.'

7. Cf. Toynbee, Painter 1986; and see ch. 5, nn. 64–7.

8. Arias 1950; Bollini 1965, 93–111; Arias 1978, 17–20, revising his earlier and unconvincing proposal that the banquet scene has a symbolic funerary significance. Cf. also Dunbabin 1996, 76, on the ambiguous setting, part outdoor, part indoor, and ch. 5, n. 91.

9. For example, Varro, *R.R.* 3.4.3; 3.5.9–17; 3.13.2–3. I discuss the fashion for outdoor dining and the development of the *stibadium* in more detail in Dunbabin 1991, 128–36; Dunbabin 1996.

10. See Soprano 1950; Jashemski 1979, 89–97, 346, n. 1; Jashemski 1993, 38–41, no. 41 (House of Ephebe); Salza Prina Ricotti 1979; Salza Prina Ricotti 1987; Amedick 1993 (although I am not convinced by her arguments that the term *stibadium* should be applied to all these outdoor installations, regardless of shape); further references in Dunbabin 1991, 124–5, nn. 23–8; Dunbabin 1996, 70–2, nn. 22–9. Cf. also ch. 2, n. 8.

11. Baiae, nymphaeum at Punta Epitaffio: Pozzi et al. 1983. Sperlonga: Neudecker 1988, 220–3, Beilage 3; Salza Prina Ricotti 1979, 131–47; ead. 1987, 138–69, figs. 2–7. On the fashion, see Viscogliosi 1996.

12. Hadrian's Villa: Salza Prina Ricotti 1987, 175–8, figs. 13–20. One example of a semicircular couch in masonry is known at Pompeii, in House VIII 3.15: Soprano 1950, 306–7, no. 28, fig. 8, no. 7; all other outdoor installations at Pompeii are rectilinear triclinia.

13. See Dunbabin 1991; Morvillez 1996; ch. 2, n. 22; ch. 5, 'Rooms for Stibadium Dining.'

14. Ch. 2, nn. 54–5.

15. Cf. Ghedini 1992, 76–83. On the place of hunting in the Roman world, see Aymard 1951; Anderson 1985, chs. 5–7.

16. Philostr.Jun. *Im.*3; see also Ghedini 1992, 80–1; Amedick 1991, 39–43.

17. Lib. 8.470–2 Foerster (= *Descr.* 4); cf. Hebert 1983, 219–26 (who does not quote any late antique parallels).

18. Carandini, Ricci, de Vos 1982, 175–87, room 30, pl. XXIV, 53; Ghedini 1991.

19. Voza 1983, 9–12, figs. 5, 9; Ghedini 1992, 82, fig. 14. The villa probably dates from the second half of the fourth century.

20. See ch. 4, n. 70; also Ghedini 1992, 78–80, figs. 6–7.

21. Amedick 1991, 39, 148, nos. 167, 168, pls. 27.1, 31.1; Andreae 1980, 102–3: 83–6, no. 149, pls. 52.2, 58.1–2; 99–100, no. 150, pl. 74.2, 76.1–6. The hunters' picnic appears at an earlier date on the lids of sarcophagi with the story of Meleager: Koch 1975, 48–50, 125–9. Cf. also Jastrzebowska 1979, 52–6; Ghedini 1992, 78, with n. 75, fig. 6.

22. It seems to me most unlikely that the fish are meant as a mark of Christianization (on which see ch. 5, n. 6), as suggested tentatively by Mundell Mango 1990, 6. Fish are common as a symbol of a luxurious meal in many contexts quite unconnected with Christianity; for example, on the sarcophagus of Caecilius Vallianus, ch. 4, n. 37, and ch. 5, n. 56; see also ch. 6, n. 77. For the significance of fish as the height of gastronomic luxury, see Purcell 1995.

23. The suggestion of Ghedini 1992, 81, that at least four of the figures are women is clearly wrong. The short tunics of the two figures at either end of the *stibadium* undoubtedly identify them as male. The undulating hairstyles of these two are identical to those of the central figure and the one to his right; they are not therefore to be seen as a version of a late Severan female hairstyle, but all must be male. The figure second from the left is identified as female not only by her longer and much more elaborate hairstyle, but also by her necklace; in contrast, the tunics of the males all have the same narrow *clavi* and *orbiculi*. Arias 1950, 312, identifies one of the diners on the Cesena plate as female, again on the basis of the hairstyle, but the costume appears to be identical to that of the other, clearly male, figures. On women hunting, see Anderson 1985, 90–1, 136–8, where he suggests that one of the hunters on a mosaic of a hare hunt from El Djem should be identified as a girl: in fact, the shoulder-length hair and knee-length tunic are characteristic of an elegant boy, like those discussed ch. 5, nn. 47–51.

24. The diners on the Tellaro mosaic are also richly dressed, but appear to be wearing longer tunics than the typical hunters' dress; this would enhance the impressive effect of their presentation, but correspondingly lessen their integration into the surrounding hunting scenes. Regrettably, no good photographs or detailed description of this mosaic have ever been published.

25. These vessels can be identified as hot water heaters or *authepsae*, in which water was heated to mix with wine for the preparation of the hot drink *caldum*; see Dunbabin 1993, 133–8, and ch. 5, n. 77. A related scene also appears on several of the sarcophagus lids: ch. 4, n. 71. For the Black servant, see ch. 5, n. 54.

26. For the hand washer and his equipment, see further ch. 5, n. 53. On the Sevso plate, the jug and two of the characteristic long-handled basins appear on the ground beside the wine flasks, although they are not here shown in use. For the earlier history of the scene of the skinning or disembowelling of the carcass hanging from the tree, see Amedick 1988, 209–11, 223–7; it differs from the two scenes of dissection on the Sevso plate.

27. See ch. 2, nn. 43, 67; ch. 3, nn. 43–4.

28. See ch. 3, n. 43. Etruscans: ch. 1, 'Etruscan banquets and early Rome'. Hellenistic Totenmahl reliefs: Fabricius 1999, 86–91; ch. 4, nn. 8, 9.

29. See D'Arms 1991.

30. Sen. *Ep.* 47.2; other sources in D'Arms 1991, 172–3.

31. Sen. *Ep.* 47.5–8.

32. For example, *CIL* 6.8815–7 (*a cyatho*); *CIL* 9.1880 = *ILS* 5170 (*poculi minister*); *CIL* 6.8866 = *ILS* 1793 (*a lagona*).

33. *CIL* 6.1884 = *ILS* 1792: M. Ulpius Phaedimus. For other imperial freedmen who rose from jobs in the triclinium to higher office in the civil service, cf. *CIL* 11.3612 = *ILS* 1567 (*praegustator* and tricliniarch); *CIL* 3.536 = *ILS* 1575 (tricliniarch, *praepositus a fiblis, praepositus a crystallinis*).

34. Cf. D'Arms 1991, 173, 177.

35. For example, in the House of the Chaste Lovers at Pompeii: ch. 2, nn. 41, 44.

36. Ch. 2, n. 49.

37. Ch. 3, nn. 80–1.

38. On these representations of servants, see Balty, J. 1982; Fless 1995, 56–63; Dunbabin 2003. Fless (57, n. 397, pls. 26–9) draws attention to an early example of the theme in the atrium of the House of the Vettii at Pompeii (VI 15.1), where twelve little figures of children appear, many of them offering vessels or holding equipment such as a jug and basin. However, they occupy a comparatively minor position in the overall decoration of the room (small panels in the socle zone), and the association with a banquet does not appear to be carried through consistently with all the figures.

39. Donati 1998, 292, nos. 67–9; Baratte 1990, who reproduces the engravings of the destroyed figures published by G. Cassini in 1783; Mielsch 1978, 167–8 (esp. pl. 86.2, reproducing the engraving showing the original arrangement of the figures on the walls). Santa Maria Scrinari 1991, 50–2, 142, figs. 117–23, suggests that the building may have formed part of the imperial palace of the Lateran, but see Liverani 1988, for doubts about the identification; it may be no more than a rich private house. The three surviving figures are in the Museo Archeologico Nazionale, Naples, Inv. 84284–6.

40. Cf. M. Martin in Cahn et al. 1984, 112, pl. 32, with parallels for the sieve.

41. Fernández-Galiano 1984, 135–47.

42. Dunbabin 1978, 123, pl. 114, with further African examples; Blanchard-Lemée et al. 1995, 76–9, fig. 48. Mid- to late third century AD.

43. For comparable examples of *pie* and *zêsês*, used alongside Latin drinking mottoes on ceramic wine vessels from the Roman Rhineland, see Loeschcke 1932, 40–9.

44. Ch. 4, nn. 37–9.

45. Two especially fine fragments are in Berlin: Amedick 1991, 124, nos. 19, 20, pls. 22.1–3, 23.1–2. The first, from a chest 117 cm high, has a long-haired youth carrying a plate with a fowl among vegetables, a live bird at his feet, and fragments of two similar youths; they wear flowing knee-length tunics, high soft shoes, and a torquelike necklace. The servants in attendance on Caecilius Vallianus are almost identically dressed. The second Berlin fragment shows a young servant holding a long-handled basin and a fringed towel over his shoulder, identifying him as the water carrier (Fig. 89). He has long corkscrew curls, sometimes called Libyan locks, and the characteristic features used on sarcophagi to identify Blacks: see further ch.5, n. 54. On all these figures, see Amedick 1991, 19–22.

46. Barbet, Gatier, Lewis 1997. For further examples of the theme, in domestic and funerary contexts, see Strocka 1995, 87–8.

47. Juv. 5.56–62; Sen. *Ep.* 47.7.

48. Sen. *Ep.* 119.14; 123.7; Philo *de vit. cont.* 50–2; cf. Fless 1995, 58–9. Further refs. in Marquardt 1886, 147, n. 7.

49. Ch. 4, n. 30; on the servants, see Fless 1995, 56, pl. 25.1.

50. Cf. Fless 1995, part A, esp. 38–45, 56–69. Fless also quotes the interesting mosaic in Capua (from S. Angelo in Formis), showing what has usually been identified as a girls' choir, and argues that in fact it represents a group of luxury pages (*paedagogiani*), with their long hair arranged in various fashionable Flavian hairstyles (ibid. 60, pl. 25.2).

51. See Balty, J. 1982, who rightly observes that the long-haired and more elegant type is used to characterize a privileged category of servants in close attendance on their masters. It should be noted, however, that the distinction is not consistent; the short-haired type continues to be used in many late antique documents even where an honorific function is required; and there seems no reason other than the desire for variety why two of the Caelian food bearers have long hair, the rest short.

52. Cf. Amedick 1991, 21–4; the servant with a fly-whisk appears ibid. 150, no. 174, pl. 11.1. Heating apparatus: see ch. 5, n. 25, 77.

53. Hand washing: cf. Nuber 1972, esp. 83–90, 117–21, 128–9; Fless 1995, 15–17, on the jug-and-basin set as the typical equipment of attendants at the sacrifice, a role in which they

appear from a much earlier date than in secular scenes. For similar figures on funerary monuments in the Northwest provinces, see Guerrier 1980. Tellaro: ch. 5, n. 19; Cesena: ch. 5, n. 8; Constanza: ch. 5, nn. 78–9.

54. Cf. Amedick 1991, 21; Berlin fragment: Amedick 1991, 124, no. 20, pl. 23.1–2; ch. 5, n. 45. For the tradition of luxury Black slaves, see G. Ako-Adounvo, *Studies in the Iconography of Blacks in Roman Art* (Diss. McMaster 1999), ch. 4.

55. In addition to the woman holding a vessel on the sarcophagus of Caecilius Vallianus (ch. 4, n. 37), see e.g. Amedick 1991, 142, no. 124, pl. 14.2; 158, no. 228, pl. 18.1; 171, no. 308, pl. 9.1. These figures are clearly distinguished from the long-haired boys in shorter tunics. See also ch. 6, 'The Catacomb of Peter and Marcellinus,' with nn. 23–24, for female servants at banquets in a Christian context.

56. Ch. 5, nn. 39, 45; ch. 4, nn. 37–9.

57. Ch. 5, n. 19, 79; also ch. 6, n. 75.

58. Ch. 2, nn. 62–4; Croisille 1965.

59. See the articles in Balmelle et al. 1990. Pl. XI shows panels from the mosaic of a triclinium at Thysdrus (El Djem), now in the Musée du Bardo in Tunis (Cat. A 268/278): M. Ennaïfer, in Balmelle et al. 1990, 24, pls. IV, V.3. For the range of Roman foods, see André 1981; Dosi, Schnell 1990, 129–259.

60. Triclinia: e.g. Ostia, House next to the Serapeum, Becatti 1961, 144–8, no. 283, pls. CIII–CIV, CCXII–CCXIII; Acholla, House of the Lobster, S. Gozlan, in Balmelle et al. 1990, 29–40; Thuburbo Maius, House of the Bound Animals, Alexander et al. 1980, 102–8, no. 83, pls. XL–XLI, LXXI–II. See also A. Ben Abed-Ben Khader, in Balmelle et al. 1990, 79–84. Thysdrus (El Djem), mosaic of dice players: W. Ben Osman, ibid. 76, pl. XII, and see refs. ibid. 106.

61. Thysdrus (El Djem), House of the Months: Foucher 1961, third century. For the *asarotos oikos* mosaics, see ch. 2, nn. 65–6; they have only limited reflections on the mosaics of the later Empire.

62. Levi 1947, 127–36, pls. XXIII–IV, CLII–III; Baratte 1990, 97–104; Morvillez 1996, 133–4; Kondoleon 2000, 182–3.

63. Lucian *Merc.Cond.* 15. For the conventional order of dishes at a Roman banquet, *ab ovo usque ad mala* ('from egg to apples'), see Marquardt 1886, 323–7.

64. See S. Martin-Kilcher, 'Römisches Tafelsilber: Form- und Funktionsfragen', in: Cahn, Kaufmann-Heinimann 1984, 393–404; ch. 2, n. 67.

65. Mundell Mango, Bennett 1994, 98–193, nos. 2–4.

66. Cahn, Kaufmann-Heinimann 1984, 180–315, nos. 56–63; Kaufmann-Heinimann 1999, with a preliminary publication of the eighteen items from the treasure recovered in 1995. (I have counted only the plates with a diameter over 45 cm. Several of the simpler plates also have elegant geometric decorations; no. 114 has a metrical inscription celebrating the *decennalia* of Constans in 342 AD.) Other comparable plates include the Cesena plate (ch. 5, n. 8), and the Mildenhall Oceanus dish (Painter 1977, 26, no. 1, pls. 1–6). See also Pirzio Biroli Stefanelli 1991, 87–110, 118; Toynbee, Painter 1986.

67. On the relationship between the plates and vessels portrayed in the figured monuments and surviving examples of silver and bronze (and the imitations of these in glass and ceramic), see Baratte 1990; Baratte 1993, 231–52. Similar great silver dishes (*lances*) were also used to hold the gifts of money distributed by munificent donors and would have served to evoke associations of euergetism. One is seen, for instance, laden with money bags in the hands of an elegant long-haired youth exactly like those in the banquet scenes, on a mosaic from Smirat in Africa Proconsularis with amphitheatre scenes and a lengthy record of the munificence of a certain Magerius: Dunbabin 1978, 67–9, pl. 53.

68. On the value of glass and its place in the hierarchy of materials in antiquity, see Stern 1997, 206, answering Vickers 1996; Stern 1999, 478–84; for the techniques and decoration of Roman glass, see Harden et al. 1987.

69. For example, Harden et al. 1987, 186, 238–49, nos. 134–9; Vickers 1996, 58–63; Harden, Toynbee 1959; on the technique of cage cups, see Scott 1993, 1995. For drinking inscriptions (e.g. *bibe vivas multis annis*), see Harden et al. 1987, 238–41, nos. 134–5, and compare those on ceramic drinking vessels cited ch. 5, n. 43. Fig. 96 shows a cage cup found in a grave near Cologne, with the inscription around the rim πίε ζήσαις καλῶς ἀεί ('drink, may you live well always'): Harden et al. 1987, no. 135.

70. The pairs of flasks in wicker carriers which appear in many of the banquet scenes discussed in this chapter are also undoubtedly intended to be seen as glass.

71. Ch. 5, nn. 2, 8, 18, 19.

72. See ch. 2, nn. 54–5; ch. 4, n. 67; also Ghedini 1990, 48–53, on the tradition of the hedonistic banquet. An important representation of the convivial banquet at an outdoor *stibadium* of masonry, complete with servants and entertainers, appears on a recently published mosaic *emblema*, reportedly found in Ostia, now in the Detroit Institute of Arts (Inv. 54.492): Kondoleon 2000, 184–6, no. 68. I refrain from discussing it in detail in this chapter because of the uncertainty about its provenance and date.

73. For example, Amedick 1991, 131, no. 59; 159, no. 235; 169, no. 293; and especially 145–6, no. 146, where one man has torn off his tunic and waves it above his head: pl. 31.6. Several of these scenes appear on sarcophagi with explicit Christian symbolism, including no. 146, which accompanies a scene of Jonah asleep under the gourd; see also ch. 6, n. 4.

74. Jobst 1976–7, 73–82, figs. 21–3; Dunbabin 1993, 120–2, fig. 6. Probably early fourth century.

75. Weiss, Netzer 1998, 26–7, Col. Pl. i. Probably second half of third century. See also Talgam, Weiss forthcoming. I am grateful to Zeev Weiss for information about this mosaic.

76. For dice players in a convivial setting on a *xenia* mosaic from Thysdrus (El Djem) in North Africa, see ch. 5, n. 60. For gaming and dicing as a frequent diversion before a meal, see Rossiter 1991, 200–1, quoting Sid. *Ep.* 2.9.4; Macrob. *Sat.* 1.5.11.

77. I discuss both the representations of hot water heaters and surviving examples, along with literary sources, in detail in Dunbabin 1993, which I summarize here. For further examples, see also ch. 6, n. 15; and cf. ch. 1, n. 37; ch. 2, n. 70. On the vessels themselves, see Tomasevic Buck 2002.

78. Barbet 1994; ead. in Blanc 1998, 108–11.

79. For the rolls, see ch. 5, n. 57; Barbet 1994, 33, identifying them as a type of cake. She quotes in comparison the similar objects on the table in the mosaic showing a banquet of women from the Tomb of Mnemosyne at Antioch (pl. XIV): Levi 1947, 295–304, pl. LXVI (who mistakes them for wreaths); see ch. 6, n. 28. The object in the central dish at Constanza is hardly the remains of a meal, as Barbet suggests, but should be some prestigious food; the rendering is unclear, but a cake seems a possibility. Also obscure is the interpretation of the triangular objects carried by the wine server; Barbet suggests a pair of conical glasses, I am inclined to see them as cone-shaped linen strainers.

80. Barbet, Bucovală 1996, with a date of the mid-fourth century at the earliest; Barbet, Bucovală 1997.

81. For orant figures in pagan funerary art, see Klauser 1959; for Christian use, see ch. 6, n. 35.

82. For what follows, see my discussions in Dunbabin 1991, 128–131, and Dunbabin 1993, 74–8, and more recently the collection of evidence with full references in Morvillez

1996; also ch. 5, nn. 86–8, and ch. 6, 'The Last Centuries of the Ancient World,' nn. 59–67.

83. Vaquerizo Gil, Carrillo Diaz-Pines 1995, 145–7; Vaquerizo Gil, Noguera Celdrán 1997, 60–77, pls. 18–21. On *sigma* fountains, see Morvillez 1996, 124–5, 129–30, and cf. ch. 5, nn. 10–11.

84. Guidobaldi, Guiglia Guidobaldi 1983, 230–8, fig. 66; Arce, Sánchez-Palencia, Mar 1989, 311–14; Morvillez 1996, 129.

85. Åkerström-Hougen 1974, 34–6, 101–17, pl. VII, col. pl. 7.2; Sodini 1984, 354–5, 379–80; see ch. 6, n. 59. Probably early sixth century.

86. In addition to the works cited in the preceding notes, see Duval 1984; Rossiter 1991; Ellis 1991; Ellis 1997 (some details in these last two works need to be treated with caution); and for specific regions of the empire Sodini 1984, 375–83 (Greece); Ellis 1995 (Britain). For a survey and bibliography of domestic architecture in late antiquity throughout the empire, arranged regionally, see Sodini 1995; id. 1997.

87. See dimensions in Morvillez 1996, 137–9, 158.

88. Morvillez 1995 lists eighteen western examples, from Italy and Sicily, Gaul, the Iberian provinces, and Africa Proconsularis, dating from the fourth and fifth centuries, and three from the East of the fifth and sixth centuries; to these should be added an example from Buthrotum (Butrint) in Epirus of the early sixth century: R. Hodges et al. 1997, 221–3. For earlier studies, see Lavin 1962; Duval 1984; Rossiter 1991, 203; Dunbabin 1996, 77–8. See also ch. 6, n. 64.

89. Sid. *Carm.* 22. 204–10; *Ep.* 2.2.11; cf. ch. 6, n. 53. See Rossiter 1991, 203–5; Dunbabin 1996, 66, 76–7.

90. Cf. Amedick 1994, esp. 113–15, although she does not recognize the extent to which the *stibadium* meal can take on a ceremonial quality in late antiquity (see also ch. 2, n. 22, on her attempts to apply the term *stibadium* to the T + U triclinia of the High Empire). Needless to say, hunting scenes also suggest other associations: heroic effort, the wealth and status of the owner, and also the supply of game for the table.

91. Cf. ch. 2, n. 20; ch. 3, n. 47; and see Bek 1983; D'Arms 1999.

92. Cf. Ellis 1997, 48–9, rightly pointing out that from a *sigma* couch set in an apse the diners' view out of the room would have been very limited, and from the side apses of a triconch nonexistent; ibid. 44, 48 with references for lighting. For entertainment in the central area before the couches, see Rossiter 1991, 203; Dunbabin 1996, 78. See also ch. 6, n. 55, for the place of honour on the *sigma*.

CHAPTER 6

1. Jastrzebowska 1979, 13–29, lists twenty-one examples; she does not discuss the representations of the solitary banquet cited in ch. 6, nn. 2 and 11, nor does she discuss some questionable or ambiguous examples. Guyon 1987, 164, fig. 95D, and Nestori 1993, 194, list 27, again excluding the solitary banqueters, but including some that are probably or certainly non-Christian in the hypogaea of the Aurelii and Vibia (ch. 6, nn. 44–8). Several of the scenes are now lost or very fragmentary. On the banquet scenes in the catacombs, see also Bisconti 2000, 81–90.

2. One, from the hypogaeum of the Flavii in the catacomb of Domitilla, showed a couple seated upon a high-backed couch, a table with food before them, a servant bringing wine: Nestori 1993, 122, no. 11; Pani Ermini 1969, 138–40, fig. 10; Wilpert 1903, 518–19, pl. 7.4. The scheme is clearly taken from the standard funerary motif of the reclining couple, but the seated position is unusual. However, the painting, which is now lost and known only from a drawing, may well belong to a phase of pagan use of the hypogaeum,

before its use by Christians: Pani Ermini 1969, 158–61, 168; Février 1978, 218. Cf. also ch. 6, n. 11, for scenes from the catacomb of Peter and Marcellinus with single figures or a couple.

3. Callixtus: Nestori 1993, 106–7, nos. 21, 22, 24, 25; Jastrzebowska 1979, 14–16, nos. I–IV; Wilpert 1903, 289–92, pls. 15.2, 27.2, 41.3–4; all probably date from the second quarter of the third century. Priscilla: Nestori 1993, 27–8, no. 39; Jastrzebowska 1979, 17, no. V; Tolotti 1970, 265–75, fig. 12.5; Wilpert 1903, 286–7, pl. 15.1. The date is highly disputed; Tolotti places it certainly after the mid-third century, probably in the early fourth century, although others have placed it substantially earlier: cf. De Bruyne 1970, with a review of the dates previously proposed, and arguing for ca. 180 AD. See also Février 1989, 111–3, on this problem; the later date seems better supported. Coemeterium Maius: Nestori 1993, 32–6, nos. 3, 16 (cf. also 19, showing the banquet of the Wise Virgins). Jastrzebowska 1979, 19, no. VIII, adds a lost painting in the catacomb of the Giordani.

4. On the sarcophagus lids with *sigma* banquets associated with Christian scenes or inscriptions, see Jastrzebowska 1979, 29–35, 72–80; Amedick 1991, 44–5; for earlier studies, see Gerke 1940, 110- -50. See also ch. 4, n. 70; ch. 5, nn. 20–1, 73.

5. Amedick 1991, 44, 169, no. 293, pl. 29.4; cf. also ibid. no. 101. For a single basket of loaves, see ibid. nos. 186–188, 207, 294. Jastrzebowska 1979, 79–80, suggests that such baskets may be confined to Christian sarcophagi and have appeared there under the influence of similar scenes in catacomb painting, but isolated baskets of this sort occur on earlier reliefs of the Totenmahl type and are likely to have been derived from there. For Caecilius Vallianus, see ch. 4, n. 37; ch. 5, n. 44.

6. For the multiplication on Christian sarcophagi, see e.g. Gerke 1940, 221–3; for catacomb paintings, Wilpert 1903, 292–300.

7. For a review of the controversy, extending over more than a century, see Jastrzebowska 1979, 8–13.

8. Jastrzebowska 1979, 62–71, who compares the paintings on the facade of the mausoleum of Clodius Hermes beneath S. Sebastiano in Rome showing four groups of banqueters at *stibadia*, while a row of servants in the foreground carry similar baskets on their shoulders: ibid. 37, no. XXIV; Jastrzebowska 1981, 52–4; Tolotti 1984, 133–47. It is disputed whether the Clodius Hermes paintings are to be seen as pagan or Christian, but the proposed interpretation is compatible with both views.

9. See especially the detailed review of both paintings and sarcophagi in Jastrzebowska 1979, with her conclusions 81–90; followed (with a few qualifications) by Ghedini 1990, 40–3. Cf. also Dölger 1943, esp. 503–40; Stuiber 1957, 124–36, with the review of De Bruyne 1958; W. Schumacher, in Deckers, Seeliger, Mietke 1987, 166–7; the summary by Engemann 1982, 248–50, who argues that not all the scenes should be taken as representing the funerary meal of the survivors, but that some are to be interpreted allegorically with reference to the happiness of the deceased in the next world (see ch. 6, n. 33); and most recently, Bisconti 2000, 85–8, who stresses the multiple semantic layers present in the banquet scenes, and their oscillation between symbol and reality, but believes that the symbolic, eschatological sense comes increasingly to prevail over the realistic. For the Christian funerary banquet, see ch. 6, nn. 36–43.

10. Full publication in Deckers, Seeliger, Mietke 1987, with references to the extensive earlier bibliography; Guyon 1987, esp. 198–200; Nestori 1993, 49–71. The numbering system of Nestori, adopted for individual scenes in these works, will be used here for reference. In addition to those cited in ch. 6, nn. 11 and 12, the following may be recognized as banqueting scenes: nos. 13.2, 48.2, 52, 60.2(?), and 62.4 (this last combined with a scene of Christ turning the water to wine). The traditional form of the name 'SS. Peter

and Marcellinus' will be retained here, despite the arguments for preferring the order 'Marcellinus and Petrus' and the identification of the original name as '*inter duas lauros*': see references in Dückers 1992, 147, n. 1.

11. Single figures: Deckers, Seeliger, Mietke 1987, 209–10, no. 10.2,5, plan 10: figure reclining on a couch in the traditional Totenmahl scheme, with two orants in separate panels and the inscription B]INKENTIA, apparently identifying the deceased; on the opposite wall are two larger figures of servants with jug and cup. Ibid. 269, no. 45.3, col. pl. 21, plan 45: man seated beside table with food. Ibid. 302, no. 59.2, pl. 42c, col. pl. 39: man leaning against cushion or couch, servant with cup. Couple: ibid. 215, no. 14.0, pl. 7a, plan 14, associated with what is apparently a scene of sale.

12. The eight are Deckers, Seeliger, Mietke 1987, nos. 39, 45.2, 47, 50.2 (from region A); 75, 76.2, 78.2, 78.3 (from region I), also the fragment no. 73; they are examined as a group by Dückers 1992. See also Jastrzebowska 1979, 19–27, nos. IX–XVII; Février 1977.

13. See Guyon 1987, 135–46 (esp. 143–4), for a date for the *cubicula* containing these paintings at the very end of the third century and opening decades of the fourth century; 151–2, on the absence of paintings of banquets and similar themes after 325 AD; 198–200; also his contribution to Deckers, Seeliger, Mietke 1987, 117–31. The varying datings that have been proposed in the past are listed under each entry in the catalogue of Deckers, Seeliger, Mietke 1987. Deckers himself prefers somewhat later dates in the Constantinian period for many of the banquet scenes: cf. ibid. 30–5; also Deckers 1992, with arguments against Guyon. Dückers 1992, 147– 8, n. 2, gives a review of the controversy over the chronology of these paintings, but misleadingly quotes Guyon for a view that the paintings are to be placed exclusively in the second half of the third century. See most recently, Guyon 1994, repeating his arguments for a date early in the fourth century for the majority of the *cubicula* with paintings in the catacomb, including the banquet scenes; Bisconti 1994, confirming a date between the end of the third and the first 20 years of the fourth century.

14. Woman reclining at *sigma*, among four men: Deckers, Seeliger, Mietke 1987, 280, no. 50.2, col. pl. 276. Children at *sigma* (both boys): ibid. 268–9, no. 45.2, pl. 30b, col. pl. 20. Seated women: ibid. 256, no. 39, pl. 24, col. pl. 12a (on low-backed seat); 340, no. 76.2, col. pl. 57 (in high-backed chair). See also Dückers 1992, 147–156. Standing women: see ch. 6, n. 22. Servant boys: Deckers, Seeliger, Mietke 1987, nos. 39, 50.2 (head only), 78.2; on no. 47, the gender of the fragmentary servant to the left cannot be distinguished.

15. Deckers, Seeliger, Mietke 1987, 337–8, no. 75, pls. 55, 56a, col. pl. 55; Dückers 1992, 154–5, pl. 7a. See also Jastrzebowska 1979, 22–3, no. XII; Engemann 1982, 245–6. For the *authepsa*, see Dunbabin 1993, 139–40, fig. 28, and ch. 5, n. 77.

16. Deckers, Seeliger, Mietke 1987, 339–40, no. 76.2, col. pl. 57; Dückers 1992, 155–6, pl. 7b–c; Jastrzebowska 1979, 21–2, no. XI; Engemann 1982, 245, pl. 18b; Dunbabin 1993, 139–40, figs. 29–30.

17. See Février 1977, 29–37.

18. Compare the phrases written on two of the paintings with tavern scenes from *caupona* VI 10,1 in Pompeii: Fröhlich 1991, 214–22 (cf. ch. 3, n. 26); or the numerous examples on drinking vessels from Roman Germany collected in Loeschke 1932, 43–50: e.g. *misce* (n. 115), *imple me copo vini* (n. 107), *parce aquam* (nn. 117–8).

19. See review of the controversy in Dückers 1992, 161–7.

20. Deckers, Seeliger, Mietke 1987, 345–7, nos. 78.2, 78.3, pls. 63–4, col. pls. 62–3; Dückers 1992, 156–8, pl. 8a–b; Zimmermann 2001, 53–7.

21. See review of contrasting opinions in Dückers 1992, 159–61, nn. 90–3. For the application of the names in the inscriptions, see ch. 6, n. 26.

22. Dückers 1992, 159–61, esp. n. 92: 'Einen solchen Wandel zu postulieren bzw. das Stehen oder Sitzen der Frauen zum ausschlaggebenden Merkmal der Unterscheidung zwischen Dienerinnen und Mahlgefährtinnen zu machen, muss jedoch angesichts der ansonsten stets gleichen Darstellung der Figuren in den angesprochenen Szenen als problematisch erscheinen'.

23. See ch. 4, n. 11; the former dates from the early third century, the latter perhaps from the mid-second century. Many other parallels could be quoted.

24. Amedick 1991, 168, no. 286; 155, no. 201; 171, no. 308; also nos. 124; 228; 246; cf. ibid. 21, with n. 81; cf. ch. 5, n. 55.

25. Ch. 6, n. 68, and compare the mosaic from the Tomb of Mnemosyne at Antioch, ch. 6, n. 28.

26. See discussion of this problem in Dückers 1992, 161–2, with examples of further anomalies.

27. Février 1977 has well compared the inscription from a funerary *mensa* in the necropolis at Tipasa: *In (Christo) Deo pax et concordia sit convivio nostro*; see ch. 6, n. 39.

28. Levi 1947, 296–304, pl. LXVI; Kondoleon 2000, 121–2, no. 9. The two women standing at the left are described here as carrying wineskins over their shoulders, but in fact the objects they carry appear to be swags of cloth containing small coloured objects: I know of no parallels. The use of allegorical inscriptions both as a title for the scene and to identify specific figures has parallels in other Antioch mosaics, for instance, in the banquet of Agros and Opora, where *Oinos* serves the wine (Levi 1947, 186–90: ch. 2, n. 74); the role of Irene and Agape in the Peter and Marcellinus paintings seems comparable.

29. Speidel 1994, 1–3; Guyon 1987, 30–3; see ch. 4, n. 14.

30. On these, see ch. 6, nn. 36–43.

31. For the Christian *agape* at this period, see White 1990, 119–20, with earlier references; Hamman 1968, 151–227. There is no indication in the Peter and Marcellinus paintings that the meal is intended to be seen as an act of charity towards the poor.

32. For example, Stuiber 1957, 133–6; Schumacher 1977, 139; id., in Deckers, Seeliger, Mietke 1987, 166; Himmelmann 1973, 25–8 (who, however, sees the *sigma* meal on sarcophagi as an allegory of idyllic existence).

33. Engemann 1982, especially his pl. 14b, the fragment of a sarcophagus lid where the head of the figure at the centre of the *sigma* is left in boss: cf. also Amedick 1991, 125, no. 23, pl. 33.5; 31, with further examples of sarcophagus lids with *sigma* meals where one figure is individualized by a portrait.

34. Deckers, Seeliger, Mietke 1987, 343–8, pls. 57–65, col. pls. 59a, 60–63, drawing no. 78; Zimmermann 2001, 53–8; see ch. 6, n. 20.

35. For the good shepherd and the problem of its significance, see Schumacher 1977, 193–216; Klauser 1967. Orant: Klauser 1959. For the overall interpretation of such scenes in Christian funerary art at this period, see e.g. Finney 1994, 184–91, 197–222 (on the earliest paintings at Callixtus, with a valuable discussion of the general problems of interpretation); Engemann 1997, 106–22; Bisconti 2000, 81–90.

36. Aug. *Ep.* 22.3–6: *sed feramus haec in luxu et labe domestica et eorum conviviorum, quae privatis parietibus continentur...*; Ep. 29.9–11, referring to the custom of the Donatists of celebrating banquets in their basilica; *Serm.* 311.5 (*PL* 38, 1415), on the funeral feasts with profane singing and dancing held on the anniversary of St. Cyprian; further references in Saxer 1980, 133–49.

37. Aug. *Conf.* 6.2; cf. Ambr. *Hel.* 17.62 (*CSEL* 32, 448). Cf. also Doignon 1969, on the homilies of the fourth-century bishop Zeno of Verona and their references to contemporary Christian attitudes towards *refrigerium*.

38. Spain: Barral i Altet 1978, on the installations in the necropoleis at Tarragona and Cartagena. North Africa: Di Vita 1978, on the hypogaeum of Adam and Eve at Gargaresc, near Tripoli, equipped with a roughly shaped *stibadium*, and paintings showing pages holding torches and perhaps an amphora; the date is second quarter to mid-fourth century. Tipasa: Christern 1968, 206; Bouchenaki 1975. Cf. also Giuntella et al. 1985, esp. 17–27, identifying similar installations at Cornus in Sardinia, with review by Duval 1987. Further references in Jastrzebowska 1981, 164, with nn. 201–11; also MacMullen 1997, 110–12.

39. Tipasa: Bouchenaki 1974, proposing a date in the second half of the fourth century or beginning of the fifth century; Février 1977; see ch. 6, n. 27. For older scholarship on the Christian funerary banquet, see Klauser 1928; for more general Christian festivities accompanied by eating and drinking, see Dihle 1980.

40. These are collected by Jastrzebowska 1981, 141–78; see also Février 1978, esp. 228–39, and the discussion following his paper, ibid. 312–29.

41. Jastrzebowska 1981, 67–92; Tolotti 1984.

42. W. Schumacher, in Deckers, Seeliger, Mietke 1987, 166; cf. also Février 1978, 321.

43. *ICUR* IV (1964) no. 9913: *Ianuaria bene refrigera et roga pro nos.* For related images, cf. also *ICUR* II (1935), no. 6141; *ICUR* III (1956), no. 6618. For *refrigerium*, see Jastrzebowska 1981, 194–5, 205; Stuiber 1957, 110–17, with the review of De Bruyne 1958; Février 1978, 258–60.

44. For the catacomb as a whole, see Ferrua 1971 (date: 58–61); Ferrua 1973. Paintings: Wilpert 1903, 144, 392–3, pls. 132–3; Dölger 1943, 485–91; Cecchelli 1945, 167–80, pls. 34–6. For the banquet scenes, see Jastrzebowska 1979, 38–40 nos. XXV–XXVI, with earlier bibliography; Ghedini 1990, 41, 47, figs. 10, 24; Engemann 1982, 243–4, 248–9, pl. 17.

45. Inscriptions on the lunette scene: *inductio Vibies*; *angelus bonus*; *bonorum iudicio iudicati*; *Vibia* over the third figure from the left at the *stibadium*. For Alcestis, see *LIMC* I (1981), 533–44, s.v. Alkestis (M. Schmidt), esp. 543.

46. *Septem pii sacerdotes*; *Vincentius* is written above the third figure from the right, but more likely should be referred to the bearded figure to the left of him, in the centre of the group: Engemann 1982, 243–4.

47. *CIL* 6 142e:... *manduca, vibe (= bibe), lude e[t] beni (= veni) at me...*. etc. For earlier variants of the motif see ch. 4, nn. 49–54. On the cult of Sabazius, see Turcan 1996, 315–25, esp. 323–5, with references; Lane 1985, 31–2, no. 65; also Nilsson 1949. All three writers erroneously describe the catacomb of Vibia as part of the catacomb of Praetextatus.

48. Cf. A. Ferrua, review of Dölger 1943, *RACrist* 33, 1957, 216–7; *contra* e.g. Jastrzebowska 1979, 66–7.

49. Ferrua 1971, 36–46, 56–8, 61–2.

50. Both the sarcophagi with the *sigma* banquet and the catacomb paintings with the subject appear to come to an end ca. 325–30 (Guyon 1987, 151–3; Deckers' dating of the Peter and Marcellinus paintings would prolong their use to about the mid-fourth century, which is probably too late: ch. 6, n. 13). An isolated late example of the traditional 'kline-meal' may be preserved on the fragmentary lid of the Christian sarcophagus of Junius Bassus, who died in 359: Himmelmann 1973, 15–28. For examples probably of the late fourth century in the provinces, see e.g. ch. 6, n. 28; ch. 4, n. 11 (Asgafa El Abiar); ch. 5, nn. 78–80.

51. On the proscription of pagan funerary feasts in a law of 408 AD (although also their persistence), see MacMullen 1997, 63–4.

52. See Rossiter 1991, 205–8, with sources for reclining dining in the Latin West in the fifth and sixth centuries; he suggests that it may have become associated particularly with older buildings designed for this specific ceremony.

53. Sid. *Ep.* 2.2.11: *in hac* [sc. *diaeta sive cenatiuncula*] *stibadium et nitens abacus... quo loci recumbens, si quid inter edendum vacas, prospiciendi voluptatibus occuparis.* Cf. Rossiter 1991, 203–4.

54. Sid. *Ep.* 1.11.10–16.

55. For the place of honour *in dextro cornu* and the order of precedence, see Marquardt 1886, I, 308, with references: it is first attested ca. 330 in Juvencus, and this passage of Sidonius is one of the main sources. Engemann 1982, argues that this was a change from an earlier emphasis on the central position, still sometimes perceptible in the figured monuments (cf. ch. 6, n. 33). Ellis 1997, 50, mistakenly claims that Sidonius' place was at the left end of the couch (explicitly said to be the place of the consul Severinus) and that he was there in the role of parasite to provide entertainment: his awkward position in fact arose from the claim that he was the author of satirical verses against one of the other guests, and from the emperor's charge that he defend himself in impromptu verse. There is no suggestion, at least in Sidonius' account, that his presence at the banquet in the first place had any connection with the affair.

56. Sulp. Sev. *V.M.* 20.1–7; cf. Roberts 1995, on the versions of the same story given by Paulinus of Périgueux in the later fifth century and Venantius Fortunatus in the later sixth century.

57. Rossiter 1991, 206–7; see also Ward Perkins 1984, 174–7, on the Popes in Rome and bishops in other cities of Italy building dining rooms described as triclinia or *accubita* between the fifth and the ninth centuries. Although the terms need not necessarily imply that the practice of reclining continued, they are occasionally explicitly said to be equipped with couches.

58. See ch. 3, n. 58. See also Jeremias 1980, 34–5, on the panel of the wooden doors of S. Sabina in Rome showing the miracles of the quails and manna in the wilderness, where the participants sit to eat: she sees the seated diners in these and other Old Testament scenes as perhaps derived from Jewish models, and not reflecting changed customs in late antiquity.

59. Åkerström-Hougen 1974, 34–6, 101–17, pls. VII–VIII, col. pl. 7; ch. 5, n. 85. The mosaic panel in front of the *sigma* shows the Dionysiac thiasos, also a very traditional subject at such a date, which perhaps alludes to the entertainment that would be offered in that setting. Sodini 1984, 375–83, 393–6, gives further examples of houses in Greece with similar rooms; they continued to be constructed or restored into the mid-sixth century. For written sources for *stibadium* dining in the East in the sixth century, see Rossiter 1991, 207–8.

60. Cf. Balty, J.Ch. 1984, 476–7, 495–7. The building history of the houses, not yet fully published in detail, is evidently complicated; it would certainly be wrong to assume that all the grand 'reception rooms' with apses or alcoves were permanently used for dining throughout their history (cf., for example, Balty, Balty 1995, 207–8, on the changes in the House of the Stag). But the presence of the *sigma* tables discussed in ch. 6, nn. 62–63, provides the proof that some were indeed so used.

61. Balty, J.Ch. 1969. For the inscription and its relationship to the Hunt mosaic in which it was set as a later repair, see Balty, J. 1969; for a date for the original laying of the Hunt mosaic between the mid-fifth and early sixth centuries, Balty, J. 1995, 16–17, 23.

62. Donnay-Rocmans, Donnay 1984; Balty, Balty 1995: the larger of the two *sigma* tables measures 1.54 × 1.53 m. The house was destroyed at the end of the sixth century or beginning of the seventh century.

63. Balty, J.Ch. 1984, 478, 495–6, pl. XCIII. For the controversy over the use of such tables and others of related type, many of which have been found in Christian contexts, see Chalkia 1991.

64. Cf. Rossiter 1991, 208; Morvillez 1995, 17–19; ch. 5, n. 88.

65. Guilland 1962–3; Krautheimer 1966; see ch. 6, n. 79.

66. Naumann 1965; Lassus 1971, 195–6, fig. 3; on its identification (not the Palace of Lausus) and the uncertainty of dating, see Bardill 1997, 69, 86–9, fig. 1. The hall is 52.5 m long, with an additional 5 m for the apse at the end; the side apses 6.7 m wide. Bek 1983, 96–7, wrongly identifies this hall as the Triclinium of the Nineteen Couches itself.

67. Blanchard-Lemée 1984, with the discussion of N. Duval, ibid. 143; Lassus 1971; also Dunbabin 1991, 130. Given the uncertainty of the dating, the possibility of a date in the mid-sixth century after the Byzantine reconquest should probably be left open.

68. Baltimore, Walters Art Gallery 71.64, Egypt, early sixth century: Weitzmann 1979, 137–8, no. 115 (with identification of the reclining figures as Poseidon, Zeus, and Athena, but the central figure wears the same diadem as the nude Aphrodite in the scene of the Judgement of Paris on the reverse, and the figure in the place of honour at the right end is surely Zeus); Volbach 1976, 75, no. 104, pl. 55.

69. Cod. Vat. Lat. 3867, fol. 100v: Wright 1992, 86–90, fig. 31; good colour illustration in Rosenthal 1972, 54–8, pl. ix. For the date, see Wright 1992, 9–12. Long-haired pages: ch. 5, 'The Servants'.

70. Bianchi Bandinelli 1955, 67, fig. 190: min. XXVII, fol. 24b; 69, fig. 191: min. XXX, fol. 27b.

71. Cod. Vindob. theol. gr. 31, fol. 17v; Mazal 1980, 121, pl. 34, fol. 17v; 154–5. Date: probably first half of the sixth century, ibid. 175–6.

72. See Böhm 1998, 51, fig. 12, who identifies the bowls as the instrument called *acetabula* or *oxybapha* and compares the mosaic of the Musicians from Mariamin in Syria, which decorated a room almost certainly designed for *stibadium* dining (cf. Dunbabin 1999, 171, figs. 178–80).

73. Grabar 1966, 204, fig. 227 (fol. 10v); Weitzmann 1979, 491–2, no. 442. Caelian: ch. 5, n. 39.

74. Volbach 1976, 84, no. 119, pl. 63.

75. Grabar 1966, 206, fig. 230; Cavallo, Gribomont, Loerke 1987, 131–4, page 5, pls. I, 6. Date in the 'full 6th century': ibid. 27. Loerke (ibid. 131–2) claimed that there is neither bread nor wine on the table, and that the two crescent-shaped objects 'cannot represent bread, which does not take this shape in either Judaism or the early church, but seem rather to be decorative inlays in the "marble" top' of the table. But the two objects clearly correspond to the crescent rolls represented in numerous other late antique banqueting scenes (ch. 5, nn. 57, 79); the artist has included a standard motif, regardless of the particular requirements of the specific subject.

76. Deichmann 1958, figs. 180–3; Deichmann 1974, 173–4.

77. For fish, see ch. 5, n. 22; Dölger 1943, 329–610, esp. 578–89, 601–10.

78. See Wessel 1964.

79. For the Decaenneacubita and its probable reflection in the slightly smaller Triclinium of the Lateran Palace built by Pope Leo III around 800, which had eleven apses for *sigma*-shaped couches, see Krautheimer 1966; ch. 6, n. 65.

80. Liutprand, *Antapodosis* 6.8 (*MGH, Scriptores Rerum Germanicarum* ed. J. Becker (1915), 156).

CONCLUSION

1. Ch. 5, n. 41; Fig. 87. For the mosaics of the triclinium, see Fernández-Galiano 1984, 148–86; Dunbabin 1999, 152, figs. 158–9.
2. Ch. 5, n. 75; Pl. XII. For the Orpheus mosaic, see Weiss, Netzer 1998, col. pl. i.
3. It must be noted, however, that there is by no means invariably a thematic connection between even adjacent panels in the same mosaic, and that attempts to decipher a programme behind the overall decoration of a room have often been unsuccessful.
4. Varone 1993, 623: 'Il tema decorativo dell'ambiente . . .è un vero e proprio inno alla gioia del banchetto e un invito alle delizie conviviali'; cf. ch. 2, 'Paintings of the Banquet in Pompeii and Herculaneum.' The winged figures are described briefly ibid. 629, but not yet published in detail. For the building, see ch. 3, n. 79.
5. Constanza: ch. 5, n. 78; Pl. XIII. Peter and Marcellinus, *cubiculum* 78: ch. 6, n. 34; Figs. 107, 108.
6. For the manner of exhibiting grave monuments, see e.g. Toynbee 1971, 245–81; von Hesberg 1992, esp. 202–30; and many of the articles in von Hesberg, Zanker 1987.
7. Ch. 3, n. 23; Fig. 40.
8. Rubrius Urbanus: Introduction, nn. 1–2; Fig. 1. Flavius Agricola: ch. 4, nn. 1–3; Fig. 54.
9. Ch. 4, n. 80.
10. Amiternum: ch. 3, 'The Amiternum Relief'; Fig. 40. Needless to say, we are not justified in assuming that something which appears to us as a unicum never had parallels, but in that case, the argument would be extended to the (hypothetical) first use of a particular theme.
11. House of the Buffet Supper: ch. 5, n. 62; Figs. 93, 94.
12. For this tradition, see Felletti Maj 1977, 302–4, 360–1, 375.

Glossary

This glossary is designed to explain the way in which terms are used in this book. Many of them are also used in other senses, which are not given here.

abacus	A sideboard, used for the exposition of cups and other vessels at a banquet.
aedile	A magistrate in Rome or some municipalities.
agape	(Greek 'love') The communal meal celebrated by the early Christians.
andron	(Greek; pl. *andrones*) The dining room of a Greek house, square or rectangular, sometimes with a raised band for the couches around three-and-a-half sides.
arcosolium	A burial niche surmounted by an arch in the walls of a tomb, used especially in the Roman catacombs for more honorific burials.
asarotos oikos	(Greek 'unswept room') A mosaic representing the debris of a meal lying on the ground.
Augustales	Members, almost exclusively freedmen, of colleges devoted to the Imperial cult in the municipalities. Also *seviri Augustales*: see ch. 3, n. 21.
authepsa	(Greek 'self-boiler') A vessel, often very elaborate, used for heating liquids, especially water for mixing with wine.
biclinium	An arrangement of two dining couches at right angles or facing one another (cf. triclinium).

bisellium	A seat of honour twice the usual size, for use at public functions, awarded to prominent men in the Italian municipalities; hence, *bisellarius*, the recipient of an award of the *bisellium*.
broad room	Main reception room of a Hellenistic house, broader than it is long and opening off peristyle.
caduceus	The staff borne by heralds (and by Mercury).
calda	Hot water to be mixed with wine.
caldum	Wine and hot water mixed together.
cathedra	A high-backed chair, used especially by women and older men as a mark of distinction; also used of chairs of this type carved from rock in some catacombs.
caupona	An inn or tavern.
cena	Dinner, the main meal of the day, normally eaten by the Romans in the midafternoon.
Chi-Rho	The monogram formed by the first two letters (X and P) of the name of Christ in Greek.
cippus	A rectangular block or pillar used for funerary purposes, often decorated with relief sculpture.
clavus	A stripe, especially used as an ornament on clothing.
collegium	An association, guild, or corporation united by common interests and often holding regular communal feasts.
columbarium	Literally a dovecote; hence, a type of tomb containing numerous niches to hold cinerary urns.
comissatio	A Roman drinking party, usually distinct from and following the actual dinner.
convivium	(Latin: 'living together') The most general Latin word for banquet or feast.
crater see *krater*	
crustulum et mulsum	Crunchy cake and mulled wine, often given as a handout by benefactors.
cubiculum	A bedroom in a Roman house, used for day-time relaxation as well as sleeping; also used of individual burial chamber in the catacombs.
cursus honorum	The sequence of public offices held by an individual, often listed in funerary inscriptions.

cyathus	(Greek *kyathos*) A ladle for wine; also used of a liquid measure.
decurion	Member of the governing council of a municipality in Italy or in the Roman Empire.
deipnon	(Greek) The main meal, distinct from the *symposion* (q.v.) that followed it.
diatreton	Open work glass vessel, sometimes of great complexity, also known as cage cup.
epulum	A public feast or banquet.
equites	Literally 'horsemen'; the second order of the Roman state (below the Senate) normally selected on the basis of their financial standing.
equites singulares	Detachment of cavalry stationed in Rome as part of the imperial guard.
euergetism	A sociopolitical system of munificence by the rich towards the community (or sections of it), reciprocated by the favour and support of the recipients.
fasces	The bundle of rods carried by lictors (q.v.) before a magistrate as symbol of his power.
flamen	The personal priest of some of the greatest Roman deities, one of the highest ranks of the public priesthood at Rome.
freedman, freedwoman	An ex-slave, formally freed by his/her owner; if the owner was a Roman citizen, the freed slave also acquired Roman citizenship.
fulcrum	The curved headrest at one end of a Hellenistic or Roman couch.
hetaera	Courtesan, usually implying a member of a sophisticated and elegant Greek or hellenized demimonde.
hortus	A garden; in the plural (*horti*) often used of the extensive parks or pleasure grounds of the rich.
hypogaeum	Underground chamber tomb.
kantharos	(Greek; also Latin *cantharus*) A two-handled drinking cup, used especially by Dionysus and his followers.
kline	(Greek) Couch for dining; in the Greek world, suitable for accommodating one or two people.

kline-band	Raised band or platform around the sides of a Greek *andron* (q.v.) to hold the couches; some-times also called trottoir.
kline monument	A free-standing funerary monument consisting of a three-dimensional image of the deceased lying on a couch, originally standing over the grave or containing the urn with the ashes of the dead.
kottabos	A game played at the Greek *symposion*, in which the lees of the wine were thrown from a cup at a target.
krater	(Greek; also Latin *crater*) Wide-mouthed bowl for mixing wine and water.
kylikeion	(Greek) A stand for exhibiting drinking vessels.
lararium	The shrine of the Lares or household gods in a Roman house.
lectisternium	A Roman festival at which couches were spread for images of the gods, and offerings of food and drink placed before them.
lectus	(Latin; pl. *lecti*) Couch, used for dining or sleep-ing. *lectus summus, medius, imus*: the highest, middle, and lowest couches in the typical Ro-man triclinium (q.v.).
lictor	An attendant on a consul or other public mag-istrate.
loculus	An individual niche for burial in the wall of a tomb; especially used of the rows of such burial niches cut in the walls of the Roman catacombs. *Loculus* slab: a slab of marble or other stone to cover the front of such a niche, often carved like the front of a sarcophagus.
locus consularis	(Latin 'the consul's place') The place of honour in a traditional Roman triclinium (q.v.), at the lowest (left) end of the middle couch; also *imus in medio*.
mensa	Roman table for dining, normally small and round, less often rectangular.
munus	A gift or pledge made by a rich man to his community, frequently as part of his civic

	obligations; especially a gladiatorial show given under such conditions.
necropolis	Literally 'city of the dead': a cemetery, normally on the outskirts of ancient cities.
nymphaeum	Decorative monumental fountain, outdoors or as part of house.
oecus	(Latin; Greek *oikos*) Large reception room with interior colonnade in Roman houses; also used in Hellenistic domestic architecture as equivalent to 'broad room' (q.v.).
orant	A figure, male or female, in the attitude of prayer with arms outstretched and palms held up.
orbiculus	A round ornament on clothing, usually a piece of embroidered material.
ordo	Political order or class, used especially of the governing council of a municipality.
pandurium	A stringed musical instrument resembling a lute.
Parentalia	The Roman festival of the family dead, celebrated in February.
peristyle	Courtyard or garden of a Roman house, surrounded by colonnaded porticoes.
pontifex	A priest of the Roman state religion.
popina	A cook-shop or low-class eating house.
praeco	(pl. *praecones*) Public herald.
refrigerium	Rest, refreshment, used both of the memorial feast for the dead and of refreshment in the next world.
sarcophagus	A coffin for the body of the dead, usually of marble or other stone, often elaborately decorated.
Saturnalia	The festival of Saturn celebrated in midwinter, when license reigned and normal social order might be inverted.
schola	A multipurpose building, especially one used for meetings of a *collegium* (q.v.) or similar body.
sevir	Member of a college of six officials, found as the governing administration in some Italian municipalities; also a variant form of the Augustales (q.v.).

sigma	(The Greek letter 'S', normally written as 'C' in the Imperial period) Semicircular couch used for dining; *sigma* table: semicircular or round table fitting within curve of such a couch.
sportula	A small basket containing food; hence, a handout of food, or of money in place of food, by a benefactor or patron.
stele	An upright slab carved or inscribed on one side, especially a gravestone.
stibadium	Semicircular cushion or bolster used for outdoor dining; subsequently, semicircular couch (see *sigma*) used both indoors and out.
suffibulum	The characteristic headdress worn by the Vestal Virgins, a square white cloth tied under the chin.
summus, medius, imus	(Latin 'highest, middle, lowest') The three couches of a traditional Roman triclinium (q.v.), and the three places on each of the couches, starting from the (viewer's) right. *summus in summo* etc.: the highest place on the highest couch. Cf. also *lectus*.
symposion	Greek drinking party, distinct from the meal which normally preceded it.
T + U plan	Arrangement of mosaic (or other type of) pavement found in Roman houses of the Empire, often identifying a dining room: distinguished by a plainer area for the couches around three sides, and a more highly decorated area in the centre and at the entrance.
taberna	An inn or tavern.
Totenmahl	(German 'meal of/for the dead') A term frequent in scholarly literature to refer to representations of the banquet in a funerary context; here reserved for the scheme showing a single male banqueter reclining on a couch, often with a seated woman: for definition, see ch. 4, n. 5.
triclia	A light pavilion or bower used for dining out of doors.
tricliniarch	The steward in a wealthy household responsible for the organization of a banquet.

triclinium	Arrangement of three dining couches fitted together in the form of the Greek letter Pi; Roman dining room designed to hold such an arrangement; later used of any room used primarily for dining, regardless of its size or shape.
triconch	Room with three apses opening off side and back walls.
trottoir see *kline*-band	
venatio	A hunt; especially used of the animal hunts of the arena.
xenia	(Greek 'gifts between host and guests') Representation of groupings, primarily of edible objects.

Abbreviations

For periodicals and standard reference works, the abbreviations listed in *American Journal of Archaeology* 104, 2000, 10–24, are followed wherever possible; otherwise, those of *Année Philologique*. Note especially the following:

ACIAC	*Atti del Congresso internazionale di Archeologia Cristiana*
ANRW	*Aufstieg und Niedergang der römischen Welt*, ed. H. Temporini (Berlin 1972–)
ASR	*Die antiken Sarkophagreliefs* (Berlin 1890–)
BolldArch	*Bollettino di Archeologia*
CIL	*Corpus inscriptionum latinarum*
CLE	*Carmina latina epigraphica*, ed. F. Buecheler (Leipzig 1895–7, suppl. ed. E. Lommatsch 1926)
CSEL	*Corpus scriptorum ecclesiasticorum latinorum*
CSIR	*Corpus signorum imperii romani*
Helbig[4]	W. Helbig, *Führer durch die öffentlichen Sammlungen klassischer Altertümer in Rom*, 4th ed., supervised by H. Speier (Tübingen 1963–72)
ICUR	*Inscriptiones Christianae urbis Romae septimo saeculo antiquiores. Nova series* I–(1922–)
ILS	*Inscriptiones latinae selectae*, ed. H. Dessau (1892–1916)
LIMC	*Lexicon iconographicum mythologiae classicae* (Zurich and Munich 1974–)

LTUR	*Lexicon topographicum urbis Romae*, ed. E. M. Steinby (Rome 1993)
Matz–Duhn	F. Matz and F. von Duhn, *Antike Bildwerke in Rom* (Leipzig 1881–2)
MonPittAnt	*Monumenti della pittura antica*
OLD	*Oxford Latin Dictionary* (Oxford 1982)
PL	*Patrologia latina*, ed. J. P. Migne (Paris 1979)
PPM	*Pompei. Pitture e mosaici* I–IX, eds. I. Baldassarre, T. Lanzilotta, S. Salomi (Rome 1990–9)
RE	Pauly-Wissowa, *Real-Encyclopädie der klassischen Altertumswissenschaft* (1893–)

Bibliography

Abramenko, A. 1993 *Die munizipale Mittelschicht im kaiserzeitlichen Italien. Zu einem neuen Verständnis von Sevirat und Augustalität.* Frankfurt am Main

Adamo Muscettola, S. 2000 'Miseno: culto imperiale e politica nel complesso degli Augustali', *RM* 107: 79–108

Adriani, A. 1963–6 *Repertorio d'arte dell'Egitto greco-romano, C. Architettura e Topografia, I–II.* Palermo

Agasse, J.-M. 2001 'Entre *antiquaria* et archéologie moderne: le *lapis rhamnusianus*', *Les Cahiers de l'Humanisme* 2:21–48

Agnoli, N. 1998 'Note preliminari allo studio delle lastre di chiusura di loculo di Ostia', in Koch 1998: 129–37, pls. 66–71

Åkerström-Hougen, G. 1974 *The calendar and hunting mosaics of the Villa of the Falconer in Argos. A study in early Byzantine iconography.* Acta Instituti Atheniensis Regni Sueciae, 4°, XXIII. Stockholm

Alexander, M., Ben Abed, A., Besrour-Ben Mansour, S., Soren, D. 1980 *Corpus des mosaïques de Tunisie II. Thuburbo Maius. 1. Les mosaïques de la région du Forum.* Tunis

Alexandrescu-Vianu, M. 1977 'Le banquet funéraire sur les stèles de la Mésie Inférieure: schémas et modèles.' *Dacia* 21: 139–66

Amedick, R. 1994 'Herakles im Speisesaale.' *RM* 101: 103–19, pl. 43

1993 'Stibadia in Herculaneum und Pompeji,' in L. Franchi dell'Orto ed., *Ercolano 1738–1988. 250 anni di ricerca archeologica.* Rome: 179–92

1991 *Die Sarkophage mit Darstellungen aus dem Menschenleben 4. Vita Privata.* ASR 1, 4. Berlin

1988 'Zur Motivgeschichte eines Sarkophages mit ländlichem Mahl.' *RM* 95: 205–34, pls. 76–85

Amelung, W. 1985 'ΦΑΓΩΜΕΝ ΚΑΙ ΠΙΩΜΕΝ. Griechische Parallelen zu zwei Stellen aus dem Neuen Testament.' *ZPE* 60: 35–43

Amelung, W. 1908 *Die Sculpturen des Vaticanischen Museums II.* Berlin

Anderson, J. K. 1985 *Hunting in the Ancient World.* Berkeley/Los Angeles/London

André, J. 1981 *L'alimentation et la cuisine à Rome.* 2nd ed. Paris

Andreae, B. ed. 1995 *Bildkatalog der Skulpturen des Vatikanischen Museums I. Museo Chiaramonti 2, 3.* Berlin/New York

1980 *Die Sarkophage mit Darstellungen aus dem Menschenleben 2. Die römischen Jagdsarkophage.* ASR 1, 2. Berlin

Andreau, J. 1977 'Fondations privées et rapports sociaux en Italie Romaine (Ier–IIIe s. ap. J.-C.)', *Ktéma* 2: 157–209

Apollonj Ghetti, B. M., Ferrua, A., Josi, E., Kirschbaum, E. 1951 *Esplorazioni sotto la confessione di San Pietro in Vaticano, eseguite negli anni 1940–1949.* Vatican City

Arce, J. 1988 *Funus Imperatorum: los funerales de los emperadores romanos.* Madrid

Arce, J., Sánchez-Palencia, J., Mar, R. 1989 'Monumento junto al Arco de Tito en el Foro Romano (campaña de abril de 1989)', *AEspArq* 62: 307–15

Arias, P. E. 1978 'Problematica dei "missoria" tardo-antichi', *FelRav* 115: 9–26

 1950 'Il piatto argenteo di Cesena', *ASAtene* [24–26] n.s. 8–10 (1946–8): 309–44, pls. XXVI–IX

Ausbüttel, F. 1982 *Untersuchungen zu den Vereinen im Westen des römischen Reiches.* Frankfurter Althistorische Studien 11. Kallmünz

Aymard, J. 1951 *Essai sur les chasses romaines des origines à la fin du siècle des Antonins.* BEFAR 171. Paris

Bacchielli, L., Falivene, M. R. 1995 'Il Canto delle Sirene nella tomba di Asgafa El Abiar', *QAL* 17: 93–107

Bairrão Oleiro, J. M. 1992 *Conimbriga. Casa dos Repuxos.* Corpus dos Mosaicos de Portugal. Conventus Scallabitanus I. Conímbriga

Baldassarre, I. 1998 'Documenti di pittura ellenistica da Napoli', in *L'Italie méridionale et les premières expériences de la peinture hellénistique. Actes de la table ronde organisée par l'École française de Rome (Rome, 18 février 1994).* CEFR 244. Rome: 95–159

Baldassarre, I., Bragantini, I., Morselli, C., Taglietti, F. 1996 *Necropoli di Porto—Isola Sacra.* Itinerari dei musei, gallerie, scavi e monumenti d'Italia n.s. 38. Rome

Balmelle, C., Ben Abed-Ben Khader, A., Ben Osman, W., Darmon, J.-P., Ennaïfer, M., Gozlan, S., Hanoune, R., Guimier-Sorbets, A.-M. 1990 *Xenia. Recherches Franco-Tunisiennes sur la mosaïque de l'Afrique antique, 1.* CEFR 125. Rome

Balty, J. 1995 *Mosaïques antique du Proche-Orient: chronologie, iconographie, interprétation.* Paris

 1984, ed., *Actes du Colloque Apamée de Syrie. Bilan des recherches archéologiques 1973–1979. Aspects de l'architecture domestique d'Apamée, Bruxelles 1980.* Fouilles d'Apamée de Syrie. Miscellanea 13. Brussels

 1982 '*Paedagogiani* – pages, de Rome à Byzance', in L. Hadermann-Misguich, G. Raepsaet edd., *Rayonnement grec. Hommages à Charles Delvoye.* Brussels: 299–312, pls. XXVIII–X

 1969 *La grande mosaïque de chasse du triclinos.* Fouilles d'Apamée de Syrie. Miscellanea 2. Brussels

Balty, J. Ch. 1969 'L'édifice dit "au triclinos"', in J. Balty ed., *Apamée de Syrie. Bilan des recherches archéologiques 1965–1968. Actes du colloque tenu à Bruxelles 1969.* Fouilles d'Apamée de Syrie. Miscellanea 6. Brussels: 105–16, pls. XXXIX–XLVI

 1984 'Notes sur l'habitat romain, byzantin et arabe d'Apamée. Rapport de synthèse', in Balty, J. 1984: 471–503

Balty J., Balty J. Ch. 1995 'Nouveaux exemples de salles à *stibadium* à Palmyre et à Apamée', in *Orbis Romanus Christianusque. Travaux sur l'Antiquité Tardive rassemblés autour des recherches de Noel Duval.* Paris: 205–12

Baratte, F. 1998 *Silbergeschirr, Kultur und Luxus in der römischen Gesellschaft.* 15. Trierer Winckelmannsprogramm 1997. Mainz: 1–26

 1993 *La vaisselle d'argent en Gaule dans l'antiquité tardive (IIIe–Ve siècles).* Paris

 1992 'Vaisselle d'argent, souvenirs littéraires et manières de table: l'exemple des cuillers de Lampsaque', *CahArch* 40: 5–20

1990 'La vaisselle de bronze et d'argent sur les monuments figurés romains. Documents anciens et nouveaux', *BAntFr* 1990: 89–108

1986 *Le trésor d'orfèvrerie romaine de Boscoreale*. Paris

Barbet, A. 1994 'Le tombeau du banquet de Constanţa en Roumanie', in *Édifices et peintures IVᵉ– XIᵉ siècles. Colloque CNRS 1992, Auxerre*. Auxerre: 25–47

Barbet, A., Bucovală, M. 1997 'La tombeau des orants à Constanţa (Roumanie)', in D. Scagliarini Corlàita ed., *I Temi figurativi nella pittura parietale antica (IV sec. a.C.– IV sec. d.C.). Atti del VI Convegno Internazionale sulla Pittura Parietale Antica*. Bologna: 173–5

1996 'L'hypogée paléochrétien des orants à Constanta (Roumanie), l'ancienne Tomis', *MEFRA* 108: 105–58

Barbet, A., Gatier, P.-L., Lewis, N. 1997 'Un tombeau peint inscrit de Sidon', *Syria* 74: 141–60

Bardill, J. 1997 'The Palace of Lausus and nearby monuments in Constantinople: a topographical study', *AJA* 101: 67–95

Barnett, R. D. 1985 'Assurbanipal's feast', *Eretz-Israel* 18: 1*–6*

Barral i Altet, X. 1978 'Mensae et repas funéraire dans les nécropoles d'époque chrétienne de la Péninsule Ibérique: vestiges archéologiques', in *Atti del IX Congresso Internazionale di Archeologia Cristiana, Roma 21–27 settembre 1975, II*. Vatican City: 49–69

Bauchhenss, G. 1978 *Germania Inferior. Bonn und Umgebung. Militärischer Grabdenkmäler*. CSIR Deutschland III, 1. Bonn

Becatti, G. 1961 *Scavi di Ostia 4. Mosaici e pavimenti marmorei*. Rome

Bedello Tata, M. 1999 'Mobili in un interno', *MededRom* 58, *Antiquity*: 209–18

Bek, L. 1983 'Questiones convivales. The idea of the triclinium and the staging of convivial ceremony from Rome to Byzantium', *AnalRom* 12: 81–107

Berczelly, L. 1978 'A sepulchral monument from Via Portuense and the origin of the Roman biographical cycle', *ActaAArtHist* 8: 49–74, pls. I–XI

Bergquist, B. 1990 'Sympotic Space: a functional aspect of Greek dining-rooms', in Murray 1990: 37–65

Bianchi, L. 1985 *Le stele funerarie della Dacia. Un' espressione di arte romana periferica*. Rome

1975 'Rilievi funerari con banchetto della Dacia Romana, II. Il cosiddetto "Pannonische Totenmahl" e altre figure di offerenti', *Apulum* 13: 155–81

Bianchi Bandinelli, R. 1955 *Hellenistic-Byzantine Miniatures of the Iliad (Ilias Ambrosiana)*. Olten

Bisconti, F. 2000 *Mestieri nelle catacombe romane. Appunti sul declino dell'iconografia del reale nei cimiteri cristiani di Roma*. Vatican City

1994 'Materiali epigrafici dal cimitero dei SS. Pietro e Marcellino. Spunti e conferme per la cronologia della Regione I', *RACrist* 70: 7–42

Blanc, N. ed. 1998 *Au royaume des ombres. La peinture funéraire antique, IVᵉ siècle avant J.-C. –IVᵉ siècle après J.-C.* Saint-Romain-en-Gal, Vienne

Blanchard-Lemée, M. 1984 'La "Maison de Bacchus" à Djemila', *BAC* n.s. 17b [1984]: 131–43

Blanchard-Lemée, M., Ennaïfer, M., Slim, H., Slim, L. 1995 *Sols de l'Afrique romaine. Mosaïques de Tunisie*. Paris

Blanck, H. 1981 'Ein spätantikes Gastmahl. Das Mosaik von Duar-ech-Chott', *RM* 88: 329–44, pls. 142–9 and colour plate

Blümner, H. 1911 *Die römischen Privataltertümer*. Munich

Bodel, J. 1999 'Death on display: looking at public funerals', in B. Bergmann, C. Kondoleon edd., *The Art of Ancient Spectacle*. Studies in the History of Art 56. Washington: 259–81

Böhm, G. 1998 ' "Quid acetabulorum tinnitus?" Bemerkungen zum "Musikantinnen"-Mosaik in Hama und zu einer Miniatur der sog. Wiener Genesis', *Mitteilungen zur spätantiken Archäologie und byzantinischen Kunstgeschichte* 1: 47–73

Börker, C. 1983 *Festbankett und griechische Architektur.* Xenia 4. Konstanz

Bollini, M. 1965 'Elementi antiquari nei piatti argentei romani. Considerazioni sugli esemplari di Cesena e di Augusta Raurica', *Studi Romagnoli* 16: 85–111

Bollmann, B. 1998 *Römische Vereinshäuser. Untersuchungen zu den Scholae der römischen Berufs-, Kult-, und Augustalen-Kollegien in Italien.* Mainz

Bookidis, N. 1990 'Ritual Dining in the Sanctuary of Demeter and Kore at Corinth: some questions', in Murray 1990: 86–94

Boppert, W. 1992 *Militärische Grabdenkmäler aus Mainz und Umgebung.* CSIR Deutschland II,5. Germania Superior. Mainz

Boschung, D. 1987 *Antike Grabaltäre aus den Nekropolen Roms.* Acta Bernensia X. Bern
1987a 'Die republikanischen und frühkaiserzeitlichen Nekropolen vor den Toren Ostias', in von Hesberg and Zanker 1987: 111–24

Bossu, C. 1982 'M' Megonius Leo from Petelia (Regio III): a private benefactor from the local aristocracy', *ZPE* 45: 155–65

Bouchenaki, M. 1975 *Fouilles dans la nécropole occidentale de Tipasa (1968–1972).* Algiers
1974 'Nouvelle inscription à Tipasa (Maurétanie Césarienne)', *RM* 81: 301–11, pls. 173–4

Bozzini, P. 1975–6 'Coperchi di sarcofago di Pretestato e di S. Callisto', *RendPontAcc* 48: 325–65

Bracchi, L. C. 1960 'Orologi solari di Aquileia', *AquilNost* 31: 49–70

Bradley, K. 1998 'The Roman Family at Dinner', in Nielsen, Sigismund Nielsen 1998: 36–55

Bragantini, I. 1990 'L'occupazione dello spazio: lo spazio rituale', in S. Angelucci et al., 'Sepolture e riti nella necropoli dell'Isola Sacra', *BolldArch* 5–6: 61–70

Braund, D., Wilkins, J. 2000 *Athenaeus and his World. Reading Greek culture in the Roman Empire.* Exeter

Brelich, A. 1937 *Aspetti della morte nelle iscrizioni sepolcrali dell'impero romano.* Dissertationes Pannonicae. Budapest

Brenk, B. 1975 *Die frühchristlichen Mosaiken in S. Maria Maggiore zu Rom.* Wiesbaden

Briguet, M.-F. 1988 *Le Sarcophage des Époux de Cerveteri du Musée du Louvre.* Paris

Burkert, W. 1991 'Oriental symposia: contrasts and parallels', in Slater 1991: 7–24

Cagiano de Azevedo, M. 1947–9 'Osservazioni sulle pitture di un edificio romano di Via dei Cerchi', *RendPontAcc* 23–4: 253–8

Cahn, H., Kaufmann-Heinimann, A. 1984 *Der Spätrömische Silberschatz von Kaiseraugst.* Derendingen

Cahn, H. A., Kaufmann-Heinimann, A., Painter, K. 1991 'A Table Ronde on a treasure of late Roman silver', *JRA* 4: 184–91

Calza, G. 1940 *La necropoli del Porto di Roma nell'Isola Sacra.* Rome
1939 'Un documento del culto imperiale in una nuova iscrizione ostiense', *Epigraphica* 1: 28–36

Calza, R. 1964 *Scavi di Ostia V, I ritratti. Ritratti greci e romani fino al 160 circa D.C.* Rome

Cameron, A. 1992 'Observations on the distribution and ownership of late Roman silver plate', *JRA* 5: 178–85
1985 'The date and the owners of the Esquiline Treasure', *AJA* 89: 135–45

Camodeca, G. 1996 'Iscrizioni nuove e riedite da Puteoli, Cumae, Misenum', *AION Arch-StorAnt (Napoli)*: 149–73

Carandini, A., Ricci, A., de Vos, M. 1982 *Filosofiana. The Villa of Piazza Armerina. The image of a Roman aristocrat at the time of Constantine.* Palermo

Carpenter, T. H. 1995 'A *symposion* of gods?', in Murray, Tecuşan 1995: 145–63

Castrén, P. 1975 *Ordo populusque pompeianus. Polity and society in Roman Pompeii.* Acta Instituti Romani Finlandiae 8. Rome

Cavallo, G., Gribomont, J., Loerke, W. 1987 *Codex Purpureus Rossanensis. Commentarium.* Graz

Cèbe, J.-P. 1985 'Considérations sur le lectisterne', in R. Braun ed., *Hommage à Jean Granarolo. Philologie, littérature et histoire anciennes.* Annales de la Faculté des Lettres et Sciences humaines de Nice, 50: 205–21

Cecchelli, C. 1945 *Monumenti cristiano-eretici di Roma.* Rome

Chalkia, E. 1991 *Le mense paleocristiane. Tipologia e funzioni delle mense secondarie nel culto paleocristiano.* Studi di Antichità Cristiana 46. Vatican City

Christern, J. 1968 'Basilika und Memorie der heiligen Salsa in Tipasa', *BAAlg* 3: 193–258

Coarelli, F. 1995 'Vino e ideologia nella Roma arcaica', in Murray, Tecuşan 1995: 196–213
 1963–4 'Il rilievo con scene gladiatorie', *StMisc* 10: 85–99

Compostella, C. 1996 *Ornate Sepulcra. La "borghesie" municipali e la memoria di sé nell'arte funeraria del Veneto romano.* Florence
 1992 'Banchetti pubblici e banchetti privati nell'iconografia funeraria romana del I secolo D.C.', *MEFRA* 104: 659–89
 1989 'Iconografia, ideologia e status a Brixia nel I secolo D.C.: la lastra sepolcrale del seviro Anteros Asiaticus', *RdA* 13: 59–75, figs. 1–11

Courtney, E. 2001 *A Companion to Petronius.* Oxford

Cremer, M. 1992 *Hellenistisch-römische Grabstelen im nordwestlichen Kleinasien, 2. Bithynien.* Asia Minor Studien 4. Bonn
 1991 *Hellenistisch-römische Grabstelen im nordwestlichen Kleinasien, 1. Mysien.* Asia Minor Studien 4. Bonn

Criniti, N. 1973 'A proposito di "crustulum" e "mulsum"', *Aevum* 47: 498–500

Cristofani, M. 1987 'Il banchetto in Etruria', in *L'Alimentazione nel mondo antico. Gli Etruschi.* Rome: 123–32

Croisille, J.-M. 1965 *Les natures mortes campaniennes. Répertoire descriptif des peintures de nature morte du Musée National de Naples, de Pompéi, de Herculanum et Stabies.* Coll. Latomus 76. Brussels

Culican, W. 1982 'Cesnola bowl 4555 and other Phoenician bowls', *RivStudFen* 10: 13–32, pls. VII–XIX

D'Agostino, B. 1989 'Image and society in archaic Etruria', *JRS* 79: 1–10

Dalby, A. 1996 *Siren Feasts. A history of food and gastronomy in Greece.* London/New York

D'Ambra, E. 1989 'The cult of virtues and the funerary relief of Ulpia Epigone', *Latomus* 48: 392–400, pls. II–III

D'Ambrosio, A., De Caro, S. 1989 'Un contributo all'architettura e all'urbanistica di Pompei in età ellenistica. I saggi nella casa VII.4.62', *AION ArchStAnt (Napoli)* 11: 173–215, figs. 27–58

Dareggi, G. 1972 *Urne del territorio perugino. Un gruppo inedito di cinerari etruschi ed etrusco-romani.* Quaderni dell'Istituto di Archeologia dell'Università di Perugia, I. Rome

D'Arms, J. 2000 'Memory, money, and status at Misenum: three new inscriptions from the *collegium* of the Augustales', *JRS* 90: 126–44
 2000a 'P. Lucilius Gamala's feasts for the Ostians and their Roman models', *JRA* 13: 192–200
 1999 'Performing culture: Roman spectacle and the banquets of the powerful', in B. Bergmann, C. Kondoleon edd., *The Art of Ancient Spectacle.* Studies in the History of Art 56. Washington: 301–19
 1998 'Between public and private: the *epulum publicum* and Caesar's *horti trans Tiberim*', in M. Cima, E. La Rocca edd., *Horti Romani.* Rome: 33–43

1995 'Heavy drinking and drunkenness in the Roman world: four questions for historians', in Murray, Tecuşan 1995: 304–17

1991 'Slaves at Roman Convivia', in Slater 1991: 171–83

1990 'The Roman *convivium* and the idea of equality', in Murray 1990: 308–20

1984 'Control, companionship, and *clientela*: some social functions of the Roman communal meal', *EchCl* 28 [n.s. 3]: 327–48

De Bruyne, L. 1970 'La "cappella greca" di Priscilla', *RACrist* 46: 291–330

1958 'Refrigerium interim', *RACrist* 34: 87–118

Deckers, J. G. 1992 'Wie genau ist eine Katakombe zu datieren? Das Beispiel SS. Marcellino e Pietro', in *Memoriam Sanctorum Venerantes. Miscellanea in onore di Mons. Victor Saxer*. Studi di Antichità Cristiana [P.I.A.C.] 48. Vatican City: 217–38

Deckers, J. G., Seeliger, H. R., Mietke, G. 1987 *Die Katakombe "Santi Marcellino e Pietro." Repertorium der Malereien*. 2 vols, text & plates. Roma sotterranea cristiana VI. Vatican City/Münster

De Marinis, S. 1961 *La tipologia del banchetto nell'arte etrusca arcaica*. Rome

Dentzer, J.-M. 1982 *Le motif du banquet couché dans le proche-orient et le monde grec du VIIe au IVe siècle av. J.-C.* BEFAR 246. Rome

1978 'Reliefs au banquet dans la moitié orientale de l'empire romain: iconographie hellénistique et traditions locales', *RA* 1978: 63–82

1971 'Aux origines de l'iconographie du banquet couché', *RA* 1971: 215–58

1970 'Un nouveau relief du Pirée et le type du banquet attique au Ve siècle av. J.-C.', *BCH* 94: 67–90

1969 'Reliefs au "banquet" dans l'Asie Mineure du Ve siècle av. J.-C.', *RA* 1969: 195–224

1962 'La tombe de C. Vestorius dans la tradition de la peinture italique', *MEFR* 74: 533–94

De Simone, A., Nappo, S. 2000... *Mitis Sarni opes. Nuova indagine archeologica in località Murecine*. Naples

Dickmann, J.-A. 1999 *Domus frequentata. Anspruchsvolles Wohnen im pompejanischen Stadthaus*. Studien zur antiken Stadt 4/1. Munich

Diez, E. 1959–61 'Zur Darstellung des Totenopfers auf norischen Grabsteinen', *Schild von Steier* (Graz) 9: 47–57

Di Vita, A. 1983 'Il tema del "Banquet couché" dei rilievi attici di IV secolo in una nuova pittura da Sabratha (Libia)', *ACIAC* XII, 2: 72–6

1980–2 'L'area sacro-funeraria di Sidret el-Balik a Sabratha', *RendPontAcc* 53–4: 273–82

1978 'L'ipogeo di Adamo ed Eva a Gargaresc', in *Atti del IX Congresso Internazionale di Archeologia Cristiana, Roma 21–27 settembre 1975, II*. Vatican City: 199–256

Doignon, J. 1969 '*Refrigerium* et catéchèse à Vérone au IVe siècle', in *Hommages à Marcel Renard II*. Coll. Latomus 102. Brussels: 220–39

Dölger, F. J. 1943 *Ichthys V. Die Fisch-Denkmäler in der frühchristlichen Plastik, Malerei und Kleinkunst*. Münster in Westf.

Donahue, J. F. 1999 'Euergetic self-representation and the inscriptions at *Satyricon* 71.10', *CP* 94: 69–74

1996 *Epula publica: the Roman community at table during the principate*. Ph.D. Diss. University of North Carolina

Donati, A. ed. 1998 *Romana pictura. La pittura romana dalle origini all'età bizantina*. Rimini

Donnay-Rocmans, C., Donnay, G. 1984 'La Maison du Cerf', in Balty, J. 1984: 155–80

Dosi, A., Schnell, F. 1990 *A tavola con i Romani antichi*. Rome

Drerup, H. 1980 'Totenmaske und Ahnenbild bei den Römern', *RM* 87: 81–129, pls. 34–55

Dückers, P. 1992 'Agape und Irene. Die Frauengestalten der Sigmamahlszenen mit antiken Inschriften in der Katakombe der Heiligen Marcellinus und Petrus in Rom', *JAC* 35: 147–67, pls. 6–8

Ducrey, P., Metzger, I., Reber, K. 1993 *Le quartier de la maison aux mosaïques.* Eretria 8. Lausanne

Dulière, C., Slim, H., Alexander, M., Ostrow, S., Pedley, J., Soren, D. 1996 *Corpus des mosaïques de Tunisie* III. *Thysdrus (El Jem)* 1. *Quartier sud-ouest.* Tunis

Dunbabin, K. M. D. 2003 'The waiting servant in later Roman art', *AJP* 124.3 (forthcoming)

1999 *Mosaics of the Greek and Roman World.* Cambridge

 1998 'Ut graeco more biberetur: Greeks and Romans on the banqueting couch', in Nielsen, Sigismund Nielsen 1998: 81–101

 1996 'Convivial spaces: dining and entertainment in the Roman villa', *JRA* 9: 66–80

 1993 'Wine and water at the Roman convivium', *JRA* 6: 116–41

 1991 'Triclinium and Stibadium', in Slater 1991: 121–48, figs. 1–36

 1986 'Sic erimus cuncti... The skeleton in Graeco–Roman art', *JdI* 101: 185–255

 1978 *The mosaics of Roman North Africa. Studies in iconography and patronage.* Oxford

Duncan-Jones, R. 1982 *The Economy of the Roman Empire. Quantitative Studies.* 2nd ed. Cambridge

Duthoy, R. 1978 'Les *Augustales', *ANRW* II.16.2: 1254–309

 1974 'La fonction sociale de l'augustalité', *Epigraphica* 36: 134–54

Duval, N. 1987 'Des installations pour banquets funéraires dans la Sardaigne paléochrétienne?' *Karthago* 21: 163–70

 1984 'Les maisons d'Apamée et l'architecture "palatiale" de l'antiquité tardive', in Balty, J. 1984: 447–70

Elia, O. 1961 'Il portico dei triclini del pagus maritimus di Pompei', *BdA* 46: 200–11

Ellis, S. 1997 'Late-antique dining: architecture, furnishings and behaviour', in R. Laurence, A. Wallace-Hadrill edd., *Domestic space in the Roman world: Pompeii and beyond.* JRA suppl. 22. Portsmouth, RI: 41–51

 1995 'Classical reception rooms in Romano-British houses', *Britannia* 26: 163–78

 1991 'Power, architecture, and decor: how the late Roman aristocrat appeared to his guests', in E. Gazda ed., *Roman Art in the Private Sphere. New perspectives on the architecture and decor of the domus, villa, and insula.* Ann Arbor: 117–34, figs. 61–7

Engemann, J. 1997 *Deutung und Bedeutung frühchristliches Bildwerke.* Darmstadt

 1982 'Der Ehrenplatz beim antiken Sigmamahl', in *Jenseitsvorstellungen in Antike und Christentum. Gedenkschrift für Alfred Stuiber.* JAC Ergänzungsband 9. Münster: 239–50

Ennabli, A. 1975 'Maison aux banquettes ou à banquets à Sousse', in *La mosaïque gréco-romaine II. Colloque internationale pour l'étude de la mosaïque antique, Vienne 30 août–4 septembre 1971.* Paris: 103–18, pls. XXXVII–XLII

Eschebach, L. 1993 *Gebäudeverzeichnis und Stadtplan der antiken Stadt Pompeji.* Cologne

Fabricius, J. 1999 *Die hellenistische Totenmahlreliefs. Grabrepräsentation und Wertvorstellungen in ostgriechischen Städten.* Studien zur antiken Stadt 3. Munich

Faccenna, D. 1956–8 'Rilievi gladiatori', *BullCom* 76: 37–75, pls. I–VIII

 1949–50 'Rilievi gladiatori', *BullCom* 73: 3–14, pl. I

Faust, S. 1989 *Fulcra. Figürlicher und ornamentaler Schmuck an antiken Betten.* RM ErgH. 30. Mainz

Fehr, B. 1984 Review of Dentzer 1982, *Gnomon* 56: 335–42

 1971 *Orientalische und griechische Gelage.* Bonn

Felletti Maj, B. M. 1977 *La tradizione italica nell'arte romana.* Rome

 1953 'Le pitture di una tomba della Via Portuense', *RivIstArch* n.s. 2: 40–76

Fernández-Galiano, D. 1984 *Complutum II. Mosaicos.* Excavaciones arqueologicas en España. Madrid

Ferrua, A. 1973 'La catacomba di Vibia II', *RACrist* 49: 131–61

 1971 'La catacomba di Vibia', *RACrist* 47: 7–62, pl. I

Février, P.-A. 1989 'À propos de la date des peintures des catacombes romaines', *RACrist* 65: 105–33, pl. I

1978 'Le culte des morts dans les communautés chrétiennes durant le IIIe siècle', in *Atti del IX Congreso Internazionale di Archeologia cristiana, Roma 21–27 settembre 1975* I. Vatican City: 211–74, 303–29 (discussion). (= *La Méditerranée de Paul-Albert Février* I. Rome–Aix-en-Provence 1996: 39–102, 103–29)

1977 'A propos du repas funéraire: culte et sociabilité', *CahArch* 26: 29–45

Finney, P. C. 1994 *The Invisible God. The earliest Christians on art.* New York/Oxford

Flambard, J.-M. 1987 'Éléments pour une approche financière de la mort dans les classes populaires du Haut-Empire. Analyse du budget de quelques collèges funéraires de Rome et d'Italie', in F. Hinaud ed., *La mort, les morts et l'au delà dans le monde romain. Actes du colloque de Caen, 20–22 novembre 1985.* Caen: 209–44

Fless, F. 1995 *Opferdiener und Kultmusiker auf stadtrömischen historischen Reliefs. Untersuchungen zur Ikonographie, Funktion und Bedeutung.* Mainz

Floriani Squarciapino, M. 1958 *Scavi di Ostia III, Le Necropoli I. Le tombe di età repubblicana e Augustea.* Rome

Flower, H. 1996 *Ancestor masks and aristocratic power in Roman culture.* Oxford

Fogolari, G. 1956 'Ara con scena di convito', *AquilNost* 27: 39–50

Foucher, L. 1961 'Une mosaïque de triclinium trouvée à Thysdrus', *Latomus* 20: 291–7, pls. XI–VIII

Franchi, L. 1963–4 'Rilievo con pompa funebre e rilievo con gladiatori al Museo dell'Aquila', *StMisc* 10: 23–32, pls. V–XII

de Franciscis, A. 1991 *Il sacello degli Augustali a Miseno.* Naples

Friend, A. M. 1941 'Menander and Glykera in the mosaics of Antioch', in R. Stillwell ed., *Antioch-on-the-Orontes III. The excavations 1937–1939.* Princeton: 248–51

Friedländer, L. 1922 *Darstellungen aus der Sittengeschichte Roms.* 10th ed., ed. G. Wissowa. Leipzig

1906 *Petronii Cena Trimalchionis. Mit deutscher Übersetzung und erklärenden Anmerkungen.* 2nd ed. Leipzig (Rep. 1960)

Fröhlich, T. 1991 *Lararien- und Fassadenbilder in den Vesuvstädten. Untersuchungen zur 'volkstümlichen' pompejanischen Malerei.* RM ErgH 32. Mainz

Gabelmann, H. 1984 *Antike Audienz- und Tribunalszenen.* Darmstadt

Gantz, T. 1974 'Terracotta figured friezes from the workshop of Vulca', *OpRom* 10: 3–22

Garnsey, P. 1999 *Food and Society in Classical Antiquity.* Cambridge

Gentili, M. D. 1994 *I sarcofagi etruschi in terracotta di età recente.* Tyrrhenica 4. Rome

Gerke, F. 1940 *Die christlichen Sarkophage der vorkonstantinischen Zeit.* Studien zur Spätantiken Kunstgeschichte 11. Berlin

Ghedini, F. 1992 'Caccia e banchetto: un rapporto difficile', *RdA* 16: 72–88, figs. 1–15

1991 'Iconografie urbane e maestranze africane nel mosaico della Piccola Caccia di Piazza Armerina', *RM* 98: 323–35, pls. 75–9

1990 'Raffigurazioni conviviali nei monumenti funerari romani', *RdA* 14: 35–62, figs. 1–34

1988 'Un rilievo da Golgoi e il culto di Apollo Magirios', *AM* 103: 193–202, pls. 26–7

Ghedini, F., Salvadori, M. 1999 'Vigne e verzieri nel repertorio funerario romano: fra tradizione e innovazione', *RdA* 23: 82–93, figs. 1–10

Gibbs, S. L. 1976 *Greek and Roman Sundials.* New Haven/London

Giglio, R. 1996 *Lilibeo: l'ipogeo dipinto di Crispia Salvia.* Palermo

1996a 'Marsala: recenti rinvenimenti archeologici alla necropoli di Lilibeo. L'ipogeo dipinto di *Crispia Salvia*', *Sicilia archeologica* 29: 31–51

Giuliano, A. ed. 1981 *Museo Nazionale Romano. Le Sculture I, 2.* Rome

1963–4 'Rilievo con scena di banchetto a Pizzoli', *StMisc* 10: 33–8, pls. XIII–VIII

Giuntella, A. M., Borghetti, G., Stiaffini, D. 1985 *Mensae e riti funerari in Sardegna. La testimonianza di Cornus.* Mediterraneo tardoantico e medievale. Scavi e ricerche 1. Taranto

Gleason, K. et al. 1998 'The promontory palace at Caesarea Maritima: preliminary evidence for Herod's Praetorium', *JRA* 11: 23–52

Goethert, F. 1969 'Grabara des Q. Socconius Felix', *AntP* 9: 79–87, pls. 50–6

Goette, H. R. 1991 'Attische Klinen-Riefel-Sarkophage', *AM* 106: 309–38, pls. 89–112

Gowers, E. 1993 *The loaded table. Representations of food in Roman literature.* Oxford

Gozlan, S. 1992 *La maison du triomphe de Neptune à Acholla (Botria, Tunisie). 1. Les mosaïques.* CEFR 160. Rome

Grabar, A. 1966 *Byzantium, from the death of Theodosius to the rise of Islam.* London

Gras, M. 1983 'Vin et société à Rome et dans le Latium à l'époque archaïque', in *Modes de Contacts et Processus de Transformations dans les sociétés anciennes. Actes du colloque de Cortone (24–30 mai 1981).* CEFR 67. Pisa/Rome: 1067–75

Greenfield, J. 1990 'The Sevso Treasure. The Legal Case', *Apollo*, July: 14–6

Griffin, J. 1985 *Latin poets and Roman life.* London

Gros, P. 1997 'Maisons ou sièges de corporations? Les traces archéologiques du phénomène associatif dans la Gaule romaine méridionale', *CRAI* 1997: 213–41

Grottanelli, C. 1995 'Wine and Death—East and West', in Murray, Tecuşan 1995: 62–89

Guerrier, J. 1980 'Le serviteur à serviette dans la sculpture gallo-romaine', *RAEst* 31: 231–40

Guilland, R. 1962–3 'Études sur le Grand Palais de Constantinople. Les XIX lits', *JÖBG* 11–2: 85–113

Gütschow, M. 1938 'Das Museum der Prätextat-Katakombe', *Memorie della Pontificia Accademia di Archeologia,* Ser. III, IV: 29–268, pls. I–XLV

Guidobaldi, F., Guiglia Guidobaldi, A. 1983 *Pavimenti marmorei di Roma dal IV al IX secolo.* Studi di Antichità cristiana 36. Rome

Guyon, J. 1994 'Peut-on vraiment dater une catacombe? Retour sur le cimetière "Aux deux Lauriers" ou catacombe des saints Marcellin-et-Pierre sur la via Labicana à Rome', in M. Jordan-Ruwe, U. Real edd., *Bild- und Formensprache der spätantiken Kunst. Hugo Brandenburg zum 65. Geburtstag.* Boreas 17, 89–103

 1987 *Le cimetière aux deux lauriers. Recherches sur les catacombes romains.* BEFAR 264/Roma sotteranea cristiana 7. Rome

Hamman, A. 1968 *Vie liturgique et vie sociale.* Paris

Harden, D. B., Hellenkemper, H., Painter, K., Whitehouse, D. edd. 1987 *Glass of the Caesars. The Corning Museum of Glass, Corning, The British Museum, London, Römisch-Germanisches Museum, Cologne.* Milan

Harden, D. B., Toynbee, J. 1959 'The Rothschild Lycurgus Cup', *Archaeologia* 97: 179–212, pls. LIX–XXV

Harmon, D. P. 1978 'The Family Festivals of Rome', *ANRW* II.16.2: 1592–603

Hebert, B. 1983 *Spätantike Beschreibung von Kunstwerken. Archäologische Kommentar zu den Ekphraseis des Libanios und Nikolaos.* Diss. Graz

Helbig, W. 1868 *Die Wandgemälde der vom Vesuv verschütteten Städte Campaniens.* Leipzig

Herbig, R. 1952 *Die jüngeretruskischen Steinsarkophage.* ASR 7. Berlin

Herklotz, I. 1999 *Cassiano Dal Pozzo und die Archäologie des 17. Jahrhunderts.* Munich

Hermansen, G. 1981 *Ostia. Aspects of Roman City Life.* Edmonton

Herz, P. 1980–1 'Kaiserbilder aus Ostia', *BullCom* 87: 145–57

von Hesberg, H. 1992 *Römische Grabbauten.* Darmstadt

von Hesberg, H., Zanker, P. edd. 1987 *Römische Gräberstrassen. Selbstdarstellung–Status–Standard. Kolloquium in München vom 28. bis 30. Oktober 1985.* Munich

Himmelmann, N. 1973 *Typologische Untersuchungen an römischen Sarkophagreliefs des 3. und 4. Jahrhunderts n. Chr.* Mainz am Rhein

Hodges, R., Saraçi, G., Bowden, W. et al. 1997 'Late-antique and Byzantine Butrint: interim report on the port and its hinterland (1994–5)', *JRA* 10: 207–34

Hoepfner, W. ed. 1999 *Geschichte des Wohnens, I. 5000 v. Chr.–500 n. Chr. Vorgeschichte, Frühgeschichte, Antike.* Stuttgart

1996 'Zum Typus der Basileia und der Königlichen Andrones', in Hoepfner, Brands 1996: 1–43

1993 'Zum Mausoleum von Belevi', *AA* 1993: 111–23

Hoepfner, W., Brands, G. edd. 1996 *Basileia. Die Paläste der hellenistischen Könige.* Mainz am Rhein

Hoepfner, W., Schwandner, E.-L. 1994 *Haus und Stadt im klassischen Griechenland* (2nd ed.). Wohnen in der klassischen Polis I. Munich

Horn, R. 1972 *Hellenistische Bildwerke auf Samos.* Samos XII. Bonn

Hurschmann, R. 1985 *Symposienszenen auf unteritalischen Vasen.* Würzburg

Jannot, J.-R. 1984 *Les reliefs archaïques de Chiusi.* CEFR 71. Rome

Jashemski, W. 1993 *The Gardens of Pompeii, Herculaneum and the villas destroyed by Vesuvius II.* New Rochelle, NY

1979 *The Gardens of Pompeii, Herculaneum and the villas destroyed by Vesuvius I.* New Rochelle, NY

Jastrzebowska, E. 1981 *Untersuchungen zum christlichen Totenmahl aufgrund der Monumente des 3. und 4. Jahrhunderts unter der Basilika des Hl. Sebastian in Rom.* Frankfurt am Main

1979 'Les scènes de banquet dans les peintures et sculptures chrétiennes des IIIe et IVe siècles', *Recherches Augustiniennes* 14: 3–90

Jeremias, G. 1980 *Die Holztür der Basilika S. Sabina in Rom.* Tübingen

Jobst, W. 1976–7 'Das "öffentliche Freudenhaus" in Ephesos', *ÖJh* 51: 61–84

Johannowsky, W. 1989 *Capua antica.* Naples

Jones, C. P. 1991 'Dinner Theater', in Slater 1991: 185–98

Kajanto, I. 1969 '*Balnea vina venus*', in *Hommages à Marcel Renard II.* Coll. Latomus 102. Brussels: 357–67

Kajava, M. 1998 'Visceratio', *Arctos* 32: 109–31

Kane, J. P. 1975 'The Mithraic cult meal in its Greek and Roman environment', in J.R. Hinnells ed., *Mithraic Studies* II. Manchester: 313–51

Kaufmann-Heinimann, A. 1999 'Eighteen new pieces from the late Roman silver treasure of Kaiseraugst: first notice', *JRA* 12: 333–41

Klauser, Th. 1967 'Studien zur Entstehungsgeschichte der christlichen Kunst IX', *JAC* 10: 82–120

1959 'Studien zur Entstehungsgeschichte der christlichen Kunst II', *JAC* 2: 115–45

1928 'Das altchristliche Totenmahl nach dem heutigen Stande der Forschung', *Theologie und Glaube* 20: 599–608. (= E. Dassmann ed., *Gesammelte Arbeiten zur Liturgiegeschichte, Kirchengeschichte und christlichen Archäologie.* JAC Ergbd. 3 (1974): 114–20)

Kleberg, T. 1957 *Hôtels, restaurants et cabarets dans l'antiquité romaine.* Uppsala

Kleiner, D. E. E. 1981 'Second-century mythological portraiture: Mars and Venus', *Latomus* 40: 512–44, pls. XVIII–XVII

1977 *Roman Group Portraiture. The funerary reliefs of the late Republic and early Empire.* Diss. Columbia 1975. New York/London 1977

Klinger, S. 1997 'Illusionist conceit in some reclining symposiast scenes painted by Euphronios and his colleagues', *AA* 1997: 343–64

Kneissl, P. 1980 'Entstehung und Bedeutung der Augustalität. Zur Inschrift der Ara Narbonensis (CIL XII, 4333)', *Chiron* 10: 291–326

Koch, G. ed. 1998 *Akten des Symposiums "125 Jahre Sarkophag-Corpus." Marburg, 4.–7. Oktober 1995.* Sarkophag-Studien I. Mainz-am-Rhein

1975 *Die mythologischen Sarkophage, 6. Meleager.* ASR 12, 6. Berlin

Koch, G., Sichtermann, H. 1982 *Römische Sarkophage*. Handbuch der Archäologie. Munich

Kockel, V. 1983 *Die Grabbauten vor dem Herkulaner Tor in Pompeji*. Beiträge zur Erschliessung hellenistischer und kaiserzeitlicher Skulptur und Architektur 1. Mainz am Rhein

Koeppel, G. 1983 'Die historischen Reliefs der römischen Kaiserzeit. I. Stadtrömische Denkmäler unbekannter Bauzugehörigkeit aus augusteischer und julisch-claudischer Zeit', *BJb* 183: 61–144

 1982 'Die "Ara Pietatis Augustae": ein Geisterbau', *RM* 89: 453–5

Kondoleon, C. ed. 2000 *Antioch: The lost ancient city*. Princeton

 1994 *Domestic and divine. Roman mosaics in the House of Dionysos*. Ithaca/London

Koortbojian, M. 2002 'A painted *exemplum* at Rome's Temple of Liberty', *JRS* 92: 33–48, pls. V–VIII

Krautheimer, R. 1966 'Die Decanneacubita in Konstantinopel. Ein kleiner Beitrag zur Frage Rom und Byzanz', in W. N. Schumacher ed., *Tortulae. Studien zu altchristlichen und byzantinischen Monumenten*. RömQSchr Suppl. 30. Rome/Freiburg/Vienna: 195–9

Lafon, X. 1989 'Vitruve et les villas "de son temps"', in H. Geertmann, J. J. de Jong edd., *Munus non ingratum. Proceedings of the International Symposium on Vitruvius' De Architectura and the Hellenistic and Republican Architecture, Leiden 20–23 January 1987*. BABesch suppl. 2, Leiden: 188–93

Landolfi, L. 1990 *Banchetto e società romana. Dalle origini al I sec. a.C.* Rome

Lane, E. N. 1985 *Corpus Cultus Iovis Sabazii (CCIS)* II. *The other monuments and literary evidence*. EPRO 100, Leiden

Lassus, J. 1971 'La salle à sept absides de Djemila-Cuicul', *AntAfr* 5: 193–207

Lavin, I. 1962 'The House of the Lord. Aspects of the role of palace triclinia in the architecture of Late Antiquity and the early Middle Ages', *ArtB* 44: 1–27, figs. 1–26

Leach, E. W. 1997 'Oecus on Ibycus: investigating the vocabulary of the Roman house', in S. Bon, R. Jones edd., *Sequence and Space in Pompeii*. Oxford: 50–72

Leary, T. J. 2001 *Martial Book XIII: the Xenia*. London

 1996 *Martial Book XIV: the Apophoreta*. London

Lepelley, C. 1979 *Les cités de l'Afrique romaine au bas-empire. 1. La permanence d'une civilisation municipale*. Paris

Levi, D. 1947 *Antioch Mosaic Pavements*. Princeton

 1944 'Aion', *Hesperia* 13: 269–314

Ling, R. 'The decoration of Roman triclinia', in Murray, Tecuşan 1995: 239–51

Lissarrague, F. 1990 *The aesthetics of the Greek banquet: images of wine and ritual*. Trans. A. Szegedy-Maszak. Princeton. (English translation of *Un flot d'images: une esthétique du banquet grec*. Paris 1987)

 1990a 'Around the krater: an aspect of banquet imagery', in Murray 1990: 196–209

Liverani, P. 1988 'Le proprietà private nell'area Lateranense fino all'età di Costantino', *MEFRA* 100: 891–915

Loeschke, S. 1932 'Römische Denkmäler vom Weinbau an Mosel, Saar und Ruwer', *TrZ* 7: 1–60

Lombardo, M. 1989 'Pratiche di commensalità e forme di organizzazione sociale nel mondo greco: "symposion" e "syssitia",' in O. Longo, P. Scarpi edd., *Homo edens. Regimi, miti e pratiche dell'alimentazione nella civiltà del Mediterraneo*. Verona: 311–25

MacMullen, R. 1997 *Christianity and Paganism in the fourth to eighth centuries*. New Haven/London

Maiuri, A. 1954 'Il "balneum venerium" nella Villa di Giulia Felice (CIL IV, 1136)', in *Saggi di varia antichità*. Venice: 285–99

1945 *La cena di Trimalchione di Petronio Arbitro*. Naples

1938 *Le pitture delle case di 'M. Fabius Amandio', del 'sacerdos Amandus' e di 'P. Cornelius Teges' (Reg. I, ins. 7)*. MonPittAnt sez. 3a. La pittura ellenistico-romana, Pompeii II. Rome

1927 'Pompei. Relazione sui lavori di scavo del marzo 1924 al marzo 1926', *NSc* 1927: 3–83

Marchetti, D. 1892 *NSc* 1892: 44–8

Marquardt, J. 1886 *Das Privatleben der Römer*. 2nd ed. rev. A. Mau. Leipzig. (Rep. 1975)

Mattern, M. 1989 'Die reliefverzierten römischen Grabstelen der Provinz Britannia. Themen und Typen.' *KölnJb* 22: 707–801

Matthäus, H. 1999 'The Greek symposion and the Near East. Chronology and mechanisms of cultural transfer', in R. Docter, E. Moormann edd., *Proceedings of the XVth International Congress of Classical Archaeology, Amsterdam 1998*. Amsterdam: 256–60

Matz, F., von Duhn, F. 1882 *Antike Bildwerke in Rom* III. Leipzig

Mau, A. 1896 'Fulcra lectorum. Testudines alveorum', *Nachrichten von der Königl. Gesellschaft der Wissenschaften zu Göttingen. Philologisch-historische Klasse* 1896: 76–82

1885 *BdI* 1885: 69–71

1883 'Scavi di Pompei', *BdI* 1883: 71–83

Mazal, O. 1980 *Kommentar zur Wiener Genesis. Faksimile-Ausgabe des Codex theol. Gr. 31 der Österreichischen Nationalbibliothek in Wien*. Frankfurt am Main

van der Meer, L. 1984 'Kylikeia in Etruscan Tomb Paintings', in H. Brijder ed., *Ancient Greek and Related Pottery. Proceedings of the International Vase Symposium in Amsterdam, 12–15 April 1984*. Amsterdam: 298–304

1983 'Eine Sigmamahlzeit in Leiden', *BABesch* 58: 101–15

1977–8 'Etruscan urns from Volterra. Studies on mythological representations', *BABesch* 52–3: 57–131

Mellink, M. J. 1998 *Kızılbel: an archaic painted tomb chamber in northern Lycia*. Philadelphia

1973 'Excavations at Karataş-Semayük and Elmalı, Lycia 1971', *AJA* 77: 293–303, pls. 41–6

1972 'Excavations at Karataş-Semayük and Elmalı, Lycia 1971', *AJA* 76: 257–69, pls. 55–60.

Mercando, L. Paci, G. 1998 *Stele romane in Piemonte*. Monumenti Antichi serie miscellanea V. Rome

Mercky, A. 1995 *Römische Grabreliefs und Sarkophage auf den Kykladen*. Europäische Hochschulschriften Reihe XXXVIII, Archäologie. Frankfurt

Meyboom, P. 1995 *The Nile Mosaic of Palestrina. Early evidence of Egyptian religion in Italy*. Religions in the Graeco–Roman World 121. Leiden/New York/Cologne

Meyer, K. 1999 'Axial peristyle houses in the western empire', *JRA* 12: 101–21

Mielsch, H. 1978 'Zur stadtrömischen Malerei des 4. Jahrhunderts n. Chr.', *RM* 85: 151–207, pls. 80–100

Miller, S. G. 1993 *The Tomb of Lyson and Kallikles: a painted Macedonian tomb*. Mainz am Rhein

Miniero, P. 2000, ed. *The archaeological museum of the Phlegraean fields in the castle of Baia. The sacellum of the Augustales at Miseno*. Naples

Mols, S. T. A. M. 1999 *Wooden furniture in Herculaneum. Form, technique and function*. Circumvesuviana 2. Amsterdam

Mols, S. T. A. M., Moormann, E. M. 1993–4 '*Ex parvo crevit*. Proposta per una lettura iconografica della Tomba di Vestorius Priscus fuori Porta Vesuvio a Pompei', *RStPomp* 6: 15–52

Moormann, E. M. 2000 'La bellezza dell'immondezza. Raffigurazioni di rifiuti nell'arte ellenistica e romana', in X. Dupré Raventós. J.-A. Remolà edd., *Sordes Urbis. La eliminación de residuos en la ciudad Romana*. Rome: 75–94

Morricone Matini, M. L. 1967 *Mosaici antichi in Italia. Regione prima. Roma: Reg. X Palatium.* Rome

Morvillez, E. 1996 'Sur les installations de lits de table en sigma dans l'architecture domestique du Haut et du Bas-Empire', *Pallas* 44: 119–58

 1995 'Les salles de réception triconques dans l'architecture domestique de l'Antiquité tardive en Occident', *Histoire de l'Art* 31, octobre: 15–26

Mrozek, S. 1992 'Caractère hiérarchique des repas officiels dans les villes romaines du haut-empire', in M. Aurell, O. Dumoulin, F. Thélamon edd., *La sociabilité à table. Commensalité et convivialité à travers les ages. Actes du colloque de Rouen, 14–17 novembre 1990.* Rouen: 181–6

 1987 *Les distributions d'argent et de nourriture dans les villes italiennes du Haut-Empire romain.* Coll. Latomus 198. Brussels

 1972 '*Crustulum* et *mulsum* dans les villes italiennes', *Athenaeum* 50: 294–300

Mundell Mango, M. 1990 'The Sevso Treasure Hunting Plate', *Apollo*, July: 2–13, 65–7

Mundell Mango, M., Bennett, A. 1994 *The Sevso Treasure. Part One.* JRA suppl. 12. Ann Arbor

Murray, O. 1990, ed. *Sympotica. A Symposium on the symposion.* Oxford

 1990a 'Sympotic History', in Murray 1990: 3–13

 1988 'Death and the Symposion', *AIONapoli* 10: 239–57

 1985 'Symposium and genre in the poetry of Horace', *JRS* 75: 39–50

 1983 'The Greek symposion in history', in E. Gabba ed., *Tria Corda. Scritti in onore di Arnaldo Momigliano.* Como: 257–72

Murray, O., Tecuşan, M. 1995, edd. *In Vino Veritas.* London

Napoli, M. 1970 *La Tomba del Tuffatore. La scoperta della grande pittura greca.* Bari

Nappo, S. 1999 'Nuova indagine archeologica in località Moregine a Pompei', *RstPomp* 10: 185–90

Naumann, R. 1965 'Vorbericht über die Ausgrabungen zwischen Mese und Antiochus-Palast 1964 in Istanbul', *IstMitt* 15: 135–48, pls. 38–41

Nestori, A. 1993 *Repertorio topografico delle pitture delle catacombe romane.* 2nd ed. Roma sotterranea cristiana V. Vatican City

Netzer, E. 1999 *Die Paläste der Hasmonäer und Herodes' des Grossen.* Mainz am Rhein

Neudecker, R. 1988 *Die Skulpturen-Ausstattung römischer Villen in Italien.* Beiträge zur Erschliessung hellenistischer und Kaiserzeitlicher Skulptur und Architektur. Mainz am Rhein

Nielsen, I. 1998 'Royal Banquets: the Development of Royal Banquets and Banqueting Halls from Alexander to the Tetrarchs', in Nielsen, Sigismund Nielsen 1998: 104–33

 1994 *Hellenistic Palaces. Tradition and renewal.* Studies in Hellenistic Civilization 5. Aarhus

Nielsen, I., Sigismund Nielsen, H. 1998, edd. *Meals in a Social Context. Aspects of the communal meal in the Hellenistic and Roman world.* Aarhus

Nielsen, M. 1993 'Cultural orientations in Etruria in the Hellenistic period: Greek myths and local motifs on Volterran urn reliefs', in P. Guldager Bilde, I. Nielsen, M. Nielsen, edd., *Aspects of Hellenism in Italy: towards a cultural unity?* Acta Hyperborea 5: 319–57

 1975 'The lid sculptures of Volterran cinerary urns', in P. Bruun et al., *Studies in the Romanization of Etruria.* ActInstRomFinl 5: 263–404, figs. 1–65

Nilsson, M. 1949 'A propos du tombeau de Vincentius', in: *Mélanges d'archéologie et d'histoire offerts à Charles Picard.* RA 1949: 764–9

Noelke, P. 1998 'Grabreliefs mit Mahldarstellung in den germanisch-gallischen Provinzen—soziale und religiöse Aspekte', in P. Fasold, T. Fischer, H. von Hesberg, M. Witteyer edd., *Bestattungssitte und kulturelle Identität. Grabanlagen und Grabbeigaben den frühen römischen Kaiserzeit in Italien und den Nordwest-Provinzen.* Cologne: 399–418

Nuber, H. U. 1972 'Kanne und Griffschale. Ihr Gebrauch im täglichen Leben und die Beigabe in Gräbern der römischen Kaiserzeit', *Bericht der Römische-Germanischen Kommission* 53: 1–232, pls. 1–31

Ogilvie, R. M. 1965 *A commentary on Livy Books 1–5.* Oxford

Ostrow, S. 1985 '*Augustales* along the bay of Naples: a case for their early growth', *Historia* 34: 64–101

Overbeck, J., Mau, A. 1884 *Pompeji in seinen Gebäuden, Alterthümern und Kunstwerken.* 4th ed., Leipzig

Packer, J. 1978 'Inns at Pompeii: a short survey', *CronPomp* 4: 5–53
 1971 *The Insulae of Imperial Ostia.* MAAR 31

Pagano, M. 1983 'L'Edificio dell'Agro Murecine a Pompei', *RendNap* 58: 325–61, pls. I–XXXI

Painter, K. S. 1993 'Late-Roman silver plate: a reply to Alan Cameron', *JRA* 6: 109–15
 1977 *The Mildenhall Treasure. Roman Silver from East Anglia.* London

Pani Ermini, L. 1969 'L'ipogeo detto dei Flavi in Domitilla, I. Osservazioni sulla sua origine e sul carattere della decorazione', *RACrist* 45: 119–73

Parlasca, K. 1998 'Palmyrenische Sarkophage mit Totenmahlreliefs—Forschungsstand und ikonographische Probleme', in Koch 1998: 311–7, pls. 126–8
 1984 'Probleme der palmyrenischen Sarkophage', in B. Andreae ed., *Symposium über die antiken Sarkophage, Pisa 5.–12. September 1982. MarbWPr* 1984: 283–96
 1975 'Hellenistische Grabreliefs aus Ägypten', *MDIK* 31: 303–14, pls. 93–101
 1970 'Zur Stellung der Terenuthis-Stelen. Eine Gruppe römischer Grabreliefs aus Ägypten in Berlin', *MDIK* 26: 173–98, pls. LX–IX

Parslow, C. 1995–6 'Additional documents illustrating the Bourbon excavations of the *Praedia Iuliae Felicis* in Pompeii', *RStPomp* 7: 115–32

Patterson, J. R. 1994 'The collegia and the transformation of the towns of Italy in the second century AD', in *L'Italie d'Auguste à Dioclétien.* CEFR 198. Rome: 227–38

Pernice, E. 1900 'Bronzen aus Boscoreale', *AA* 1900: 178–98

Pesando, F. 1997 *Domus. Edilizia privata e società pompeiana fra III e I secolo a.C.* Rome

Peschel, I. 1987 *Die Hetäre bei Symposion und Komos in der attisch-rotfigurigen Vasenmalerei des 6.–4. Jahrh. v. Chr.* Frankfurt am Main

Pfuhl, E., Möbius, H. 1979 *Die ostgriechischen Grabreliefs.* Vol. II. Mainz am Rhein
 1977 *Die ostgriechischen Grabreliefs.* Vol. I. Mainz am Rhein

Pirzio Biroli Stefanelli, L. 1991 *L'argento dei Romani. Vasellame da tavola e d'apparato.* Rome
 1990 *Il bronzo dei Romani. Arredo e suppellettile.* Rome

Pollard, N. 1998 'Art, benefaction and élites from Roman Etruria. Funerary relief fragments from Saturnia', *PBSR* 66: 57–70

Pozzi, E., Zevi, F., Sciarelli, G. T., Gianfrotta, P. A., di Stefano, A., Andreae, B., Piccioli, C. 1983 *Baia. Il ninfeo imperiale sommerso di Punta Epitaffio.* Naples

Pozzi, E. et al. 1989 *Le Collezioni del Museo Nazionale di Napoli. La scultura greco-romana, le sculture antiche della collezione Farnese, le collezioni monetali, le oreficerie, la collezione glittica.* Rome
 1986 *Le Collezioni del Museo Nazionale di Napoli. I mosaici, le pitture, gli oggetti di uso quotidiano, gli argenti, le terrecotte invetriate, i vetri, i cristalli, gli avori.* Rome

Praschniker, C., Theuer, M. 1979 *Das Mausoleum von Belevi.* Forschungen in Ephesos 6. Vienna

Pucci, G. 1968–69 'L'epitaffio di Flavio Agricola e un disegno della collezione Dal Pozzo-Albani', *BullComm* 81: 173–7, pl. LXXV

Pudliszewski, J. 1992 'L'*epulum* dans les inscription espagnoles', *Eos* 80: 69–76

Purcell, N. 1995 'Eating fish: the paradoxes of seafood', in J. Wilkins, D. Harvey, M. Dobson edd., *Food in Antiquity.* Exeter: 132–49

1994 'The City of Rome and the *Plebs urbana* in the late Republic', in *CAH* 9²: ch. 17, 644–88

1983 'The *apparitores*: a study in social mobility', *PBSR* 51: 125–73

Rathje, A. 1995 'Il banchetto in Italia centrale: quale stile di vita?', in Murray, Tecuşan 1995: 167–75

1994 'Banquet and ideology. Some new considerations about banqueting at Poggio Civitate', in R. De Puma, J. P. Small edd., *Murlo and the Etruscans. Art and Society in ancient Etruria*. Madison, Wisconsin: 95–9

1991 'Il banchetto presso i fenici', *Atti del II Congresso Internazionale di Studi Fenici e Punici. Roma, 9–14 novembre 1987* III. Rome: 1165–8

1983 'A banquet service from the Latin City of Ficana', *AnalRom* 12: 7–29

Reade, J. E. 1995 'The *symposion* in ancient Mesopotamia: archaeological evidence', in Murray, Tecuşan 1995: 35–56

Rebecchi, F. 1986 'Appunti per una storia di Modena nel tardo-impero: monumenti e contesto sociale.' *MEFRA* 98: 881–930

Reber, K. 1998 *Die klassischen und hellenistischen Wohnhäuser im Westquartier*. Eretria X. Lausanne

Rebuffat, R., Hallier, G. 1970 *Thamusida. Fouilles du Service des Antiquités du Maroc* II. Rome

Richardson, L., Jr. 1988 'Water Triclinia and Biclinia in Pompeii', in R. Curtis ed., *Studia Pompeiana et Classica, in honor of Wilhelmina F. Jashemski, I: Pompeiana*. New Rochelle, NY: 305–15

1955 'Pompeii: the Casa dei Dioscuri and its painters', *MAAR* 23

Ridgway, B. S. 1990 *Hellenistic Sculpture I. The styles of ca. 331–200 BC*. Wisconsin

Riposati, B. 1939 *M. Terenti Varronis De Vita Populi Romani. Fonti—esegesi—edizione critica dei frammenti*. Milan

Roberts, M. 1995 'Martin meets Maximus: the meaning of a late Roman banquet', *REAug* 41: 91–111

Robotti, C. 1974 *Il Museo Provinciale Campano di Capua*. Caserta

Rogge, S. 1995 *Die attischen Sarkophage 1. Achill und Hippolytos*. ASR 9.I.1. Berlin

Ronke, J. 1987 *Magistratische Repräsentation im römischen Relief. Studien zu standes- und statusbezeichnenden Szenen*. BAR-IS 370, i–iii. Oxford

Rosenthal, E. 1972 *The Illuminations of the Vergilius Romanus (Cod. Vat. Lat. 3867). A stylistic and iconographical analysis*. Zurich

Rossiter, J. 1991 'Convivium and villa in late antiquity', in Slater 1991: 199–214, figs. 1–8.

1989 'Roman villas of the Greek east and the villa in Gregory of Nyssa *Ep*. 20', *JRA* 2: 101–10

Rotroff, S. 1996 *The Missing Krater and the Hellenistic Symposium: Drinking in the Age of Alexander the Great*. Broadhead Classical Lecture No. 7, University of Canterbury. Christchurch, NZ: 1996

Rouveret, A. 1974 'La tombe du Plongeur et les fresques étrusques: témoignages sur la peinture grecque', *RA* 1974: 15–32

Russell, J. 1984 'Funerary scenes from Roman Anemurium', *Yayla* 5: 16–24

Ryberg, I. S. 1955 *Rites of the State Religion in Roman Art*. MAAR 22

Salza Prina Ricotti, E. 1989 'Le tende conviviali e la tenda di Tolomeo Filadelfo', in R. Curtis ed., *Studia Pompeiana et Classica, in honor of Wilhelmina F. Jashemski* II. New Rochelle, NY: 199–239

1987 'The importance of water in Roman garden triclinia', in E. MacDougall ed., *Ancient Roman Villa Gardens*. Dumbarton Oaks Colloquium on the History of Landscape Architecture 10. Washington, DC: 135–84

1983 *L'arte del convito nella Roma antica. Con 90 ricette*. Rome

1979 'Forme speciali di triclini', *CronPomp* 5: 102–49

1978–80 'Cucine e quartieri servili in epoca romana', *RendPontAcc* 51–2: 237–94

Santa Maria Scrinari, V. 1991 *Il Laterano Imperiale. I. Dalle 'aedes Laterani' alla 'Domus Faustae'*. Vatican City

Saxer, V. 1980 *Morts martyrs reliques en Afrique chrétienne aux premiers siècles. Les témoignages de Tertullien, Cyprien et Augustin à la lumière de l'archéologie africaine*. Paris

Schäfer, A. 1997 *Unterhaltung beim griechischen Symposion. Darbietungen, Spiele und Wett-Kämpfe von homerischer bis in spätklassische Zeit*. Mainz

Schäfer, T. 1990 'Der Honor Bisellii', *RM* 97: 307–46, pls. 91–102

Schefold, K. 1962 *Vergessenes Pompeji*. Bern/Munich

Scheid, J. 1985 'Sacrifice et banquet à Rome. Quelques problèmes', *MEFRA* 97: 193–206

1984 'Contraria facere: renversements et déplacements dans les rites funéraires', *AION* 6: 117–39

Schmidt, S. 1991 *Hellenistische Grabreliefs. Typologische und chronologische Beobachtungen*. Cologne/Vienna 1991

Schmitt Pantel, P. 1992 *La cité au banquet. Histoire des repas publics dans les cités grecques*. CEFR 157. Rome

1990 'Sacrificial meal and *symposion*: two models of civic institutions in the archaic city', in Murray 1990: 14–33

1982 'Éuergetisme et mémoire du mort. A propos des fondations de banquets publics dans les cités grecques à l'époque hellénistique et romaine', in G. Gnoli, J.-P. Vernant edd., *La mort, les morts dans les sociétés anciennes*. Cambridge/Paris: 177–88

Schmitt, P., Schnapp, A. 1982 'Image et société en Grèce ancienne: les représentations de la chasse et du banquet', *RA* 1982: 57–74

Scott, G. D. 1995 'A study of the Lycurgus cup', *JGS* 37: 51–64

1993 'Reconstructing and repreducing the Hohensülzen cage cup', *JGS* 35: 106–18

Shapiro, H. A. 2000 'Modest athletes and liberated women: Etruscans on Attic black-figure vases', in B. Cohen ed., *Not the Classical Ideal. Athens and the Construction of the Other in Greek Art*. Leiden: 315–37

Shelton, K. 1985 'The Esquiline Treasure. The nature of the evidence', *AJA* 89: 147–55, pls. 29–30

1981 *The Esquiline Treasure*. London

Sinn, F. 1987 *Stadtrömische Marmorurnen*. Beiträge zur Erschliessung hellenistischer und Kaiserzeitlicher Skulptur und Architektur 8. Mainz am Rhein

Slater, W. J. 2000 'Handouts at dinner', *Phoenix* 54: 107–22

1991 ed., *Dining in a classical context*. Ann Arbor

Small, J. P. 1994 'Eat, drink and be merry. Etruscan banquets', in R. De Puma, J. P. Small edd., *Murlo and the Etruscans. Art and Society in ancient Etruria*. Madison, Wisconsin: 85–94

1971 'The Banquet Frieze from Poggio Civitate (Murlo)', *StEtr* 38: 25–61, pls. XIII–XVI

Smith, R., Mare, W. H. 1997 'A Roman tomb at Abila of the Decapolis' *JRA* 10: 307–14, fig. 13 (colour)

Sodini, J.-P. 1997 'Habitat de l'antiquité tardive', *Topoi Orient-Occident* 7: 435–577

1995 'Habitat de l'antiquité tardive', *Topoi Orient-Occident* 5: 151–218

1984 'L'habitat urbain en Grèce à la veille des invasions', in *Villes et peuplement dans l'Illyricum protobyzantin. Actes du colloque organisé par l'École française de Rome. Rome 12–14 mai 1982*. CEFR 77. Rome: 341–96

Soprano, P. 1950 'I triclini all'aperto di Pompei', in *Pompeiana*. Naples: 288–310

Spano, G. 1943 'La tomba dell'edile C. Vestorio Prisco in Pompei', *Atti della Reale Accademia d'Italia, Memorie della classe di scienze morali e storiche*, ser. 7ª, 3, fasc. 6: 237–315

Speidel, M. 1994 *Die Denkmäler der Kaiserreiter. Equites singulares Augusti*. BJb Beiheft 50. Cologne

Spinazzola, V. 1953 *Pompei alla luce degli scavi nuovi di via dell'Abbondanza (anni 1910–1923)*. Rome

Steingräber, S. 1986, ed. *Etruscan Painting. Catalogue raisonné of Etruscan wall paintings*. New York

Steinhart, M., Slater, W. J. 1997 'Phineus as monoposiast', *JHS* 117: 203–11, pls. V–VIII

Stein-Hölkeskamp, E. 2001 'Ciceronische *Convivia*: der rastlose Republikaner und die zügellosen Zecher', *Hermes* 129: 362–76

Stern, E. M. 1999 'Roman Glassblowing in a cultural context', *AJA* 103: 441–84
 1997 'Glass and rock crystal: a multifaceted relationship', *JRA* 10: 192–206

Stillwell, R. 1961 'Houses of Antioch', *DOP* 15: 45–57

Stopponi, S. 1985, ed. *Case e palazzi d'Etruria*. Milan
 1983 *La Tomba della "scrofa nera"*. Materiali del Museo Archeologico di Tarquinia VIII. Rome

Strocka, V. M. 1995 'Tetrarchische Wandmalereien in Ephesos', *AnTard* 3: 77–89
 1971 'Kleinasiatische Klinensarkophag-Deckel', *AA* 86: 62–86

Stuart Jones, H. 1912 *A Catalogue of the Ancient Sculptures preserved in the Municipal Collections of Rome. The sculptures of the Museo Capitolino*. Oxford

Studniczka, F. 1914 *Das Symposium Ptolemaios II*. Abhandlungen der Kön. Sächsischen Gesellschaft der Wissenschaften, Phil.-hist. Kl. 30.2. Leipzig

Stuiber, A. 1957 *Refrigerium interim. Die Vorstellungen vom Zwischenzustand und die frühchristliche Grabeskunst*. Theophaneia 11. Bonn

Talgam, R., Weiss, Z. forthcoming *Mosaics in the house of Dionysus at Sepphoris*. Qedem. Jerusalem

Tamm, J. 2001 *Argentum potorium in Romano-Campanian wall-painting*. Ph.D. Diss. McMaster

Tchernia, A. 1995 'Le vin et l'honneur', in Murray, Tecuşan 1995: 297–303
 1986 *Le Vin de l'Italie romaine. Essai d'histoire économique d'après les amphores*. BEFAR 261. Rome

Thébert, Y. 1987 'Private life and domestic architecture in Roman Africa', in P. Veyne ed., *A History of Private Life* I. *From pagan Rome to Byzantium*. Cambridge, MA: 319–409

Thimme, J. 1957 'Chiusinische Aschenkisten und Sarkophage der hellenistischen Zeit II.' *StEtr* 25: 87–160
 1954 'Chiusinische Aschenkisten und Sarkophage der hellenistischen Zeit.' *StEtr* 23: 25–147

Thönges-Stringaris, R. 1965 'Das griechische Totenmahl.' *AM* 80: 1–99, Beilage 1–30

Tolotti, F. 1984 'Sguardo d'insieme al monumento sotto S. Sebastiano e nuovo tentativo di interpretarlo.' *RACrist* 60: 123–61
 1970 *Il Cimitero di Priscilla. Studio di topografia e architettura*. Collezione "Amici delle Catacombe" 26. Vatican City

Tomasevic Buck, T. 2002 'Römische *Authepsae*, auch ein Instrument der ärztlichen Versorgung?', in C. Mattusch, A. Brauer, S. Knudsen edd., *From the parts to the whole. 2, Acta of the 13th International Bronze Congress, Cambridge MA 1996*. JRA suppl. 39: 213–32

Torelli, M. 1982 *Typology and structure of Roman historical reliefs*. Ann Arbor
 1963–4 'Il monumento di Lusius Storax: il frontone', *StMisc* 10: 72–84, pls. XXX–II, figs. 72–7

Toynbee, J. M. C. 1971 *Death and burial in the Roman World*. London

Toynbee, J. M. C., Ward Perkins, J. 1956 *The Shrine of St. Peter and the Vatican Excavations*. London/New York/Toronto

Toynbee, J. M. C., Painter, K. 1986 'Silver Picture Plates of Late Antiquity: A.D. 300 to 700', *Archaeologia* 108: 15–65, pls. VII–XXX

Tran Tam Tinh 1974 *Catalogue des peintures romaines (Latium et Campanie) du musée du Louvre.* Paris

Trümper, M. 1998 *Wohnen in Delos. Eine baugeschichtliche Untersuchung zum Wandel des Wohnkultur in hellenistischer Zeit.* Rahden/Westf.

Tsibidou-Avloniti, M. 2002 'Excavating a painted Macedonian tomb near Thessaloniki. An astonishing discovery', in M. Stamatopoulou, M. Yeroulanou edd., *Excavating Classical Culture. Recent Archaeological Discoveries in Greece.* Oxford: 91–7, pls. 21–4

1994 'Αγ. Αθανάσιος 1994. Το χρονικό μιας αποκάλυψης,' Το Αρχαιολογικό Εργο στη Μακεδονία καί Θράκη 8: 231–40

Tuck, A. 1994 'The Etruscan seated banquet: Villanovan ritual and Etruscan iconography', *AJA* 98: 617–28

Tudor, D. 1976 *Corpus Monumentorum Religionis Equitum Danuvinorum (CMRED)* II. *The analysis and interpretation of the monuments.* EPRO 13. Leiden

Turcan, R. 1992 *Cults of the Roman Empire.* Oxford

Turcan-Deleani, M. 1964 'Frigus amabile', in M. Renard, R. Schilling edd., *Hommages à Jean Bayet.* Brussels: 691–6

Vagenheim, G. 1992 'Des inscriptions ligoriennes dans le Museo Cartoceo. Pour une étude de la tradition des dessins d'après l'antique', *Cassiano dal Pozzo's Paper Museum* I: 79–104

Van Bremen, R. 1996 *The limits of participation. Women and civic life in the Greek East in the Hellenistic and Roman period.* Amsterdam

van Nijf, O. 1997 *The civic world of professional associations in the Roman East.* Amsterdam

Vaquerizo Gil, D., Carrillo Diaz-Pines, J. R. 1995 'The Roman villa of El Ruedo (Almedinilla, Córdoba)', *JRA* 8: 121–54

Vaquerizo Gil, D., Noguera Celdrán, J. M. 1997 *La villa romana de El Ruedo (Almedinilla, Córdoba). Decoración escultórica y interpretación.* Murcia

Varone, A. 1997 'Pompei: il quadro Helbig 1445, "Kasperl in Kindertheater", una nuova replica e il problema delle copie e delle varianti', in D. Scagliarini Corlàita ed., *I Temi figurativi nella pittura parietale antica (IV sec. a.C.—IV sec. d.C.). Atti del VI Convegno Internazionale sulla Pittura Parietale Antica (Bologna, 20–23 settembre 1995).* Bologna: 149–52, 351–2 figs. 1–6

1993 'Scavi recenti a Pompei lungo la via dell'Abbondanza (Regio IX, ins. 12, 6–7)', in L. Franchi dell'Orto ed., *Ercolano 1738–1988. 250 anni di ricerca archeologica.* Rome: 617–40

1990 'Pompei. Attività dell'Ufficio Scavi: 1990', *RStPomp* 4: 201–11

1989 'Pompei. Attività dell'Ufficio Scavi: 1989', *RStPomp* 3: 225–38

Vermeule, C. 1966 *The Dal Pozzo-Albani drawings of classical antiquities in the Royal Library at Windsor Castle.* Transactions of the American Philosophical Society n.s. 56.2

Veyne, P. 1959 'Une fondation alimentaire sur un bas-relief d'Ascoli Piceno.' *BAntFr* 1959: 113–23, pl. VIII

Vickers, M. 1996 'Rock crystal: the key to cut glass and *diatreta* in Persia and Rome.' *JRA* 9: 48–65

Vierneisel, K., Kaeser, B. edd. 1990 *Kunst der Schale—Kultur des Trinkens.* Munich

Villard, P. 1988 'Le mélange et ses problèmes', *REA* 90: 19–33

Viscogliosi, A. 1996 '*Antra cyclopis*: osservazioni su una tipologia di *coenatio*', in *Ulisse. Il mito e la memoria.* Rome: 252–69

Vollmoeller, K. G. 1901 'Über zwei euböische Kammergräber mit Totenbetten', *AM* 26: 333–76, pls. XIII–VII

Voza, G. 1983 'Aspetti e problemi dei nuovi monumenti d'arte musiva in Sicilia', in R. Farioli Campanati ed., *III Colloquio Internazionale sul mosaico antico, Ravenna 6–10 settembre 1980.* Ravenna: 5–18

Ward-Perkins, B. 1984 *From Classical Antiquity to the Middle Ages. Urban public building in northern and central Italy, AD 300–850.* Oxford

Ward-Perkins, J. B., Claridge, A. 1976 *Pompeii AD 79.* London

Weber-Lehmann, C. 1985 'Spätarchaische Gelagebilder in Tarquinia', *RM* 92: 19–44, pls. 4–33

Weiss, Z., Netzer, E. 1998 'Zippori—1994–1995', *Excavations and surveys in Israel* 18, 106, 1998, 22–7 (= Hadashot Arkheologiyot 106, 1996)

Weitzmann, K. ed. 1979 *Age of Spirituality. Late Antique and Early Christian Art, Third to Seventh Century. Catalogue of the exhibition at the Metropolitan Museum of Art, November 19 1977–February 12 1978.* New York

Wesch-Klein, G. 1990 *Liberalitas in Rem Publicam. Private Aufwendungen zugunsten von Gemeinden im römischen Afrika bis 284 n. Chr.* Antiquitas I, 40. Bonn

White, L. M. 1990 *Building God's House in the Roman World. Architectural adaptation among pagans, Jews, and Christians.* Baltimore

Whitehead, J. 1993 'The 'Cena Trimalchionis' and biographical narration in Roman middle-class art', in P. Holliday ed., *Narrative and Event in ancient art.* Cambridge: 299–325

Wiegartz, H. 1974 'Marmorhandel, Sarkophagherstellung und die Lokalisierung der Kleinasiatischen Säulensarkophage', in *Mansel'e Armağan—Mélanges Mansel I.* Ankara: 345–83

 1965 *Kleinasiatische Säulensarkophage. Untersuchungen zum Sarkophagtypus und zu den figürlichen Darstellungen.* IstForsch 26. Berlin

Wiel Marin, F. 1997 'Due diverse associazioni di vasi nel banchetto etrusco', *RM* 104: 514–8

Wiemer, H.-U. 1998 'Zwei Epigramme und eine Sonnenuhr im Kaiserzeitlichen Sillyon', *EA* 30: 149–52, pl. 13

Wiggers, H. B., Wegner, M. 1971 *Caracalla. Geta. Plautilla. Macrinus bis Balbinus.* Das römische Herrscherbild III.1. Berlin

Wilkins, J. 2000 *The Boastful Chef. The discourse of food in ancient Greek comedy.* Oxford

Will, E. 1997 'Les salles de banquet de Palmyre et d'autres lieux', *Topoi* 7: 873–87

 1985 *Le sanctuaire de la déesse syrienne.* Délos 35. Paris

 1976 'Banquets et salles de banquet dans les cultes de la Grèce et de l'Empire romain', in P. Ducrey ed., *Mélanges d'histoire et d'archéologie offerts à Paul Collart.* Lausanne: 353–62

Wilpert, J. 1903 *Die Malereien der Katakomben Roms.* Freiburg i. Br.

Wrede, H. 2001 *Senatorische Sarkophage Roms. Der Beitrag des Senatenstandes zur römischen Kunst der hohen und späten Kaiserzeit.* Monumenta Artis Romanae 29. Mainz am Rhein

 1990 'Der Sarkophagdeckel eines Mädchens in Malibu und die frühen Klinensarkophage Roms, Athens und Kleinasiens', in *Roman Funerary Monuments in the J. Paul Getty Museum Volume 1.* OPA 6. Malibu: 15–46

 1984 'Stadtrömische Klinensarkophage', in B. Andreae ed., *Symposium über die antiken Sarkophage, Pisa 5.–12. September 1982. MarbWPr* 1984: 105–7

 1981 'Klinenprobleme', *AA* 1981: 86–131

 1981a *Consecratio in formam deorum. Vergöttlichte Privatpersonen in der römischen Kaiserzeit.* Mainz am Rhein

 1977 'Stadtrömische Monumente, Urnen und Sarkophage des Klinentypus in den beiden ersten Jahrhunderten n. Chr.', *AA* 92: 395–431

1971 'Das Mausoleum der Claudia Semne und die bürgerliche Plastik der Kaiserzeit', *RM* 78: 125–66, pls. 74–90

Wright, D. 1992 *Codicological Notes on the Vergilius Romanus (Vat. Lat. 3867).* Studi e Testi 345, Vatican City

Zaccaria Ruggiu, A. P. 1995 'Origine del triclinio nella casa romana', in G. Cavalieri Manasse, E. Roffia edd., *Splendida civitas nostra. Studi archeologici in onore di Antonio Frova.* Rome: 137–54

Zahn, R. 1950–1 'Das sogenannte Kindergrab des Berliner Antiquariums', *JdI* 65–6: 264–86

1923 *KTΩ XPΩ. Glasierter Tonbecher im Berliner Antiquarium.* Berliner Winckelmannsprogramm 81

Zanker, P. 1994 'Veränderungen im öffentlichen Raum der italischen Städte der Kaiserzeit', in *L'Italie d'Auguste à Dioclétien.* CEFR 198. Rome: 259–84

1992 'Bürgerliche Selbstdarstellung am Grab im römischen Kaiserreich', in H.-J. Schalles, H. von Hesberg, P. Zanker edd., *Die römische Stadt im 2. Jahrhundert n. Chr. Der Funktionswandel des öffentlichen Raumes. Kolloquium Xanten 1990.* Cologne: 339–52

1979 'Die Villa als Vorbild des späten pompejanischen Wohngeschmacks', *JdI* 94: 460–523

1975 'Grabreliefs römischer Freigelassener', *JdI* 90: 267–315

Zaphiropoulou, Ph. 1991 'Banquets funéraires sur des reliefs de Paros', *BCH* 115: 525–43

Zimmer, G. 1996 'Prunkgeschirr hellenistischer Herrscher', in Hoepfner, Brands 1996: 130–5

Zimmermann, N. 2001 'Ausstattungspraxis und Aussageabsicht. Beobachtungen an Malereien römischer Katakomben', *Mitteilungen zur Christlichen Archäologie* 7: 43–59

Index of Ancient Sources

B. *Inscriptions*

Index of Sites and Monuments

General Index

Achilles as banqueter, 16, 19
agape, 177, 186
allegorical figures, in banquet scenes,
 69–70, 180, 184–5
andron, 36–8, 46, 47
antiquarian interest in dining, Renaissance,
 4, 6
asarotos oikos, 64, 159
Assurbanipal, 14–15
Augustales, 78–9, 82–3, 89, 98
authepsae/hot water heaters, 22, 67, 149–50,
 165, 166–8, 178, 179, 185, 229 n.76

banqueting scenes,
 in Christian art, 175–87
 in Etruscan art, 25–32
 in Greek art, 15–17, 19–20, 22
 in Hellenistic art, 17–18
banquet,
 in next world, Christian, 177, 186, 189
 Etruscan, 29–30
 Roman ideas, 126, 190
 mythological, 196–8
 public, 13, 72–4, 79, 82–4, 88, 92
 solitary, 15–16, 122; *see also* Totenmahl
 motif
biblical scenes, 176–7, 186–7, 198–9, 247
 n.58
 Last Supper, 199–202
biclinium, 128–9, 211 n.9, 217 n.10
bisellium, 79
broad room, Hellenistic, 47

calda, see authepsa; wine, mixing
cena, 78, 82
Chi-Rho, 144
children, in Christian banquets, 178–185
Christianity, 144, 169, 190–1
collegia, 72–3, 78, 93, 94, 97–9, 100
comissatio, see drinking party
convivium, 4, 13
couches, Greek, 38
 Hellenistic, 38, 211 n.10
 Roman, 38, 111, 231 n.16; *see also*
 stibadium; triclinium

decurions, 78–9, 82
deipnon, see symposion
dining rooms, *see andron*; broad room;
 stibadium; triclinium; triconch
dining customs, archaic Rome/Latium,
 32–3
 Etruria, 25–8
dining, out of doors, 51, 53–4, 58, 60–1,
 92, 145–6, 172, 186
Dionysiac scenes in dining rooms, 8–9,
 203
Dionysus, as banqueter, 8, 16, 19, 70
drinking mottoes, 152, 163–4, 179–80
drinking party, 21–2, 53–4, 56, 58–9
drunkenness, 58, 63, 139–40, 151, 187

entertainment at banquet, 43, 173–4
 dice-players, 82, 157, 166
 music, 90, 130, 199